Lady of the Beasts

Lady of the Beasts

BUFFIE JOHNSON

Ancient Images

of the Goddess and Her

Sacred Animals

1817

HARPER & ROW, PUBLISHERS,
SAN FRANCISCO

Cambridge, Hagerstown, New York
Philadelphia, Washington, London
Mexico City, São Paulo
Singapore, Sydney

Photo editor: Lindsay Kefauver, assisted by Caroline
Pincus and Gail Scharf.

Credits for photos and drawings appear on pp. 371–378.

Photograph of author in 1943 by Edward Weston.
Copyright © 1981 Arizona Board of Regents, Center
for Creative Photography.

Chart on p. 5 courtesy of Ashley Montagu. Based on
chart in *Man: His First Million Years*, by Ashley
Montagu.

Library of Congress Cataloging-in-Publication Data
Johnson, Buffie.
 Lady of the beasts.

 Bibliography: p.
 Includes index.
 1. Mother-goddesses. 2. Animals—Religious aspects.
I. Title.
BL325.M6J64 1988 291.2'12 88-45140
ISBN 0-06-250423-1

88 89 90 91 92 RRD 10 9 8 7 6 5 4 3 2 1

To the living spirits

of

NATASHA RAMBOVA

and

CARL GUSTAV JUNG

Contents

Preface

In February of 1954 I wrote a letter to Carl Jung. I was in Salzburg, lecturing at the Seminar in American Studies, and had arranged to go next month to Ascona, in the Ticino, on the Swiss side of Lago Maggiore, to examine an archive of photographs pertaining to the Great Goddess. I asked Dr. Jung if I might visit him in Zurich, but I did not mention that my visit would be a stop on the way to the Ticino. He wrote back to say he wouldn't be in Zurich and suggested I come to the hotel in Ascona where he and his wife would be taking a three-week holiday.

I already had a reservation at the same little hotel on the quay, and thus began a series of coincidences that has always seemed to me an example of Jung's theory of synchronicity. When we met at the Casa Manasa, the doctor and I hit it off at once. I had been greatly influenced by his passionate exploration of human consciousness and told him so. He questioned me at length and with kindness about my as-yet-unwritten book, interested, no doubt, because the Great Mother and her sacred animals were among his basic archetypes.

We talked often over breakfast in the hotel dining room, sometimes at tea on the terrace overlooking the lake, and always after dinner in the sitting room, a cozy place with simple wooden furniture upholstered in bright Swiss blues and whites. The shades on the glass doors to the courtyard were always pulled down at sunset, as if to hold in the light.

Just as we took our meals in different places, so too did our conversation revolve around different subjects at various times of day. At night Dr. Jung liked to talk about Africa. He had lived in Kenya and Uganda and considered his years there the most revealing experience of his life. He seemed to think naturally in images and mentioned that seeing the profile of an African man silhouetted against the rosy afterglow of a twilight sky had been the occasion for a revelation that helped him to understand the initial unfolding of the human psyche.

At tea the Jungs usually had visitors from Zurich, so the opportunities for private conversations with the doctor were limited. Occasionally, we took walks on the quay, and on one of these walks I asked him to explain synchronicity. He pointed to the smooth stones on the bottom of the lake and the unruffled surface above, two levels of the same experience accessible at the same time.

But breakfast was my favorite time. The dining room was almost empty those two weeks, and, over tea, muffins, and honey, we talked about the sources and development of my work.

I cannot remember my exact words, but I told the doctor that when I was a child my favorite occupations were painting and writing. I wrote short poems about nature, about the woods and ponds circled by wild irises where I lived by the sea in Duxbury, Massachusetts, and typed with one finger a book on astronomy. Dr. Jung was uncommonly receptive to the intimacy of reminiscence, so I may have told him about my secret childhood dances—the Egyptian, the Japanese, the Butterfly. But most important was my preoccupation with the Goddess, long before I heard the word *goddess* or knew what it meant. At the age of eight I had painted a series of forty watercolors, feminine images I called "The Spirits Of." I made spirits of the sun, the moon, the stars, the winds, the sky, and the earth.

In the thirties, when I was painting and exhibiting in Paris, a friend told me about a lecture on the Goddess she had heard in New York, and "The Spirits Of" came flooding back. On my return to the States I met Egyptologist Natasha Rambova, an extraordinary woman who, when she lived in Versailles with her aunt Elsie de Wolf, later Lady Mendel, grew up in the circle around the mystic, Gurdjieff. Natasha danced with the Ballet Russe and later married her ballroom dancing partner, Rudolph Valentino. With her I studied

esoteric symbolism and mythology for five years, and a deep rapport grew between us. During this time I decided to write a book about the virtually forgotten Goddess. Natasha suggested an oblique approach: Why not write a study of the Goddess as manifested in the iconic representations of her sacred animals? I took up her suggestion immediately.

The Goddess reasserted herself in my paintings; in 1950 I received a small stipend from the Bollingen Foundation and began to collect photographs. It was the search for images of the Great Mother that had led to the seat across the table from the tall, keen-eyed man with white hair who so generously encouraged me to continue my research. Later that year he invited me to Zurich to use his library.

I did not know it then, but those breakfasts would have to tide me over a long time. After I returned to New York in the fifties, I tried discussing the Goddess. The philosophers, psychoanalysts, and theologians I knew responded with interest; but writers and fellow artists phased out of these conversations at various speeds. So I kept quiet, combing the museums and archives of Europe for photographs. Throughout these years of work on the book, my principal occupation was painting. I wrote a few hours each morning when I was fresh and kept an eye open for pertinent images

The author in 1943,
the year her work
on the book began.

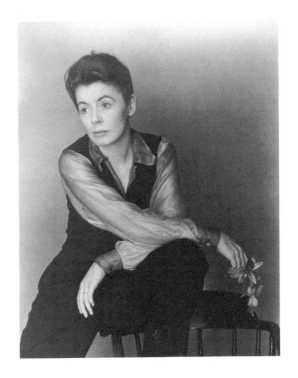

for my book. The visual object was my clue;
I wrote the book around the pictures.

The original lack of interest in the book's
subject slowed me down; yet time has
worked in my favor. The scholarship that
has proliferated since J. J. Bachofen's
rediscovery in 1859 of matriarchal culture
has been helpful. Now many people are
interested in the subject. My key twentieth-
century sources have been Harrison,
Briffault, Neumann, and Gimbutas.

I owe a great debt to my generous friend,
Marija Gimbutas, the archaeologist whose
discoveries are changing the formerly
accepted perceptions of ancient cultural
history. Her work, especially *The Language
of the Goddess,* influenced the focus of
this book considerably, and her friendly
support over the last years has been of
inestimable value.

But this kind of research, amplification, and
burnishing could go on forever. Here is the
book Natasha Rambova asked for in New
York in 1943, and I promised to Dr. Jung in
Ascona in 1954. I hope *Lady of the Beasts*
would have met with their approval.

BUFFIE JOHNSON
New York City
October 1987

ACKNOWLEDGMENTS

I would especially like to thank my good friend, Marija Gimbutas, for all her help. I also want to thank Joseph Campbell, Mircea Eliade, Clayton Carlson, Kermit Lansner, David Gascoyne, Ingrid Kepler-May, Yvonne Keller, Dr. Violet de Laszlo, Ashley Montagu, Michael Scott, Eugene Schwartz, Gerald Sykes, Paul Tillich, Robert Amussen, Blair Seagram, Gloria Orenstein, Barbara Walker, Grace Shinell, Joan Iten Sutherland, Rollo May, Sam Francis, Elinor Gadon, William Barrett, Josephine Graff, Merlin Stone, Paul Bowles, Donna Wilshire, Jenny Sykes, Kamado, Seth Rosen, William McGuire, the Bollingen Foundation, and Annmari Ronnberg at ARAS (Archives for Research in Archetypal Symbolism, New York and Los Angeles).

Lady of the Beasts

The Primal Female

Cave painting from Cogus pictures women performing the Dance of the Hours. Spain, Upper Paleolithic, after 10,000 B.C.E. Detail of fig. 317.

The Earth Mother is a cosmogonic figure, the eternally fruitful source of everything. She is simply The Mother. All things came from her, return to her and are her. The totality of the cosmos is her body, she gives birth to everything from her womb, and she nourishes all from her breasts. There is no essential change or individuation. Each separate being is a manifestation of her; all things share in her life through an eternal cycle of birth and rebirth.

—ENCYCLOPEDIA BRITANNICA

The image came first, and seeing remains the most natural mode of apprehension. Through the imagery of the Great Goddess in this book, I attempt to recapture that nonverbal manner of comprehending the world. Her icons speak to us across the vast silence of the millennia in ways that can only be fathomed without words. They may be "translated" into words, but they are understood only in the deep recesses of the psyche where words are often ineffectual. The first symbols appeared long before the advent of the Cro-Magnons;[1] each one is part of a vast interlocking system. Every image or symbol presented here arises from this worldwide, nonverbal language used in the worship of the divinity. The animals painted on the cave walls point to a prehistoric cosmic view; the more important ones are seen in the sky as constellations.

Myths and rituals 50,000 years old verify Neanderthal belief in an afterlife, but images of the Great Goddess, the first deity, did not emerge until about 30,000 years ago. Some points that may appear speculative are in fact based on reconstructions from archaeological remains. Since writing had not been invented in the Paleolithic era, the Great Mother's name is unknown; doubtless she was worshiped by each clan under a different title. Far later, in literate Crete, we know her as Lady of the Beasts and Goddess of Vegetation. As Mistress of All Creation, she governed life from birth to death, encompassing animals, plants, and humans among her children.

In Ice Age art, the Great Goddess or Great Mother is responsible not only for life and death but also for regeneration. She is an archetype, a primordial image that derives from racial experience inherent in the individual.[2] It is no coincidence that the esoteric number for woman is four; just as in the Christian trinity, the idea of the Great Goddess in three of her aspects— Maiden, Mother, and Crone—cuts across history. Her fourth, and less well known aspect, the Death Goddess, makes her the Lady of Transformation. As her worship evolved, her manifestations and sacred attributes multiplied to fulfill the psychic needs of each community. Not only is the iconography of figures and vessels a manifestation of the ancients' belief, it

contributes a visual language through which their ideas can be deduced and interpreted.

At the core of prehistory loom the animal archetypes, symbols of fertility and death, that stand beside the Great Mother in what can only be described as an epiphany.[3] Her animals are neither totems nor the independent divinities of polytheistic beliefs. They embody the deity herself, defining her personality and exemplifying her power. Her sacred animals act in the myths as guides and soul carriers, much as they do in fairy tales and dreams.

Worship of the divinity continued from the Paleolithic era, through Neolithic times, and into the Bronze Age as a cult practice devoted to increasing the fruitfulness of the earth and the productivity of its creatures. In those ancient times the whole world was viewed as a manifestation of the sacred. People were filled with awe by the mystery of nature, understood as a magical whole. Every aspect of daily domestic routine was considered holy and imbued with ritual intent: the birth of new life, the hunting of animals, the art of the caves, and the later planting and gathering of crops.

The Great Mother exemplified the natural generative forces of the belly or womb of the earth, the cave of subterranean darkness.[4] As the Great Goddess, she is not per se a mother or a fertility deity; she has a far wider concept—that of Cosmic Creatrix. For Stone Age people, God was female. The natural abundance of the earth suggested that the fecund, nourishing female was divine, since all life proceeds from her. Women continued their role as nourishers, introducing agriculture in the Neolithic era, ca. 7000 B.C.E.; it was believed their experience in producing life could best evoke the seed to sprout and flower. Caves, crevices, and caverns are natural manifestations of the primordial womb of the Universal Mother, and the art of the deep recesses of the earth seems to be dedicated to her in much the same way that cathedrals such as Chartres are consecrated to the Virgin Mary.

In the early Neolithic period, birth giving was a sacred function presided over by the Goddess and taking place in rooms designed for the purpose. Birth was linked with nourishment, since the first sustenance comes from the mother. Women also provided for their families on a day-to-day basis. Food gatherers from earliest times, their familiarity with the way things grew led them to become the first gardeners; using their knowledge of herbs, they became, quite naturally, the first practitioners of medicine, and evolved into shamans, familiar with poisons, intoxicants, and magic.

In addition to providing food, women—whose domestic lives centered around the hearth and fire—created weaving. The patching of old baskets with clay led to the making of pottery and its decoration. We know this was done by women from the fingerprints left in the clay.[5] In the Paleolithic era, women developed the first shelters: tents made of skin supported by horns. They went on to dwellings of unfired brick; thus began architecture. These female contributions to the civilizing process led directly to art and culture. Women may have been the painters, too, since in Çatal Hüyük, Anatolia, in modern Turkey, only the women's graves contained painter's tools.[6]

The existence of this matrifocal environment, then, does not mean that women ruled as a matriarchy; but it shows the high prestige of women throughout the Paleolithic and Neolithic epochs. (See the chart at right for a guide to the sequence of prehistoric and historic periods.) Children were named after their mothers; all members of the extended family bonded for survival. Chieftains were nonexistent, and an egalitarian spirit reigned.

The roles and interplay of the sexes remain a mystery; certainly women and men worshiped, celebrated, and made love together. Later came the institution of marriage, a patriarchal expediency that identified the father for purposes of inheritance. The male has been more or less left out in this book since his story has been told; it constitutes history.

Beginning with common roots, growing into separate branches, and continuing to reroot, grow, and interrelate, like the tropical banyan, human society became an entire forest while remaining a single tree. In their search for the meaning of existence, our ancestors used the symbols we see on the cave walls to create the beginnings of art.

The continuity of the ancient graphic artists' splendid search for meaning illuminates the shadow land of time. Nonverbal material from preliterate cultures forms the core of our knowledge of their search. The pictures in painted caves and the sacred objects of the Paleolithic and New Stone ages show a total correspondence between image and idea, a correspondence that has been central to me as a painter. Although the art lay hidden for millennia, the pattern was unbroken. It influenced the ideas of early people and can be recognized by exploring sacred beliefs of Eastern and Western thought. All we need do is look with the inner, as well as the outer, eye.

PRINCIPAL CULTURE STAGES OF EUROPE, EGYPT, AND THE NEAR EAST

AGE	APPROXIMATE DATES (B.C.E.)	NORTHWESTERN CONTINENTAL EUROPE	WEST CENTRAL EUROPE	EGYPT AND THE NEAR EAST	HUMAN TYPES
NEOLITHIC	50 —	Iron Age Introduced	Historic Times Begin		Persisting Varieties of *Homo Sapiens*
	500 —		Iron Age Introduced		
	1000 —	Bronze Age Introduced		Iron Age Begins	
	1500 —	Traces of Copper	Bronze Age Introduced		
	2000 —		Copper Age Introduced	Bronze Age Begins	
	2500 —	Late Neolithic		Alloys in use	
	3000 —	Middle Neolithic	Late Neolithic	History Begins Writing Invented	
	3500 —			Amratian Industry	
	4000 —	Early Neolithic: Shell Mounds	Middle Neolithic Industries	Iron Use Begins	
	4500 —			Agriculture and Domestication of Animals	
	5000 —				
MESO-LITHIC	5500 —	Norse Petroglyphs	Early Neolithic Industries	Use of Copper Begins	
	6000 —	Maglemose Industry			
	6500 —				
PALEOLITHIC — Upper/Late	8500 —		Late Magdalenian		
			Early Magdalenian	Probable beginning of Neolithic culture in Nile valley floor silts	Předmost Cro-Magnon
			Late Aurignacian		
PALEOLITHIC — Middle	15,500 —		Early Aurignacian		Grimaldi Cro-Magnon
	18,500 —				Emergence of Cro-Magnon
	35,000 —		Mousterian Culture		
PALEOLITHIC — Lower/Early	75,000 —				Emergence of Neanderthal
	100,000 —				
	600,000 —				
	1,000,000 —				Emergence of *Homo Erectus*
	2,000,000 —	*Start of Pleistocene*			

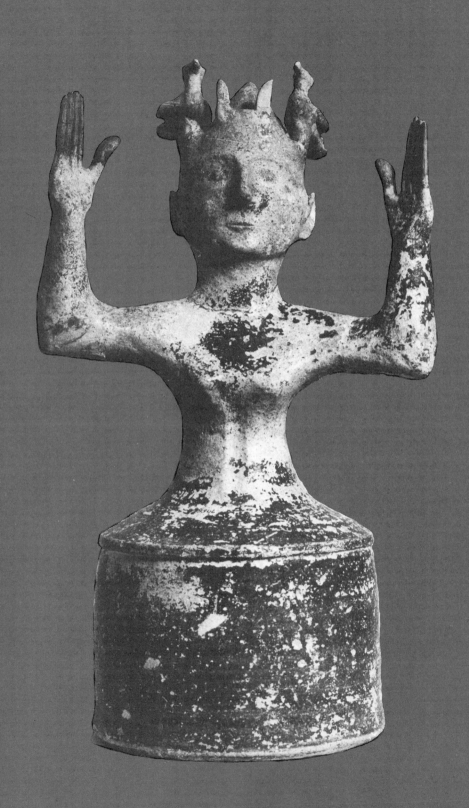

The Bird

The Dove Goddess
of Crete crowned
with birds, cone,
and bull horns.
Crete, Middle
Minoan III, 1700–
1400 B.C.E. See fig.
28 and plate 6.

Bird Deities
of the Paleolithic
Era

The bird peeps out through the thicket of time wearing the ritual mask of the Old Stone Age. Coming from the sky, the bird portrays not only the spirit of life but also the human soul. Because of this and because its twofold birth, first as an egg and then as a chick, suggests rebirth and regeneration, the bird was considered by ancient worshipers of the Goddess to be sacred above all other creatures.

BIRD MAGIC

Since birds inhabit the upper air where weather originates, the bird was believed in primitive times to magically command the weather, bringing rain and controlling thunder and lightning. Water birds were responsible for rain, while the woodpecker governed storms and especially thunder; the movement of these birds was watched closely for signs of weather to come.[1] The ancient Greeks forecast the weather by observing birds, and in preconquest Peru there existed a college of augurs for this purpose.[2] In the British Isles in the twentieth century, the coming of the cuckoo is a signal to start the spring plowing.

Avian symbolism is found all over the world. The use of birds in the art of the Paleolithic era is associated with specific beliefs. The wearing of bird masks is integral to the custom of ritual dancing and drama, through which the needs of the worshipers are made known to the numinous power, that is, to a supernatural presence whom they worship. These magical rites act as prayers.[3]

Tarahumara Indians dance to the music of their shaman's song to invoke the favor and protection of their deities. They claim that the birds taught them to leap and fly, play and stomp, in worship of a transcendental being behind the veil of nature, a being who sends rain and food to the owl, the dove, and the turkey. The Indians infer from this that the deity will answer their petitions for good crops and good health.[4] From dance to prayer sums up the history of religion.

The bird was used for magical purposes in a number of different ways. Its costume of beak, wings, and feathers endowed the wearer with the bird's powers, each physical attribute signifying a different spiritual quality. The wisdom of birds was symbolized by, and transmitted through, their feathers. The single feather worn by many American Indians kept each warrior in touch with the world of the spirit. In contrast, the ancient Mayans, Aztecs, and Peruvians wore the fantastic plumage of tropical birds for public rituals, not only in headdresses but also in intricately patterned capes and skirts.[5]

Another way the bird was used for magical purposes was in the eating of the deity in bird form. In ancient Hebrew, "good" means good to eat. It carried much the same meaning in ancient Mexico, and the ancient Greek writer Porphyry says,

Those who wish to take unto themselves the spirits of prophetic animals swallow the most effective parts of them.[6]

The hearts of eagles bring courage, the flesh of crows and owls imparts wisdom, and the flesh of keen-sighted hawks may lend visual acuity. The purpose of eating a bird is not simply to consume a deity but to partake of its substance and to absorb its mana. "Mana," a term first used among Polynesian people, refers to a mysterious spiritual power concentrated in certain objects or persons that is still prized in many parts of the world. Currently, in the city of Fez, Morocco, hoopoes, handsome birds with lovely crests, are sold in cages in the market. The hoopoe is rich in magic and is used for many practical charms. When a Moroccan boy reaches the age of seven, he is given a hoopoe's heart to eat so that his memory will be strengthened, for to it he must commit the Koran.[7]

Bird bones are imbued with magic, too. Many worked bird bones come from the Magdalenian site of Le Placard, France. Some have holes drilled into them, so that when blown they give a high flutelike sound.[8] One bone is engraved with a chevron, a moisture ideogram associated with the Bird Goddess. Music from these bird-bone flutes, enhanced by other high-piping instruments and accompanied by drums, must have been used at the sacred festival to celebrate the return of the large water birds in spring.

The painting of animals on cave walls was a magical attempt to ensure good hunting and may represent a propitiation of the spirits of the sacred animals that had to be killed for food. The human figure is rare in Stone Age art, where animals reign supreme. The few tiny figures that represent humans, such as the female in the image from Pech Merle, France, contrast sharply with the large animals often fully developed and painstakingly realized.

ART OF THE CAVES

Bird-masked people appear and reappear in the caverns of the Paleolithic age, culminating in a great flowering of the bird cult of the Mother Goddess in the Neolithic era.[9] In the Ice Age art of France alone there are more than one hundred painted symbols of the vulva, whereas only four male symbols have been discovered.

Certain places emanated a special magic and consequently were invested with a special awe.[10] In the grotto-temple of Pech

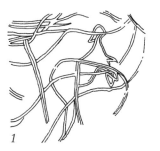

1. First known bird deity in a tangle of finger-drawn lines, in the grotto of Pech Merle. Lot, France, Aurignacian.

1

2. Amulet of the buttocks silhouette. Petersfel, Germany, Upper Paleolithic.

Merle, France,* a central hall with a high vaulted ceiling creates a magical impact. The walls of this chamber are perforated by two natural galleries, where a central rock pillar with translucent stalactites produces a mysterious transparent effect.[11] The emblematic stones were regarded as concentrations of cavern sanctity.[12] On the ceiling of the upper gallery, a large, dazzling, finger-drawn picture generates a maze of radiant lines, a labyrinth of barely perceptible images.

Painted on the lower part of the mural the Abbé Lemozi discovered several pregnant female figures and noted that one has a backward-turned bird's head with short winglike arms emerging from a full body. (Gimbutas later pointed out many bird-headed figures in the subsequent Neolithic era.) The legs of the image end in human feet, but she is bent forward in an unnatural manner that draws attention to her large egg-shaped buttocks. The egg is charged with magical potency in the art of the period. The meaning will become clear with further illustration. The figure doubtless represents the Great Mother Creatress, whose name is unknown since writing did not evolve until 3000 B.C.E.

*Unless otherwise specified, all sites mentioned in this chapter are in France.

2

3

3. Headless female
figure exhibiting
the **P** silhouette
engraved on a boul-
der. La Roche, Dor-
dogne, France, ca.
17,000–14,000 B.C.E.

As Siegfried Giedion writes, "A bird's head upon a human figure is one of the most venerable mythological inventions. It appears in an early phase of the Aurignacian period as well as on the female figures at Pech Merle."[13] These goddess figures are not set apart; three of them remain entangled in the labyrinthine lines with the mammoths. The one with a head has been named the Lady of the Mammoths. As the earliest known bird deities, they express the emotional intensity of early perceptions and beliefs covering an extremely rich system, one far more complex than had previously been imagined.

Another example of exaggerated egg-shaped buttocks is found in the otherwise slender form of a Magdalenian nude figurine of polished lignite, 1¾ inches high, from Petersfel, Baden, Germany. The coal-black, headless form glides wavelike from the top of her neck to the tips of her tapered legs. The black wave eliminates every physical feature—head, breasts, vulva, stomach—except her buttocks. This Magdalenian amulet was made to be handled and is easily portable. Since the belly is not extended, the enlargement of the buttocks has nothing to do with either pregnancy or obesity. The buttocks silhouette is found so frequently that it must be considered a purposeful convention.[14]

Exaggerated buttocks are ubiquitous not only in sculpture of the period but also in stone engravings. The authority with which the engraver was able, in a few sure strokes, to call up a human figure or an individual animal testifies to a strong visual memory. Etched on a stone slab from La Roche, Dordogne, many schematic headless females of the Middle Magdalenian period were discovered. Four to six inches tall, they exhibit the familiar backward thrust of the enlarged buttocks, a posture common to the egg-carrying Bird Goddess. An arc and a straight line suffice to create the so-called **P** shape. In the museum at Les Eyzies a stone block presents many such magic images.[15]

4. Unlike other figures with the exaggerated buttocks position, this one has breasts. Cave of La Gare de Couze, Dordogne, France, Upper Paleolithic, ca. 17,000–14,000 B.C.E.

In the cave at La Gare de Couze, Dordogne, the typical buttocks image, usually so simplified, has been given a breast. Most of these figures lack not only head but also breasts and are recognizable as feminine only through their exaggerated posterior. The secret of the buttocks silhouette that has confused archaeologists lies in mythic interpretation, for it is in the buttocks that the cosmic egg is stored.

Another image featuring the buttocks silhouette, rare because of its bird's mask, was found by the Abbé Lemozi, engraved on a pebble from Abri Murat in the district of Lot. Lemozi's research leaves no doubt that it is a bird mask. Among these usually headless images, the bird-masked figure is conspicuous. The ends of the strings with which the mask is fastened stream back as if in the wind, a detail that gives the image charm and a distinctly personal quality.

An early head, 1⅜ inches high, ca. 22,000 B.C.E., in mammoth ivory from Grotte du Pape, Brassempouy, demonstrates that Paleolithic artists were perfectly capable of depicting a human head with naturalistic features. They omitted the mouth, which appeared threatening, since it "takes in": rending, devouring, and swallowing. Only the features suggesting abundance were considered desirable; other features were ignored in sculpture of this period.

4

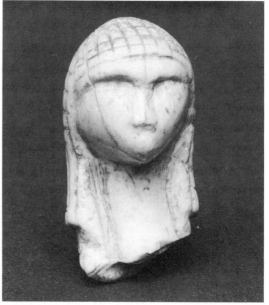

5

6

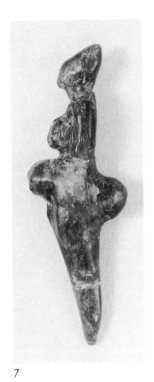

7

8

5. Head of a lost figurine from Grotte Du Pape, Brassempouy, Landes, demonstrates the existence of good portraiture during Gravettian–Upper Perigordian, France, ca. 22,000 B.C.E.

6. Etched on a pebble, a rare bird-masked figure with an exaggerated posterior. Found at Abri Murat, Lot, France, Late Magdalenian, ca. 10,000 B.C.E.

7. Carved stone Venus with enlarged buttocks from Menton. France, Aurignacian, 40,000–26,000 B.C.E. (See plate 2.)

8. Adolescent Gravettian figure with enlarged posterior from the rock shelter of Cazelle, Sireuil. Dordogne, France, Gravettian, 20,000–18,000 B.C.E.

La Polichinelle is the name given a small nude figurine from Late Aurignacian times that stands only 1¾ inches high, yet is beautifully articulated. She was brought to light by a worker near the caverns of Grimaldi, in Menton,[16] where the people's dwellings had probably stood. The vivid and expressive figure, purple as a plum, appears slender from the front; the profile shows a sharp projection of buttocks, breast, and belly. The head has been described as hooded or veiled. Artistically, the head repeats the lines of the figure and resembles the crested head of a pileated woodpecker. A Neolithic image of a triangular woodpecker's head wearing the three-channeled necklace of a goddess, from Sitagroi Mound in northeastern Greece (ca. 4000 B.C.E.), appears as Gimbutas's figure 124.[17] As mentioned, the woodpecker with its mimetic drumming creates the thunderstorm. This concept of sympathetic magic is repeated by Aristophanes, who notes in *The Birds* that Zeus stole the woodpecker's scepter to become the God of Thunder.[18]

The Lady of Sireuil is carved with considerable dexterity in the tradition of the buttocks silhouette. The beautiful translucent quartz was procured from a distance to make the torso, which was discovered near the Cazelle rock shelter, Dordogne. Elegantly polished, the young headless figure, certainly Gravettian, vibrates with

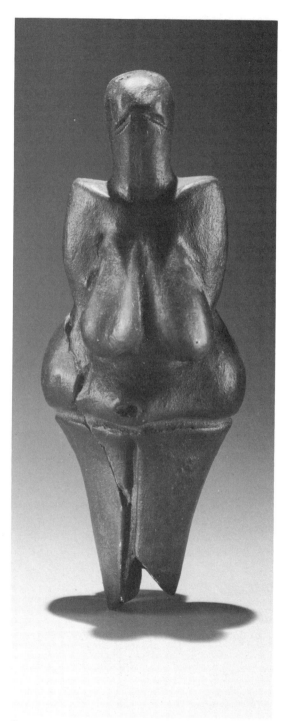

energy. It has small breasts and short folded arms and legs. Its vestigial limbs reveal traces of hair on the shoulders. Like most Stone Age figures, it is considered to have been primarily an object of worship rather than a work of art.[19]

The full-breasted Ostrava Petrkovice torso of baked clay from Dolni Vestonice, Czechoslovakia (27,000–26,000 B.C.E.), was found near a hearth, indicating her worship within a dwelling. Although her buttocks are flat, her shoulders and upper arms mimic wings. The drama lies in the balance between bird and human characteristics. The holes in her head indicate the insertion of feathers and flowers, and moisture lines stream from the beak onto her chest.

The bird theme is particularly emphasized in the Venus of Lespugue, from the French Pyrenees. This sculpture is perhaps the most beautiful expression of the female figure in all the Perigordian period (ca. 25,000–18,000 B.C.E.), with the repetition of the splendid oval resonating from head to breasts to buttocks and thighs. Three views of the figure call attention to her bird features. In the front view (see plate 3), her upper arms represent wings, heavy and hunched forward where they attach to the body yet thin and feathery, almost atrophied, below the bent elbow.

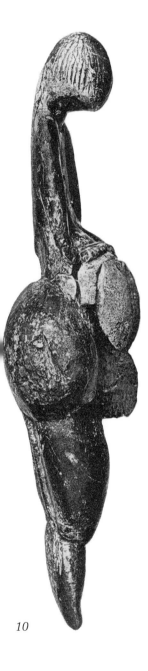

9. Ice Age deity
with winglike
shoulders. Dolni
Vestonice, Czecho-
slovakia, ca. 27,000–
26,000 B.C.E.

10. Profile view of
Venus of Lespugue
is distinguished
by egg-shaped
haunches and a
birdlike head and
tail. Pyrenees,
France, ca. 25,000–
18,000 B.C.E.

11. The justly
famous Venus of
Lespugue, seen
from the rear, has a
tailpiece scored
with vertical lines
that resemble tail
feathers. Pyrenees,
France, ca. 25,000–
18,000 B.C.E. (For
front view see plate
3.)

10

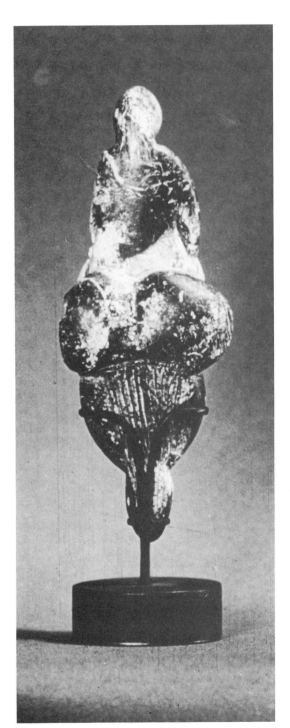

11

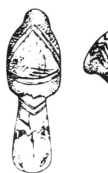
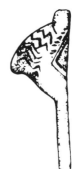
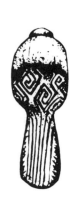

12

In profile, Lespugue's delicately forward-bent head on its long neck resembles that of a dove. Other figurines in Western Europe, such as the Venus of Willendorf, display the bent head, an attitude that suppresses human features and suggests a bird. As with the Grotte du Pape statuette, the mouth is often eliminated, recalling the bird since a bird's beak combines nose and mouth. The back view reveals a large, fanlike object beneath her buttocks reaching to her ankles. The softly tapering tailpiece is scored with about a dozen vertical lines that resemble tail feathers. The size and length of the quills are proportionate to her body; the crosshatched barbs resemble feathers and further identify her as a bird goddess; feathers imbue the wearer with supernatural powers. Her bird epiphany, or alternate form, explains the eccentricities of her form, including the enlarged buttocks.

Some archaeologists believe that the buttocks silhouette exemplifies steatopygia, an inherited characteristic resulting in excessive fatty tissue stored in the buttocks.[20] This is incorrect; the bizarre bulging in Stone Age figurines is not a matter of anatomical distortion but a startling and ingenious metaphor for the hybridization of woman and bird.[21] The deity's buttocks are apparently shaped to carry huge eggs that are mature and ready for hatching.

SIMPLIFIED FORMS OF THE GODDESS

A geometric figure, one of six found in a dwelling in Mezin, Ukraine, in the Late Aurignacian era, is characterized by a long headless neck and avian buttocks. Abstract engravings cover the front, rear, and side, and an enormous triangular symbol, a chevron, combines bird and female characteristics in the Bird Goddess. The chevron has an association with water; when striated it signifies torrents of rain. As the female sexual triangle, the chevron is a sign of prestige. A water sign is often marked below the tail. Motifs, such as the Greek key design, the archetype of the key of life that opens "the way" to the eternal return, which remains a religious convention well into our own era, are also inscribed on the figures. These amulets, dated ca. 14,000 B.C.E., were useful in the ritual that marked the spring return of water birds, which were sacred to hunting tribes and a major source of food.

The Late Magdalenian figure engraved on a cave wall at Fontales, in Tarn-et-Garonne, is not pregnant with a human child. She bears the Cosmic Egg, whose size and contour account for the exaggerated posterior of the Bird Goddess.

The egg-carrying figures in this chapter illustrate a concept of the deity as Bird-Goddess-Creatrix. We have a record of twenty-five thousand years, from the

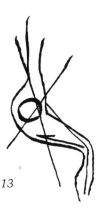

12. Three views of a type of stylized amulet in bird form, incised in front with a female triangle. Mezin, Ukraine, U.S.S.R., ca. 14,000 B.C.E.

13. Engraving of a female figure with Cosmic Egg in rump. Fontales, southern France, Magdalenian, ca. 18,000–14,000 B.C.E.

13

thirtieth to the fifth millennia B.C.E., in which the bird and the Goddess are fused. They express the idea of creation taking place from the Universal Egg laid by the deity. The Paleolithic origin of the Primordial Egg explains the "buttocks silhouette" or egg-carrying stance of the leaning figures found in art throughout the Paleolithic, Neolithic, and Chalcolithic eras. This visual evidence testifies to a widespread belief that the Cosmic Egg was carried in the posterior of the Bird Goddess. The primordial life substance, the germ of matter, grew inside her body until it no longer needed protection, and the universe burst forth.

RITES OF THE BIRD-MASKED PEOPLE

An extraordinary quirk of fate revealed a group of bird-masked people, who must have been associated with a Paleolithic bird cult, engaged in a ritual observance. During the intensive bombardment of Sicily in World War II, a layer of crystalline limestone sheared off the wall of a cave on the small island of Addaura, near Palermo, and revealed an engraving executed not much later than 8000 B.C.E.[22]

In the finest delineation of the human figure in all of Mesolithic art, people wearing bird masks are seen dancing. The clarity and elegance of line with which the body is defined in the composition are unmatched at this time. The inhabitants of these caves were tall, well proportioned, and had a brain capacity equal to our own.

In the center of the dancing figures lie two men on the ground, their sexual arousal probably the result of the threat of death. Each is bound from neck to ankle with a rope so short, that if their bowed bodies were straightened they would strangle. Superbly drawn, the masked figures dance in a circle around the ithyphallic men. Rhythmical movements often induce collective ecstasy. The two men may be members of a cult that stages mock deaths to ensure rebirth for all. The participants in such rituals were usually masked, and the fact that the rites often took place in the most remote and inaccessible chambers of the caverns indicates a secret purpose for the ceremonies.

Mimetic dancing, accompanied by bird wing whistles and pipes, was a prelude to music and poetry. Dancing grew out of observing the movements of animals and implies human identity with them. Dance gave rise to rapture, which led to consciousness, the realization of death, and the hope of rebirth. Out of this, art is born.

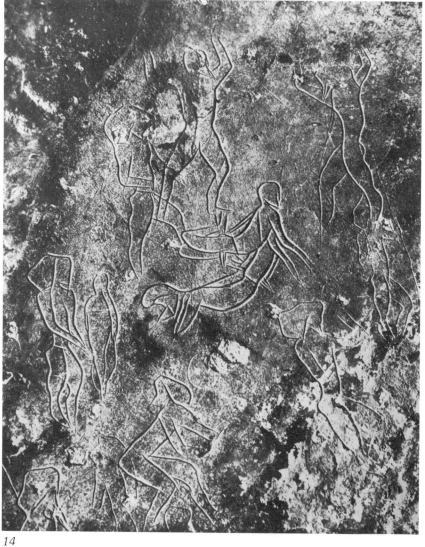

14. Mesolithic bird-masked figures engraved on a cave wall. Addaura, Italy, ca. 8000 B.C.E.

15. Deity directs her magical force into the hunter. Algerian Sahara, Mesolithic.

14

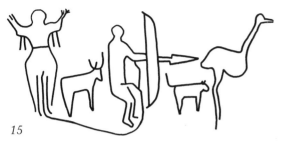

15

THE GODDESS AS HERALD
OF THE HUNT

About two-thirds of all Paleolithic figures come from the Soviet Union. Soviet archaeologists agree that the image of woman predominates this age and acknowledge her primacy reflected in the deity of the cults. She links the mystic identity of the hunter with the hunted. In the Soviet view, there were "in the first stage collective spirits and images of real living Woman-Mothers. As time went on their characteristic traits were preserved as they developed into female deities, that is, into the image of a mother goddess, and this image in turn passes into the religions of the ancient world and up to our time."[23]

The Tungas, a northern Asiatic people, speak of a Mistress of the Hearth and Home taking the form of an old, wise, still vigorous woman. Her image presided in each dwelling. Regarded as the guardian of the birds and the owner of the forest, she held a mysterious power over the multiplication of game animals and the hunt. Ethnographic literature is full of descriptions of hunting rites in which women take part. According to some beliefs, women magically brought the animals to the hunters. The Goddess played a vital role in the various cosmologies and seems to have been involved not only with the animals' death, but also with their resurrection.

A design engraved on the rock walls in the Oasis of Tiout, in the Algerian Sahara, gives a view of the significance during the Mesolithic era (which preceded the Neolithic or New Stone Age) of the Goddess of the Hunt, identifiable through her upraised arms.[24] The hunter's chance of killing the creature against whom he raises his bow depends entirely on the line of force flowing from the Mother's womb through his sex and arms. The hunting arrow points straight to the egg-shaped body of an ostrich, which may be an alternate form of the Goddess.

After the retreat of the glaciers, immigrants from the painted caves followed the herds to Mal'ta, Siberia, near Lake Baikal, where similar tundra existed. There, the relationship continues between goddess and bird; sixteen goddess figures were found at Lake Baikal, accompanied by images carved from mammoth ivory that have the necks and heads of swans, yet the bodies are of women. These possible precursors of the long-necked figures of the Neolithic times evoke the swan maidens of European myths and fairy tales.[25]

16. Two swan goddesses combine the features of bird and female. Mal'ta, near Lake Baikal, Siberia, late Paleolithic.

17. From Gravettian Předmost, an engraved geometric deity with triangular head and chevrons. Moravia, Czechoslovakia, ca. 26,000 B.C.E.

17

16

A unique geometric deity etched on a mammoth tusk found at Gravettian Předmost expresses through its organization a concern with the themes of creation and nourishment, a theme that absorbed the attention of early human beings.[26] The triangular chevron design of the head may refer here to the beak of the Bird Goddess. The chevrons often flank the orifices of moisture: eyes, mouth, navel, and sex. Here the greatest prestige is given to the navel and sexual areas. A series of barred bands on the head indicate the use of feathers or may relate to lunar chronology involved with weather changes that influence the water supply. The enormous breasts, outlined four times, accent the theme of nourishment.

The peculiarities of the figures are not due to ineptitude but to a profound belief in the creation of the world from the Divine Egg carried in the haunches of the Bird Goddess. She is concerned equally with creation and regeneration. Death is seen as an endless cycle of rebirths; the potential of renewal is ever present. Such a conception of death dissolved the elements of nature and, through ritual, brought an unfolding of the human mind and its ability to think abstractly.

The Creatrix

The Mother Creatrix is the eternally fruitful source of the universe, the origin or fountainhead. Unbounded, she transcends definition; all elemental aspects are hers.

Fire, the highest cosmic component, emanates from the sun and stars and acts as a generator of life and a symbol of transformation. It provides an archetypal image of physical and spiritual energy. Woman first controlled fire at the hearth, recognizing it as the tool of tools, a weapon that could be used offensively or defensively. She used it magically to protect herself and her young. Her connections with fire appear in countless myths of genesis. Certainly, without fire the great caves could not have been used for rituals or art. Legends recount how woman kept fire in her genital organs,[1] or at the end of her digging stick, or, sometimes, hidden in her fingernails. And fire remained in her hands for millennia, as we know from the enduring influence of Rome's vestal virgins and Vesta herself, whose form was fire.

By 10,000 B.C.E., however, the European climate had changed dramatically. As the glaciers retreated, great forests grew up where the beasts of the tundra had grazed. The caves of the Paleolithic era were abandoned, and the traditions and myths that had flourished there were transported to fertile valleys.

The advent of agriculture marked the opening of the most revolutionary epoch in history. Not even the innovations of the machine age and the awesome atomic age can be compared to the culture-shaking transformations of the Neolithic era. These transformations are all the more remarkable for having taken place in a few thousand years that seem like a minute when compared to the Paleolithic period, whose eons are as endless as the stars.

The use of fire by women during the Neolithic period led to great innovations. Pottery evolved from the method used to repair the woven baskets in which water was first carried. Worn-out baskets were lined with clay; when discarded and thrown on the fire, the straw burned away and left the crude pots. This observation inspired the first consciously crafted pottery. On an archaic level, all pottery was created by women. The vessel is woman. Clay became sacred to the female; no man could be present at the making of a pot, nor could he touch the taboo clay until the invention of the potter's wheel.[2] Women, the first potters, went on to become the first artist-decorators. There followed a constellation of far-reaching inventions by women, the most important of which was the evolution

of agriculture from simple gathering. Each discovery must have strengthened her identification with the Great Mother Creatrix, both for women and in the minds of men.

THE PRIMORDIAL EGG

The cult of the egg-carrying Bird Goddess of Paleolithic times gains momentum during the Neolithic era. The Great Mother's ability to effect generation, which made her the vehicle of transformation, did not substantially change. A jar stands upon the altar as her preeminent symbol. As creative vessel, the female expresses the godhead of the Bird Mother, carrier of the Primal Egg.

The fragile egg so carefully stored within the deity contains the germinating essence of the universe. Both heaven and earth develop from the Cosmic Egg.[3] In many cosmologies the World Egg is born of the primordial sea, and from it emerges the universe of starry sky, oceans and rivers, and earth. From the Universal Egg sprang the cosmos.

In India now, the Cosmic Egg is no longer an attribute of the Goddess, but of the god Vishnu. The life-giving aspect of the Bird Goddess remains, however. She is usually portrayed nude with a large pubic triangle.[4] The pointed reference to her sex and, by inference, to her womb, serves as a reminder that she is the source from which life springs and to which it returns. The Great Round encompasses the beginning of life and the transformation through death to rebirth.[5]

THE EGG-CARRYING DEITIES

The numinous egg-carrying female encountered in Paleolithic art is depicted as a bird deity. She is incised on cave walls in France and Spain and sculpted in tiny figurines of stone and sacred mammoth ivory. From the Paleolithic age onward, we find bird-shaped vases and egg-shaped jars or pitchers in which souls await rebirth.

Between the Paleolithic and Neolithic eras, a break occurred in the occupation of southwestern Europe, in what is known as the Mesolithic age. The postglacial chill of the retreating ice was followed by a misty gray-green climate that encouraged the growth of the forests. The great beasts, needing more open tundralike feeding grounds, followed the retreating ice. Some of the hunter-gatherers pursued the animal herds as far as Mal'ta, in Siberia, where their remains are found along with deer and mammoth bones.[6] We know who they are because the skull structure matches that of the people of the French and Spanish caves; here as there, the Great Mother and her animals furnish the themes of their art.[7]

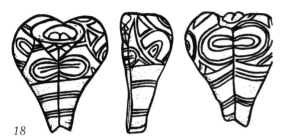

18

18. Demitorso of deity with twin eggs in her womb. Novye Ruseshty I, Moldavia, U.S.S.R., end of the fifth millennium B.C.E.

Many figures are nude or marked with an all-over design indicative of fur clothing.[8]

In Neolithic times, other groups moved to the fertile valleys of "Old Europe," which is Gimbutas's designation for pre-Indo-European southeastern Europe, including the Adriatic coast of Italy, mainland Greece, and the island of Crete.[9] The magnificent caves were deserted. This break in the chronological development of Europe is comparable to a geological fault line. The basic links of the old chronology snapped, and Europe no longer appears to be directly linked with the Near East.[10]

The basic features of Paleolithic mythology, however, continued through Neolithic times, the symbols of the earlier hunter-gatherers remaining rooted in the psyche of the now agricultural people. When it took nine people to kill a cave bear nine feet tall, life was necessarily risky and often cut short. Human remains reveal the average Paleolithic lifespan was about thirty-three years. Their emphasis on fertility and rebirth was a natural reaction to the imminence of death.

As mentioned, in the more settled environments of the Neolithic age, women, familiar with the needs of plants from their gathering of food, developed the art of cultivation.[11] Pockets of agriculture, uncovered along the Nile, are carbon-dated to 18,000 B.C.E. Planting was not widespread before 7000

B.C.E.; then it advanced sporadically, even in settled communities.[12] A relatively peaceful time ensued; no weapons appear among the grave goods. The population increased with the availability of food, and the goddess religion survived in detail its move to new environments. After the retreat of the glaciers, the forest appeared, the caves were deserted, and all traces of that civilization seem to have disappeared. The Paleolithic conventions of art reappeared in southeastern Neolithic Europe in the seventh millennium B.C.E. and continued through the fifth millennium B.C.E. The script on figures of the Lady represents the first known iconography used by the Neolithic people to communicate their beliefs. The egg-carrying posture continued to be a signature of the Creatrix in the mythical world of the New Stone Age.

A striped and truncated divinity from Novye Ruseshty, in Soviet Moldavia, dated to the end of the fifth millennium B.C.E., has a pair of eggs tucked inside her womb. On the exterior surface of the demitorso, elaborately decorated double eggs are incised front and back. Many of the figures contain double eggs placed inside complete figures. The location of the eggs and the surface decorations identify the origin of the universal life force. The symbolic pattern incised on these idols may have acted as a visual means of invoking the Goddess.[13]

19. Triangular-headed deity with buttocks silhouette. Karanovo I, central Bulgaria, Neolithic era, ca. 7000–5500 B.C.E.

19

20. From Copper Age Vidra, a large red and white vessel figure incised with symbols. Rumania, fifth millennium B.C.E.

A deity, recognizable as a Bird Goddess because of her enlarged posterior, was discovered at Karanovo I in Bulgaria. She possesses a widespread type of triangular head, similar to the shape of the Venus figure *La Polichinelle*, found at a Paleolithic site outside the cave near Menton in France (see "Bird Deities of the Paleolithic Era," fig. 7).[14]

From Copper Age Vidra, in Rumania (fifth millennium B.C.E.), comes a terra-cotta pot in the form of a standing figure holding both hands over her body in a magical gesture. The head, which comprised the lid, is missing. Cosmic eggs, lozenges, and concentric circles are engraved on the body, once gaily painted in red and white.

A NEW VIEW OF NEOLITHIC HISTORY IN EUROPE

Before we move to the islands of the Mediterranean, strongholds of goddess worship, some historical background is needed. From the opening of this book to the Kurgan invasions described below, thirty thousand years have passed; we are in the sixth millennium B.C.E. From our perspective, boxed in as we are to the Christian era of roughly the last two thousand years, it is difficult for us to expand our minds and conceive of life before ancient Greece.

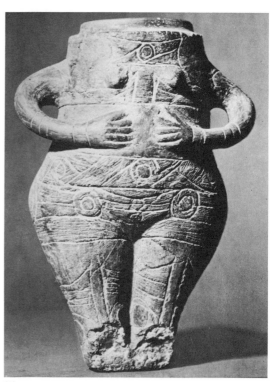

20

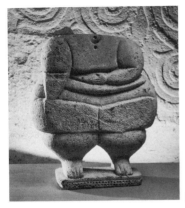

21

21. Mother Goddess
figure. Malta, 5000–
2500 B.C.E. (See
plate 5.)

Marija Gimbutas's application of new dating techniques to the Neolithic period of southeastern Europe has radically changed the perception of human cultural history and broadened immeasurably our understanding of this history. Gimbutas has designated the section of Europe she discusses as Old Europe. It consists of the central and eastern Balkans, Moldavian Ukraine, middle Danube, Adriatic, and Aegean regions.

According to Gimbutas, the peaceful, egalitarian, goddess worshiping, agricultural life of Old Europe that flourished from the seventh to the fourth millennium B.C.E. was violently breached by the Kurgan invasions. Despite these invasions, the old farming culture continued for three thousand years in southeastern Europe and in the Aegean islands for almost five thousand years. The aggressive intrusion of three separate waves of horse-riding herders, who came from beyond the Black Sea between 4500 and 3000 B.C.E., created disastrous cultural upheavals. From the second half of the fifth millennium B.C.E., evidence that the horse was both a riding and a cult animal is documented through antler cheek pieces (part of the bridle), horse figurines, and horse-headed sculptures. After the Kurgan invasions, very little of the old culture and religion remained in the region. Gimbutas's research opened new avenues for the reconstruction of

Neolithic religion. Her findings have been accepted by Mircea Eliade, the great authority on the history of religious ideas.

MALTA

Malta, with its awesome stone temples described at the end of the chapter entitled "Shrines," is embodied in the massive figure of the Creatrix, Mother-of-All, 5000–2500 B.C.E. Female deities of ample proportions abound in these temples. Since, in ancient symbolic terms size usually determines importance, the shrines and figures sometimes express power through their dimensions. Only the lower portions remain of one such six-foot divinity, her creativity signified by her double spirals.

22. Nut spans the star-studded sky. Tomb of Ramses VI, Egypt, ca. 20th Dynasty, 900 B.C.E. (See plate 4.)

23. Ancient Egyptian tomb drawing of the Great Cackler who lays the Universal Egg. Predynastic.

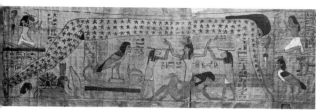

22

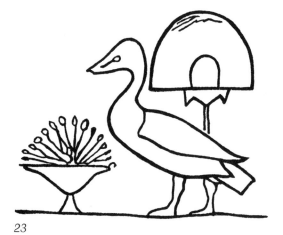

23

EGYPT

In Egyptian myth, the generation of the Primal Egg takes place in what is known as the Time of Non-Being. The sublime goose appears among the imperishable stars, cleaving the night sky with her great wings. While the world is still flooded by silence, the voice of the Great Cackler breaks the stillness, and she lays the egg containing the germ of life. Priestly reinterpretations turned the Great Cackler into a gander; however, it is clearly the female who cackles at the laying of an egg, and thus the first Egyptian myths denote an original Goddess-Creatrix. From her egg bursts forth a bird of celestial light.[15]

The Primal Egg laid by a sacred bird in the watery abyss contains the germ of life and typifies the universal creation story. The cosmic matter from which the universe is formed comes from various parts of the Primal Egg. The precise details have been lost due to the change in religious orientation. Some Egyptian texts maintain that the Primal Egg is formed by eight creatures, male and female, with heads of frogs and snakes, who swim in the waters of nothingness, invisible because this genesis takes place before the illumination of the world.[16]

The image of the Bird Goddess appeared in Egypt at about the time she disappeared from Old Europe. North Africa, enclave of

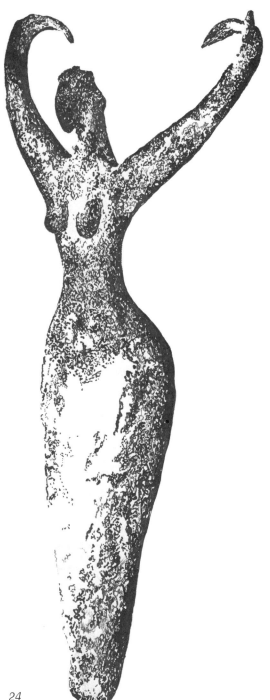

24. Predynastic
funerary divinity
poised as if for
flight with bird's
beak, feathery
hands, and enlarged
buttocks. Egypt,
ca. 4000 B.C.E.

24

undivulged secrets, region of strange
sorceries, produced in early predynastic
times (ca. 4000 B.C.E.) funerary figures with
strongly beaked faces and winglike arms
and hands. The vigorous stance of the
figures expresses the energy and mystery
of flight, and their posteriors are greatly
enlarged by the Cosmic Egg. These painted
terra-cotta figures, less than a foot high and
much alike, were found in graves in
Mohamerian, near Edfu. They serve as a
superb blend of bird, woman, and deity, and
exercise an almost incorporeal magic upon
the viewer.

On a wall of the tomb of Ramses VI, the
Egyptian Sky Goddess, Nut, spans the
heavens with her star-studded body arched
across the sky; she carries the sun within
her body. On rising, it enters her mouth and
travels through her mighty form all day to
emerge at sunset, when it descends into the
underworld for rebirth. The human soul, as
a ba-bird in its little boat, accompanies the
sun from nightfall to dawn.[17]

CRETE, MYCENAE, AND TROY

There is clear evidence that a bird cult with
regular, established rituals existed in
Minoan times as late as 1400–1200 B.C.E.,
when only vestiges of it remained on
the mainland. The fascination of Minoan
civilization lies partly in the fact that a
culture so well researched should still

25. Gold divinity with three doves. Mycenae, Greece, 1550–1400 B.C.E.

26. Bronze of the Indian goddess Laksmi riding an owl. India, 1700–1800 C.E.

remain mysterious. We know these people's architecture, their furniture, and the streets of their towns. The documentation of their literate society is remarkably complete. We are familiar with their trade, their coiffures and clothes, their cosmetics and scents; their art shows us how they looked. Their religious ideas are familiar as well as the exquisite taste and style of their way of life. And yet they elude us.

One reason we fall short of understanding the ancients is that their sense of time was completely different from ours. The West now lives by a solar calendar, whereas all ancient peoples followed lunar calendars, believing the moon to be more important than the sun. The moon rules the tides, the rain, and the menses of women, hence all liquids. Plants grow at night, and water, ruled by the moon, is essential to their growth.

Cretan culture evolved toward the close of the period of acausal thinking, with its circular concept of time. They believed events that occurred simultaneously partook of each other in quality. The Minoans were not alone in this view. All prehistoric people experienced time in this acausal or cyclical manner. This is very different from our clock time, a linear or causal sense of time, in which events follow one another in a strict line of cause and effect.

From Mycenae (1550–1400 B.C.E.), a mainland culture with strong ties to Crete, comes a golden image of the naked deity in a state of nature, recalling her Neolithic presence as the Naked Goddess. Doves perch and flutter about her in demonstration of affinity. Crowned with a diadem, she touches her breasts in a gesture of fertility and abundance noted later in idols of Aphrodite in Cyprus.

MILK

Some ancient cosmologies held that the life principle, the power of nature, resides in milk. In India, where matrifocal religion has never really been interrupted, the Mother Goddess is mentioned at least three hundred times in the *Rig-Veda*. An early Indian creation myth tells of the sea being churned until it became a milky foam called Amrita, from which came solid land. From it, too, like Aphrodite, sprang Laksmi, Goddess of Wisdom and Fortune, Mother of the World, and source of gems and certain cult animals.[18] In one bronze, Laksmi rides on the back of an owl.

THE CONE

The horned crown prevalent in Sumerian art was first worn by the prehistoric Mother Goddess; changed to an emblem of phallic force, it serves deities everywhere.

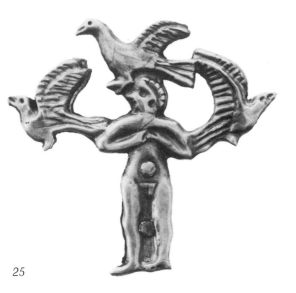

25

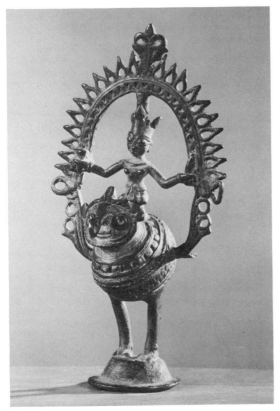

26

It is the coronation proper that invests a king or queen with the power of divine rule. The horns of the crown are the curved posts of the gate between heaven and earth, a channel of vital force.[19] Resembling the sickle moon, they serve as conductors of its animating force. In the temple-palace of Knossos, Crete, horns represent the creative powers of the bull and dominate all other symbols in size and number. Arthur Evans calls them the Horns of Consecration.

The cone, which can also take the form of a mound, hill, or mountain, represents the earth's navel and is seen as a sign of stability. The cone also represents the womb; this interpretation is the original significance of Omphalos, the sacred center of the world at Delphi, which acted as a means of communication between the living and the dead.

The image of the divinity became a simple white cone or pyramid. Conical stones, which apparently served as idols, were found buried beneath the floors of temples to the Goddess on Malta. The cone is almost certainly the origin of the Mountain Mother; at Byblos, in modern Lebanon, it served as the symbol of Astarte. Her coins were stamped with an image of the cone not only at Byblos but also at Sidon, Paphos, and other cities of the Near East. Votive cones made of clay have been found in large numbers in Babylonia, particularly at

Lagash and Nippur. On the coins of Perga, the sacred cone is richly decorated and stands in a temple between two sphinxes as a symbol of earth's safety.[20]

Among the barren hills and precipices of Sinai, cones in sandstone, maternal symbols of the deity,[21] were unearthed at the shrine of the Mistress of Turquoise. An image of Aphrodite, the Dove Goddess, found at her favorite haunt in antiquity, the island of Cyprus, took the form of a white pyramidal cone.[22] Other goddesses in Greece share the dove, but only Aphrodite is designated by a white cone; this is crowning evidence that the Dove Goddess of Crete is her prototype (see fig. 28).

The hill, cone, and omphalos, as well as mounds and tombs, are all symbols of the Earth Mother. Silbury Hill, situated on the Wiltshire downs, Britain, is larger than the Pyramids and quite simply the largest goddess effigy in the world. It figures as a carefully planned and magnificently engineered configuration of the pregnant Goddess, with the mound as her burgeoning belly, ready to give birth. Fed by a spring, the wellhead beneath Silbury Hill filled the encircling ditch in imitation of the waters of parturition. The ditch is her body. As usual among Neolithic figures, a shaft was sufficient to indicate head and neck.[23] Radiocarbon dated to the Neolithic age, it dates back forty-five hundred years.

The Dove Goddess from Middle Minoan III wears a crown of birds and horns; in the center arises her emblem, the cone, symbol of her womb. These signs not only proclaim her divinity but recall times that far antedate Cretan civilization.

The Great Mother was worshiped as a cone on high places, hills, or mountains sometimes crowned with a stone, believed rich in fertilizing magic. From the Near East to the Baltic Sea, these places were and still are visited, by women seeking fertility. The renowned Omphalos at Delphi is a cone or hill; before Apollo's usurpation of Delphi it was sacred to the goddess Themis or Gaia.

CREATION MYTHS

The Cosmic Egg refers both to the world of the spirit, the world within, and the exterior world as conceived by the Goddess. The idea of the Universal Egg born of a bird is common to the myths of many cultures.

According to the Guatemala Indians of Central America, in the beginning all was water, and the face of the land was hidden. There was only the silent sea and the sky; nothing broke the stillness but the maker and molder, the Bird-Serpent, covered with green feathers and stretched out in the limpid twilight waters, brooding upon an egg. Over this scene passed Hurakan, a night wind, and laid bare the

27. The Earth Mother: Silbury Hill and its moat. Britain, ca. 2500 B.C.E.

28. The Dove Goddess of Crete crowned with birds, cone, and bull horns. Crete, Middle Minoan III, 1700–1400 B.C.E. (See plate 6.)

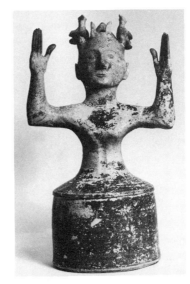

28

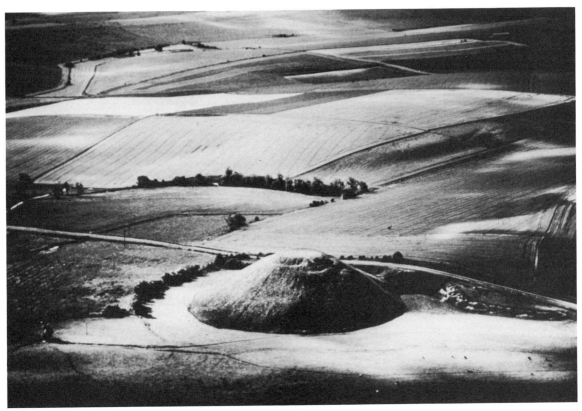

27

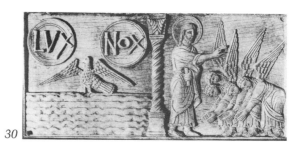

30

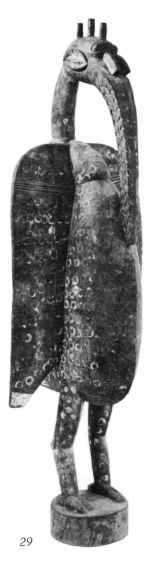

29

29. Crane spirit. Senofu tribe, Ivory Coast, contemporary.

30. The Holy Ghost as a dove "broods" over the waters in Genesis. Altar of Salerno Cathedral, Italy, fifth to eleventh century C.E.

31. Larger than life-size figure creates birds and vegetation in a prehistoric Indian rock painting from the Fremont culture. Utah, 1300–400 B.C.E.

land.[24] Although this story strongly suggests creation by a firmly feminine figure, the feathered serpent, the gender was later switched to masculine.

A comparable creation myth from the Hopi Indians of Arizona possesses considerable charm. The Hopi believe that in the beginning there was water everywhere. Two deities live in the ocean, one in the east and the other in the west. The Goddess of the Eastern Ocean and the Goddess of the Western Ocean met, passing over the sea on the rainbow bridge. The two deities put their heads together and, by concentrating, caused dry land to appear in the midst of the ocean.

When they realized that there were no living creatures on the land, the Goddess of the East made a little wren out of clay and both goddesses chanted an incantation over it until the clay image came to life (just as Jesus in the Koran makes and animates clay birds). They created many different species of birds and beasts; then they created the first woman, followed by the first man, breathing life into them as they had breathed it into the birds and beasts.[25]

In most cosmologies the first act of creation is the generation of light. The Judeo-Christian tradition is no exception. Furthermore, in the Christian tradition the Holy Ghost is imagined as a dove. In Genesis, the

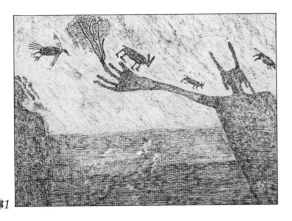

31

Hebrew word *tehom*, "the deeps," or in the King James Version, "the firmament," is used to describe the movement of the Spirit of God on the face of the waters. *Tehom* is also used in Hebrew to describe the brooding of birds over their young, usually a female occupation.

On the medieval ivory altar of the Salerno Cathedral, creation is unveiled with the Latin words for night and day. "The darkness precedes the light and is its mother."[26] The first wisdom was dark and feminine, followed by a masculine wisdom of light. In the Egyptian and Greek religions, the soul or breath broods in the form of a bird, used to represent a Divine Presence. A New World myth attributes creation to the action of the winds, imagined as rising on the primeval ocean from the fanning wings of a bird.[27]

The bird figures prominently in African creation myths. The idea of the bird that gave birth to the cosmos, the earth, and humankind is common to many tribal religions. In the Sandwich Islands there is still a belief that in the beginning there was nothing but water, until a big bird descended from on high and laid an egg in the sea. When the egg burst, the islands came out. In both Europe and Africa, the wind was considered a fructifying bird, an ancestral spirit, that blew upon women and made them fruitful.

The symbol of the African Senofu tribe is the bird-woman called Kono, evidently their female ancestor.[28] In the regalia of the Ivory Coast cult, the great wooden figure of a crested crane resembles a gigantic spirit. The cult's sacred masks, with elongated beaked faces, were so carefully hidden from outsiders that only recently have they come to light. Five or six feet tall, the masks were not only carved in relief on the sacred houses and on the chief's hut, but were also worn during ritual dances in which the wearer of the mask becomes the deity.

Arresting pictographs painted by the Fremont Indians enliven the burnt sienna walls of the maze area of Horse Canyon in Canyonlands National Park, Utah. One six-foot goddess figure caught in the act of creation brings forth plants, birds, and animals from her hands; a tree springs magically from her middle finger (1300–400 B.C.E.).

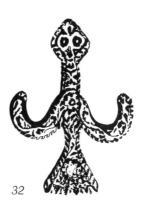

32. Silver amulet of a bird's body with serpent arms and human head. Sachros, Morocco, contemporary.

32

THE CREATRIX AS SPINNER AND WEAVER

The Bird Goddess was a spinner and a weaver from the beginning. Her signs and symbols are found on hundreds of spindles; a large number discovered in Troy illustrate Schliemann's book *Ilios*.[29] Represented in Greek myth by the Fates, the three enigmatic sisters have spindles, shuttles, and shears that become symbolic instruments of birth, life, and death. They determine human history by spinning, twisting, and finally cutting the thread of life. The sacred meaning attached to weaving as a metaphor for the creation of new life has been observed since the time women began to create fabric out of wool thread. It is a natural parallel to the human mother who spins new life in her womb.

In Ecuador and Peru, as far back as 300 B.C.E., the owl and the Mother Goddess became favorite decorations on spindle whorls, the deity usually taking the birth-giving position. The owl is presented as an emblem of the womb. Spindles strung together as funerary gifts are found in abundance in graveyards and in the ceremonial sites associated with the dead.

CONTEMPORARY BIRD GODDESSES

In Morocco, ancient symbols of the Goddess can still be found in the jewelry and handwoven rugs ferreted out by dealers and brought down from the extremely primitive towns of the High Atlas mountains. The figure of the Mother Goddess and her signs are also apparent in the geometric forms and designs on the black goatskin tents of the Megalithic Berbers who, under a thin veneer of Islam, preserve their Old Stone Age animal worship.

A strange silver amulet comes from Sachros, in Tanger, Morocco. Extremely small and chased with a design of flowers and vegetation, the amulet has a human head on a bird's body. The arms take the form of serpents and the hands of serpent heads. A spread tail completes the composition of this bird-serpent-human divinity that uses many of the emblems of the ancient Mother Goddess. The Old Religion, as it was called, has been preserved throughout the world by the simple people resistant to change, who inhabit such unapproachable places as the Atlas Mountains.

Also contemporary, the pregnant Bird Goddess by sculptor Costantino Nivola is an extraordinarily magical sculpture. The piece is one in a long series of Bird Goddesses on which the artist has been working for years.

33. Pregnant Bird
Goddess by Costan-
tino Nivola, one
in a long series on
which the artist
has been working
for years. U.S.A.,
contemporary.

33

Lady of the
Waters

The association of water with maternity is widespread and well known. Moisture is literally the source of life; since the beginning of time water has acted as the primordial womb, the vessel, chalice, or grail from which life springs. The early Greeks saw the sea as a symbol of maternity and generation; long before Christianity, children were baptized with the sprinkling of magical drops. In the Neolithic era, an intense concern with moisture gave rise to such watery symbols as nets, zigzags, and parallel lines. These symbols frequently cover the entire body of the Bird Goddess to designate her Mistress of Water. As the Divine Water Jar, she pours cleansing rains from her heavenly abode. Holy wells and sacred water, once revered, have been undeservedly neglected. Recently, renewed interest in the field, hill, and wood of our environment has been growing.

In early times women took care of the water supply. Until the invasion of Greece from the north, early in the second millennium B.C.E., the magical art of rainmaking remained a prerogative of women; within our own era, the vestal virgins of Rome, like the latter-day priestesses of Benin in Africa, went to the spring daily to fetch water in special ceremonial jars for the temple. In some African kingdoms, the reigning monarch still acts as the living representative of the rain-god. Yet, oddly enough, it is not he who takes part in the rites on which the water supply depends; it is his wives, called the Mothers, who fulfill this function.[1]

Countless European Neolithic and Paleolithic terra-cotta figures exemplify the relationship between water and the divinity. Compared to the abundant archaeological finds of the Neolithic age, few pieces survive from the Paleolithic epoch; yet one or two clear examples have surfaced to tell us that the chevron, with its bird-water connection, was already at that time a living symbol. An early appearance of the chevron in Paleolithic times is boldly engraved on the body of the hybrid bird-woman from Mezin, in the Ukraine (fig. 12 on p. 16).[2] The V formations of the flying birds, heralds of spring and springtime festivals, may be the origin of the V sign, or the shape of their beaks may have been a strong influence. The continuous V sign (W) is an obvious symbol for running water; two inverted V's (M) became the Phoenician glyph for running water and evolved into the letter M. In Arabic, the word for water is *ma*.

A number of humanized hourglass figures composed of two triangles form striking geometric images of the bird and water goddess, who is identified by her three-fingered hand. One triangle, base up, forms

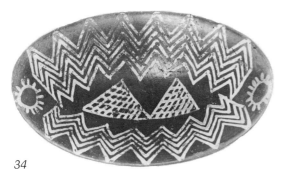

34

34. Amratian platter gives a view of the water above and below the earth, symbolized as net-covered pyramids; the sun rises on the right, sets on the left. Egypt.

35. Geometric hourglass deity decorates a water jar with huge meanders. Traian, Rumania, 4000 B.C.E.

her upper body; the other, base down, her lower body. On a vase from Traian in northeastern Rumania (4000 B.C.E.) one such figure stands at the center of the vase's decorative motifs with a lightly indicated pinhead and feet.[3] The meanders on pottery vases and figurines tell the story of a cosmos in which the water above, like the Greek key design, signifies the empyrean abode of this water deity. According to Gimbutas, the narrative shows three levels in her paradisal dwelling place: sky, earth, and water. Large rhombic meanders, symbolic of cosmic water, bracket the geometric deity.[4]

The realm of the Goddess, traced by the sun's orbit, is portrayed graphically on an Amratian platter from prehistoric Egypt. Day and night pass above and below the earth symbolized by the net-patterned, pyramidal mountains of the east and west. Zigzags depict two oceans; the divinity lives above the heavenly waters, while the sea below corresponds to the underworld through which the soul, like the sun, must pass for resurrection. The sun, when it goes down in the west, reaches the hidden fountain of its life, and at sunrise it is reborn in the east. Millennia later in Egypt, the same two mountains with the sacred net pattern across them were carved over the main entrance of the Great Pyramid of Giza, signifying the place of the

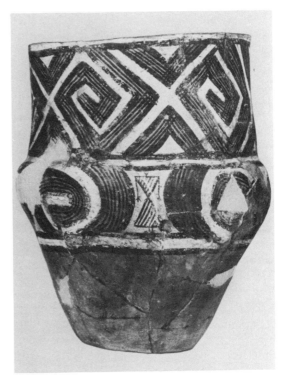

35

36

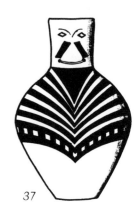

37

sunrise, namely, the Pharoah's resurrection. They are still there in full view for anyone to see.

WATER GODDESSES

The Neolithic water divinity also appears on an early Vinca pottery lid from Yugoslavia, late sixth millennium B.C.E. From the front her mask resembles an engaging young woman in a beret with bangs and catlike whiskers. The profile, however, reveals an entirely different personage: that of a fiercely beaked bird of prey. The fringe on her forehead proves to be a frieze of chevrons, a sign of the Bird Goddess, with parallel lines beside her mouth.[5] The protruding eyes are punctured in their centers to release water, and her oval mouth creates a spout; the mask as a whole expresses an obsession with water during a period of drought.

In Neolithic and Chalcolithic times, water vessels played a considerable role on the sacred altars and in the rituals of her worship. Some of these vessels are decorated simply with eyes and a beak on the neck of the vase; others show the Goddess's eyes molded in relief on the cylindrical neck. Water is closely related to phallus, horns, snake, and water bird. The neck of one double-sexed figurine is unmistakably a phallus, with a hole at the tip, and wings. It also has the posterior of a Bird Goddess.[6] As anyone who walks down a city street knows, the winged phallus has survived to our own day as grafitti.

The head on a big, early Vinca bird jar from Anza IV in Macedonia (ca. 5300–5000 B.C.E.) painted with red on cream, is an icon for the holy womb. Brows meet over molded diamond eyes, and two heavy diagonal shapes cross the cheeks with a central hole. Starting at the neck, the heavily inscribed chevrons of the Bird Goddess descend sharply to form a continuous pattern of V's that ends halfway down in a wide, checkered band. The diamond eyes of the deity, along with the parallel lines and chevrons, mark the Mistress of Water. The space left at the throat is filled by a great red triangle. The size of the jar suggests an altar storage jar such as those used for holy water in modern religious ceremonies.[7]

The face of a seated goddess from Hacilar IV in Anatolia (ca. 5000 B.C.E.) is decorated with rain lines in heavy red on cream. The Goddess of Moisture is characterized by eyes of neatly inlaid obsidian; the heavy, shadowing brows meet over a beaklike nose. Torrential lines stream from the deity's eyes, covering the entire face with parallel rain lines; her neck is encircled with closely placed horizontal chevrons.[8]

36. The Mistress of Waters appears on the lid of a jar; her eyes and mouth are punctured to indicate centers of moisture, and water-signs mark her face. Malco, Yugoslavia, 5000 B.C.E.

37. Large birdlike water jar found beside an altar is decorated with water chevrons. Vinca culture, Anza IV, Macedonia, ca. 5300–5000 B.C.E.

38. Rain lines stream from the face and body of a water deity in the form of a jar. Hacilar IV, Anatolia, Turkey, ca. 5000 B.C.E.

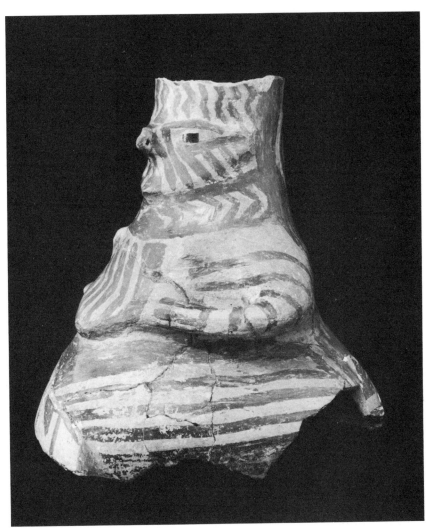

38

39. Long-necked goddess, shaped like a jug and carrying a jar, has tree and net emblems. Crete, 2000 B.C.E.

39

An archaeological mystery was recently solved. Some strange terra-cotta figures from Greece were difficult to date; the best guess assigned them to the eighth century B.C.E. Displaying water symbols reminiscent of far earlier times, the images are much alike in form, but vary somewhat in decoration. All are characterized by the exaggerated pillar neck of the Bird Goddess that mimics the long necks of water birds. Articulated legs dangle from her skirt, the bell shape of which recalls Paleolithic times but is an anachronism in the eighth century. Orifices of moisture (noses, mouths, and breasts) are carefully modeled and picked out in red. In some, the irises of the eyes, inlaid with white beads, protrude and glitter; the pierced ears once contained earrings; and the hair, painted in rippling wavy lines, trickles down their necks.

The initial uncertainty about the date and identity of these idols continued until a discovery at Early Bronze Age Myrtos in Crete settled the matter. A similar long-necked figure was unearthed beside the oldest domestic stone altar yet found in Crete (dated about 2000 B.C.E.). The image, which has lost her articulated legs, wears a bell-shaped tunic. The moisture theme is indicated by the little jug held in the crook of her arm, the painted moisture motifs, and the location of the find.[9] The jugs suggest portage; since there are no wells on the village's hill site, water must have been carried up in jars.

The goddess's tunic is decorated front and back with a series of check-and-net patterned squares. The checkered pattern, like the net motif, denotes the cycle of life and death. For this reason, the little figure's eyes, nose, and nipples are painted in the consecrated red ochre of blood and life.

Criss-crossed with a net pattern, water of life, two long-necked water birds, facing each other across an eight-legged swastika, decorate the robe of a goddess at the Boston Museum. The swastika denotes sun, moon, womb; eight legs, in place of four, double its potency. On each arm are two swastikas flanking the double-axe of rebirth. Most of the swastikas move counterclockwise, alluding to the moon instead of the sun. Between her breasts hangs a necklace decorated with a life column of vertical lozenges. Its pendant is a comb with parallel lines that look like rain from a cloud. In Paleolithic figures, a child carrying a comb was an emblem for rain cloud. Both child and rain symbolize new life. In Europe and Asia, the comb frequently signifies rain, although the emblem in Europe has lost its significance; as in India, the comb still represents rain to the Hopi tribes in the New World.

40. Bell-shaped
divinity decorated
with a double swas-
tika that is flanked
by long-necked
birds, a comb pat-
tern, and a double-
axe. Crete, ca. 900
B.C.E.

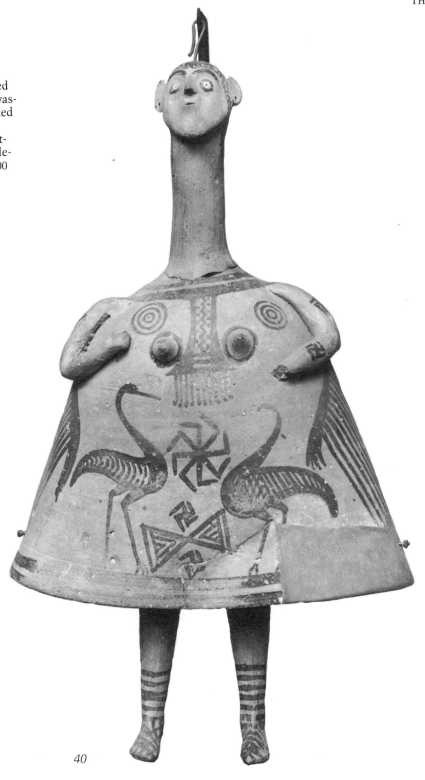

40

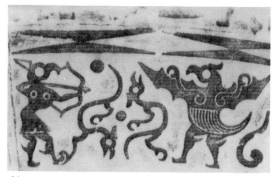

41

These figures bear careful examination for they are rich in symbolism of an earlier period. Another idol, now in the Louvre, uses the same symbols with variations. Heavily outlined in the center is an enormous column marked with the sacred net pattern and flanked by snakey trickles of water; two net-covered water birds with water dripping from their beaks guard the image. Each symbol supports in detail the Mistress of Water theme, and the net pattern is outlined five times for emphasis. These anachronisms assure us that the symbolism has come down intact from early times. The Greek word *kteis* is commonly used for "comb" and also means "vulva" or "scallop shell."[10]

Since no one could understand what the idols stood for, the identity of the goddess was lost for nearly four thousand years. The ideograms could not be deciphered because the key to the code had been lost with time and the passing of the goddess religion. The symbols, which constitute a language of signs and thus the beginnings of writing, had gone unrecognized because of overwhelming cultural changes.

CHINA

Millennia later, far from the Aegean Sea and Greek religion, the bird was used in much the same way for a rite pertaining to water. Two deities confront each other dramatically on a Chinese Hu bronze vessel that dates from the period of the Warring States (476–221 B.C.E.). Both dancing figures have the strong beaked heads of owls, and both have female breasts. The skirt of the figure on the right swirls into a curving tail as she dances on spurred human legs, her arms outstretched. The female deity on the left wears a skirt.[11] Among the Tungas and Yenesei tribes of Siberia, shamans' coats are still cut to resemble the wings and tail of an owl.[12]

In this astrological scenario, a female figure portrays the archer of Sagittarius, who aims her bow at two dragons, emblems of spiritual strength in China associated with the rain cycle. A vertical dragon and a horizontal dragon accompany two orbs that represent phases of the moon. To this day, in astrology the ascending node of the moon is called the dragon's head and the descending node, the dragon's tail.

At the astrological conjunction of the moons with the dragons of water, a dangerous situation is averted by rituals; dancing is necessary to reinforce the magical effectiveness of the rite. The deities

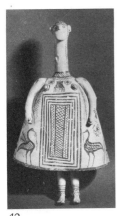

42

43

or shamans direct the ceremony that draws down the fertilizing rains.[13] Magical forces control conflicting elements to release moisture, which often results in the slaying of the dragon by the bird. Dancing wards off the risk of the moon's orbs being swallowed by the dragons, which would cause a disastrous drought. Pierced by an arrow, the moon spills its contents as rain.[14]

NORTH AMERICA

The Kwakiutl tribe of the Mamalelekala culture of Canadian Indians in the Pacific Northwest adds a new element to the mythic relationship of bird and water. A mask of Qiumugwe, King of the Sea, was bestowed as a reward for merit to both males and females. The Indians believed that the bird-crowned mask brought good luck. It portrays a diving bird of curious construction. Manipulated by pulling attached strings marionette-style, the remarkable mask opens and closes its beak, moving its neck from side to side and flapping its canvas wings. The symbolic meaning of diving birds differs greatly from that of other water birds; since the diving bird disappears beneath the water it belongs both to the air and to the underwater realm of death. It is therefore considered not only a denizen of the physical and spiritual worlds but a guide through death and rebirth.

41. Relief on sacred bronze vessel shows two female shamans dancing for rain. China, 476–221 B.C.E.

42. Deity with a central net pattern design, long-necked birds, double swastikas, and a comb symbol. Boeotia, Greece, ca. 900–700 B.C.E. (See plate 1.)

43. Diving bird mask of Pacific Northwest Coast Indians symbolizes bird's connection to underworld. Canada, contemporary. (See plate 10.)

The Nourishing Mother

Many origin myths conceive of the Milky Way as a dazzling effluence of stars that streams from the milk of the Great Mother Goddess. The word "galaxy" is derived from *laktos*, the ancient Greek word for milk. Milk's sacred significance was recognized early in human life. A miraculous gift of the female, it received special veneration; the female deity became the source of nourishment and abundance. The flowing breast, our first perception in life, remains in the human consciousness as an image of intense power.

The prominent breast of the Bird Goddess, source of nourishment and abundance, evoked reverence in prehistoric artists. Since art was religious in purpose, it is unlikely that breasts and other sexual features suggested lovemaking to males. Sex and reproduction were not symbolically connected.

BREASTS

That breasts were a dominant motif in the Paleolithic era can be seen in an East Gravettian ivory, shaftlike figurine (25,000–20,000 B.C.E.) from Pavlov, near Dolni Vestonice, in Czechoslovakia. Everything on the abstract rod has been subordinated to one principal idea; the polished shaft creates an icon for the sacred source of nourishment. Slightly arched and curved backward, it displays well-formed breasts notched along the edges and decorated with horizontal and slanting lines with possible notational purpose.[1] The attachment of the breasts to the shaft creates a natural V shape that often forms a necklace, a repetition of the bird's bill.

The idea of breasts as a divine source of moisture is expressed in a pendant of mammoth ivory (26,000 B.C.E.), also from Dolni Vestonice. Between the breasts is engraved the double-V chevron, sign of the Bird Goddess. A whole necklace of such pendants was found there and in at least fifty other sites from the Upper Paleolithic period. These images of breasts were not used for erotic purposes; they were worn by women as amulets of nourishment.[2]

At Le Combel, Pech Merle, France, just before the original entrance to the inner sanctuary, a small stalactite that exactly resembles a human breast, even to the nipple, has been singled out and encircled by dots of red ochre. Since early times, red ochre, the color of blood, had been used to designate holy objects. It was sprinkled on the dead to invoke renewed life. Within the innermost sanctuary, another group of stalactites creates an amazing wreath of stone breasts. Stalactites form concentrations of cavern sanctity as extrusions of the mother-cave body.[3]

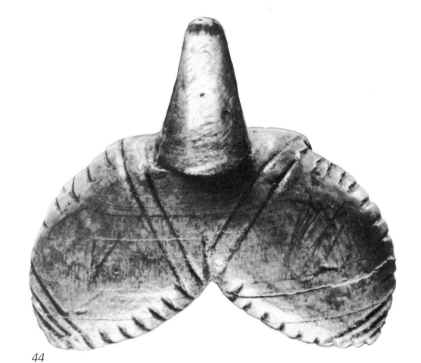

44. Mammoth ivory pendant of breasts. Dolni Vestonice, Czechoslovakia, 26,000 B.C.E.

45. Stone Age shaft with breasts. Site of Pavlov, Czechoslovakia, 25,000–20,000 B.C.E. (See plate 7.)

46. At Le Combel, Pech Merle, stalactites figure as breasts wreathed with red or black dots. France, Solarian, ca. 20,000–18,000 B.C.E.

44

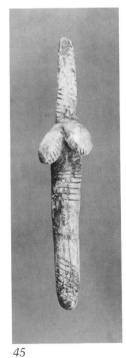

45 *46*

47. Owl-headed
Madonna from
Cyprus holds a baby
to her breast.
Cyprus, 1450–1225
B.C.E. (See plate 9.)

48. Revered breasts
of Iron Age. Den-
mark, 900 B.C.E.

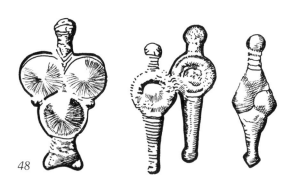

48

47

Later, in the Bronze Age, which began about
1500 B.C.E. in southern Europe and some-
what later in the northwest, curious
figurines composed of single or triple
breasts depicting the Nourishing Mother
were found. The neck of one of these
schematized amulets from Denmark bears
multiple V-shaped chevrons; the heads
appear masked and birdlike.[4]

THE BIRD GODDESS AS NOURISHER

The Bird Goddess displays her breasts in a
terra-cotta divinity from the Late Bronze
Age. The fiercely beaked, owl-eyed Madonna
from Cyprus (1450–1225 B.C.E.) holds an
infant to her breast, its nakedness stressing
her ability to nourish. Her strongly drawn
sex marks her role as a creatrix. She wears
earrings and sacred necklaces, typifying
the female deity.

At an early time, the owl became an
emblem of the uterus; in Europe, Asia, and
Africa the owl was one in a family of
maternal symbols, uterine in nature, both
containing and protective and therefore
much beloved. In addition to symbolizing a
living and nourishing function, however,
the owl presides over the cult of the dead.
The Cyprus madonna borrows the magic
mask of the owl, with its rending beak
and flashing eye, to illuminate the Mother
Goddess's power over death. Today, we

49. Ewer resembling a long-necked bird, with breasts, necklaces, and spouts for bill and eye. Thera, Greece, 1500 B.C.E.

50. Winged-owl vase with human breasts and four necklaces. Mallia, Crete, third millennium B.C.E.

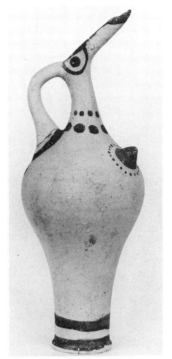

49

make a sharp contrast between life and death; it is evident that early in history they were viewed as extensions of each other. In the prehistoric deity pictured by the figurines, resolution of these opposites takes place.

A winged-owl vase, its spouted human breasts perforated to allow the flow of milk, comes from the cemetery at Mallia, in eastern Crete, and dates from the end of the third millennium B.C.E. The body is covered with bands of painted white zigzags that stand for rippling lines of water and parallel vertical lines that represent streaming rain. Four sacral necklaces circle its throat. The spouted breasts indicate ritual use.

A ewer from the island of Thera (ca. 1500 B.C.E.) gives the theme witty form. Its spout a bill, the ewer portrays the Great Goddess as milk-bringing Mother, as a long-necked water bird with upthrust head and watchful eye. A pattern of dots outlines sharply protruding breasts, and more dots form two necklaces that indicate her ritual importance as Mother Goddess. The vessel, body of the feminine that stores food as milk, and its connection with birth are revered as aspects of the Great Mother. Hundreds of similar pitchers have recently been unearthed on the island.

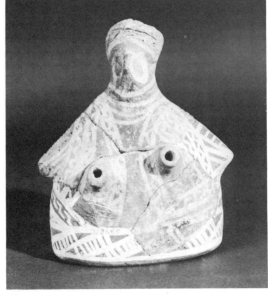

50

51. Owl-faced Pot Mother holds out a container and carries another on her head. Troy, twelfth century B.C.E.

52. Vessel in female form with multiple necklaces carries an open bowl. Prussia, ninth to seventh century B.C.E.

53. Alabaster statuette of Astarte as Pot Mother with breasts, holding a vessel in her lap. Turgi, Spain, fifth century B.C.E. (See plate 8.)

54. The manybreasted Diana (Artemis) of Ephesus, protected by her animals. Rome, second century C.E.

51

52

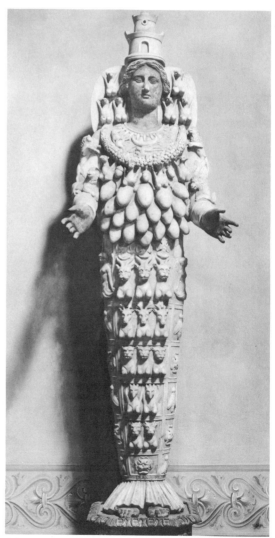

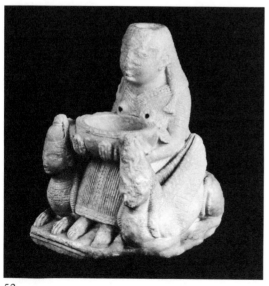

53

54

THE POT MOTHER

In old Egyptian hieroglyphics, the pot was the sign for woman.[5] A figure from the Hisarlik site of Troy furnishes a curious duplication: The Pot Mother holds a jar on her head; at the same time she carries in her hands a small vessel connected to her larger pot body. The pot, in turn, represents the inexhaustible womb of the Bird Goddess, the primeval deep. As noted, women were responsible for the earliest pottery making, so pots were imbued from the beginning with feminine magic. Four necklaces draw attention to her importance as life-sustaining divinity. She dispenses milk for humans and animals, who feed physically and spiritually on her elixir.

Other vessel divinities carry pots as well. An anthropomorphic clay jar from Prussia, dating from the ninth to seventh centuries B.C.E., wears multiple necklaces and holds a bowl. Her skirt, incised with triangles (feminine symbols), shows hairlike lines at the apex, and her ears are pierced for rings. Earth's generative powers encompass birth, life, and death or life, death, and rebirth.

A finely executed alabaster statuette of the Phoenician goddess Astarte, seated on a throne, was unearthed in old Tutugi, Spain. When the hollow figure is filled with milk, the liquid flows from the spouted breasts into a vessel in her lap. The artistry and iconography, as well as the winged sphinxes, point to Eastern workmanship.

Romans, seeking to arouse sensual excitement through shock, created the extravagant image of the many-breasted Diana (Artemis) of Ephesus. The Ephesian goddess is presumed to have sustained both humans and animals with her milk. Protected by her animals, she dons the mural crown with the moon disk behind; in place of a necklace, she wears a garland of seeds and acorns. Her temple at Ephesus, on the coast of Asia Minor, was one of the Seven Wonders of the Ancient World.[6]

55. Great Bronze
Age cauldron, or
Mother vessel,
embellished with
birds and bulls,
promises transfor-
mation. Tiryns,
Greece, ca. 1400
B.C.E.

THE CAULDRON

Basically, the cauldron is interchangeable
with the pot. As vessels, both signify the
universal womb of the Goddess. The
pot and the cauldron foreshadow the Grail
of Arthurian legend. The cauldron symbol-
izes cyclical time, which in turn denotes
the pagan linear calendar, a year of thirteen
months and a day. This time count is
retained in Fferyllt (fairy wisdom), female
menstruation, and the tides of the sea.[7]

Shakespeare's handling of the Three
Witches stirring their cauldron follows the
ancient pattern of associating prophecy
with the cauldron and Three Wise Women.
The ingredients of their cauldron seem
gruesome to modern readers but, in fact,
are the common names for plants. The
Goddess's cauldron in Norse myth, like
Indian Kali's bowl, is filled with blood,
symbolizing the womb of rebirth. It is still
central to the Christian religion as the
chalice and the baptismal font.

A cauldron from Tiryns, Greece, dated to
the Bronze Age (ca.1400 B.C.E.) supports the
mother vessel in which chemical mutations
take place. Both the pot and tripod are
decorated with bull heads and birds.

55

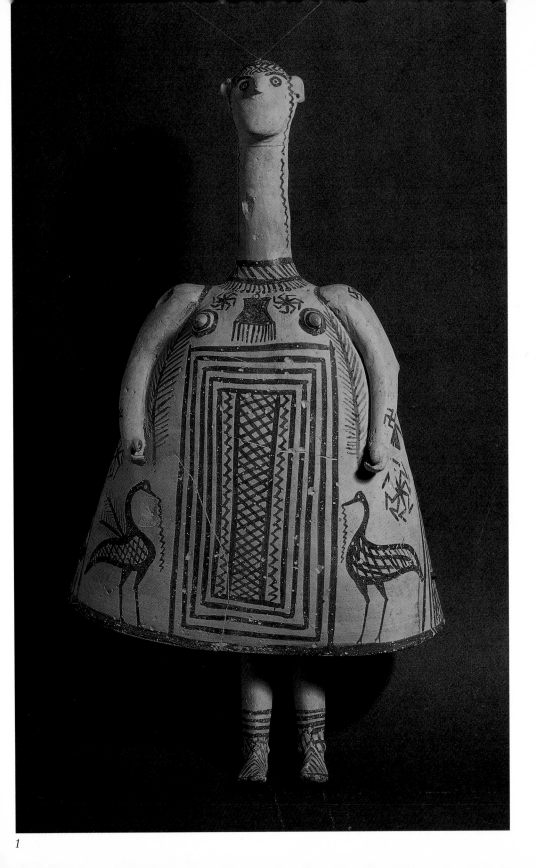

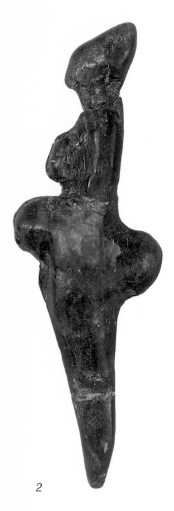

Plate 1. Bell-shaped deity with a central net pattern, long-necked birds, double swastikas, and a comb symbol. Boetia, Greece, ca. 900–700 B.C.E. (See fig. 41.)

Plate 2. Carved stone Venus with enlarged buttocks from Menton. France, Aurignacian, 40,000–26,000 B.C.E. (See fig. 7.)

Plate 3. The justly famous Venus of Lespugue displays wing-like arms and handsome repetition in her figure of the egg-shaped form. France, ca. 25,000–18,000 B.C.E. (See figs. 10 and 11.)

Plate 4. Nut spans the star-studded sky. Tomb of Ramses VI, Egypt, ca. 20th Dynasty, 900 B.C.E. (See fig. 22.)

Plate 5. Mother Goddess figure. Malta, ca. 5000–2500 B.C.E. (See fig. 21.)

Plate 6. The Dove Goddess of Crete crowned with birds, cone, and bull horns. Crete, Middle Minoan III, 1700–1400 B.C.E. (See fig. 28.)

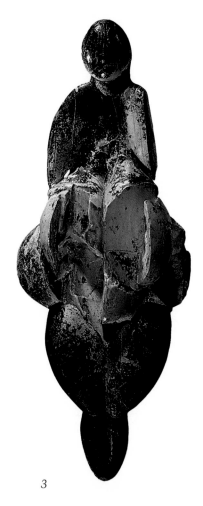

2

3

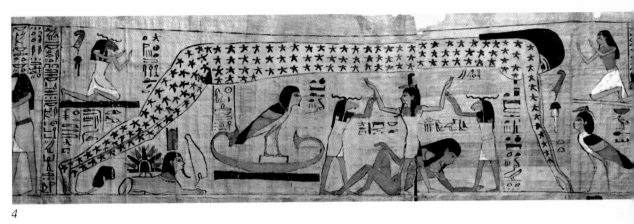

4

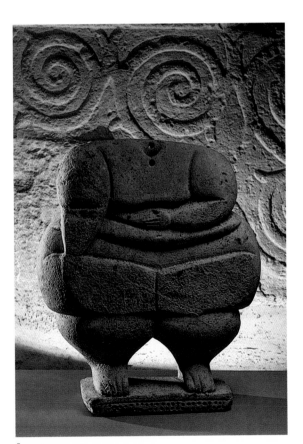

5

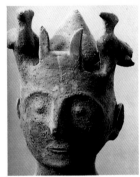

6

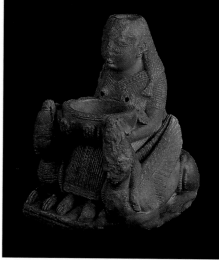

8

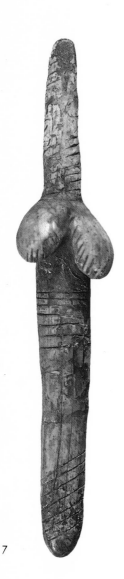

7

Plate 7. Stone Age shaft with breasts. Site of Pavlov, Czechoslovakia, 25,000–20,000 B.C.E. (See fig. 45.)

Plate 8. Alabaster statuette of Astarte as Pot Mother with breasts, holding a vessel in her lap. Turgi, Spain, fifth century B.C.E. (See fig. 53.)

Plate 9. Owl-headed deity embodies death carrying new life in her arms. Cyprus, 1450–1225 B.C.E. (See fig. 47.)

Plate 10. Diving-bird mask of Pacific Northwest Coast Indians symbolizes bird's connection to underworld. Canada, contemporary. (See fig. 42.)

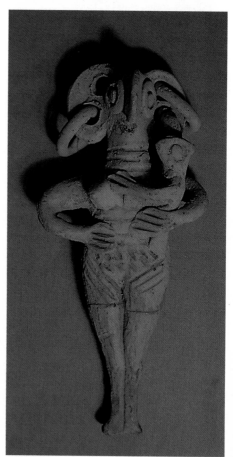

9

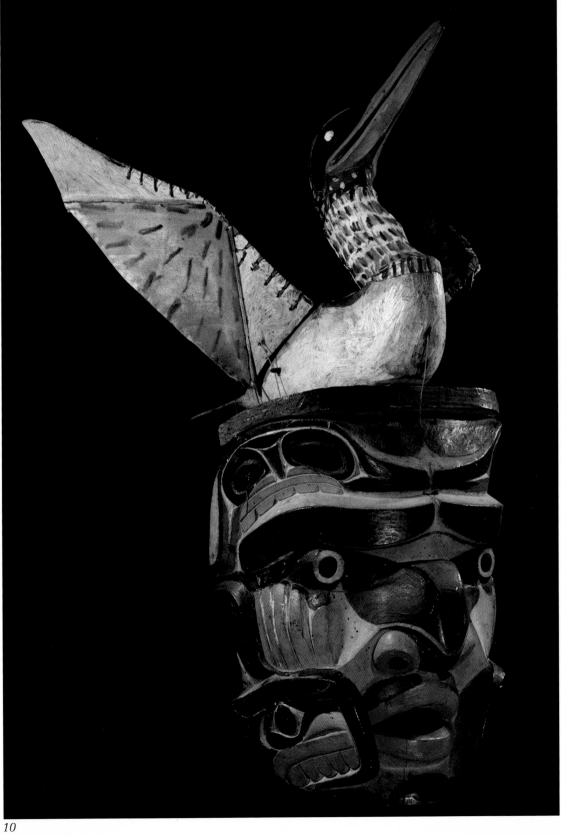

Plate 11. Sarcophagus from Hagia Triada depicts an altar with a high priestess presiding and an obelisk topped by a double-axe and a bird. Crete, 1500–1300 B.C.E. (See fig. 61.)

Plate 12. Mycenaean altar in the form of the Mother Goddess. Greece, 1550–1500 B.C.E. (See fig. 78.)

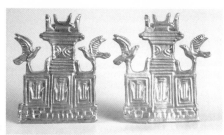

12

11

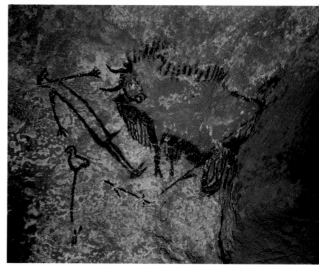

15

13

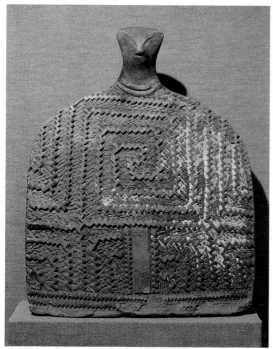

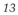
14

Plate 13. Reconstruction of mammoth-bone shrine from the original materials. Mezhirich, U.S.S.R., Paleolithic. (See fig. 69.)

Plate 14. Reconstructed shrine as the Goddess's body with a bird's head and beak. Vadastra, Rumania, first half of fifth millennium B.C.E. (See fig. 75.)

Plate 15. Bird-masked shaman from Lascaux with bird-tipped staff lies prostrate in a well. Cave of Lascaux, France, 17,000–12,000 B.C.E. (See fig. 58.)

The Bird and
the Tree

The tree is central to the realm of the sacred;[1] it is an upward extension of the revered earth. Venerated as divine, *tree* encompasses an incredible variety of meanings: placed by Yahweh at the center of the garden, it became the Tree of Knowledge; at Dodona, where the oracle spoke through the murmuring leaves in the grove of the deity, it became the tree of Fate. Since the divine energy resides in its boughs and leafy sprays, it suggests a fountain of vegetative energy. In spring the tree symbolizes rebirth, as it puts out leaves or flowers.

As a pole the tree represents the axis mundi; it points to the Pole Star out in space. Therefore it is placed in the center of ancient temples as a pillar that represents the Great Goddess or Tree of Life as shown in both Crete and Mycenae.[2] The Porch of the Maidens at the Acropolis in Athens is one example of the pillar-tree as the body of the Mother Goddess.

Today, in Greece, in the Celtic countries, and as far away as Japan, trees near a goddess temple are often white with rags tied to the branches as prayers. Material symbols of her mysterious power, trees offer shelter with their overhanging branches and nourishment in the form of nuts, berries, and fruits. In earlier times, the shaman had simply to climb a tree to reach paradise.[3] Belonging half to the earth and half to the sky, trees were anointed with unguents as if they were people. At sanctuaries, oracles spoke in the murmuring voice of the wind as it sifted through the branches of sacred groves. People of earlier rural cultures believed that the deity lives in the tree and that her fire inhabits the wood. The evergreen promises eternal life, which is why we deck our halls with boughs of holly to celebrate the winter solstice. Then the sacred tree becomes a tree of illumination: hence the lighted candles placed upon it. So the seven-branched candlestick described in Exodus stands for the illuminated tree that dies and is reborn each year and represents the regeneration of human life with its physical and spiritual seasons.[4]

IN PALEOLITHIC TIMES

The concept of bird-soul-ecstatic flight was current in the Paleolithic epoch.[5] Human beings wear bird masks in early cave art. Few images from this period have stimulated more discussion than the man in the well at Lascaux (17,000–12,000 B.C.E.) whose mysterious bird-masked appearance suggests both a naturalistic story and magical rites. A man does not wear a bird mask to hunt birds or other animals.[6]

Assumed to be a shaman, the man from Lascaux is generally photographed lying

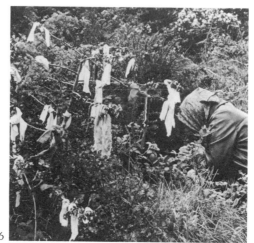

56

56. The tying of rags to trees at goddess temples spans time and space. Contemporary.

57. The Porch of the Maidens personifies the pillar-tree as body of the Mother Goddess. Acropolis, the Erectheum, Greece, fifth century B.C.E.

58. Bird-masked shaman from Lascaux lies prostrate in a well with bird-tipped staff. Cave of Lascaux, France, 17,000–12,000 B.C.E. (See plate 15).

59. Bird-masked shaman appears erect when viewed from above. Cave of Lascaux, France, 17,000–12,000 B.C.E.

57

58

59

prostrate on the ground with a bird-crowned staff nearby. But if one looks into the well from ground level, the shaman suddenly springs erect, a position that suggests an entirely different interpretation. He no longer lies comatose in a trance but seems ready to take flight, his chest expanded, puffed out. From this angle, he seems to point with his three-fingered avian hand to the bird on the pole and with the other hand to the wounded bison. His ithyphallic condition indicates a state of intensity; all his concentration is focused upward, in the direction of his journey. The misinterpretation of his position is due to the rationalistic view that relates objects in space to the vertical and the horizontal, a practice not always adhered to in cave painting; in fact, often ignored.[7] As a sorcerer, the Lascaux shaman may be compared to the creative artist, able to approach spheres inaccessible to the average person.

ASIA

The so-called Mountain Men, or Immortals, of China, pictured as feathered birds, soar through the air on animals. They are the vestigial remnants of early bird cults and sacrificial rites. Even now, Siberian medicine men are believed to be descended directly from the birds they impersonate. The Yakut word for the shaman's bird coat, *tanara*, means "sky."[8] The Tungus people,

Mongols of central and east Siberia today, use ecstatic states to fly through the sky and descend into the underworld to recover souls. The shaman, considered an external image of the soul, is expected to speak the language of birds. His states of transport are analogous to those of birds soaring through the air in flight.

In China, during the first millennium B.C.E., the stick and bird symbolism gained greater expression in the images of the period. One figure, excavated from a tomb in northwest China, is a bronze shaman who holds in his right hand a long pole surmounted by a bird. Another piece, a bronze from circa fourth century B.C.E. (Warring States Period), shows a Mongolian youth or shaman with a stick with a bird on the end in both hands. In this culture, as with the others, the bird on a pole is identified with the tree of the Goddess.

ARTEMIS

As Tree Divinity, Artemis embodies the bird and pole motif. Of all the Greek goddesses, Artemis is the most closely related to the Goddess as Lady of the Wild. During the Early Ionic period (eighth century B.C.E.), before her fabulous temple was erected, a primitive tree shrine was built nearby on protective sheepskins laid between the arms of a stream in order to lessen the perils of earthquakes. The ivory figure of a priestess of Artemis, recovered in this small shrine, supports on her head a pole crowned by a hawk.[9] Amulets of the solar hawk, the bird on the pole, made of gold, ivory, and bronze, have been found in profusion in her shrines. The Greek Sun Goddess, Kirke (Circe), whose island domain Homer places at sunrise, was believed to be a hawk. As D'Arcy Thompson comments, kirke, a poetical and mystical name for hawk (kirkos), means hawk, falcon, circle (circus), or sun in Latin. The sun in the Rig-Veda is frequently compared to a hawk circling in the air. The hearts of hawks were often eaten to obtain prophetic powers.

On Crete in Minoan times (ca. 2000 B.C.E.), Artemis was worshiped as the Divine Virgin, an identity that related her to the Great Goddess. During the Neolithic and Early Bronze ages, she was revered as a deity of the sun and moon, the Queen of Heaven, but finally became Goddess of the New Moon.

CRETE

In the palaces and private houses of Crete, archaeologists discovered cavelike, windowless rooms containing the bases of vanished wooden columns, with trenches dug around the bases to receive libations from the jars stored nearby. Worship of the pillar, as a center of numinous energy, began with the worship of stalactites in caves.

60. Mongolian
youth, probably
shaman, holding in
each hand a stick
with bird. Mongo-
lia, ca. fourth cen-
tury B.C.E.

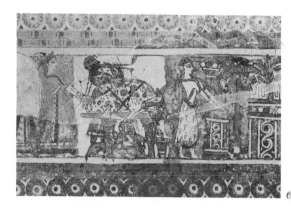

61. Sarcophagus from Hagia Triada depicts an altar with a high priestess presiding and an obelisk topped by a double-axe and a bird. Crete, 1500–1300 B.C.E. (See plate 11.)

Stalactites were viewed as holy because they extended the cave-body of the deity, and the first shrines on the island were peak sanctuaries close to the caves.

On a remarkably beautiful sarcophagus, probably that of a prince, from Hagia Triada (1500–1300 B.C.E.), obelisks crowned with birds and double-axes serve as formalized symbols of the tree. Scenes painted on the long sides of the casket represent symbolic rites for the dead. The funeral cortege, which includes priestesses wearing bull skins, is similar to those in Egyptian ceremonies. Beneath a cypress tree, the dead man, wrapped in a bullhide robe, stands at the door of his tomb. According to the Egyptian *Book of the Dead*, the deceased is always wrapped in the skin of a bull and accompanied by priests similarly clothed.

The scene continues on the other side of the sarcophagus where priestesses direct and enact the religious ceremony. One, apparently the high priestess, places an oblation on an offering table decorated with spirals. A motley bird perches on each obelisk, above the double-axe.[10] Behind the priestess, a flute player provides musical accompaniment for a bull who lies upon a table, his life blood streaming from his neck into a vessel below. A procession of women (whose upper bodies have been obliterated by dampness) completes the cortege.[11]

The deity herself stands at each end of the Hagia Triada casket upon which her principal symbols are displayed. Having driven to the ceremony in a horse-drawn chariot, she departs when it is over, the lifeless man beside her in a chariot drawn by griffons, benign and powerful creatures of the underworld that combine the features of two of her holy animals, the bird and the lion.

A Cretan terra-cotta from the Late Minoan-Mycenaean period (1400–1100 B.C.E.) shows the Goddess in the form of a tree with her birds fluttering joyously about her. The trunk and outstretched arms of this figure are clad in ceremonial robes decorated with a broad cross-hatched pattern. Six birds perch on the seven branches of the tree, while the seventh bird, undoubtedly the alternate form of the deity, settles on top with wings spread wide. Most of the birds are painted with three dark stripes and a chevron.

EGYPT

The mythological correspondence between tree and Goddess goes back to earliest Egypt and persists throughout the religion. The sycamore of the south was regarded as the body of the deity Neith, the oldest goddess. The Tree of Life and the funeral tree of the netherworld are the sacred sycamore; the

62

63

62. Minoan-Myce-
naean Tree Goddess
in bird epiphany.
Crete, 1400–1100
B.C.E.

63. Egyptian tomb
painting shows the
Tree Goddess feed-
ing the dead from
her sacred syca-
more. Egypt, six-
teenth to four-
teenth century
B.C.E. (See plate 16.)

deity in its branches dispenses food and
drink to the dead. Described in *The Book of
the Dead*, this deity holds a vase to pour the
Water of Life to the worshiper;[12] in her
other hand she carries a tray heaped with
the Food of Life. On the ground beneath the
tree a pair of human-headed ba-birds
represent the souls of the worshiping dead.[13]

The early Egyptians, like the ancient
Chinese, believed in a double soul and
envisioned the two souls as human-headed
birds called the *ka* and the *ba*. The *ka*
exemplifies the intellect and sexual vitality,
while the *ba* stands for the immortal spirit.
Of the two, it is the *ba* that outlasts the
body. Leaving at death, it hovers over the
dead person. It floats above the cemetery at
night, waiting to reenter the body. Belief in
the *ba* antedates most other tenets of the
religion and persists in Egypt today. The
soul bird flies through the underworld with
the sun, which travels the waters of the
abyss in a specially designed boat, emerging
anew each morning in the East.[14]

Hastily painted on a pillar in the burial
chamber of King Thutmose III at Thebes,
the tree ritual of the dead centers about the
image of the goddess Isis. Wearing a brief
kiltlike garment, the young king grasps the
human arm of the Tree Goddess and sucks
her breasts. As a sycamore, she imparts
nourishment; as a family tree, she exempli-
fies generation. The presence of the tree

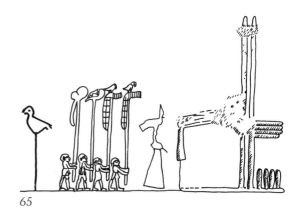

65

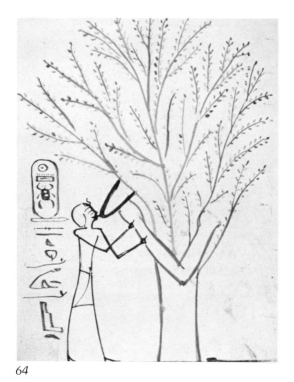

64

deity in Egypt can be traced back to the Old Kingdom, ca. 2780 B.C.E. In fact, the early inhabitants who worshiped stones and mountains included trees in their rituals.[15]

The original house of the deity in Egypt appears to have been a fragile hut rather than a permanent structure. On an ebony tablet from the first Egyptian dynasty (3000 B.C.E.), two astonishingly tall poles support one of these huts. They are engraved with the hieroglyphic sign for Neith, the oldest Egyptian goddess. These poles stand as the first hint of the slender stone needle, the obelisk, that was metamorphosed from the ancient female pillar. The obelisk plays a considerable part in the vertical orientation of Egyptian art. On the left side of figure 65 the upward movement begins with the bird-on-the-pole motif from Lascaux, progresses through Egyptian nome standards, includes the Egyptian phoenix-heron and ends with the earliest discovered shrine, that of Neith.

CHINA

In the Chinese Han period (206 B.C.E.–220 C.E.), small ceramic urns shaped like pavilions hold offerings. Known as moon houses, these shrines were placed on poles over the graves and contain the spirits of the dead. On the highest point of the roof a spirit bird perches. The ancestor's name,

64. King Thutmose III in his tomb suckled by Isis in tree form. Thebes, Egypt, sixteenth to fourteenth century B.C.E.

65. Chart of the female pillar evolving into the masculine pole. Egypt, ca. 3000 B.C.E.

66. Terra-cotta house urn as an outgrowth of Paleolithic tree theme. China, 206 B.C.E.–220 C.E.

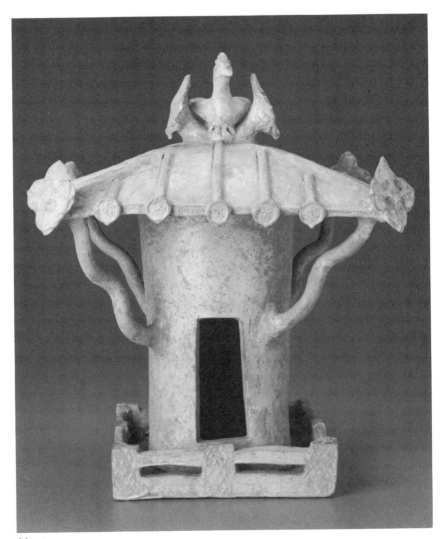

66

67

67. Two figures pick figs from the sacred tree. Pre-Columbian Mayan codex, Fejérváry, Pre-Columbian.

68. Navaho sand-painting of Changing Woman between cornstalks. American Southwest, contemporary.

repeated three times, is often inscribed on the spirit bird's head. The bird, named Luan, is the very essence of the soul.[16] Decorating the foundations of these houses is a frieze of lozenges. Each represents the sacred ancestral womb through which the ancestor may be reborn.

In China these spirit houses, reminiscent of prehistoric times, express the concept of renewal. For three thousand years, the spirit house on a pole has stood for the abode of an ancestral spirit, a member of the family who could at any time be consulted for guidance.[17]

MEXICO

On the other side of the world, the combination of bird and pole continues. Among the Mayans and Mexicans, the spirit is a bird that descends in order to impart life to the pillar. Among the Mexican and American Indians, crosses meant to invoke rain are usually composed of tree trunks, each with two horizontal branches and a bird perched on top.

Among the Mayans, the Sacred Tree blossoms in the form of the "tau cross" with a quetzal bird alight on the upper fork. Under the tree's snakelike roots the great earth serpent arises, and from the trunk hang figs resembling human breasts. It is a peculiarity of the sycamore fig that the fruit

stems from the stock of the tree and not, as in the common fig, from the branches. Two figures, whose feathered crowns indicate spiritual distinction, face each other across the tree trunk and reach out to pick the nourishing fruit for humankind.

A sacred Navaho sand painting shows Changing Woman reaching toward two cornstalks. A bluebird perches atop each treelike stalk. A path, marked by footprints, leads to the arc of the rainbow. Spirits or shamans use this as a magical road to the upper world. The bluebirds flanking the Goddess are symbols of joy; as birds of the dawn, they renew the promise of each day's beginning.

THE BIBLE

The Old Testament contains many allusions to oracular trees. Besides the Tree of Life and the Tree of Knowledge in Genesis, the burning bush speaks to Moses, and the palm of Bethel instructs the prophetess Deborah. David, asking the Lord when to attack the Philistines, is answered with a sighing from the tops of the mulberry trees. The Tree Goddess lingers on in Asherah, and the Tree of Life figures even today in holiday celebrations, such as Christmas, that are rooted in tree worship.

Both the bird and the tree are intermediaries between worlds: the tree has its roots deep

68

in the earth while its branches reach toward the sky, the bird passing between them. At the center, the two worlds of myth and nature meet; they fuse and become a place of absolute reality and consequently sacred.

Robert Graves, in *The White Goddess*, has pointed out an ancient vocabulary of trees.[18] In early times, a specific type of tree was identified with a specific oracle center. In addition, a design, in no way arbitrary, existed in the choice of sites for these oracle centers. Situated according to complicated, strategic patterns that lie along the telluric lines relating to or proceeding from the earth, they are ordered by latitude, longitude, and geodetic currents covering the known world, including the Chinese capital An-Yang. Particular trees belonged to the prime places where the magic powers of prophecy were practiced.

For example, Dodona, where according to legend humankind was born, was famous for its speaking oaks. Though it lay far to the northwest, in wild country quite out of the way for most Greeks, Dodona was strategically placed in order to line up exactly on the same longitudinal line with Metsamor in distant Colchis, the scene of the Golden Fleece.

Like Dodona, Colchis was an oracle center famed for its pythoness, Medea. Her name in Sanskrit means "female wisdom."

She was the presiding priestess of the temple. It was her incantations that won the Golden Fleece for Jason.

Delphi, at Mount Parnassus, was tree-coded to the laurel and the most famous of all oracles. Its related center was across latitude 38°30' at Mount Sipylus at Sardis.

Delos was identified with the palm tree and the moon since Artemis preceded her twin Apollo as the first born. It shared the latitudinal degree with Miletus, and Didyma, at Mount Latmus. A lost piece in the configurations, Thera, the sacred island north of Crete, was destroyed by a catastrophic volcanic eruption. It had its antithesis at Hierapolis. Another lost oracle center, Omphalos, or Thenae, near Knossos, was linked with the willow and had Latakia as its logical counterpart. Aphrodite's birthplace, located somewhere on the south coast of Cyprus, holds sacred an oracle from which her tree, the cypress, took its name. Its corresponding center must have been Tripoli or Palmyra. Lake Tritonis (Triton), on the Libyan/Tunisian border, is Athena's birthplace. Any corresponding site in Lebanon would, of course, be related to cedars.[19]

Shrines

The shrine represents the abode of the deity. The shrine is often a place set apart, shielded from sight by a screen or veil, which indicates a sacred area consecrated to the adoration of the deity. Early shrines were caves, where the free-form space embodied the Mother Goddess. Later, the holy spaces of caves were replaced by sacred rooms or shrines that took the form of circular huts. The form progressed to a horseshoe design. As society became more complex, towns evolved, and as buildings grew in size and grandeur, palaces such as that of Knossos, which contained many sacred rooms, became regarded as temples.

CAVES, HUTS, AND SACRED ROOMS

The beliefs and practices of the Cro-Magnon people come to light in the limestone caves and rock shelters of southwestern France and northwestern Spain. Since that which is sacred is secret and hidden, the caverns and grottoes of the Aurignacian and Magdalenian eras were believed to represent the body of the Earth Mother. At Niaux, in the Pyrenees, the decorated caverns lie as much as half a mile from the entrance to the underground complex. Many painted cave areas can only be reached by crawling, or occasionally slithering, long distances through narrow tunnels. In some, rough altars have been hewn from the rock. Other altars are formed naturally, by water or stalagmites, as in the cave of La Pasiega in Cantabria, Spain, and at nearby Castillo where altars are formed by stalagmite projections.[1] Hardened footprints in the soft earth indicate that ritual ceremonies took place there.

Used as temples, the caves became centers of intellectual and ceremonial activity. The painting of the walls was itself a sacred ceremony. Shell palettes have been found, still filled with colored earth to which vegetable oil had been added as a binder. Tiny lamps of stone that fit neatly into the hand of the artist were hollowed for oil and set about on the ground, making perfect work lamps for illuminating the surfaces to be painted. A test at Lascaux by Mario Ruspoli proved that a few of these lamps easily light a low-ceilinged cave. Brilliantly illuminated, the paintings sprang to life before the archaeologists' eyes.

The evidence points to women as the cave artists, as the size of the hand- and foot-prints found in the Paleolithic cave of Pech Merle fit the skeletal remains of women. In Neolithic Çatal Hüyük, Anatolia (modern-day Turkey), painters' palettes were found among the female grave goods under the beds and floors of their houses. The palettes still bore color for painting the murals of the sacred rooms.

69

69. Reconstruction from the original materials of mammoth-bone shrine. Mezhirich, U.S.S.R., Paleolithic. (See plate 13.)

Women may have painted the caves as part of the rites to honor the deity or for ceremonies over which the Goddess presided as Mistress and Protector. One would expect the stone and bone figurines to have been carved by men, the flint-makers who had dominated and perfected the use of tools. However, since the stone and ivory female figures, ranging from southern France to Siberian Mal'ta, are found largely in the women's quarters, it is likely that women were the sculptors.

While Paleolithic men hunted and fished, women gathered food and made the caves habitable. In the warmer months, the group members moved to their summer houses. In all probability, these homes were destroyed yearly by winter weather and predators, but on the stone hearth that withstood each year's ravages, women rebuilt the structure of skins sewn over wood frames.

Rituals grew out of attempts to influence the deities that controlled important aspects of life, such as the weather and the food supply. The woolly mammoth provided the actual framework for primitive shrines in the Ukraine: Because of their immense size, the mammoths' skeletons were particularly suitable for building small structures that could be covered with moss and sod. Several Paleolithic huts found in Mexhiric, Russia, were made entirely from interlocking bones of these sacred beasts, with every part of the skeleton meticulously used. Ritual objects found in the bone frames confirm their purpose as places of worship: A dented and elaborately decorated mammoth skull, for example, was used as a ceremonial drum. Since the mammoth was particularly sacred to the Goddess, her figurines were often carved from its ivory.

THE TEMPLES OF NEOLITHIC EUROPE

In southeastern Europe, a tradition of temple building arose to support the cultural worship of the Great Goddess at the time when the glaciers retreated and her caves were abandoned. Appearing as early as the seventh millennium B.C.E., this tradition persisted for five thousand years. It included the time of the fabulous temples of Malta and the palaces of Crete and Mycenae.

About fifty models of early temples have been uncovered, each small enough to be held in the hand. Found mostly in the now-ruined temples of Rumania and Bulgaria, these beautiful miniature shrines, probably votive gifts, were placed near the altar or in the temple courtyard. Along with the sanctuaries themselves, the models provide invaluable glimpses into the workings of cult practice.[2]

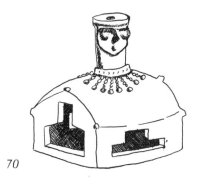

70

Rosy terra-cotta shrine models, from a Cucuteni-Tripolye settlement dating from early in the fourth millennium, were discovered in the Bug Valley of the western Ukraine. The inner walls of the models are painted with a pattern of lozenges flanked by the chevrons of the Bird Goddess. One model contains miniature female figures engaged in baking;[3] the oven probably symbolized the transformative character of the womb. Pottery is arranged around the wall, and a cross-shaped sacrificial table stands at the back.

In shrines like this, offerings were doubtless made to the Grain Goddess. She was an important manifestation of the Great Mother in Neolithic times when the introduction of agriculture led to new activities such as the production, storage, and processing of grain. As noted, women had learned about the soil and moisture needs of each plant when they gathered roots, berries, bark, and fruits, just as they had learned about the nutritional and medicinal uses of these gatherable foods.

Paleolithic caves were regarded as the body of the Goddess; so Neolithic worshipers fashioned temples in the form of her body. A curious shrine model of clay from the Starcevo culture near Bitolj, Macedonia, early sixth millennium B.C.E., has a cylindrical chimney set into the roof encircled by a necklace. The chimney

suggests a human neck with a mask of the deity affixed; thus the house itself symbolizes her body. The temple as a whole becomes her incarnation.[4]

As noted, the earliest temple, the Paleolithic cave, was considered the body of the Mother Goddess; it follows that the concept would extend into the Neolithic era. A terra-cotta altar screen from Trusesti, Moldavia, Rumania, ca. 4300 B.C.E., has finials in the form of the Bird Goddess with a necklace and is pierced with portholes. Another screen from Cascioarele, lower Danube, mid-fifth millennium B.C.E., also features portholes for the deity's birds and is adorned with four little shrines at the top suggesting that the architectural motif is based on the body of the bird deity.

The Bird Goddess appears repeatedly in Neolithic architecture. A schematized bird's head crowns the gable of one distinctly birdlike edifice with deeply incised wings and plumage. Directly below the head, a round hole, too high and too small for human use, provides convenient access for the Goddess in bird form. The doorway stands as an especially sacred feature of this shrine from Turdas, west Rumania (ca. 5200 B.C.E.).[5]

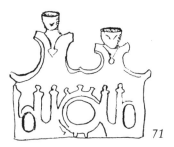

71

72

70. Necklace on model temple suggests reconstructed chimney with mask. Porodin, Macedonia, sixth millennium B.C.E.

71. Terra-cotta altar screen in the form of the Bird Goddess. Trusesti, Moldavia, Rumania, ca. 4300 B.C.E.

72. Clay altarpiece with shrines and portholes. Cascioarele, lower Danube, Rumania, mid-fifth millennium B.C.E.

73. Neolithic shrine model shows baking activities. Western Ukraine, fourth millennium B.C.E.

74. Bird shrine with circular entrance. Turdas, Rumania, ca. 5200 B.C.E.

73

74

75. Reconstructed shrine as the Goddess's body with a bird's head and beak. Vadastra, Rumania, first half of fifth millennium B.C.E. (See plate 14.)

75

Dating from the first half of the fifth millennium B.C.E., a singular temple model from Vadastra, Rumania, takes the form of a divinity, part human and part bird. The damaged head (reconstructed in the photograph) features both a bird's beak and a human mouth. The formidable goddess wears three sacred necklaces. A tall narrow door cut into the body at bottom center serves as entrance to a womblike chamber. Incised on the surface is a labyrinthine design of running-water zigzags filled with white paste. Related to the labyrinth, meanders always connote cosmogonic significance in the ancient myths and fairy tales.[6]

CRETE, ÇATAL HÜYÜK, AND MYCENAE

During the Early Palace period in Crete, palaces and houses served as places of worship along with caves and mountain peak sanctuaries. In the lower level of the Palace of Knossos a shrine composed of a triad of sacred baetyls, meteoric stones, was discovered sculpted into a miniature shrine. Atop each stone perches a dove, a manifestation of divine life, and between each dove and pillar lie two round cylinders. The threefold shrine has been interpreted as symbolic of the divinity in her lunar aspect: waxing, full, and waning.[7]

Presented in monumental relief on the wall of a shrine dedicated to the Goddess at Çatal Hüyük, a bicylindrical object is set into the pediment that surmounts three pillars. Although the contents of the shrine are extraordinary, the architecture of Çatal Hüyük's sacred rooms is simple. Patterned on human dwellings, the rooms are entered from above. Thousands of years lie between the civilizations of Çatal Hüyük and Crete, yet amazing parallels connect them and serve as an example of the profound conservatism of ancient religions.

A BIRTHING SHRINE AT ÇATAL HÜYÜK

Çatal Hüyük, an Anatolian town of a high artistic level, covers a period in the Neolithic radiocarbon dated between ca. 6500 and 5700 B.C.E. Many shrines, wall reliefs, and paintings of female deities were carved in stone or modeled in clay there. The importance of such a site, along with the high order of the culture, lies in the fact that it is well documented in clearly defined strata.

The chapter entitled "The Creatrix" talks about birth through the Goddess-Creatrix. At Çatal Hüyük, a special birthing room was uncovered, supplying insights of striking interest. The contents of Shrine VII.31, named by excavator James Mellaart the "Red Shrine," are unique. A special feeling of mystery permeates this shrine;

76. Goddess shrine with three pillars topped by double cylinders. Çatal Hüyük, Turkey, ca. 6000 B.C.E.

77. Cretan shrine of three pillars each with two cylinders and a dove. Palace of Knossos, Crete, Early Palace Period.

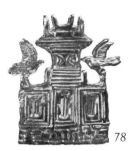

78. Mycenaean altar in the form of the Mother Goddess. Greece, 1550–1500 B.C.E. (See plate 12.)

78

76

77

the walls and the floor, made of red-burnished lime plaster, have been relaid twice and painted red throughout, the color of life. Women came here to bear their children six thousand years ago. The birth of a child was surely a sacred event in early societies. Çatal Hüyük devoted a number of murals and reliefs to the subject.[8]

Since Paleolithic times, religious worship took place largely within the home, and it is in private habitations that most early goddess figurines have been found. Excepting the caves and mountain peaks and the Gournia snake sanctuary, shrines in Crete set apart for the veneration of the Goddess are all found within palaces or private dwellings.

The golden Mycenaean horned shrine (1550–1500 B.C.E.) provides a double image; the precious miniature piece has a foundation of jointed slabs as in mountain shrines. It can also be seen as a subtle configuration of the Goddess with arms raised in blessing. The deity's eyes gaze out from beneath a horned headdress; five necklaces mark her divinity. Doves alight on the Horns of Consecration as if on her arms. Each of the three panels that form her body contains the deity's column springing from a pair of horns. Two of the pillars are thrice framed, and the two side altars support the figure's horned arms. This altar literally embodies the divinity, like the temples on Malta and

79

the painted caves. All parts of the temples, including the great halls with their forests of columns and the shrines themselves, are places of passage between worlds and so remind one of the Egyptian belief that the soul wanders in the afterlife.

MALTA

Malta, at the center of the Mediterranean, lay far south of the usual shipping lanes; consequently, it remained separated from its neighbors. Between 5000 and 2500 B.C.E., an exceptional culture appeared there about which little is known. Where it came from and where it went is still a mystery; yet it survived as an isolated pocket of matrifocal values for hundreds of years. Were it not for its mysterious temples, it would have gone unnoticed. Even in the monument-strewn islands of the Mediterranean, the spiritual singularity of the goddess temples of Malta is conspicuous. Built with monumental boulders, yet finished with the first dressed stone within, these temples were designed in a unique apsidal arrange-ment resembling the cloverleaf form of the Goddess herself. Some temples, large enough to be compared with cathedrals, were expanded through the addition of vaulted circular chambers. They contained altars, fonts, ovens for baking sacred bread, and many goddess figures; the remains of one are nearly six feet in height.

A visit to the monuments there reveals convincing evidence of goddess worship.[9] These great stone shrines with rock-cut altars date from about the fourth and early third millennia B.C.E.[10] We know from radiocarbon dating and comparison with the growth rings of the bristlecone pine that these temples antedate the pyramids and are the oldest stone temples known to us. Four groups of these Neolithic temples stand in the comparatively treeless terrain, weather-worn but remarkably intact; others are in ruins.

The original inspiration for the temples is unknown, but sculpted cones found buried at several of the temple gateways are considered proof of a relationship between the cultures of Malta and Mesopotamia. No one seems to have considered the possibility that this vision goes back to the finely polished rods and cones of mammoth ivory found buried at Paleolithic Dolni Vestonice and that the Maltese and Mesopotamian cultures derived from a common source elsewhere.

IRELAND

The mound of New Grange on the Boyne (ca. 3200 B.C.E.) is one of the most celebrated monuments of the ancient world, measuring 265 feet in diameter and 45 feet in height. Inside the temple-grave a large stone block

79. Cloverleaf floor plan of goddess temple. Malta, ca. 5000–2500 B.C.E.

80. Gateway to one of the goddess temples of Malta, the oldest stone temples in the world. Malta, ca. 5000–2500 B.C.E.

80

81. The mound of New Grange in its wild state before renovation. Ireland, ca. 3200 B.C.E.

82. Great stone slab placed before the portal is decorated with gigantic double spirals. Malta, 5000–2500 B.C.E.

83. Eye Temple of Tell Brak. Syria, 3000 B.C.E.

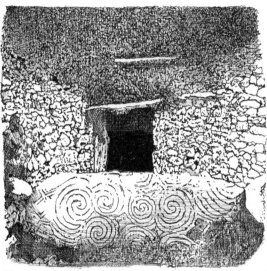

81

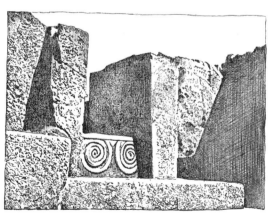

82

in the form of an altar testifies to its character as a sanctuary rather than a king's tomb. Outside, a rim of stone slabs, creating a wainscoting effect, encloses the bottom of the mound. These newly restored white stones gleam like marble. A single giant menhir once crowned the mound, and near the entrance stood figures of the deity as a ring of thirty-five menhirs. Now only twelve of these remain. A great stone slab placed before the portal is decorated with gigantic double spirals, startling in their resemblance to those that guard the sanctuary of the goddess temples of Malta. These spirals depict the eyes of the goddess and were made to guard the entrance at both sites.

THE EYE GODDESS

A special aspect of Inanna-Ishtar, the Eye Goddess has her own Eye Temple at Tell Brak in eastern Syria, which dates from 3000 B.C.E. It is crowded with countless figures of the Eye Goddess. High on the walls of the dramatic interior, great eye-faces alternate with symbols of the gate guarded by Inanna's reed bundles. Her special role was evidently to stare back an attacker at the gate. Punctuating the design are rosettes, vortices of petals that look like eyes with lashes (the vagina surrounded with hair). The design, which displays three

83

symbols with similar meaning, is repeated around all the walls. The shrine overflows with hundreds of variations of the eye figure, each apparently a votive presentation. Alone on an altar is an enormous pair of hypnotically staring eyes that resembles nothing so much as a pair of opera glasses.[11]

The power of the eye to guard against danger extends to protection against the so-called evil eye. The greatly feared eye was both an amulet for protection and a death-dealing aggressor. Thus the Eye Goddess is always equally identified with the source of creation and Goddess of Death. The power to "overlook," to turn the gift of protection against adversaries, was believed to be a gift enjoyed by all women. More than four thousand years after the Eye Temple was built, the judges of the Inquisition were terrified by the evil eye. So great was their fear of being "overlooked" that they made accused witches enter their presence backward.

THE ORACLE AT SMYRNA

A colossal statue of the Mountain Mother, thirty feet high, is cut from the living rock of Mount Sipylus behind the city of Smyrna in Asia Minor.[12] An oracle center, it lies along the same latitude as Delphi and Parnassós. Pausanias, the ancient Greek historian, maintained it to be the oldest of all the images of the Great Goddess in the Near East.[13] Its reputation as the oldest was shaken when Hittite hieroglyphics were discovered engraved in the niche behind her head. On the other hand, many other goddess figurines were found there antedating the Hittites by many millennia.[14] Archaeologists still dispute its date (2000 to 1200 B.C.E.). However, the present age fully demonstrates the lengths to which vandals will go to deface a monument.

EASTERN EUROPE

By this time, the reader must have garnered a sense of the power and the continuity, both over area and over time, of the symbols. The confusion of symbolic meaning begins now, in the Late Bronze and Iron ages. With the patriarchal takeover, came also the commandeering of the symbols of the goddess for patriarchal ends.

A bird-headed deity stands in a three-wheeled vehicle drawn by a pair of water birds. A swan precedes the divinity. Found in Dupljaja, Yugoslavia, it dates from the mid–second millennium B.C.E.[15] The deity wears a long bell-shaped skirt and has the short-beaked, rounded head of a dove with eyes indicated by encircled dots. Triangles decorate the waist and hem; from them extend more dotted circles repeated on the four-spoked wheels.[16] (The four-spoked

84. Chariot carrying bird-headed deity and drawn by three birds. Dupljaja, Yugoslavia, mid-second millennium B.C.E.

85. Thirty-foot statue of the Mother Goddess. Mount Sipylus, Asia Minor, 2000–1200 B.C.E.

85

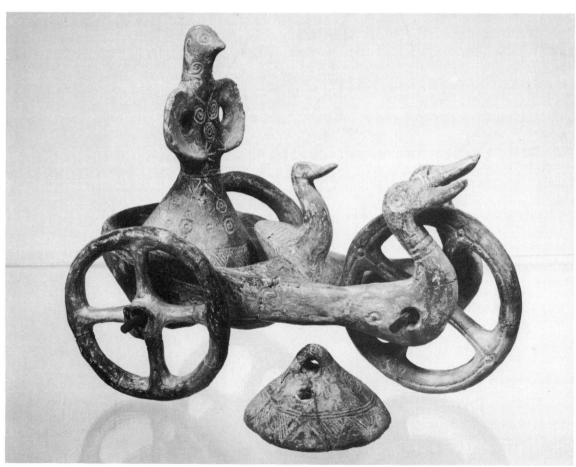

84

wheel does not appear before the sixteenth century B.C.E.) Although male genitals were attached below the skirt, the figure has both hands on the stomach with fingers spread, a gesture of the Goddess. A similar vehicle (broken) from the same region is entirely female.

JAPAN

On the banks of the translucent Isuzu River, surrounded by an eerie primordial forest where the trees are sometimes one thousand years old, lies the awe-inspiring Ise shrine. Standing in simple beauty since remote antiquity, it is believed to be the oldest holy spot in Japan. The Ise shrine is dedicated to the worship of the earliest Japanese divinity, the Sun Creatrix, Amaterasu-Omikami, meaning "Heaven Illuminating Goddess."

The shrine holds no image of the Goddess in any form; one assumes the rocks, trees, and water express her divinity. Such sensibility lies at the core of the Japanese feeling for primal nature.

That feeling is also apparent in the Japanese people's underlying awareness that behind the sun lies unknowable darkness, as shown by the following story. One day, the sun deity, Amaterasu, offended, retired to her cave and plunged the world into darkness. All the deities gathered outside trying to entice her out by laughing. At last, curiosity enticed her to look out. The first thing she saw was the mirror placed there by the other deities. Fascinated by her brilliant reflection, she emerged, and light was restored. Through this incident the mirror became sacred and remains the sole object on the Shinto altar.

Aphrodite:
Love and Death

Aphrodite reveals her descent from the ancient Bird Goddess through her many bird epiphanies. She joins the pantheons of classical Greece and Rome, bringing with her a variety of bird symbols. Of all the Greek goddesses, Aphrodite alone is intrinsically radiant. Hesiod, an eighth century B.C.E. poet who codified much of Greek myth, describes her as "golden, shedding grace."[1] Her sunlike ability to dazzle connotes light. And a clear link existed between her goldenness and her celestial character; this link points to birds as her intermediaries between the worlds.

Aphrodite's most persistent symbol is the dove. Statues of Paphos Aphrodite usually show her holding a dove, while the coins of Salamis in Cyprus, her birthplace, are stamped with the dove. A flock released during the festival of the Amagogia, at Erys in Phoenicia, was believed to accompany Aphrodite/Astarte back to her home in Libya. Tradition held that when she returned to Phoenicia from her Libyan visit, the doves were no longer a flock but a great white multitude among which flew one dove with feathers of gold: Aphrodite, the Golden One, in what may have been her original bird form.

THE GODDESS OF LOVE AND BIRTH

Aphrodite's epithet, the Golden One, refers to both honey and gold and suggests her sexual fluids. An incisive view of her comes from Jane Ellen Harrison, who sees the Goddess in her perennial luminosity as originally maiden, though virgin she is not. Rather, she is at once the eternal Nymph and Bride, but the Bride of the old matrilineal order, intolerant of patriarchal monogamy. Aphrodite is never really a wife, nor does she tolerate permanent wedlock.[2] However, since each of Aphrodite's love affairs brought forth a child, she, like the Sumerian Inanna, must be considered a form of the ancient Birth Goddess. Aphrodite is represented by fruit, flowers, nectar, and perfume.[3] On statuettes found in the Greek colony of Paestum, in southern Italy, she wears a rose and a lily as earrings. The flowers stand for her generative organs and her fruits, the quince and the pomegranate represent her offspring. A divinity of fertility, Aphrodite is the source of water and of vegetation. In short, she is the Mistress of all the earth produces.

The sea from which Aphrodite, the divinity of birth, was born and her shell must be seen as symbols. Aphrodite, "foam born," poised on a shell (ca. third century B.C.E.), is known by the epithet Anadyomene, "She who rises from the waves."[4] The sea is feminine everywhere and connected with

86

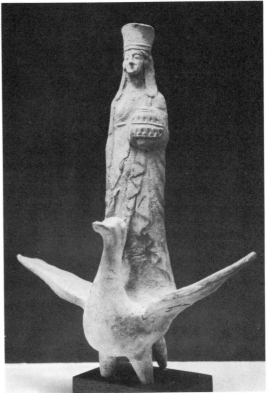

87

86. Aphrodite poised on the shell. Greece, third century B.C.E. (See plate 17.)

87. Terra-cotta Aphrodite mounted on a swan carries a casket. Boeotia, Greece, sixth century B.C.E.

emerging life; in classical Rome, the Mediterranean was called *mare nostrum*, "our sea" or "our mother." *Mar* in Sumerian means "womb," a name appropriated by the astronomers who mapped the moon.

APHRODITE'S BIRDS OF FORTUNE: THE SWAN, THE GOOSE, AND THE DOVE

A Greek terra-cotta from Boeotia (sixth century B.C.E.) shows Aphrodite standing in somber splendor on a giant swan. She wears a high tower crown and carries a small casket, a reference to her possession of the hidden knowledge of death and the secret of new life. In vase paintings, she sometimes cleaves the air on a swan or goose. A large and powerful bird, the swan is one of the earliest in the evolutionary chain, with extra vertebrae in its spine and a mechanism above its beak to adapt to either salt or fresh water. The swan's whiteness alludes to Aphrodite's purity and dignity. Throughout the Bronze Age the swan acts as her epiphany or alternate form. Later she no longer takes the form of the bird; she rides on it.

The Greek artist has drawn an exquisite picture of Aphrodite on an Attic white background kylix, or shallow bowl, found at Rhodes, 470–460 B.C.E. The graceful outline pictures the deity riding on a goose. It is

88. Aphrodite riding
a goose. Rhodes,
470–460 B.C.E.

89. Celtic tile from
Roussas shows
Aphrodite in flight
on a swan. Drome,
France.

89

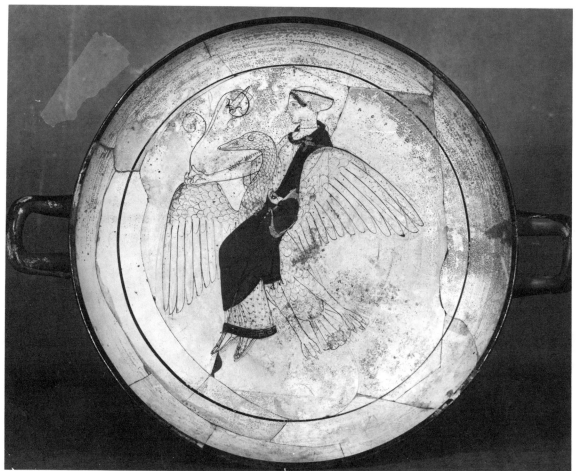

88

90. Indian deity
Devi rides her swan
epiphany wearing a
necklace. India,
nineteenth century
C.E.

amusing to see her, for in her fashionable
clothes and calm mien she could as well be
riding in a carriage.

A print from India shows a very similar
image of a goddess atop a goose. In this
nineteenth-century print, Devi, the deity of
deities and the inventor of the alphabet,
rides on a goose.

The role of the swan in rituals is not clearly
distinguishable from that of the goose and
the duck, as the symbolic characters of the
three birds appear to have been interchange-
able.[5] On a Celtic tile from Roussas, in
Drome, France, an amusing grafitto depicts
Epona-Aphrodite winging along on a giant
bridled goose. She sits sidesaddle, holding
the reins of her feathered mount and
wearing a bird's head herself. A reference to
the Horse Goddess, Epona, patron deity of
language and texts, helps to substantiate the
evidence that the Sumerian goddess Hidaba
should be credited with the invention of
writing.[6]

The following "Omen of the Swans," a
Scottish Gaelic rendition, recorded by
Carmichael in Benbecula, manifests the
quality of the swan symbol:

*I heard the sweet voice of the swans at the
parting of day and night, gurgling on journeying
wings putting forth their strength on high. I
immediately stood still, I made no movement.
I looked to see who was guiding in front, the*

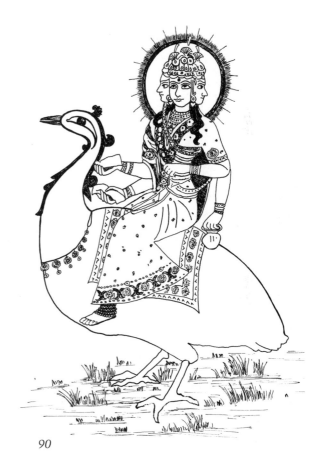

90

91. Aphrodite on a swan throne. Greece, sixth century B.C.E.

92. Celtic Riannon with headdress of two birds complemented by two more on her body. Ireland, ca. 2000 B.C.E.

91

Queen of Fortune, the white swan. That was on the Friday evening. My thoughts were of the Tuesday. I lost my possessions and my own people, a year from that Friday forever. If you should see a swan on a Friday, early in the glad, joyous morning, increase will be on your possessions and your kinsfolk, your stock will not constantly die.[7]

THE THRONE

A solemn mystery hovers over the archaic figure of Aphrodite in a sixth century B.C.E. Greek terra-cotta. Two swans form a throne on which the enigmatic goddess sits, tightly wrapped in a himation, with a bird on either side. Throne and bird, both attributes of the Goddess, literally support her divinity here.

The throne controls all beneficial relations between heaven and earth; through it the spiritual force passes to the rulers who occupy it. Enthroned female deities are pictured everywhere from Old Europe to the Fertile Crescent and, in time, from the Neolithic era to the Roman Empire, at which time the Virgin Mary assumed the throne as her symbol. Aphrodite occupies the seat of the Egyptian Mother Goddess, Isis, the source of the deified throne in Egypt. This seat of power was thought to be charged with a mysterious knowledge that had been handed down from the old Creatrix. The throne proclaims not only

92

legitimacy but divine sanction and restores harmony between the cosmos and society.[8]

TEMPLES

Temples, too, play an important part in the worship of Aphrodite. In his work on Greek sacred architecture, Vincent Scully explores the relationship between landscape settings and temples. He not only regards temples as embodiments of the divinity but also extends this view to their environmental settings and elaborates on the idea that the sanctuaries, in their placement and design, are metaphors for the deity. Aphrodite's image is simply a white cone or pyramid.[9] At Sardis, in Asia Minor, the dome that rises at Aphrodite's Lydian temple expresses power and links Greek Artemis with Asian Aphrodite.

At Aegina, an island near Athens, the temple of Aphaia (a local name for the Great Goddess) crowns a knoll between two conical hills; below lies a cave, probably the original sanctuary. And at the Lion Gate of Mycenae, the deity is symbolized as a pillar between two lions. It is no coincidence that the gate frames a fine view of Mount Zara and the cave of Argos.

THE GODDESS OF DEATH AND REBIRTH

The other side of the Goddess who gives life is the Goddess who takes it away, the Mother of Death. Of all the mysterious and devastating events of human experience, death is the most unfathomable. Initiation mysteries were designed to allow initiates to feel what it was like to be dead. A sleep lasting three days enabled the living to experience mock death and to feel reborn through the ceremonies.

In Celtic folklore, the beautiful goddess Riannon ("Great Queen") and her three birds revive the dead and put the living to sleep. In *Mabinogion*, the "Song of Branwen" recounts that these enchanting birds sing at a magical feast. As prophecied, the feast continued seven years.[10]

Riannon, a manifestation of the earlier Aphrodite, embodies life, death, and rebirth. Aphrodite and Persephone together represent the Kore, the maiden form of Demeter, the earth, with one figure passing easily into the other.[11]

In a fragment of an epic poem, probably by Parmenides, the poet speaks of the lesser mysteries of Persephone in Hades below. The path that leads to Persephone is wide and well trodden by the dying. Beneath it another track, rough and unused, "hallowed, bemired, yet best," leads to Aphrodite's "lovely grove."[12] This indicates Aphrodite's

connection with the underworld and the dark side of love, which is death. Like the Bird Goddess from whom she is descended, Aphrodite became Queen of the Underworld. At Delphi, the deity is known as She of the Tombs. Persephone of the Underworld can appear in the guise of Aphrodite: Aphrodite of the Heavens, remembered as the Goddess of Dawn, in her turn is Persephone. Thus there are two Aphrodites: one of the heavens, where she reigns as the evening and morning star,[13] and one of the underworld, where she has been sent against her will. Originally the deity of rebirth, Aphrodite was reduced in classical times to the divinity of love alone, a role that implies a view of regeneration that would have struck the Bird Goddess's worshipers as sacrilegious.

APHRODITE'S FRAGMENTATION

The conception of Aphrodite was altered by the northern invaders of Greece, who killed off the Titan gods and renovated earlier myths and symbols to suit the new religion. The Great Goddess was split into separate deities, each fragment representing one of her diverse aspects. As mentioned, Aphrodite was left with the realm of physical love, her larger relation to life and death suppressed. The other Olympian gods condescended to her, and she was generally held in low esteem among them. Homer echoes this poor opinion. He shows her simply as a divinity of sexual love, a reductive view that persists to this day.

ADAPTATIONS OF APHRODITE

"Golden winged Medusa"[14] appears on a plate from Rhodes (seventh to sixth century B.C.E.) as a double-winged gorgon. Her face is depicted with fangs and a protruding tongue. Worshiped by farmers who depend on water for their land, her extended tongue signifies a supplication for rain.[15] The double wings, body tattoos, rosettes, swastikas, lozenges, and plant motifs reveal her as an embodiment of the old Goddess. The swastikas on her black swans' wings turn both left and right in a graphic demonstration of the interchangeability of life and death. It was her ability to command this power that enabled her to turn people into stone.

The great Sumerian culture flowered in an alluvial plain at the head of the Persian Gulf (5000–2900 B.C.E.). In the fourth millennium B.C.E. the Sumerians developed pictographic script into cuneiform writing. They worshiped a goddess called the Queen of Heaven and Earth who indeed had created both.

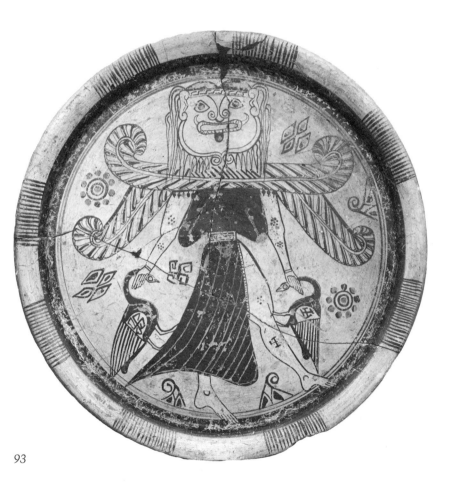

93. Double-winged
Medusa holds two
black swans with
swastikas; in the
field are leaf forms,
lozenges, and
rosettes. Rhodes,
Greece, seventh to
sixth century B.C.E.

93

94. Flanked by two
great owls, Lilith,
Goddess of Death,
grips her lion
mount with taloned
feet. Sumer, 2300
B.C.E.

LILITH

The Burney Plaque, from a late period of
Sumerian art (2300 B.C.E.), presents the
seductive figure of another great winged
Goddess, Lilith, a bird woman. Flanked by
sacred owls, she stands naked except for a
tiara of horns, which were worn by all
the great deities. She also holds the ring and
rod of power. Thus she joins the first rank
of gods. Her own bird-taloned feet grip the
backs of the reclining lions on which she
stands. Spurred and clawed, the owl feet
betray her demonic power and signify
wisdom; owls reinforce the Goddess's noc-
turnal character. In Hebrew, Lilith's name
means "screech owl." The lions are her
natural guardians, fitting protectors of the
Queen of the Netherworld. Lilith lived
on to become a demon in Jewish folklore.

The dethroning of Lilith is recounted on
cuneiform tablets. This poem is a parable of
a much earlier Goddess who was exiled;
the fate of Medusa was much the same. The
epic Sumerian poem (from the third
millennium B.C.E.) about Inanna and her
lover Gilgamesh tells the story of the deity
and her huluppu tree, a willow sacred to the
Ancient Mother. Inanna planted the tree in
her sanctuary, planning to use its wood for a
magical throne and couch. When the tree
grew large, she went to cut it down, but at
its base a snake who could not be charmed
had made its nest, and in the willow's

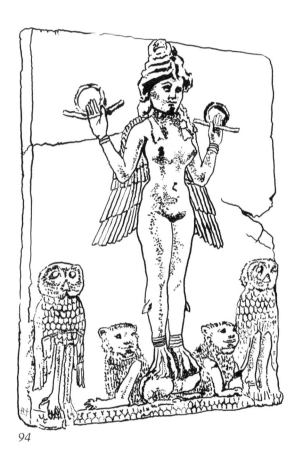

94

crown the anzu-bird had placed her young. In the middle of the tree, Lilith, Maiden of Darkness, had built her house. So Inanna, Queen of Heaven, wept. Gilgamesh heard her weeping and slew the serpent at the base of the tree. The men cut down the tree and presented it to Inanna.[16] Lilith, the former Queen of Heaven, flew away.

Lilith is a deity far older than Inanna. Owl-like, she builds her home in a tree. Lilith's lack of clothing creates an identification with the Naked Goddess, suggesting a state of nature. However powerful she may have been in early Sumerian times, she is greatly diminished in the Old Testament, where she appears as temptress and she-demon rather than the great Goddess of Death.

In the Talmudic texts of the Kabbalistic period (fourth century C.E.), Lilith's history is a record only of her vitiating qualities. She is enchanting, seductive, and fatally destructive. The Talmud says that Lilith was formed by the Lord in response to Adam's request for a mate. According to the patriarchs, God used filth and sediment to create her, rather than the pure dust he had used for Adam.[17] The children of Lilith and Adam were demons. In time, Lilith refused to lie submissively beneath Adam as he desired, and when he attempted force, she abandoned him. At Adam's request, God sent angels to bring her back. They found her living with evil spirits near the Red Sea, where each day she gave birth to more than a hundred demons.[18] She again refused to return to Adam, although the angels told her that she would die if she did not submit. She reasoned that it was not possible for her to die since she had charge of all newborn infants. So God punished her by killing one hundred of her children each day.

Repressed deities, however, capture their captors; from being an abhorred demoness, Lilith went on to become the bride of Yahweh.[19] Subsequently, Lilith was reduced to a succubus, seducing men who slept alone and strangling infants in the first days of their lives. The slander of the patriarchal scribes failed, however, and Lilith remained a powerful goddess[20] in the Jewish folklore of central Europe up to the sixteenth century C.E.

FURTHER ADAPTATIONS OF APHRODITE

We know of few goddesses from the North African coast. Yet at least one, the Phoenician Tanit, an aspect of Aphrodite, was worshiped there from at least the ninth century B.C.E. through Roman times. The image of Tanit is sculpted in the classical manner on the lid of a sarcophagus from the necropolis of St. Monique of Carthage. Great wings enfold her in radiant blue mimetic of a bird's plumage; from behind

95. On a sarcopha-
gus lid, the radiant
bluebird goddess,
Tanit, holds a cas-
ket decorated with
emblems of life and
death. Carthage,
North Africa,
Roman era, 146
B.C.E.–698 C.E.

96

95

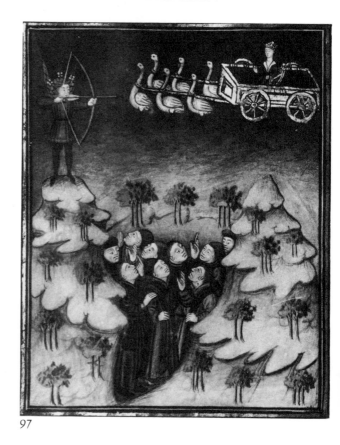

97

96. Mother Goose,
a modern vestige
of the Bird Goddess,
rides a whittled-
down version of the
Sacred Tree. North
America, nine-
teenth century C.E.
(See plate 27.)

97. French manu-
script depicts Venus
in her swan vehicle
attacked by her son,
Eros, as monks
watch. France, four-
teenth century C.E.

her head the bird's beak rises to crown her headdress. Vivid and inspirited in her bluebird guise, she carries in her hand, like Aphrodite, the closed casket containing the symbols of life and death.[21]

Roman Venus was a deity less complicated than Greek Aphrodite, although closely related. She was younger, more winsome, and connected with the fruits and flowers of the garden rather than the eternal verities.

In the fourteenth century C.E., a vignette painted for a French folio of the tragedies of Seneca portrays a pagan Venus flying through the sky in a chariot drawn by six swans. From a mountaintop, her irrepress-ible son, Eros, crowned with flowers, draws a bow against his mother, the Goddess, as monks look on.

Hel, the goddess in the Germanic pantheon corresponding to Venus, represents her dark side; as Mistress of the Afterlife, it is Hel who receives the spirits of the dead. After the Gothic conquest of Rome, Hel and Venus were united in Bertha. In old Irish literature, swans with golden chains around their necks represent the transformation of the goddesses.

In the Norse Eddas, three maidens, the Valkyrie, who weave the web of war, correspond to the Greek Fates. They spin by the lake, their swan forms beside them. Each retains a single characteristic of the

bird: One has a swan's bosom, another wears swan's feathers, and the third has a white neck. For Germanic Earth Goddess Bertha, sometimes called Hertha, only the foot of the swan remains.

It has often been pointed out that myths, rhymes, fairy tales, and children's games shelter vestiges of the old religions. Out of northern myths and rites come Mother Goose and her nursery rhymes. A turn-of-the-century book cover betrays the bird origin of Mother Goose. From the letter *M* of "Mother" in the title, hangs a pair of goose feet. Mother Goose herself is shown riding with her bird. The broomstick she rides is a whittled-down version of the sacred tree, the revered connection between sky and earth. She may not be as graceful as Aphrodite, but why should she be? She has fallen into a world turned away from nature, a world that, in the sixteenth and seven-teenth centuries C.E., used fire and water to purge away all memory of her former position and of her very existence.

98. The Virgin Mary shares symbols with the Primal Mother. North America, nineteenth century C.E.

99. The Black Virgin, symbol of wisdom and the resolution of opposites. Salzburg, Austria, eighteenth century C.E. (See plate 26.)

THE VIRGIN MARY

The most significant point about the Christian Mother of God is her continuity with archaic virgin goddesses such as Aphrodite. With her title, the Virgin Mary, she is given a certain value. In early times, virgin simply meant unwed. The so-called undefiled condition of a woman at the time of wedlock ensured inheritance through the male line. Previously, children had carried their mother's name. The angel Gabriel "came unto her" (Luke 1:28, KJV), the biblical phrase for sexual intercourse. Gabriel's name literally means "divine husband."

From the Paleolithic onward, people's demand for a protective and nourishing mother figure, as deity, to provide reassurance is evident. To promote male dominance, the Church of Rome denied the divinity of Mary but incorporated her images of Virgin and Mother, the two aspects of the Goddess that were least threatening. The cathedrals of France are built in the Virgin's name. Jung points out that the recent (1948) Catholic dogma of the Bodily Assumption of the Virgin, the earth, is in fact the acceptance, indeed the sanctification, of matter.[22]

Behind the figure of the Virgin Mary, supplicated under the title of Panaghia Aphroditessa,[23] stands the first mother, the Great Goddess. The Tower of Ivory,

98

99

Mary's emblem in the Litany of Loreto, is worn as a headdress by Aphrodite; both Mary and Aphrodite share the lily, the rose, and the dove. The dove, bird of the Annunciation, is Aphrodite's symbol of fertility.[24]

The relationship between spinning and childbearing is age-old and appears, almost surreptitiously, in a Catalonian wall painting from the twelfth-century Church of St. Pere in Barcelona. The Virgin with a golden nimbus wears a dress with a curious overblouse in the form of a chevron. With a single thread she spins the new being within her body. Flying toward her, a dove penetrates the holy nimbus around her head, a metaphor for the planting of the seed and the quickening of her womb to new life. The Virgin holds the masculine spindle in her right hand and the feminine thread in her left. The angel Gabriel points toward her head, and a woman behind a curtain gestures toward her already pregnant belly.

Raphael Patai states that the oldest cosmologies start with a primal Goddess.[25] Unlike these deities, the accent with Mary, Mother of God, is on her virginity. The Madonna descends from the Great Goddess who spins the web of destiny, and destiny here is the redemption of the world. To weave indicates creating something out of one's own substance, as the spider spins its web. Deities who spin are lunar goddesses, personifications of fate. The moon, Mistress of Transformations, weaves destiny. The lunar rhythms compose harmonies whose analogies and participations create an endless fabric, a net of invisible threads binding humans, animals, vegetation, rain, and fertility and symbolizing the world of death and rebirth.

THE BLACK VIRGIN

The image of the Black Virgin stood in the shadow for centuries, beckoning us back to Aphrodite. Some feel that her mystery has a significant intent. These virgins appear earlier than the ninth century, and by the sixteenth century there were 190 statues of her in France alone, from Chartres to Marseilles. Her image has even crossed the Atlantic Ocean; in Mexico she is the Black Virgin of Guadeloupe. Ean Begg proposes one theory for her emergence:

The return of the Black Virgin to the forefront of the collective consciousness has coincided with a profound psychological need to reconcile sexuality and religion.[26]

Because of her blackness, she has been compared with the terrible Indian Goddess of Death, Kali, but actually it is unnecessary to look so far afield. The Queen of Sheba and St. Mary Magdalene are both precursors.

Robert Graves sees quite a different meaning in her blackness. In his book *Mammon and the Black Virgin*, he draws

attention to the ancient tradition in which blackness was associated with feminine wisdom and interprets in her a symbol of a new relationship between the sexes.
One's first glimpse of a statue of the Black Virgin may surprise, but further considera- tion can make one feel that one is in the presence of a great power, in touch with the mana of the age-old Goddess.[27]

Traditionally compassionate, the much- loved and misunderstood Black Virgin lives on as an archetype of the universal female principle. Historically, the Cathars and the Gnostics of early Christianity had an attitude of real acceptance toward women and the feminine principle. The love feast of the Cathars and the elevation of Sophia to Goddess of Wisdom in the Gnostic religion demonstrate their egalitarian views.

In France, the Black Virgin, sometimes called Notre Dame de Trouvée, furnishes some intriguing links with the ancient goddess. Around the time of the Grail's influence on culture, the troubadours suggest in their love songs that heaven may be achieved through the love of an actual woman, balanced in mind, body, and spirit. The word *troubadour* is linked to trouvée, "found."

Worship of Aphrodite as the Black Virgin extends from ancient pagan goddess worship to relatively modern times. Aphrodite's

erotic star, the planet Venus, shines on the horizon when the sun goes down during certain parts of the year. During other parts, it is a morning star. Its peculiar haunting beauty in the evening sky and at daybreak partake of magic and recall her ancient presence as Goddess of Death and Rebirth. The promises of love and new life held out by Aphrodite are profound. They go deep into the psyche and change our lives utterly. Love both heals and excites. When we are loved, the world feels refreshed and new; our eyes, both the outer eye and the inner eye, are opened. A radiance transfuses the landscape of our life, changing it completely, overturning everything, shifting our condition, as physical caresses transform our bodies and alter our perceptions. Joy is only the beginning of Aphrodite's heady covenant. All is transformed, making us feel reborn even as we are struck with wonder and, perhaps, fear.

Birds of Transformation

Since all birds are born twice—as an egg first and again as a chick—they are viewed as symbols of rebirth. The offer of a new life, the knowledge of renewal mirrored in the cyclical transformation of nature, consoles the living against the threat of extinction and reassures the dying and bereaved.

GODDESS OF DEATH

Bronze Age European culture, with its megalithic sculpture inspired by the Great Mother, often portrays her as Goddess of Death. The bond between Life and Death is dramatized as a beautiful woman, the life-giving mother.

As an Etruscan cinerary urn from Chiusi in Italy (sixth century B.C.E.), the winged Goddess of Death performs a double function. In addition to holding the ashes of the dead, she poses as the Mother of Rebirth, holding her hands spread out over her full belly. Her earrings announce her divinity.

Considerable light is shed on early magical and religious practices by the cult of skulls, which dates back as far as Sinanthropus Pekinensis or Peking Man in the Middle Pleistocene era. In the green oasis of Jericho, perhaps the most ancient city on earth (6850–6770 B.C.E.), skulls were found buried beneath the floor of a house. They were placed carefully in a meaningful manner.[1] One skull was set in a corner facing into the ceremonial room; others formed a circle. The archaeologist of the site, Kathleen Kenyon, recovered three skulls in which the features of the face were molded over the bone with delicately modeled plaster tinted a rosy flesh color. One handsome skull, with an exceptionally long head, has cowrie shell eyes that, with their vertical slits, create a strikingly lifelike expression.[2] Sensitive handling of the material has metamorphosed it into a work of art.

Stuart Piggott described the figures of the Zhor Valley of India as skull-like with high smooth foreheads, staring holes for eyes, owlish beaks, and small grim slits for mouths. These gruesome doll faces sometimes resemble grinning skulls to invoke the Death Goddess.[3]

In an illustration from the Papyrus of Anhai (ca. 1100 B.C.E.), the golden-winged benou, bright bird of the sun and resurrection, waits on a bank in the underworld to greet and guard the Egyptian barge of the dead. The benou, or phoenix, symbolic of resurrection, appears once every five hundred years at the sun temple in Heliopolis to deposit an egg-shaped ball containing the body of Osiris.[4]

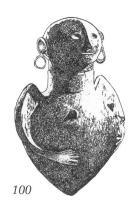

100

100. Etruscan urn contains the ashes of the dead and the seeds of rebirth. Italy, 500 B.C.E.

101. Portrait skull. Jericho, 6850–6770 B.C.E.

102. Life rekindled as the Egyptian phoenix returns for 500 years to the underworld for rebirth. Egypt, ca. 1100 B.C.E.

103. The Sleeping Lady. Malta, ca. 3000 B.C.E.

101

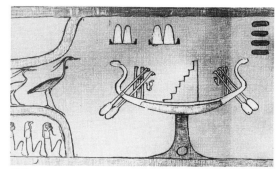

102

103

For early peoples, sleep mimics death and is the bearer of dreams believed to be messages from the deity bringing enlightenment. The mysterious little figure called the "Sleeping Lady" from the underground temple of Malta (ca. 3000 B.C.E.) evokes the practice of sleeping within the temple for a number of successive nights in order to obtain oracular dreams. The figure suggests that a form of the secret cult religion known as the Mysteries was practiced in Malta. Worshipers slept in the temple to ensure conception and to dream dreams of revelation and guidance. Later in historic Greece, the magic properties of sleep and dreams within a sacred place became part of the Mysteries.

A very different relationship to death is evident in later religions. For example, certain stratagems were devised to cheat death. The Semites abandoned a scapegoat in the desert so that death would not visit their village. In ancient England, a doll was ritually tossed into the water in place of a human sacrifice.

An altarpiece of lacquered wood dating from the eastern Chou dynasty is designed to help humans come to terms with the fear of death. More than two thousand years ago, a Chinese artist carved a pair of cranes, birds of rebirth, rising from the coils of two copulating venomous snakes; a life figure, it corresponds to the eternal spiral rising out of death. The bodies of the cranes, decorated with linked lozenges, intimate a chain of rebirth.[5] Anyone who has witnessed the excitement and gaiety of the cranes' courting dance is familiar with the sexual vitality displayed by these birds. In Greece their wild courting dance became so legendary that it entered myth. To celebrate their escape from death in the labyrinth, Theseus and his men imitated the cranes' dance of renewal when they paused at an island on their return voyage.

INITIATION AND REBIRTH, THE EGG AND THE CHICK

Since Neolithic times, young birds and chicks played a part in initiatory symbolism. An egg-shaped symbolic idol from the site of Troy combines chick and egg. A baby chick's head with a triple necklace tops an oval body. Chick and egg were used universally in the mysteries of the twice-born.

Artifacts from widely divergent cultures indicate that the Bird Mother and her chick were held sacred. The motif of the smaller bird sitting on the back of its mother appears in the Hallstatt culture of Iron Age Italy and in contemporary peasant carvings from central Europe. It is a theme in Chinese folklore as well.

104. Life in the form of two cranes towers over a pair of copulating vipers, death (and new life). China, Chou Dynasty, Warring States Period.

105

105. Egg-shaped Trojan chick with necklaces embodies initiation and transformation. Turkey, 1600 B.C.E.

106. Dove between the wheels of a cult wagon carries the chick of new life. China, Han Dynasty, ca. 206 B.C.E. to 220 C.E.

104

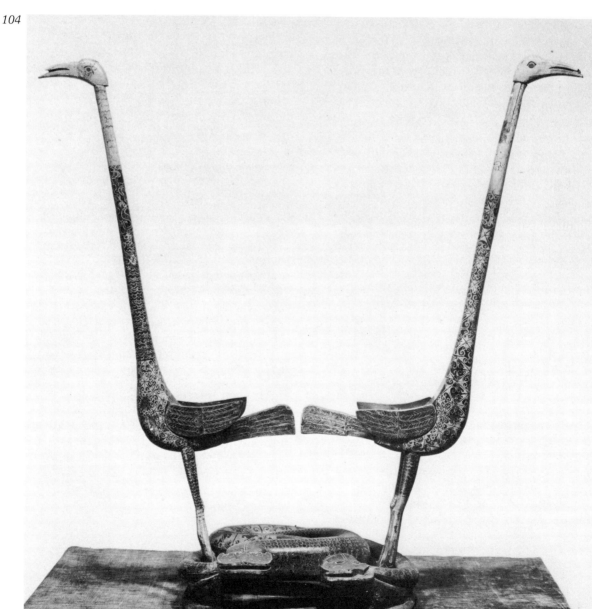

106

107. Owl with a spiraled serpent wing repeats the theme of death and rebirth. China, fifteenth to fourteenth century B.C.E.

107

The idea of the sun's rebirth is expressed in a ritual bronze cult wagon of the Han dynasty (ca. 206 B.C.E.–220 C.E.).[6] The body of the cart, shaped like a dove, carries a chick on its back. Exaggerated spoke wheels are a feature of the dove cart, and a metal ring protruding from its breast enables the toylike vehicle to be pulled. Since the bird plus wheel is doubly solar, it follows that the large and small bird together symbolize the eternal return of the sun.[7]

A Chinese owl-shaped vessel dating from the fifteenth to fourteenth century wears a necklace and a horned snake forms a spiral along the boundaries of the wing. As the relic of a bird cult with sacrificial rites in ancient Chinese myth,[8] these owl vessels express the polarity of the bird and serpent, as well as the oppositions of Yin and Yang, night and day, summer and winter.

A night bird, the owl frequents the dark evening sky, the realm of death. This, along with its weird night cry and mesmerizing stare, have earned it an evil reputation. In Latin, the word for owl is *strix*, meaning "witch." It inherited its wisdom from the Mother Goddess. From one of the levels of Troy, a large number of primitive marble owl faces were recovered, as well as vases featuring owl heads. Some even have breasts sculpted upon the lids. The vases and

108. At Çatal Hüyük a mural shows vultures consuming the flesh of the dead. Turkey, 6000 B.C.E.

109. On a Minoan vase from the necropolis of Kalyira, a flying dove carries a fish. Crete, Middle Minoan III, 1400–1200 B.C.E.

110. A Çatal Hüyük mural shows the bird's legs, bent like those of humans, indicating priestesses dressed as vultures. Turkey, 6000 B.C.E.

108

109

statuettes, all female, are dedicated to an owl deity. As we know, Homer speaks of Pallas Athena as having the face of an owl,[9] and an owl she remained.

The Ainus of Japan address the owl as "beloved deity" or "dear little deity."[10] Both owl and serpent, animals of the yin, symbolize the night, the moon, and the divinity of the dead. The owl signifies the west, the night sky, and moon-earth-water-night motifs connected with the divinity. The snake's form implies the mystery of death and resurrection.

THE DOVE AND FISH

The dove and fish were sacred to Syrian Atargatis as well as Aphrodite and her worshipers. In the Phigalian cave in western Arcadia, Greece, a wooden statue of the horse-headed, pre-Hellenic Earth Goddess, Demeter, held a fish in one hand and a dove in the other. In his *Metamorphoses*, Ovid recounts that Aphrodite and her son, Eros, were transformed into fish during their flight from Typhon. Such a rapid metamorphosis could only have been accepted in legend because of this earlier relationship of Aphrodite to the fish.

A Minoan vase (1400–1200 B.C.E.) shows a dove in flight holding a fish. The dove is not a flesh eater; it is not carrying the fish as

110

food. The meaning of the vase is clear; the soul as dove carries the corporeal fish to the underworld for its rebirth.

THE VULTURE

For reasons far more obvious in ancient times than they are today, the bird most recognized as the symbol of transformation was the vulture. This bird, a form of the Death Goddess, does not kill; it awaits death and transforms it. By eating the dead it performs an important function; it takes back into itself the perishable flesh, which it transmutes for rebirth.

At Çatal Hüyük (600 B.C.E.) on a wall beneath the head of a bull, human breasts are sculpted, molded over the skulls of vultures whose beaks protrude from the nipples.[11] These breasts repeat the theme that out of life comes death. An adjacent wall displays stylized vultures with enormous wings, drawn in red with a marvelous economy of line and movement; they repeat the message of the breasts.

The wall of Shrine VII, 21, at Çatal Hüyük, uncovered by James Mellaart, exhibits superb murals of vultures painted in dark red on a pink ground. With their nine-foot wings spread, these vultures sweep down on tiny headless corpses placed on the ground for that purpose.[12] The meaning of these tremendous murals that wrap around the walls of the shrine holds a significance beyond that of illustrating the morbid rite of exposing the corpses.[13]

On the north wall of the shrine, a similar mural features vultures with spreading wings hovering over the bodies. Yet there is a point of difference between the two pictures. In the second mural the legs of the vultures are bent like those of humans. In order to take on the bird's powers, the priestesses of the shrine apparently conducted elaborate rituals of resurrection dressed in vulture guise.[14] To wear a bird's feathers was to take on its potency. In an early shrine at Zawichemi, near northern Iraq, a pile of vulture wing bones once covered with feathers had obviously been set aside for ritual use as a costume.[15] As late as the present century, in Persia, vultures aided in rebirth by picking clean the bones of the dead on the Tower of Silence. The vulture deity controlled the life of the individual from death to rebirth.

The origin of the Egyptian hieroglyph for vulture lies far back in prehistory; it signifies both the words "compassionate" and "mother." In Hebrew, R-M-H meant "pity," "compassion," and "womb" as well as "vulture."[16] It suggests that at one time the two peoples practiced similar rites. The rite called the Weighing of the Heart,

111. Two vulture goddesses, Nekhebet and Mut, protect and nourish the dead in the pyramid text of Pepi I, Mer-En-Ra. Egypt.

111

in which the heart of the dead is weighed against the feather of truth, strengthens the connection between the air, the bird, and the afterlife. The symbol of truth in the Egyptian religion refers to feathers, which represent truth and divination. In the hieroglyphs, a connection exists between this and the goddess Mut; her name and her function link her with the word "mother."

At Abydos, Egypt, the vulture goddesses Nekhebet and Mut are guardians.[17] In that form they protect Osiris. Therefore, the furnishings of his funeral barge include sixteen vulture plumes. In the pyramid texts of Pepi I, Mer-En-Ra ("Son of the Moon") is bidden to come to his three mothers, the third being the Cat Goddess, Bast. Nekhebet and Mut, vultures with long hair (feathers) and breasts, put their nipples in his mouth and cleave to him forever. Both Nekhebet and Mut, in the form of vultures, guard the mummy and protect the dead.

The symbolism of the vulture was inherited from the Paleolithic nomads of Europe. Possible representations of vultures or other birds with large wings are known from European upper Paleolithic caves (Castillo, Gabillou, La Pileta, and others). Such a complicated symbol could not have developed without a history of many thousands of years behind it; the mesmerizing eye of this bird, so black, rimmed with

white, became the most powerful feature of the vulture symbol. The terrible eye is featured in stylized death or "spook" masks at Toleilat Chassul, Jordan (ca. 4000 B.C.E.).[18]

In ancient symbolism, a significant part of an object stands for the whole; for example, the hand stands for the individual. During the Neolithic era, burials occurred in two stages. The rites required that the flesh be stripped from the bone (by birds) and stored outside the town. In the spring they were buried beneath the platforms in the habitation room or shrine. Of four hundred interments at Çatal Hüyük only eleven were red ochre burials in the shrines.[19] As the Neolithic era passed into the Chalco-lithic Age, the bones of the dead were no longer buried under the floor; they were placed in small clay houses known as ossuaries. In many cases these ossuaries use some form of the vulture motif in their design, such as the wedge-shaped tail at the rear, or the beaked head on the lintel above the front door. An ossuary in the Israel Museum vividly recalls the vulture.[20] In later societies, the Great Goddess displays the vulture's large beaklike nose, exaggerated eyes, and the wedge-shaped tail worn sometimes as a headdress. These distinctive vulture features appear as far away as Mohenjo-Daro and Harappa in the Indus Valley and throughout the Middle East, the Aegean, and North Africa. It is likely that the Eye Goddess owes her hypnotic expression to this bird.

The mysterious Dogons of the tablelands of central Niger carved maternity statues in the shape of vultures with women's heads that are designed to protect mothers. The same hybrid is found in the statues called Nimba from Guinea, characterized by hooked noses and vulture-shaped skulls. In the Egyptian hieroglyphs, a correlation exists between this motif and the vulture of the goddess Mut, or mother.

Since life springs from death, death has the potential for renewed life; what are usually considered opposites are recognized as two sides of the same coin. Death is a journey toward the Mother in the same sense that birth is a departure from her. As we have seen, in the earliest religion, the Goddess of Life (the Virgin and the Bride) was equally the Goddess of Death and Rebirth (the Crone).

The Lion

The lioness assist-
ing the birth-giving
Medusa, who holds
her fiercely by the
throat. Perugia,
Italy, 500 B.C.E.
Detail of fig. 125.

L egendary for its physical strength and divine vitality, the lion assumes the role of guardian of the Great Mother. Lions also served as her mount. The lioness, a peerless mother, serves as her aid in childbirth. The lion is also protector of the dead; the Phoenicians had a lion death goddess. An imperial creature, naturally elegant, the lion emphasizes the commanding role played by divinity.

Since ancient times, lions have been connected with the sun. The yellow mane resembles the rays of the sun, whose torrid heat has been compared to the lion's ferociousness.

IN THE PALEOLITHIC ERA

Although the lion is extinct in Europe, its appearances in Paleolithic art confirm its former habitat. Encounters with lions were momentous enough to have been pictured on the cave walls in horrifying detail. The slaying of a lion apparently fulfilled a ritual need of the clan.

The art of the caves shows that the link between sculpture and the Mother's body was the cavern itself.[1] A recent find in the enormous cave of Pech Merle presents an extraordinary scene: the crowned, red figure called the Lion-Queen is unlike any discovered elsewhere.[2] A sanctuary cave of the Magdalenian era, Les Trois Frères, in the foothills of the Pyrenees, includes a chamber called the Chapel of the Lioness. Engraved on the face of an altarlike table is a lioness with her cub. Three versions of her head are drawn and two of her tail. The Abbé Breuil characterizes her as the Guardian of Initiation.[3] Another finely observed Magdalenian lioness, engraved on the rock wall at Les Trois Frères, conveys an awesome sense of quiet, dauntless courage. The brilliant linear engraving distinguishes the hand of a master of sensitive line. The interaction of art and religious feeling appears from the very beginning of artistic expression; the combined power reaches into the hidden depths and fundamental forces of nature.

NEOLITHIC ANATOLIA AND MESOPOTAMIA

Some examples from before Neolithic times point out connections between the Great Goddess with the lion and birth and death. The lion acts as her special protector, aiding childbirth and guarding all her ventures. The birth-giving Mother with a feline, be it lion, leopard, or cat, makes her appearance in the sixth millennium B.C.E. At Çatal Hüyük, one of the first three-dimensional sculptures discovered, dating from 7100–

112. Engraving of
Magdalenian lion-
ess from the cave
wall of Les Trois
Frères. Dordogne,
France, 18,000–
14,000 B.C.E.

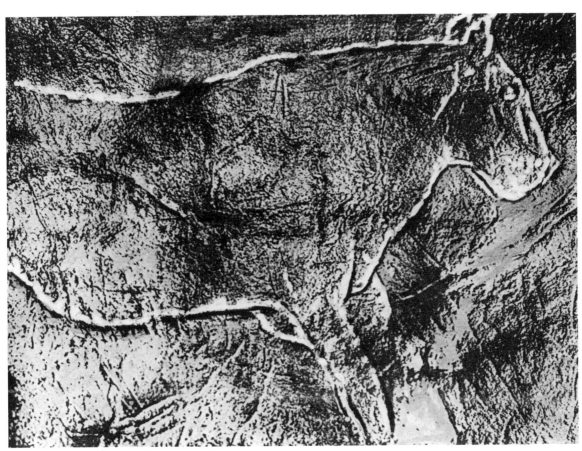

112

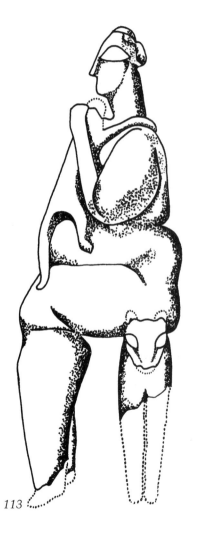

113

114

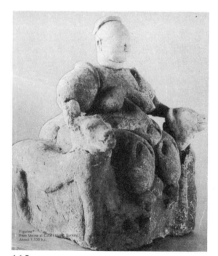

115

113. A Mother Goddess holding a leopard cub sits on a leopard throne. Halicar, Anatolia, Turkey, 6000 B.C.E.

114. Goddess dressed in leopard skins with her animal. Çatal Hüyük, Turkey, 7100–6300 B.C.E.

115. Birth scene with mother deity on throne flanked by leopards. Çatal Hüyük, Turkey, 7100–6300 B.C.E. (See plate 28.)

116. Marble lion-headed goddess. Mesopotamia, ca. 3000 B.C.E.

6300 B.C.E., shows a goddess dressed in leopard skins leaning against or riding on a leopard; both are sprinkled with spots.[4]

From the same site and period an impressive terra-cotta was found guarding the valuable cereals in a granary. It is a most explicit birth scene in which an ample Mother Goddess sits upon the lion throne of birth, her hands resting on the heads of the flanking leopards; the head of the child to whom she is giving birth emerges between her thighs.[5] More terra-cottas from this site may be seen at the Ankara Architectural Museum in Turkey. There, the Goddess is represented in her full scope, relating not only to women but equally to men. They are pictured wearing leopard skins and dancing her rituals.

The small neighboring village of Halicar, approximately 6000 B.C.E., seems to have observed similar religious practices. A somewhat less ample deity, distinguished by elongated, all-seeing eyes, sits on a throne guarded by a leopard. She holds a leopard cub to her breast, clasping it as if it were a child.[6]

A unique mythological figure of a female deity with the head of a lioness is exquisitely crafted. Its provenance and date are unknown, but it is tentatively assigned to Babylon, ca. 3000 B.C.E.

116

117

118

117. The Great Goddess rides a lion with a swastika on its flank. Hasanlu, Iran, 1800 B.C.E.

118. Yasilakaya, capital of the Hittite empire, celebrates the sacred marriage with the God by meeting the Goddess who rides on a lion. Turkey, before 1200 B.C.E.

THE GOLDEN BOWL

Among other mythological figures, the Mother Goddess is twice embossed on the golden bowl of Hasanlu, in Iran (1800 B.C.E.). One deity, wearing two necklaces, rides a bridled lion that moves with a gliding stride. In one hand the divinity holds up a mirror (the sun); in the other she carries a mace (thunderbolt). Engraved on the lion's flank is the swastika. Formerly a fertility symbol and used in association with many goddesses and gods, the swastika has been misused in our own day, and has come to mean the opposite of good fortune.

Situated on a high plateau in Turkey, characterized by fold after fold of lofty pinkish hills with limestone outcroppings, stood Yasilakaya, the capital of the Hittite empire. When the city was destroyed by conquerors from the shores of the Black Sea in about 1200 B.C.E., the archival records suddenly ceased.[7] The temple complex at Yasilakaya, situated two miles from the city, did not escape the destruction; however, beyond a rocky gorge near the temple, a fascinating pair of open-air rock chambers miraculously eluded attention. Through the millennia, these recesses, six hundred feet above the gorge, became overgrown with vegetation and kept the secret of their carved reliefs until the nineteenth century C.E., when a French traveler rediscovered them.[8]

Nearly seventy human and divine figures march across the rock face in the hidden sanctuary. Some of the figures measure six feet in height and are clearly visible down the length of the enclosure. At the heart of the group, seven deities mounted on their sacred animals perform a mystery rite to ensure the fertility of the realm. On the left, the Storm and Weather God, standing upon the shoulders of two retainers, approaches the Great Goddess, who is mounted on a lion and followed by a retinue. In her train, a small male figure, probably her son, stands on a second lion. In his wake come two females on a huge, double-headed eagle.

Although few of the extant clay tablets recording Hittite literature describe it, this meeting follows the dramatic pattern of the well-documented Sumerian-Babylonian Hieros Gamos ("sacred marriage"). The rite is intended to magically fertilize the entire realm. These annual rituals in the great kingdoms of pre-Hellenic Mesopotamia eroded over thousands of years, until the goddess religions finally disappeared altogether.

119. Enthroned lion-headed deity, Sekmet, rules over the fierce sun and Tablets of Destiny. Egypt, 1350 B.C.E.

120. Cat Goddess Bast, the quintessential Mother, embodies the greater aspects of the sun. Egypt, ca. 2nd century B.C.E.

121. Bronze statue of Bast holding a sistrum in one hand and a cat-headed aegis in the other. She shelters four tiny kittens. Egypt, after 600 B.C.E.

IN EGYPT

The lion-headed goddess Sekmet epitomizes the heat of the sun, which in a desert country such as Egypt is fierce and devouring. The sun's solar eye burns and judges. As a deity of fate, Sekmet rules over the Tablets of Destiny; so the future of humanity lies in her hands.[9]

The headdress of the heavily gilded statue of Sekmet (1350 B.C.E.) blazes like the sun. Her golden throne is decorated with sun disks, and a dotted net pattern adorns her tight-fitting garment. Presented as a divinity of fertility and a protector of the young and weak, she is nevertheless a goddess of war and destruction. Seized one day with a lust to slaughter all humanity, she killed and drank the blood of thousands. Ra, the Sun God, attempted to restrain her. Finally, he succeeded by a ruse, mixing beer with pomegranate juice to look like pools of blood. The raging deity drank herself into a stupor.

The goddess Bast, first seen as a cat, originated as a cult in the Nile Delta; by 950 B.C.E. the cult covered all of Egypt. In contrast to the fierce Sekmet ("pitiless sun"), she embodies the cat's gentler aspects, giving life to growing things and personifying life-giving heat.[10] Her best-known role is that of the quintessential Mother. Bronze statues show her as a noble-looking, seated cat wearing earrings. So great was the love and veneration for the domestic cat, the living symbol of Bast, that anyone in Egypt who killed one was himself set upon by the populace and beaten to death.[11]

In the delta city of Bubastis, Bast's festivals, described by Herodotus, were celebrated by hundreds of thousands of worshipers arriving in boats, playing flutes, singing, and feasting. Mistress of all kinds of pleasure and religious ecstasy, Bast, the Lady of Bubastis, carries the sistrum, symbol of joyous dancing and lovemaking. In one statuette from the XXII Dynasty (after 600 B.C.E.) the deity is dressed in a long robe with a cross-hatched net pattern, carrying in one hand a sistrum and in the other a cat-headed aegis with a uraeus and sun disk. Four tiny kittens shelter at the feet of the fiercely protective Mother.

Plutarch names some of the reasons for Egyptian cat worship: The cat's variegated patterns and nocturnal habits make it a natural symbol of the moon. Furthermore, the eyes of a cat appear to grow in size and luminosity as the moon waxes full.[12]

120

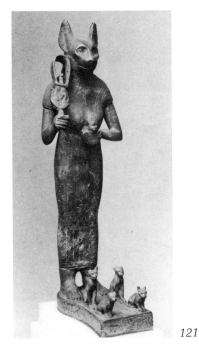

121

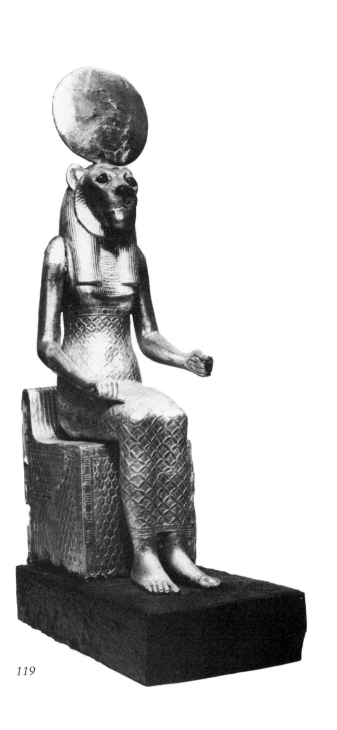

119

122. The Great Goddess on a seal ring impression with many of her symbols, including the guardian lions. Crete, Late Palace Period.

123. Gate of the Lions at the entrance to the acropolis of Mycenae. Greece, 1250 B.C.E. (See plate 21.)

123

122

CRETE AND MYCENAE

On a seal ring impression from Crete, late Palace Period, the Great Goddess conveys many of her numinous aspects. Dressed only in her seven-tiered skirt, she stands on a mountain (symbolic of the womb) holding out a wand (sacred tree). She is gesturing commandingly toward a young male who is standing in the attitude of worship. Behind the deity, a shrine supports tier upon tier of her insignia: bull horns enclosing the pillars. Lions stand on either side of the goddess as her guardians.

The well-known Lion Gate, surrounded by enormous megalithic walls, marks the entrance to the acropolis of Mycenae, 1250 B.C.E. Carved in deep relief, two lions stand with their forepaws on the altar, guarding a central pillar, symbolic of the Goddess. The capital is crowned by four disks.[13]

AMERICAN INDIAN FELINES

In the New World, the feline's powers of life and death correspond to those of Old World deities. The Indians of Central America retain many pre-Columbian rituals involving the jaguar. They wear jaguar masks, sometimes donning the entire skin, and crawl on their stomachs to mimic the animal's stealthy approach.

124. Pre-Columbian
figure. Found off
the coast of Florida,
1200 to 1500 C.E.

124

One strangely Egyptian-looking feline found in the waters off Key Marco on the Florida coast retains the feeling quality of a sacred spiritual being. Dating from six to eight centuries ago, this unique, well-preserved figure of carved and painted wood was probably used for ceremonial purposes.

CHINA

Since the dawn of Chinese history, felines have been regarded as progenitors of the race.[14] The lion, called Shih, is one of the four animals of symbolic power. It secures rain magically and watches over the living and the dead.

One fabulous winged lion with vegetation carved on its flanks thrusts out an extremely long tongue, curled at the tip to receive moisture. In China, the tongue became particularly exaggerated. Elsewhere, too, the long tongue acted as a supplication for rain. Mystery surrounded the falling of rain and the appearance of dew; the lion was believed to play a prominent part in these magical phenomena. Today, in the Chinatowns of various American cities, lion dances are ceremoniously performed on every doorstep, to the accompaniment of drums and fire-crackers (thunder and lightning), to bring moisture for the soil.

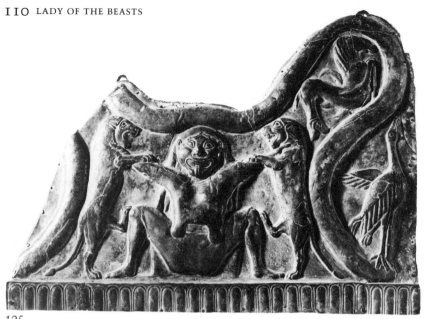

125

126

125. Gorgon Medusa in birth-giving position, assisted by two lionesses. Perugia, Italy, 500 B.C.E.

126. Winged lion with tongue thrust out to receive moisture. China.

127. Winged god-
dess surrounded by
her animals. Italy,
ca. 570 B.C.E.

As the lion became extinct in China, the
Pekingese dog, bred to resemble a lion,
became a temple animal. The dogs, when
adorned with antlers or ram horns, assume
power and are able to repel evil.[15] Revered as
gods, they guard the gates of temples and
protect crops.

GODDESSES OF GREEK ORIGIN IN ITALY

On a fragment of an Etruscan bronze
relief that decorates a chariot from Perugia,
Italy (sixth century B.C.E.), the Gorgon
Medusa, wearing the sacred girdle of
childbirth, assumes the birth-giving
position. Accompanied by a long-necked
bird and a sea horse, two lionesses assist her
by pushing against her arms and out-thrust
knees. She holds them fiercely by the
throat, a motif that extends back in time
beyond Crete, back to Çatal Hüyük.

A bronze vessel (ca. 570 B.C.E.) found in
Switzerland has a decoration on its throat of
the Goddess surrounded by many of her
animals: lions, snakes, a bird, and two
hares. The birth-giving hares she holds
firmly by the legs. The piece is the product
of an atelier in the surroundings of Tarent,
the only colony of Sparta in South Italy.

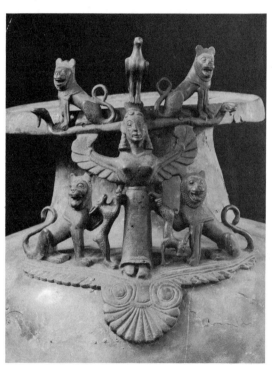

127

The Dog

Tomb painting of
Anubis and a wor-
shiper. Thebes,
Egypt, VIII Dynasty,
ca. 2130 B.C.E.
Detail of fig. 131.

Since the Neolithic era, the dog has been associated with the Goddess in the ancient myths. Its fierce yet dependable nature, nocturnal disposition, and relation to the moon bind it to her cult. The dog's violent and courageous defense of land, crops, and herds is invaluable, while its loyalty to household members and savagery toward strangers makes it a natural ally, an ideal guardian. Its high intelligence and capacity for training suits it for special jobs such as herding and makes it a natural hunting companion. Furthermore, its superior sense of smell made it magical to early people and earned it the title of the Finder of Tracks. Little wonder the dog was chosen to become the guardian of the Mother Goddess during the Neolithic era. Although after the Bronze Age the dog was rarely worshiped (the lion took its place as guardian of the divinity), the dog remains sacred in the ancient world.

A LUNAR SYMBOL OF LIFE

The choice of valuable and hard-to-work substances such as marble, rock crystal, and gold for the dog's manifold portrayals is a gauge of the high regard in which it was held.[1] We do not know why there were so many dog bones around the Neolithic site of Lepenski Vir in northern Yugoslavia, but the orderly arrangement of numerous bones, from 6000 B.C.E. on, indicates that the dogs were not eaten. Nor did the fishermen inhabitants use dogs for herding. It appears that their special relationship to the moon and regeneration had made them a natural choice of animal for sacrifice. On a painted vase from Valea, Lupului, Rumania, Late Cucuteni (fourth millennium B.C.E.), dogs tease a caterpillar. Both animal and insect are symbols of transformation.[2]

Dogs emerge early, in various parts of the world, as the principal animal of the Moon Goddess. Since they wailed at the moon, they were connected to eclipses. The Mongols, Mbocobis, Chiquitos, and Balkan peoples have histories of associations between the moon and dogs. The dog also acts as a protector against evil.

The enormous vitality of dogs clarifies their relation to the Goddess; their dynamism stimulates her life-giving proclivities and accounts for their use in sacrifice. The site of the Gorni Pasarel, near central Bulgaria, furnished a terra-cotta lid in the form of a dog that wears the human mask of the Moon Goddess.[3]

Since plants grow at night, ancient peoples believed that the moon activates their growth. Through its connection with the moon, the dog's boundless energy initiated the growth of sleeping vegetation in springtime, animating and vivifying it. On

128

129

the strength of its moon and caterpillar link pictured on several Cucuteni vases of the fourth millennium B.C.E., the dog is included among the animals of renewal and joins a long list of beasts who aid the deity and invoke transformation.

THE COMPANION OF DEATH

The underworld goddess Bau (see Part IV, "The Serpent") seems originally to have been a goddess of the dog; she appears with a dog's head. In Sumer, she emerges as the daughter of An, who is in turn embodied in the dog star, Sirius. The jackal-headed god, Anubis, unites with Isis in the star Sirius, of which she is ruler.[4] The deity's name, Bau, represents the sound of the dog's bark, as in the English "bowwow." In ancient Egypt there was an equivalent pun: Isis, called Au Set, rules the star Sirius, and the cry of the dog is "auau."

United to the goddess of the abyss in funerary rites, the dog transports the dead to the underworld. Since ghosts and apparitions appear to be visible to dogs, a howling dog is universally believed to be a harbinger of death. Various facets of the great Babylonian divinity Gula Bau identify her with Bau; she walks the earth, accompanied by her hounds, in the manner of Hecate, Goddess of the Western Gate. Both deities search for the souls of the departed,

128. Two dogs tease a caterpillar on a painted vase. Valea, Lupului, Moldavia, Rumania, fourth millennium B.C.E.

129. Dog with a human mask forms the handle of a terra-cotta lid. Site of the Gorni Pasarel, central Bulgaria, mid-fifth millennium B.C.E.

130

130. The dog's relation to death is confirmed by two other death figures—the horse and the deity. Greece, Hellenistic.

131. Theban tomb painting establishes the worship of the dog in Egypt. Thebes, VIII Dynasty, ca. 2130 B.C.E.

132. The king in the form of the god Anubis during the course of his transformation. Egypt, ca. 1325 B.C.E. (See plate 19.)

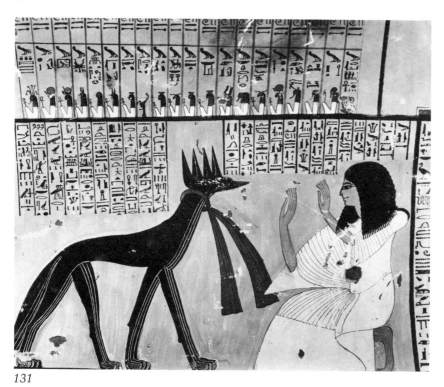

131

132

wandering in the wasteland. The individual soul is lucky to encounter the Mistress of the Way Down with her dogs. A Hellenistic plaque presents the Goddess of Death. She carries a torch that, when lowered, means death. Showing her accompanied by a hound, the relief confirms that the dog acts as her companion. The Nordic Underworld Goddess, Hel, escorts the dead to the next world and her wolflike dogs nip the flesh of the corpse. Vestiges of this symbolism linger in the ancient Indian custom of offering the dogs a morsel of the corpse. Hounds escort and protect Artemis, thus when Actaeon chances upon her bathing, her dogs tear him to pieces.

Analogically speaking, the dog and the snake are synonymous symbols in the sense that they both belong to the borderland rather than the actual underworld. Greek tragedies make clear that the Erinnyes, half-human avenging goddesses, were symbolized by dogs as well as by snakes. The dog also belonged to Hecate, Queen of Shades.[5] Her own dog, named Cerberus, became guardian of the gate to Hades' realm. The dog assumes a shifting character, situated between night and day or life and death, so its position is close to that of the snake.

EGYPT

In a painting from a Theban tomb, a figure kneels before a dog deity, confirming the dog's worship in Egypt. Traditionally associated with the cult of the dead, Anubis's name means time. This wall painting dates to the seventh year of the reign of the pharaoh Akhanaten, VIII Dynasty. In another piece, as a jet-black jackal in a gold collar, Anubis reclines on a golden pylon, supported on a gilded sledge.

Anubis, who prepared the mummy for its journey, is a descendant of an earlier dog deity, Up-Nat, from Central Asia; both were known as the Opener of the Way[6] and may have had their origin in an even earlier, undiscovered culture. Sirius, whose Greek name, Sothis, means "the eye of the dog," was Anubis's star. It forms the center of the constellation, Canis Major, "the Great Dog." It is simply the brightest star in the heavens, and was the most important star to the Egyptians.[7] Its ascendance coincided with the annual Nile flood on which their economy rested.

NORTH AMERICA

Prehistoric Mimbre ware is among the finest, most spirited pottery of the south-western American Indians. It often depicts the dog or its wild relatives. On one bowl a comic figure wearing a striped costume and a mask prances a gay improvisational dance (ca. 900–1150 C.E.). There is controversy among experts as to the kind of animal depicted on the mask. Some say it is a dog; others suggest a snake or a ram.

The dog is one of the favored sacred animals of the Northwest Coast Indians. As coyote, it stands for the arch trickster whose demonic side links him with death.[8] Dogs are in many areas recognized as clairvoyant and able to sense the presence of death.

The Aztec dog is thought to descend to earth as a star. In the Mayan codices, dog is conspicuously associated with the god of death, storm, and lightning.[9] The connection of the Mayan dog with a star or constellation is suggested by the spots sprinkled on its coat. It is pictured in the Mexican codex[10] in partly human form carrying in each hand a torch for the abyss.

NORTH AFRICA

Among the Moslems in Morocco, dogs are considered unclean and are to be avoided because of the evil they embody and represent. This notion may have its roots in an intensely masculine aversion to the original ancient goddess religion; the animals intimately connected with the goddess were looked upon with abhorrence. The greyhound is an exception. This fine hunting dog is believed to cleanse the household of evil spirits and, therefore, receives prayers and honors.[11]

ASIA

In India, the dog has been adopted by Indra, the masculine deity responsible for thunder, lightning, and rain. The Celestial Dog of China is prevalent as a storm deity.

EUROPE

An ancient Irish name for dog, *madra*, completes an etymological picture. *Madra* relates to the Latin *mater*, *matron*, *matrix*, and the Sumerian *mama*, all words relating to the mother. In early Etruscan-Roman history, the Great Goddess herself is Lupa, the she-wolf who suckles Romulus and Remus, the founders of Rome.

133. Mimbre ware painting of a dancing human figure in what may be a dog mask. American Southwest, ca. 900–1150 C.E.

133

The Serpent

The serpent-dragon of the Hesperides guards the tree of the Golden Apples. Greece, fifth century B.C.E. Detail of fig. 169.

The Paleolithic Serpent

Surrounded by mystery, the serpent glided into the human imagination at an early time. To this day it remains one of the most powerful of animal images. Grace and beauty, silent speed of movement, mesmerizing eyes, and often fatal bite all contribute to the creature's aura of wonder. Its ability to slough its skin and arise renewed places the serpent in the forefront of the animals of rebirth, evocative of both the earth's live-giving energies and the abyss, the land of the dead.

Being cold-blooded, the serpent avoided the Ice Age climate of Europe. Although its frequent representations in Neolithic times reveal the serpent as intimately related to goddess worship, its image rarely appears in the earliest period of cave art. In the cavern of La Baume-Latrone in southern France, (ca. 40,000–26,000 B.C.E.) the tracing of a gigantic snake with huge head, fangs, and forked tongue appears as one of the earliest examples of a painted outline of a serpent in that era.[1] The serpent's body resembles that of a woman. As a serpent it is terrifying; as a woman it seems benign. In view of the images that follow, this may be a visual pun. The pun continues from the serpent as woman to the serpent as goddess. The play of images is enlivened by the mammoths that literally and figuratively support the snake-woman-deity. She is often called Our Lady of the Mammoths.

As mentioned, colonists from the European caves emigrated to Paleolithic Mal'ta, near Lake Baikal, Siberia (ca. 16,000–13,000 B.C.E.). A cache was discovered of twenty symbolic items of mammoth ivory in association with the burial of a cherished child, ceremoniously turned toward the east. One of these, a pendant with a hole, pecked with the opposing spirals of rebirth, was worn as an amulet to ensure regeneration and reveals the ancient relationship of the serpent to the abstract spiral. The large spiral may be entered from below in the manner of other models of womb-spiral images. The obverse of the amulet displays three waving cobras.[2] A Siberian fish in the same cache has a similar uterine passage.

134. The serpent as
Goddess, supported
by mammoths
from the cavern of
La Baume-Latrone.
France, Aurigna-
cian, 40,000–26,000
B.C.E.

135. Mammoth
tooth amulet with
cobras and spirals.
Siberia, Paleolithic,
after 13,000 B.C.E.

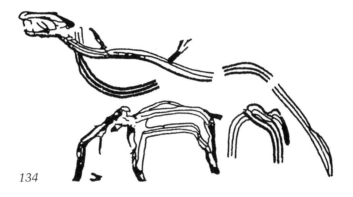

134

135

Early Snake Goddesses

One of the most archaic connections of serpent with goddess is encountered among the Pelasgians, a people mentioned by classical writers as early inhabitants of Greece. A Pelasgian creation myth tells of Eurynome, Goddess of All Things, rising from Chaos. As she divides the sky from the waters, she begins to dance upon the tossing waves. Out of the wind generated by her dance, she creates a great serpent and names it Ophion. Aroused by Eurynome's wild movements, Ophion coils about her divine limbs and couples with her. Eurynome then assumes the form of a dove and, brooding upon the waters, lays the Universal Egg. The Goddess bids Ophion coil about the Egg until it hatches. Out from the Egg tumbles all creation: sun, moon, planets, stars, earth, and all living creatures.

So the serpent and the Goddess twine about each other and in fear and delight become one. Theirs is a symbolic union, a natural conjoining of shared attributes. Both are linked with birth, death, and resurrection: the serpent through its ability to shed its skin, the goddess through lunar associations with rebirth. In a complex web of symbolic threads, they share the realms of earth, water, and underworld, and the dying and the sprouting aspects of vegetation.

As a universal symbol, the serpent, through its form, found direct access to our emotions.

As a symbol of the beginning, the uroborus, or snake biting its tail, expresses the original psychic situation of the masculine and feminine elements united so that neither is first. Many people, following Freud, see the serpent as a phallic, masculine image. Others see the serpent as an androgynous blending of male and female, and there is much to support this view. Writes Joseph Campbell:

The phallic suggestion is immediate, and, as swallower, the female organ also is suggested; so that a dual image is rendered, which works implicitly on the sentiments.[1]

Nevertheless, the predominant evidence from early times presents the snake as distinctly feminine, and etymology bears out this primal identification. In another view, the Dogons of Africa believe that the snake taught people to give birth. The swallowing rhythm of the serpent compares with the convulsive spasms of birth-giving.[2] It is an earthy, chthonic, underworld image par excellence. Like the bird divinity, the serpent deity is not intrinsically a Mother Goddess. Motherhood is not an indwelling characteristic, only one of her many functions.

136. Stripes on the enthroned Madonna suggest a Snake Goddess. Sesklo, Greece, early fifth millennium B.C.E.

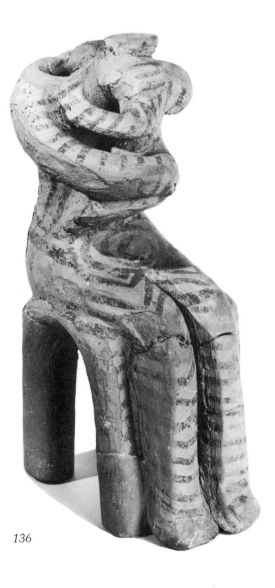

136

STRIPED SERPENT GODDESSES

Megalithic and Neolithic imagery introduces many goddesses to the world in snake form. The goddesses tend to be striped, with very small breasts or none at all. Nevertheless, they fulfill their reputation for fertility and are often shown with infants in their arms. From the Acropolis of Sesklo, Greece, in Thessaly (early fifth millennium B.C.E.) the epiphany of a Nature Goddess was unearthed, a serene enthroned madonna holding a child. She is evenly banded over all of her body; even the throne's flaking, scaling paint reveals a striped pattern beneath.

The pre-Hellenic Mycenaean idol of a seated serpent mother holds a serpent infant in her lap. Child, deity, and chair are all striped in the style characteristic of snake deities.

A snake and bird goddess of an early Cucuteni type (early fifth millennium B.C.E.) discovered in Bernovo-Luka in the Ukraine, is decorated with symbols of both creatures. Chevrons and stripes cover the neck, body, and legs, while the sexual area is incised with a lozenge. Within her enlarged buttocks, the deity carries the Cosmic Egg. Seeds impressed on the lower part of the torso suggest her role in vegetative growth.

137

A unique painted vase from Kamnik, Albania, immortalizes a Snake Goddess with tiny wide-set eyes and human form. Her exaggeratedly long, bifid tongue extends down her chin, neck, and chest and then divides, each half spiraling around one of her small breasts. Her face, neck, shoulders, and winglike arms are marked with a parallel zigzag water pattern that stops beneath her breasts. A meander pattern that signifies cosmic water covers her lower chest. The Ophidian jar speaks of water and fertility. The double spiral of the forked tongue alludes to life, death, and renewal.

The curvilinear form of the serpent resembles water running downhill. Water, always sacred, became a matter of primary importance to the agrarian Neolithic communities. The snake, an earth creature, suggests the earth's green mantle, constantly decaying and reviving. As Lady of Waters, the divinity shares her realm with the serpent as well as the bird and the fish.

A burnished terra-cotta snake goddess from Kato Ierapetra ("Holy Stone"), on the southern coast of Crete, dates from 6000 B.C.E. Incised with parallel lines on the arms, legs, breasts, shoulders, and back, she sits in the lotus position of yoga wearing a wedge-shaped crown. Eyes, fingers, and toes are plastically indicated, and her figure

137. Cucuteni Snake Goddess with dotted lines and dotted lozenge over womb. Bernovo-Luka, Ukraine, early fifth millennium B.C.E.

138. Neolithic water jar doubles as the torso of a snake deity. Kamnik, Albania, Neolithic.

139. Striped serpent mother holding snake child. Mycenae, pre-Hellenic, ca. 1300 B.C.E.

140. Seated deity covered with engraved bands. Kato Ierapetra, Crete, 6000 B.C.E.

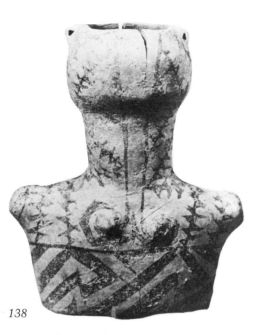

138

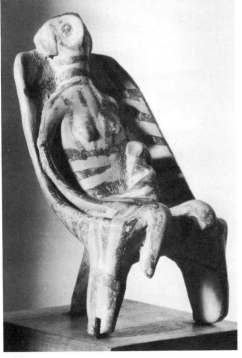

139

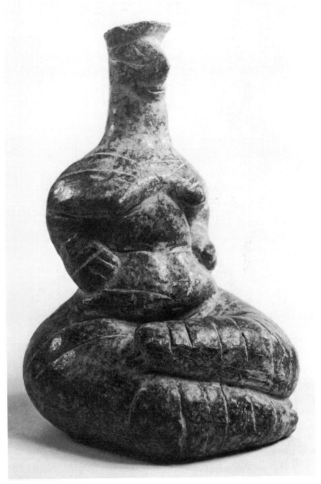

140

141. Goddess with stripes carries a serpent child. Greece, late sixth century B.C.E.

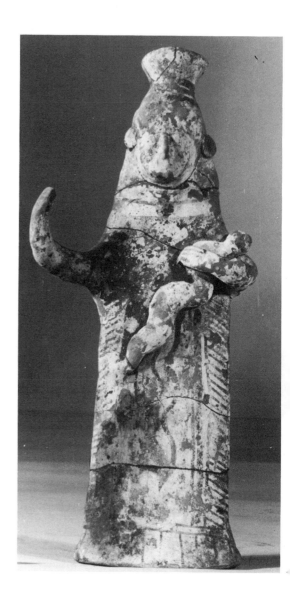

triangulates upward, with the base covering a disproportionately large area of ground. It thereby creates a sense of earthly power. Contact with the ground was important to the ancients.

A bird-headed madonna from Mycenae (1400 B.C.E.), Late Helladic III, cradles a snake child in her arms. She represents a well-known type with beaked nose and triangular crowned head. The strong, henna-on-cream horizontal patterning of stripes covers both mother and child and gives them a snakelike look. The outline of the mother's small breasts pokes through her loose winglike garment, and her banded throat is adorned with a sacred necklace.

The serpent serves as metaphor for the impenetrable manner in which our lives change, twist, and renew themselves. The nocturnal side of the Goddess symbolizes our temporary return to the maternal bosom in death. On the other hand, the union of serpent and Goddess is often quite literal in ancient art. Many serpent goddesses appear partly or wholly in serpent form or with snakes twining around them; others carry serpent babies in their arms. This figure from Greece, though primitive looking, dates from close to the high point of Greek culture, late in the sixth century B.C.E. The image wears a robe with a distinguishing striped pattern. Underneath the baby's serpentine body, another snake is

142

painted, marked with the rosette of the goddess. The artist wished to emphasize the theme by adding a plastic representation.

It is worth remembering that many ancient civilizations did not have the irrational fear of snakes prevalent today. As Charles F. Herberger writes:

The Minoans like the Egyptians had not been conditioned to see in the snake a symbol of evil. . . . The Minoan sun-serpent was a benevolent one—a guardian of the household and a healer of the sick. . . .[3]

A fascinating striped Minoan deity from Arkhanes, Crete (1100–1000 B.C.E.), stares out from the shadows of a sheltering shrine. The stripes on her body divulge her serpent connection. Her arms, raised to receive the life force, hold the ropes of a swing. The little crown, too, is painted with vertical bands, and she wears a distinguishing triple necklace. The shrine itself is painted with an undulating wave pattern, and two figures lean forward to peer through a hole in the roof.[4] Their clothes repeat the pattern of the feline lying nearby. Chevrons flank the entrance door. Her ringlike hands suggest the divinity may have been made to swing, a fertility rite still practiced on provincial Greek islands.

142. Enshrined Minoan serpent divinity with banded body wears three necklaces. Crete, 1100–1000 B.C.E. (See plate 30.)

143. Bird-headed deity, with diagonal stripes, holds snake child. Mycenae, Greece, 1400 B.C.E. (See plate 24.)

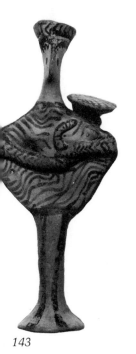

143

145

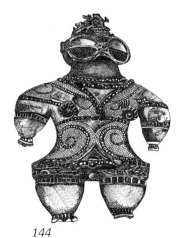

144

THE SERPENT GODDESS AND THE DOUBLE SPIRAL

The spiral, one of the most conspicuous motifs in prehistoric art, often covers the breast or sex of a divinity. As noted, it is as old as the Siberian Aurignacian era and appears throughout the world on tomb and threshold stones. Doubled, it means rebirth or renewal. It conveys the movement of the winding and unwinding labyrinth, the serpentine path to consciousness.[5]

The Lady of Sitagroi, from northeastern Greece (early sixth millennium B.C.E.), is slender of waist yet vast of belly, on which is incised a double spiral in the form of two snakes.[6] Like paths into and out of the womb, such spirals are also found engraved on stone at the entrance of the mound at New Grange, Ireland, and at the entrance to the altars of the stone temples of Malta in the Mediterranean. Although these two are far apart in time, the Lady of Sitagroi is still older.

The Lady of Pazardzik, in the central Balkans, dates from the middle of the third millennium B.C.E. She carries a similar double spiral over her vulva and wears a lozenge on each thigh and buttock. Her throne and mask disclose her substance; furthermore, she is pregnant. Her great weight, signifying the earth, resides in her lower body. Such vessel forms resemble the

144. Neolithic Jomon pottery goddess with magnified eyes and double spirals on her torso. Japan, fourth millennium B.C.E.

145. The double spiral on the belly of the Lady of Sitagroi signifies birth and rebirth. Greece, 5000 B.C.E.

146. The throned Lady of Pazardzik displays a double spiral on her vulva and a lozenge on each thigh. Bulgaria, mid-third millennium B.C.E.

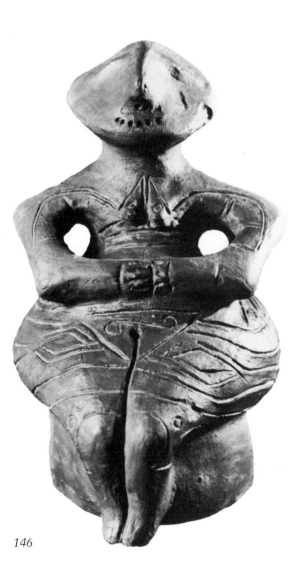

later rhytons that had lugs in the bottom to allow liquid to flow from them and over the earth when carried through the fields. The lozenges on her buttocks symbolize water, thus the pregnant womb.[7]

Another Goddess, from prehistoric Japan, bears the double spirals on her womb. She typifies the last period of Jomon pottery, which begins in the fourth millennium B.C.E. and is distinguished by primitive rigidity, cord-marked decoration, and flylike eyes that cover most of the facial area. Throughout the ancient world, such enormous eyes characterize the All-Seeing eye of the Goddess.

146

The Great Egyptian Divinities

The serpent was venerated throughout ancient Egypt. It presided especially over matters of fertility, birth, death, and the underworld. Statues and images of the goddesses of the sky, the sun, the earth, and the underworld often wear serpents on their foreheads. Divine beings are also often depicted with serpents' heads or bodies, their healing capacities linked to these underworld connections. The serpent's protection was so important that no temple could endure without it.

The well-being of the nation rested on the strength of the serpent symbol of fertility as well as on the goddess Isis, who presided over the Nile River. Evidence of the earliest Egyptian agriculture has been found near the Nile; in this desert area vegetative growth depended on the seasonal flooding of the river.

NEITH

In Egyptian hieroglyphics, the word "goddess" is expressed by the image of a cobra.[1] Among the deities of Egypt, the venerable goddess Neith appears as a great golden cobra. As the early patroness of the loom, Neith in her snake form became a goddess of life and fate. Sometimes she is shown in human form, wearing the crown of lower Egypt, her green face and hands signifying the leafy earth.

Neith is known as the Oldest One,[2] "Goddess of magic and weaving. She is the unborn goddess who originates in herself."[3] As the personification of "the great, inert, primeval watery mass . . . ,"[4] Neith is the "eternal female principle of life, which was self-sustaining and self-existent, and was secret, unknown and all-pervading. . . ."[5]

Neith is a very ancient goddess whose cult was considered old in the First Dynasty. According to legend, her two crossed arrows and mottled animal skin represent the essence of the triple community. She celebrated childbirth by bringing forth the great god Ra, then took up her shuttle, strung the sky on her loom, and wove the world. With her net she gathered up from the primordial depths living creatures for the land. Because she was a creator deity, one who gave birth, no mortal might look upon her veiled face. Plutarch transcribes the inscription on one of her statues: "I am all that is or has been or that will be and no mortal has yet raised my veil."

Neith's cobra suggests her great antiquity, the cobra itself being one of earth's oldest creatures. The splendid golden statue of Neith as snake comes from the tomb of Tutankhamen (ca. 1325 B.C.E.). Her neck is distended; her head raised, watching. The shuttle, Neith's symbol, is always superimposed on the breast of her snake, as the mark of the Goddess who rules destiny.

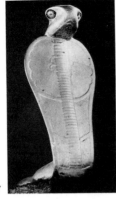

147. Neith as golden cobra wears the shuttle on her breast. Tomb of Tutankhamen, Egypt, ca. 1325 B.C.E. (See plate 23.)

147

148. Renenutet, a deity of childbirth and nursing, protects the Pharaoh Thothome III. Egypt, ca. 1500 B.C.E.

Below the shuttle, her apron is decorated with the sacred net design. Neith invented weaving, the traditional occupation of all divinities of fate, such as the Moirai, the Parcae, and the Norns. Even today among the Huichol in Mexico, when a woman sets about to weave or embroider, she first strokes a snake, then passes her hand over her brow and eyes to absorb the creature's power.

RENENUTET AND MERTSEGER

Renenutet and Mertseger, two lesser-known serpent goddesses, appear in the list of Egyptian deities compiled by E. A. Wallis Budge from the Pyramid Texts. Renenutet, the Lady of Aat, a harvest goddess, is known primarily as a deity of childbirth and nursing, occupations long connected with the serpent.[6] The emblem of the medical profession, the caduceus, links snake and childbirth still. This statue, carved from basalt, shows Renenutet as a crowned cobra protecting her protégé, the infant King Thothome III of the XVIII Dynasty (ca. 1500 B.C.E.). The shuttle at Renenutet's breast marks her as a deity of fate.

Mertseger, who has a human head and snake body, guards the Theban necropolis. She is known as She Who Loves Silence. An enormous sacred lotus shields her head. A pair of raised arms holds the crowning

148

disk—a pictograph of the word *ka*, "essence or nourishment." The whole headdress represents a pun for the name of Queen Hatshepsut. It is probable that the great architect Senenmut designed it.

ISIS

Isis of the winged arms, goddess of wisdom, was a latecomer to the Egyptian pantheon, but her cult, born at the beginning of the New Empire (1570 B.C.E.), quickly gained popularity throughout the Nile Valley. She took many emblems of the Great Mother from Hathor and absorbed most, if not all, of the various local goddesses.

First daughter of Nut, the Sky Goddess,[7] Isis is entitled the Giver of Life. Isis is a Greek transliteration of her Egyptian name, Au Set, which means She of the Throne and indicates her position as Queen of the Gods.[8] She wears a representation of the throne, and only she can authenticate the inheritance of kingship. In a solemn ritual, the new pharaoh sits enthroned on her lap to receive his kingdom.[9] The king's marriage to his sister is an additional requisite to succession, the throne being a legacy of the distaff side from matrilineal times.

A bronze head of Isis wears a small crown of snakes from which spring horns twined with serpents. That is, two serpents, whose bodies twine about the barbed horns,

149

150

149. Mertseger stands beneath the sacred papyrus flower. Egypt, New Kingdom, ca. 1500 B.C.E.

150. Winged Isis, protector of the Gods. Egypt, after 1570 B.C.E. (See plate 22.)

151. Isis wears horns and snakes. Egypt, after 1570 B.C.E.

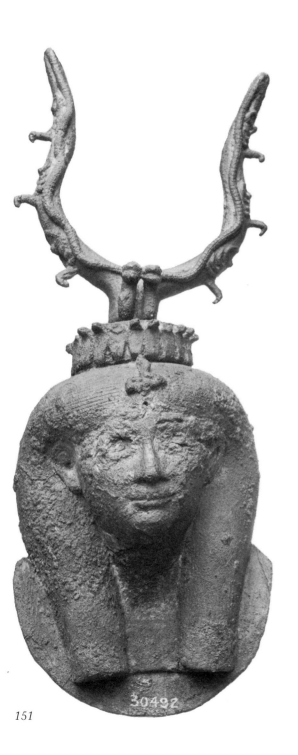

151

guard her forehead. The snake is visible everywhere as Isis's symbol, yet it is absent from her legends, with one exception: Taking saliva that the Sun God, Ra, has let fall upon the ground, Isis kneads it with earth and from this clay fashions a serpent that she places in Ra's path. As he walks through his kingdom, the snake bites him. He suffers greatly and appeals to Isis for help. "Name to me thy name, divine father," Isis boldly demands. But Ra refuses. The poison takes stronger hold, and Ra finally relents and reveals his secret name to Isis. When Isis learns the name, she repeats it in an incantation, the poison subsides, and Ra recovers.[10]

It was through her mysteries that Isis was able to bestow the gift of immortality. This more than any other single point accounts for her sudden rise to popularity. By the Saite period she had developed into a prototype of all goddesses. Greatest of all goddesses, Isis with her many gifts is called Mistress of the Gods, the Many Named, Lady of Heaven, Mother of God, the Great Enchantress, Mistress of Magic, Speaker of Spells, Giver of Barley, and Teacher of Agriculture.

Near Eastern Deities

The Near East combines two distinctly different milieus—the lush valleys of the Tigris and Euphrates rivers oppose the wild desert regions. The serpent was honored for its ability to be at home in either habitat. Its sinuous elegance and unique appearance added to the awe with which it was regarded. The serpent manages to travel rapidly without arms or legs and is therefore magical; it can shed its skin to look born anew, and its lightninglike strike relates it to cosmic phenomena. Goddesses and their followers welcomed the serpent as a giver of medical aid and as a teacher of wisdom.

Discovered in the temple of Ishtar at Assur, Assyria, a slender nude figure with snakelike head suckles a serpent-headed child. The terra-cotta deity, dating from the first half of the fourth millennium B.C.E., is distinguished by a high headdress of bitumen, long slitlike eyes that stretch down her face to the nostrils, extremely wide shoulders decorated with applied clay pellets, and a strongly accented pubic triangle. Such goddesses are characteristic of the Ubaid period in Mesopotamia. On the one hand, the warm-blooded human act of offering nourishment from her body identifies her as a divinity of fertility. On the other hand, the fact that she is a cold-blooded reptile suggests she presides over the chthonic world of death as well.

ANAT

Reverence for the snake in the Near East equalled that found in Egypt. The gold amulet of Anat (thirteenth century B.C.E.) portrays the Goddess of Ras Shamra standing on a lion and holding a lotus and writhing snakes. The sacred lotus linked heaven and earth; though rooted in mud, its delicate petals reach toward the sky. Anat's Egyptian-style headdress accentuates the spiral curls that frame her face and point to a close relationship with the Egyptian goddess Hathor. A. A. Barb sees an analogy between this type of headdress, seen often on Egyptian deities, and the spirals of the divine womb. Barb's analogy is strengthened by Anat's exaggerated genital region,[1] a testament to the fabled sexual appetite she focused on her brother Baal. Her preparations for their first encounter included bathing in dew and anointing herself with ambergris and proved very effective; they were said to have copulated seventy-eight times during this rendezvous in the wilderness.

Anat's worship flourished as far north as Zela and Ascilicena in Anatolia, present-day Turkey. Her significant aspects include those of Virgin, Mother, and Warrior.[2] The maiden Anat, like Athena, was converted to a war goddess; as Defender of Cities, she wears shield and helmet. Her detractors labeled her the bloodthirsty Ugaritic Love Goddess. Like many goddesses of the Near

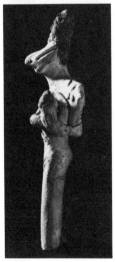

152. Gold amulet of Anat holding snakes and standing on a lion. Ras Shamra, Syria, thirteenth century B.C.E.

153. Serpent-headed Madonna from Ur, suckling her infant. Iraq, fourth millennium B.C.E. (See plate 29.)

152

153

East, Anat, Queen of Heaven, was invoked as morning and evening star.

In the great epic poem of Baal and Anat, Anat is both sister and consort of the young god Baal; his function is that of Storm God and bringer of rain—a critical role in an agricultural region such as Anatolia. The tablets of the epic, originally compiled around 1400 B.C.E., chronicle the rise of Baal as God of the Grain. This rise continues until a time of drought, when he becomes physically weak. Mot, the God of Drought and Death, takes advantage of Baal's weakness and kills him. In a fury, Anat rushes at Mot and cleaves him in two with a ritual sickle, scorches him, winnows him in a sieve, grinds him in a mill, and scatters his flesh over the ground.

Mot's dismemberment recalls that of Egyptian Osiris. Both are treated like reaped grain, and their stories suggest later rituals in which the corn spirit is slain in the harvested grain before the season of sterility.[3] The epic of Baal and Anat demonstrates that Anat's principal concern was the perpetuation of the life of plants. The snakes shown in her hands stand for the vegetation of the earth, continually decaying and reviving. Her serpents mark her as a creator and a destroyer simultaneously.

CANAANITE SNAKE GODDESS

A snake goddess of Canaan (1200 B.C.E.) brandishes two serpents. The gilded bronze figurine with small, well-defined breasts wears a bell-shaped skirt covered with a finely wrought design of solar symbols. Vestiges of heavy gold leaf still cover the figure. The body of one serpent encircles her waist, undulating over her lap and down the skirt. The other serpent twists down her raised arm and crosses under her breasts to her lowered arm. The positions of the two snakes, one entirely below and one above, are symbolic of the physical and spiritual planes; they oppose the realms of life and death. The figure appears to be weaving a spell.

The early Near Eastern Bronze Age brings us closer to the original Great Goddess, who appears at her sanctuary surrounded by a multiplicity of beasts. The snake frequently occupies the most prominent place. It characterizes her chthonic side, the aspect associated with earth, the nether regions, and death and, simultaneously, aspiration, life, and spirit.

MISTRESS OF ANIMALS

Two representations of the Goddess, the Lady of the Beasts and the Mistress of Plants, dominate a low, continuous relief carved on a chlorite bowl of the Late Argave

155

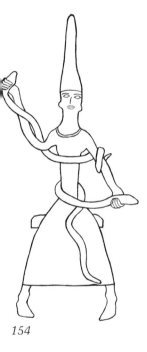

154

period (2500 B.C.E.) from Khafaje in Sumer. In the frieze, the figures wear skirts decorated with the sacred net pattern. One of the deities grasps in each hand a huge spotted serpent with sinuous coils. She stands on an altar guarded by recumbent lionesses whose heads turn toward her, their tails erect. On the right, near her head, lies the sickle-shaped crescent moon and six-pointed star of Ishtar; they identify her as a goddess of the first magnitude. Her hooked nose is modeled after a vulture's beak. On one side of her stands a humpbacked bull surrounded by vegetation. On the other, a scorpion is carved; the insect relates to the Goddess in India, Egypt, and Mesopotamia. The other figure of the deity presents her as the Goddess of the Flowing Vase, whose animals include birds of prey, small bears, and leopards. These two representations enable the vase to serve either the Lady of the Beasts or the Mistress of Plants on the domestic altar.

The religious meaning of the piece is made clear by similar iconographic works of art from other sites. Replicas of this exact bowl have been found at Mari, on the upper Euphrates; others have been excavated as far away as Mohenjo-Daro in the Indus Valley. At Tepe Yahya, in Baluchistan, on a main route between Sumer and India, thousands of similar bowls were fabricated contemporaneously. Other images of the Lady found

154. Goddess of Canaan holding two serpents. Israel or Lebanon, ca. 1200 B.C.E.

155. Lady of the Beasts and Mistress of Water rolled out in relief from a bowl. Khafaje, Sumer, 2500 B.C.E.

in the vicinity predate and postdate the bowls' manufacture.[4]

The theme of the Mistress of Animals turns up in Minoan Crete (1500 B.C.E.) and again on a vase of the Greek Geometric period (seventh century B.C.E.). Because of their similar iconographic elements and despite their identifying symbols, these stone bowls have puzzled scholars for years. Since the breasts are flattened and the noses beaked, the figures were interpreted as masculine, and known traditions did not account for their identity.

ATARGATIS, DEA SYRIA

A similar serpent goddess traveled to Italy where, in the early Christian era, Rome nurtured a welter of religions introduced by merchants and slaves from conquered countries. Among the more prominent was the worship of the ancient fertility goddess Atargatis from Syria, whose name was simplified to Dea Syria. Installed on the Janiculum, the highest of Rome's seven hills, the cult found acceptance due to the transported Nature Goddess's Roman deities, such as Cybele, and gained popularity throughout the empire.

The remarkable statue of heavily gilded bronze, uncovered from the foundations of the temple of Dea Syria (third century C.E.) shows the divinity encircled, mummy fashion, by seven coils of a great serpent. Her head emerges from the snake's maw as if the two were one. Close examination reveals seven eggs tucked between the serpent's coils and her body. This refers to the Syrian myth of her birth from an egg that the sacred fish of the Euphrates River found and shunted ashore. Lucian tells of the sacred fish of Atargatis in Syria who wore golden jewels in their fins and gills and were worshiped in the pond of her finest temple, at Herapolis.[5] Dea Syria epitomizes the fructifying spirit of water, which produces and nourishes life.

Pliny described the Atargatis he saw in images as being part fish, part woman, and it is from Atargatis that the mermaid legend no doubt originated.[6] In Greece, she took the form of the goddess Derketo, whose shrine was on the sacred island of Delos. Located among the quiet, fish-filled ponds, her temple was surrounded by trees full of doves, whose low murmuring mimics the speech of lovers.

Roman accounts show that the rites of Dea Syria followed the general pattern of the Mother Goddess cults of Asia. Her worship is accompanied by ecstatic dancing to drums, tambourines, pipes, and cymbals and includes the ritual prostitution of her priestesses, described in detail by Herodotus, along with phallic symbolism and the emasculation of her priests.

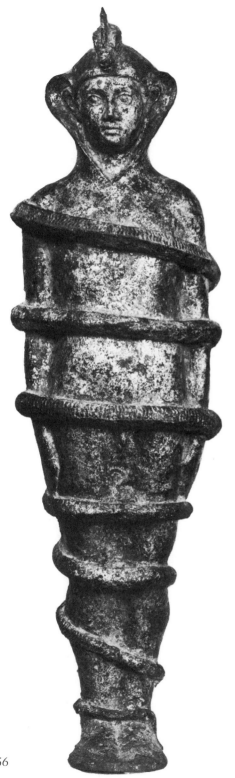

156. Within the coils of a serpent stands the golden statue of Dea Syria. Rome, third century C.E.

Lucian remarks that Semiramis, Atargatis's part human, part divine daughter, built her mother's temple at Herapolis. There the people abstained from eating fish or doves, forbidden by the people of Askalon on the Palestinian coast, where Derketo was worshiped. The innermost sanctuary of Atargatis held three golden statues, two of the Goddess herself and one of her consort, Hadad. Splendid effigies of Atargatis wear tower crowns, carry sceptres and distaffs, and stand on guardian lions. In these statues, Atargatis possesses the attributes not only of Turkish Cybele but also of Hera, Athena, Aphrodite, Rhea, Artemis, Nemesis, and the Fates. She stands for the Mother Goddess from whom all of them drew characteristics. This deity reigned supreme, far into the patriarchal period, a divinity at once celestial, earthly, and chthonic.

156

Serpent Goddesses
of Crete

Scholars speculate that the forebears of the Minoans arrived in Crete sometime between 4000 and 3000 B.C.E., having come from the Black Sea region via the Cyclades. They brought cult totems such as the serpent, the dove, the bull's horns, and the double-axe. These same symbols, dating from 6000 B.C.E., were found in Çatal Hüyük in Turkey and in the Balkans. According to Marija Gimbutas, the snake forms a significant bridge between Old Europe and Crete. The Balkans, Greece, and Crete, rather than Mesopotamia, were the nucleus from which European civilization sprang.[1] This theory is supported by a comparison of the furnishings of the shrine of Cretan Eileithyia, near Gournia, with those of the sacred snake room found below the Cretan Palace of Knossos. Both shrines contained vessels decorated with molded snakes rippling up their sides as if about to drink. The vessels duplicate far older finds excavated in the Balkans. Many similarities are apparent in the serpent vessels and the goddess imagery in both areas.

KNOSSOS

In Old Europe during the Neolithic period and in the East during the Bronze Age, the Snake Goddess is found in a number of forms and in great abundance. None, perhaps, are so mysteriously beautiful as the pair found by Arthur Evans in the shrine at the temple-palace at Knossos, Crete (ca. sixteenth century B.C.E.). The larger of the two faience figurines may represent a deity of the upper and lower worlds: Snakes twine above and below her waist as if offering life or death.

Her omnipotence is expressed through a triple tiara topped again by a snake's head. Her bodice, a laced corset exposing her full breasts, suggests her nourishing aspects. The skirt is bordered with the sacred net pattern and partially covered by a short double apron edged with the wave design. The figurine's most striking features are her staring eyes, black and hypnotic. The eyebrows are sculpted in relief to enhance the mantic expression. Her hair, cut short in front, falls down her back to her waist. Large ears, quite out of proportion, are a feature noted in other Cretan goddesses of the period.

To paraphrase Evans's description of the serpents: Three spotty snakes coil around the Goddess; one head is held in her hand. They undulate up her right arm, across the shoulders, and down her other arm. Two intertwine at her hips and form a girdle. One snake's head rests in the center. Its body loops across the front of her apron and ascends the border of her bodice to wrap its tail around her ear. A third snake, intertwined with the one at the hips, moves

157. Primal serpent divinity from the Palace of Knossos. Crete, ca. sixteenth century B.C.E. (See plate 33.)

158. One of two sister deities, or perhaps mother and daughter, from the Palace of Knossos brandishes sacred adders. Crete, sixteenth century B.C.E. (See plate 25.)

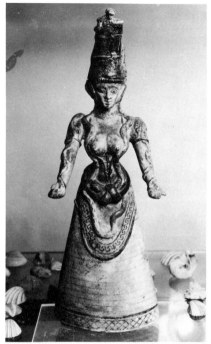

157

in the opposite direction. The tail end is woven in the girdle, and the snake edges up the bodice on the left, continuing up over the left ear to coil over the tiara to the crown of her head.[2]

The nubile figure of the smaller goddess is robed in the same fashion as the more matronly figure. A tight-fitting jacket exposes her breasts. Her bell-shaped skirt hangs from the waist in seven flounces, and her apron is covered with the cross-hatched net pattern. Like the larger goddess, the younger goddess's skirt covers her feet, a mark of divinity. On her crown of roses sits a small leopard. In her outstretched hands she grasps two snakes whose size and distinctive markings identify them as sacred adders. Abstracted into wave and dot patterns, these snakes figure on ritual objects of the cult and characterize her domination of the underworld. Her fearsome expression is a reminder of the volcanic eruptions, tidal waves, and earthquakes that destroyed the temple-palaces on more than one occasion. The greatest eruption ever known is that of the volcano on nearby Thera. It blew up the island in a terrible holocaust around 1450 B.C.E. that probably ended the high Minoan civilization.

The shrine furnishings include a large finely polished equilateral cross and provide corroborative evidence of the deity's role.

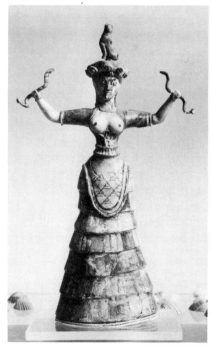

158

Vast numbers of shells accompanied the terra-cotta figures, along with votive robes for the statues.

The sacred adders held by the smaller goddess are not friendly snakes. Rather than suggesting trusty guardians of household treasure, like the domestic dog, they imply terror and swift death and recall the death-dealing side of the Goddess, in whose mystery cult one must die to be reborn.

BEYOND THE PALACE

A full-length stone statue of the Goddess as Snake Mother, at 15¾ inches the largest so far brought to light, was discovered at the harbor that served Knossos. (Her whereabouts currently are unknown.) Like the larger goddess of the palace shrine, she wears a three-tiered headdress and carries a single serpent whose tail passes, similarly, across her forehead and behind her enlarged ears. She grasps the snake by the middle of its body and by its neck, and her head inclines slightly toward it. The snake looks up at her as to a mother. Their bond points to her as a Snake Mother. Here the serpent is not held out as a symbol of infernal power, like the adders of the smaller palace deity; this snake, a python, may well be a pet. Cut from fine, beautifully veined marble, the statue's style, facial features, and details so closely resemble those of

a figure found nearby that Evans, the archaeologist of the site, believes both statues to be the work of the same hand.

The exquisite gold and ivory statuette of another Snake Goddess, now in the Boston Museum of Fine Arts, is believed to be from a reliquary at Knossos. While the museum dates it at 1600–1500 B.C.E., J. D. S. Pendlebury has dated the artifact to Late Middle Minoan I, ca. 2200–2100 B.C.E., a period when palace art was at its height. Wearing a golden crown and a bell skirt with five gold-bordered flounces, the Goddess stands with arms slightly raised. Two golden snakes coil three times around her arms, each rearing toward her naked torso with outthrust tongue. The nipple on the right breast is indicated by a golden nail that serves, like the exposure of the breasts, as a reminder of her precious nurturing role and suggests that the Goddess sometimes suckles the serpent. (Tenau of the Golden Breast, a Celtic goddess, was so called because a snake clung to her nipple so tenaciously that the breast had to be cut off and replaced with one of gold.)

A miniature shrine from Late Minoan III, unearthed by Evans in the Palace of Knossos, has a double raised platform, a pebbled floor, and plaster sides. On the lower level, which is decorated with the net pattern, stands a low tripod-shaped offering table set with cups and jugs. Horns

159

159. Minoan gold and ivory Serpent Goddess. Crete, ca. 1600–1500 B.C.E.

160. Small domestic shrine of the Goddess, with serpent-armed figure in center of shrine and also enlarged to show snakes. Palace of Knossos, Crete, Late Minoan III, 1400–1100 B.C.E.

160

of Consecration adorn the altar on the upper level, with a shaft or central socket for the double-axe found leaning against the horns. The double-axe and the butterfly both epitomize the Goddess, found together in another shrine (see Part V, "The Butter-fly"). Since Evans's time, scholars have viewed the double-axe as the Goddess's symbol.

Flanking the Horns of Consecration are terra-cotta figurines, including three bell-shaped images and two smaller statuettes of a male and a female. The male stands on the far left, while the small female is placed in the middle. The largest figure, evidently intended as the focus of the group, is placed at the far right, hands raised in blessing. The divinities are striped in a traditional numerological pattern: Marked with bands at hip level and below, the bands of the largest deity add up to the magical number seven. One Goddess raises her hands to her breasts. Her arms imply serpentine movement, in the manner of contemporary Asian dancers; the hands are actually snake heads. The gesture refers to the snake's power of regeneration.

Thousands of years later, the image of the nursing snake reappears to link life and death. In Shakespeare's *Antony and Cleopatra*, the dying Cleopatra holds the asp to her breast and says:

> *Peace, peace!*
> *Dost thou not see my baby at my breast,*
> *That sucks the nurse asleep?*[3]

CHILDBIRTH AND TRANSCENDENCE

One Minoan center of divination belonged to the Snake Goddess, Eileithyia, a goddess of childbirth[4] whose worship, with offerings of honey, is documented in Linear B tablets found in a Cretan cave on the banks of the Amnisos River in Crete, near the seaport city of the same name mentioned by Homer.

Eileithyia's link with prophecy is startlingly evident in finds unearthed near the town of Gournia in eastern Crete. A small shrine was discovered on a hill some distance from the palace. On the very center of the altar stood a primitive statuette of the Minoan Snake Goddess. Bare above the waist, she wears the usual bell-shaped skirt and a snake twines about her body. Snakes love warmth, and the shrine contained a significantly placed terra-cotta tripod hearth of the type found in sanctuaries of the Serpent Goddess. Near the hearth stood three cylindrical vessels with modeled serpents gliding up the sides to drink; on other vessels, serpents serve as the handles of the vases. Horns of Consecration and double-axes decorate yet other vessels and indicate their sacred function. The deity's

161. Contents of a
snake shrine from
Gournia. Crete,
Late Minoan, 1400–
1100 B.C.E.

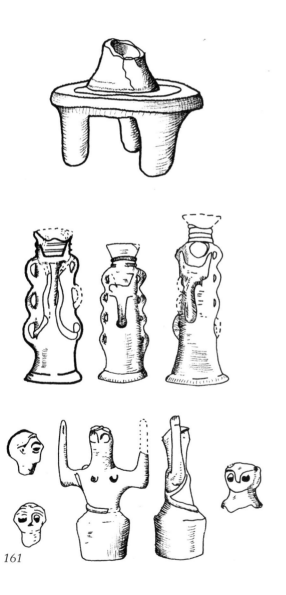

161

necklaces adorning these jars identify them
with the divinity.

Both Homer and Hesiod speak of Eileithyia
who, as a daughter or younger aspect of
Hera, took over her role as divine midwife.
We know that both these Greek goddesses
originated in Crete, since they are men-
tioned in Linear B tablets. Eileithyia takes
charge of Hera's province just as Zeus enters
Crete to replace the young god Zagreus as
son and lover of the Goddess.

On some monuments, Eileithyia carries a
burning torch. One Etruscan vase pictures
her with her left hand on her abdomen and
her right hand raised and open. Lewis
Richard Farnell mentions that her raised
hand or torch meant that delivery could
proceed.[5] Lowered, the birth was halted;
the downturned torch indicated death. By
keeping her torch lowered, Eileithyia
delayed the birth of Heracles for several
days. Only a trick made her raise the torch,
thus allowing the strong man to be born.

Eileithyia's torch acts as a reminder that
fire, the first principle, is associated with
women through the hearth. Believed
magical, fire was assumed to be a manifes-
tation of the Goddess, and the hearth on
which fire was laid became the sacred
center of the household, the hearthstone
doubling as her altar. Its construction,
with vertical stone pillars supporting the

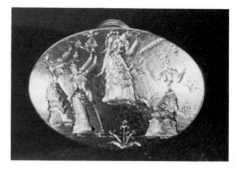

162. Ring seal picturing the descent of the deity. Isopata, Crete, Second Palace Period. (See plate 18.)

162

horizontal hearthstone, is itself symbolic of the deity of earth and sky.

Cretan art combines hints of transcendence with the utmost grace, as shown on a golden ring seal from Isopata, near Knossos. The scene's movement begins like a dance with the Goddess placed high in the center, her head inclined toward the large snake. In her spiral descent she radiates a single sacred eye to the right of her body in a manner that suggests the all-seeing presence of the divinity. In her rapid downrush, her hair flies behind her. She is naked above the waist; the ruffles on her skirt open like a flower. Clumps of iris, especially sacred, spring from the earth around her as her two worshipers stand with arms raised in reverence. On the left, a long-necked bird descends, and a small figure hovering in the air raises a hand to indicate that they have come from an upper plane. Every element of the design is meant to convey a feeling of rapid whirling movement. If these figures are the objects of possession, the orgiastic dance is the vehicle of incantation.

THE OMPHALOS AND THE ORACLE

The famous Omphalos of Delphi, conical in shape and shrouded with the net pattern, was considered the navel or center of the world. It was carved from a baetyl, or fallen meteorite—a sacred stone of celestial origin. The Omphalos at Delos is the most revered object of the shrine, decorated with the palm of Delos. The serpent of the Earth Mother coils around it protectively.

Other versions of the omphalos from Miletus, Babylonia, and the great temple of Amon in Egypt, vary from place to place. Although Delphi is popularly associated with Apollo, the cone-shaped omphalos and its guardian serpent indicate that the shrine belonged originally to the Earth Goddess, Gaea, or Themis. The cone represents her womb, the fountainhead of the deity. The yoni of present-day India echoes this shape and shares its meaning.

In ancient art, the serpent is often seen with the omphalos; its prophetic power underlies this association. At Delphi, serpents were kept in the caves of Trophonius for prophetic purposes. The main cave at Delphi was considered the entrance to the land of the dead, and the sound of running water there aided in communicating prophecies.[6] The oracular Sybil, generically known as Pythia, inhaled vapors rising from a crevice in the rock and, with her python wound about her, gave out cryptic predictions from her holy tripod seat.

A painting from Pompeii shows Apollo killing the great serpent who coils around the omphalos, a metaphoric icon of the destruction by the new male God of the

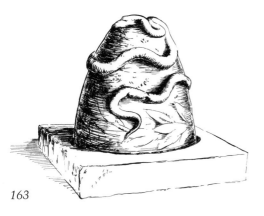

163

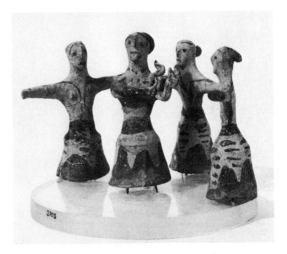

163. The Omphalos of Delphi. Greece, fourth century B.C.E.

164. Women dancing with a snake. Palaikastro, Crete, ca. 1400 B.C.E.

matrifocal forces that formerly held sway at Delphi. Jane Ellen Harrison explains the occasion with quiet irony: "What need does the glorious shining Apollo have for a snake?" Yet the snake survived Apollo's attempts to eradicate the darkness of Delphi, and so did the Sybil, whose auguries remained entrenched at the center of the Greek prophetic world. Delphi was only one among many ancient oracles; tablets have been unearthed that describe widespread oracles and oracular sites reaching far back in time.

THE SNAKE DANCE

Dances often reenact cosmic processes. A ritual of extreme antiquity, the chain dance is still practiced throughout the world; witness the snake dance in New Mexico, where the Navaho use live serpents in their biannual invocation of rain. From Palaikastro, Crete (ca. 1400 B.C.E.), comes a captivating little group of dancers wearing animal pelts over bell-shaped skirts. One dancer wears two necklaces and handles a lively serpent as they circle in a sacred dance. Although the serpent and the snake dance are found in many cultures, there is no place in the ancient world where evidence of the serpent figures more prominently than Crete.[8]

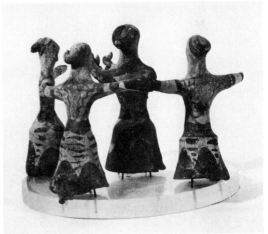

164

Serpent-Haired Deities

Ancient symbols often carry multiple meanings. Hair stands for energy and fertility. On the head, it signifies higher spiritual forces; below the waist, fertilizing forces. When snakes replace hair, as they replace the Gorgon's tresses, they represent the higher forces of creation.

Spiraling snakes adorn the head of a bird-faced goddess found in present-day Macedonia in the recently excavated Sitagroi mound of the Karanovo civilization (ca. 4500 B.C.E.). This goddess, along with the two other heads with snakelike locks found in the same mound, indicates that Gorgonian locks go back at least as far as the fifth millennium B.C.E.[1]

Ascribed to Late Minoan I, the figure in the Berlin Museum bares her breasts Cretan-fashion. The three large snakes coiled at the nape of her neck suggest heavy locks of hair, and a knot of entwined serpents circles her waist. The snakes around her neck and waist appear to be pythons, which are holy in Crete. One serpent writhes to the top of her head like the snake in the Egyptian Uraeus, a rearing cobra that is a hieroglyphic sign for the goddess Neith. Although the Berlin deity's figure is heavier than the figures of other Minoan divinities, her dress is similar and the wave-and-dot viper pattern decorates the flounce of her skirt, repeated many times as if to emphasize its importance. The pattern is found on a consecrated earthenware hearth from Voulala that has been restored as many as ten times.

THE GORGON MEDUSA

The Medusa, an archaic denizen of the netherworld, has hissing snakes for hair and boars' tusks for incisors. Her tongue is thrust out to catch moisture. Once a beautiful goddess, she had an affair with Poseidon and bore him two children. But she offended Athena, who changed Medusa's hair into snakes and gave her a glance that could turn people to stone. One of the three Gorgon sisters, Medusa is known as the Mistress of the West Gate, or death, because her home lies at the entrance to the underworld on the side of the Western Ocean. She represents the disturbing power of the abyss.

The story of Medusa and Perseus begins when he agrees to his king's request to kill Medusa. Perseus first encounters the Graiae, a fateful trio of swan maidens who were sisters of the Gorgons. The Graiae guard the entrance to Medusa's domain. Personifications of old age, they have one eye and one tooth between them.[2] In this eye and tooth lie their potency. Perseus creeps up to the Graiae and snatches the

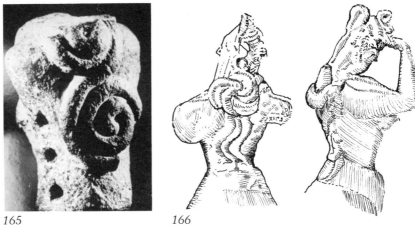

165. The bird and snake deity. Sitagroi Mound, Macedonia, ca. 4500 B.C.E.

165 *166*

166. Serpents coil like hair on a divinity who strokes the serpent rearing above the crown of her head. Crete, Late Minoan I, 1400–1100 B.C.E.

167. The Gorgon Medusa, an ancient goddess, kills with her eye; her power lay in her snake-wreathed head. Greece, sixth century B.C.E.

167

168. The pediment of the Artemis temple shows a Medusa with snakelike hair and a serpent girdle. Corfu, Greece, sixth century B.C.E.

tooth and eye, rendering the poor things helpless. He then bargains with them for information that leads him to the nymphs. From the nymphs he obtains the cape of invisibility, the shoes of swiftness, and a wallet. Athena, anxious to further Perseus's cause, lends him her magical mirror. Hermes supplies Perseus with an adamantine sickle. At last he is ready to approach the Gorgons. Wearing his cloak of invisibility and looking into the mirror so that he will not be turned to stone, he cuts off Medusa's head, stuffs it into the wallet, and flees in the shoes of swiftness.[3] Perseus gives the head to his sponsor, Athena, who wears it on her breast as a magical pouch, or aegis.

In this story, the Gorgon, whose name means "cunning one"[4] or "ruler"[5] has become the Evil Eye incarnate, a creature made hideous with tusks and outstretched tongue; "one who kills with the eye, by fascination."[6] The entwined serpents of her hair, Medusa's power, act as a reference to the netherworld. She may be related to the Syrian goddess Ishtar, whose Eye Temple at Tell Brak is linked with the Evil Eye. The Temple is so called because it is filled with figures whose principle feature is the eye. Most people view the Gorgon as malefic, a misunderstanding due to the changeover from the matrifocal religion to the patriarchal.

Robert Graves sees the Gorgons as priestesses of the Triple Moon Goddess, masked guardians of women's mysteries. He says that the Orphics saw the moon's face as a Gorgon's head.[7] Some ancient writers believed that the Gorgon's mask stood for the moon; others saw her as Athena's double. She may well personify Athena's dark side, since Medusa represents the chthonic power of the Great Goddess in the underworld.

Another archaic Medusa of the sixth century B.C.E., from the pediment of the great Artemis temple in Corfu, establishes her early status and her role as emblem of the fusion of opposites. The snakes darting from her head allude to the forces of creation, making the connection between serpent and wisdom. Like the Mexican Moon Goddess and the Cretan palace deity, the Gorgon wears the girdle of copulating vipers. Vipers are extremely dangerous snakes, although, like Artemis, they are the proverbial protectors of women in childbirth. Medusa's pose on the pediment forms a swastika, the symbol of cosmic creation. The female lions at her sides recall the protective status of the lion vis-à-vis the Great Mother, as in the lion throne from Çatal Hüyük 4,400 years earlier (see fig. 115). The meander pattern decorates the Goddess's chiton and evokes the cycle of death and new beginnings.

Greek Serpent Deities

Traces of serpent deities are found throughout Greece. Some are connected with birth, others with the worship of the dead. At Delphi the priestesses kept serpents to help them prophesy.

The snake belonged originally to Gaia (or Themis), who represents the earth, and only later did Apollo claim it for his own. Demeter also had a snake, called Kychrens, as her attendant at the temple of Eleusis. Because of its wisdom, the snake is often revered in conjunction with Athena, the goddess of wisdom.

THE HESPERIDES

Greek legend tells of a paradisal garden, the Hesperides, named after Hera, who became at times Hespera, the evening star. The garden lies at the edge of the Western Ocean. Three beautiful, sweetly singing maidens, daughters of Ladon, the never-sleeping dragon, all guard the golden apples of love and fruitfulness.

The maidens of the Hesperides typify the beauty of clouds lit by the setting sun:

The sky is green, yellow, and red, as if it were an apple tree in full bearing; and the Sun, cut by the horizon like the crimson half-apple, meets his death dramatically in the western waves. When the Sun has gone, Hesperus appears. This star was sacred to the love-goddess Aphro-dite. . . . If an apple is cut in two transversely, her five-pointed star appears in the centre of each half.[1]

The Tree of the Golden Apples is a tree of life in this first Avalon. As his eleventh labor, Heracles, a son of Zeus, slays the dragon and carries off the golden apples.

The theme of snake, woman, and tree is illustrated by a Greek vase on which the great serpent-dragon guards the golden apples and Herakles stands right beside the tree, leaning on his club. Before the tree, two of the Hesperides pose, one wearing a transparent chiton, the other raising her hands as if to bare her nourishing breasts.

ATHENA, THE VIRGIN GODDESS

In early Greek culture the word *virgin* simply meant unwed. Though Athena may have had a series of sexual partners and even borne a child, she remains eternally virgin. Mother goddesses were at the same time mother and virgin. The etymology of the word relates to the Latin *vir*, "strength," and *gen*, "race." Virgins were dedicated to the temples as cult hetaeras (sacred prostitutes) so that men could worship the Goddess through intercourse. Such, ironically, is the history of the word. Throughout the early stages of culture it was unthinkable to attach to virginity the value given today. Rather, it was fertility in

169. On a vase, the serpent-dragon of the Hesperides guards the Tree of the Golden Apples. Greece, fifth century B.C.E.

170. Marble serpent looks over Athens from a pediment. Greece, sixth century B.C.E.

169

170

the bride that was significant, in fact required, for marriage. Until a woman had had a child her fertility was in question.

A dual form—part human, part snake—characterizes the first two legendary kings of Athena's titular city. Cecrops, the first king of Athens, was buried under her sacred temple. His serpent daughters nursed Athena's mysterious snake child, Erecthonius, a creature with a serpent body and a human head. As soon as her son was born he was whisked away to preserve Athena's reputation as a virgin. By Olympian times, therefore, attitudes toward virginity had been reversed.

Despite Zeus's late claim to have fathered her, Athena's name means "I have come from myself." Plutarch identifies Athena with the Libyan-Egyptian goddess Neith, often seen wholly in serpent form. Neith ruled as Goddess in a period when children were recognized as belonging to the mother, and paternity had no real significance. Marriage had not been institutionalized; lovers came and went, and women headed the family unit of mother and children.

In Athens, the snake is preeminent. The polychrome head of a marble serpent (sixth century B.C.E.) looks out over Athens from a pediment. An ancient serpent temple, where a living serpent was kept, once stood on the site of the present Erectheon.

Excavations on the Acropolis made possible the reconstruction of two huge serpent figures. Their size and splendor must have been most impressive. A reconstruction drawing shows that they occupied nearly two-thirds of the eastern pediment of the Hecatompedon; Athena, who stands at the apex of the pediment, is flanked by a snake on each side. Two sea serpents balance the two land snakes in the same position on the western pediment.[2]

According to Herodotus, the citadel of Athens was founded and defended by a great snake.[3] The king's soul, from Cecrops to Theseus, was believed to pass into the sacred animal, revered as *Agathos Daimon*, "the Good Spirit." On the day of its invocation, the souls of the dead were released from their grave jars and a festival of first fruits and new wine ensued. A feeling of sanctity toward the snake continued for centuries thereafter. When Athena won the contest with Poseidon for the patronage of the sacred city, she gave over the care of her temple site, the Acropolis, to her serpent Erecthonius. He remained guardian of the citadel well into historic times.

Despite her association with Athens, Athena is pre-Olympian. Her earliest appearance as we know her is in Crete, where she was similarly identified with the snake. Mycenaean remains were found

171. Bronze Athena
dons a peplos
fringed with living
snakes. Greece,
fifth century B.C.E.

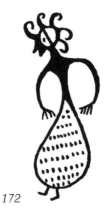

172. Dew or Bee
Goddess drawn on a
Minoan offering
table has a bird's
bill and serpent
hair. Crete, ca. 1700
B.C.E.

172

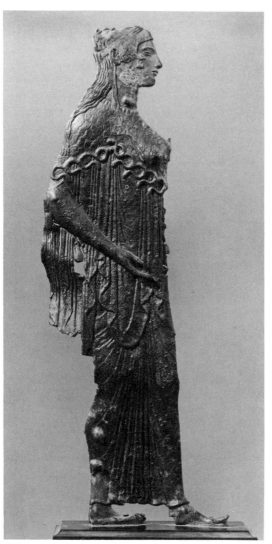

171

beneath Athena's most sacred rock temple on the acropolis. There she appears as *Potnia Atana*, "Our Lady of Athens," mentioned in a Linear B tablet found at Knossos that dates from the Mycenaean occupation of the palace (1400–1100 B.C.E.). Thus the pre-Hellenic Rock Goddess from Crete becomes the Mountain Mother of the Acropolis, accompanied by the same cluster of symbols found later in Genesis: woman, tree, and serpent. Athena herself is the goddess of wisdom, and so it makes sense that the problem in Eden revolves around a tree of knowledge.

By the fifth century B.C.E., Athens was the most powerful and civilized city in the Western world. Its citizens felt a deep devotion to their city-goddess, and Athenian artists sculpted and painted her as a maiden newly emerged from childhood, full of youthful vigor like the city itself.

The gilded bronze, from the fifth century B.C.E., is an excellent example of this outburst of energy. Athena wears a peplos fringed with living snakes, and on her breast is the aegis, a goatskin shield decorated with the Gorgon's head.

In myth, Athena's attendants were the two (sometimes three) daughters of the male serpent-king Cecrops. Their names were Herse, which means "dew," and Pandrossos, which means "the one completely bedewed." It is fundamental to our understanding of

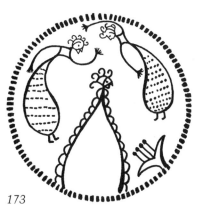

173

173. Three figures on a Middle Minoan cup; Persephone descends to the underworld gazing at a giant flower. Crete, ca. 2000–1700 B.C.E.

Athena as a vegetation goddess to know that her attendants were called dew maidens. Dew provides moisture for growth, yet its origin is mysterious. It was thought that the moon, since it was a symbol of richness, fertility, and renewal, and thus often regarded as a source of moisture, was responsible for the dew's sudden, gentle, yet magical appearance. When Olympian Zeus became the father of the much older Athena, he assumed her attributes, and dew was called "the daughter of Zeus."

Each year several maidens were selected from Locris for the ritual slaying by Athena's priestesses at her temple near Troy. After performing secret rites in the dark of night, they were killed—probably pushed from the heights of the sanctuary hill. Their broken bodies were then retrieved, burned, and cast from a mountain into the sea.[4] By the fifth century B.C.E., Athena's cult was cleansed of all taint of human sacrifice and only ceremonies such as the bathing of her idol remained as testimony to her great antiquity. In this ceremony, a statue of Athena, dressed in garments woven by her young priestesses during the year, was carried with great rejoicing and celebration to the port at Piraeus and washed in the sea.

A fantastic little figure drawn on the leg of a splendid Minoan offering table, dug up at Phaistos in Crete, dates from the Proto-Palatial period (2000–1700 B.C.E.). The figure, sometimes called a bee goddess, has a dewdrop form that suggests a dew or bee cult may have been a feature of Minoan religion and combines several other aspects of the Goddess as well. The Medusa-like head is crowned with five snakelike tresses, connecting this figure to Medusa and Athena, and has the short, blunt beak of a dove. Heavily drawn arms ending in feathery fingers or claws contrast with the lightly drawn feet. Several drawings in Arthur Evans's *The Palace of Knossos* and work by Marija Gimbutas corroborate that the bee goddess had a place in ancient Crete.

Three similar figures appear on a cup from the first palace at Phaistos, Middle Minoan period (ca. 2000–1700 B.C.E.). Carl Kerényi calls the largest of the three the earliest representation of Persephone.[5] Her companions, one of whom has a dove's head, dance around her in a lively manner while she descends, turning toward a large flower springing from the earth near her covered feet. Persephone lacks arms; instead, a series of snakelike arcs runs along each side of her body, as in Eileithyia's shrine (see fig. 161). Like the Dewdrop Queen from Phaistos, she wears a dove's head with snake hair that reveals netherworld connections, and the scene recalls the archaic myth, preceding the Homeric hymn, in which Hades abducts Persephone. Her companions often appear as Artemis and

Athena, to whom the snake is sacred. In the myth, they play and pick flowers with Persephone. A flower never before seen on earth shoots up beside her, and she looks at it with pleasure.

THE BEARDED SERPENT AND THE GUARDIAN SERPENT

When mother right (Bachofen's term for matriarchal culture), which had existed since Paleolithic times, was overturned, the serpent became a male deity. The relief of a great coiled and bearded snake, Zeus Meilichios, carved in marble from Hymettus and found at Zea Island in the Cyclades, dates from the fourth century B.C.E.

A distinctive sign of manhood, the beard acquired sanctity in the new patriarchal world and was regarded as a mark of honor. This is especially noticeable in clean-shaven Egypt, where artificial beards were worn as symbols of dignity by priests and other high officials. The pharaoh himself wore a square-cut artificial beard for ceremonials and, like the male pharaohs, Queen Hatshepsut wore a false beard when she took the throne. This symbolism remains alive today among Muslims, who swear "by the beard of the Prophet."

Some claim that Zeus is actually a chthonic deity, an *Agathos Daimon*, who in earlier times represents the power that fertilizes

the earth. In one myth, Zeus in the guise of a monstrous serpent impregnates his daughter Semele, who then gives birth to Dionysus.

The festival of the Diasia in Athens, eventually intended to honor Zeus, was originally addressed to an underworld snake whose worship antedates that of Zeus.[6] Zeus took over the snake only because the snake was available, due to the erosion of the goddess religion. Zeus never really became a snake deity, and the Greek and Roman custom of bearding the snake seems to have been simply a means of completely divorcing the animal from the Goddess.

A colossal statue of Athena once stood in the Parthenon, her temple in the city named after her. The gleaming tip of her golden spear served as a beacon for mariners at sea, and at her side an enormous serpent reared almost to the height of her statue. During the Persian invasion of 480 B.C.E., a rumor that the live serpent kept in the temple had disappeared without tasting its proffered honeycake caused the people to flee from the city.

HECATE

An ivory plaque of the winged goddess Hecate, from the Spartan sanctuary of Artemis Orthia, dating from the end of the eighth century B.C.E., shows her with a

174

175

174. Hymettus marble relief of Zeus as a coiled serpent. Zea Island in the Cyclades, fourth century B.C.E.

175. Ivory plaque of Hecate with a snake. Artemis sanctuary, Greece, eighth century B.C.E.

serpent coiling upward toward her out-stretched arm. As with other goddesses of birth and rebirth, such as Kali, Medusa, Ishtar, and Isis, the sacred net pattern covering her wings and robe represents Hecate's underworld side.

A goddess of cyclical phases, Hecate embodies the sacred number three: the sky, the earth, and the underworld. The dead in Greece were thrice invoked; mourning lasted three days; and the court watched over by the deities of the underworld sat three days.[7] Preeminent creature of death and rebirth, the snake is the natural handmaiden of the threefold Hecate.

In a Hesiodic fragment, Hecate has only one parent. Born of a virgin, she arrived fully formed, mighty in heaven, on earth, and in the sea. Her name means "the distant one" and was derived from that of her mother, Asteria ("Starry"), a creatress, Queen of Heaven and of the Planetary Powers. In addition to her name, Hecate inherited the starry firmament from Asteria. Hecate remains an echo of matrifocal times.

Hecate, often confused with Artemis, has been described as representing the dark side of Artemis's moon.[8] The two goddesses are companions in the chase, sharing their dogs and their love of the hunt. The snake and dog are symbolic of them both; but the underworld serpent belongs especially to Hecate; and like other goddesses who hold the torch and have the snake as their emblem (for example, Eileithyia), Hecate is a guardian of women in childbirth.

One of the original Titans, Hecate holds court in the sea as well, where she carries on many love affairs with lesser sea gods. Triton was one, and Zeus himself loved and revered her. He swallowed the pre-Hellenic deities one by one. Yet when he fell in love with Hecate, he allowed her to keep her share of the three worlds.

Once as powerful as her predecessor Neith, Hecate is the opener of the way to Death. It seems inevitable that Hermes, the messenger to the underworld, would meet Hecate and fall in love with her. Their offspring, according to some sources, included the Three Graces, or Charities, and the goddess Circe. Hermes' name is derived from herm, the Greek word for gravestone. Hermes, like Anubis, usually shown in Egypt as dog-headed, has the dog as his familiar.

The triune Hecate was worshiped at the crossing of three roads. On moonless nights she sat there, stirring her cauldron and whistling to her hounds. Athenians placated her with offerings known as Hecate's Suppers and erected in her honor a pole from which three wooden masks were hung, each facing a different direction. Her sacrifices were dogs, honey, and black ewe

lambs. On moonlit nights, Hecate wears a shimmering headdress that personifies the moon, and as Mistress of Black Magic her powers of sorcery are second to none. Hermes, too, acquired fame as a magician, so it is only natural that their child Circe, the Moon Goddess, is skilled in enchantment. She, in turn, passed on her gifts to her niece, Medea. Hecate plays a part in the well-known myth of Persephone, or Kore, that is recorded in the Homeric hymn to Demeter, helping Demeter search for her daughter after Persephone had been abducted by Hades.

MEDEA

Thanks to one of those happy accidents to which we owe so many archaeological treasures, a relief dating from 50 C.E. was found in a Roman villa on the Appian Way. It depicts Jason stealing the Golden Fleece, which is guarded by a serpent-dragon. Jason cuts down the Golden Fleece from the sacred oak after Medea lulls the beast with incantations and finally puts it to sleep by sprinkling on its eyelids magic drops made from freshly cut sprigs of juniper. Jason flees with Medea to escape the revenge of her father, King Aeëtes. With his crew, the Argonauts, and Medea, Jason sails back to Greece; there, in gratitude for her help, Jason marries her at the altar of Hecate, where Medea was priestess.

DEMETER

In ancient Greek, *meter* means "mother," and in a fifth-century B.C.E. terra-cotta, Demeter, Lady of the Wild Things, is seen as Corn Mother. She holds wheat and poppy pods, signs of the earth and the abyss, and snakes writhe about her. Agricultural people recognize that the buried seed is reborn as vegetation, and take this fact as an allegory of life in the netherworld. Similarly, in myth Demeter merges with her daughter Persephone, ruler of the abyss, and together they act as guardians of all stages of vegetative growth.[9]

HARMONIA AND CADMUS

Another story of the importance of the serpent has come down to us in the ancient Greek myth of Cadmus and Harmonia. Harmonia was the daughter of the serpent slain by Cadmus in his battle to secure the throne, a variation on the age-old theme of the slaying of the old king by the new king. The royal houses of Thebes and Delphi trace their ancestry to a serpent-dragon discussed by James Frazer in *The Golden Bough*.[10] These claims of kinship derived from the traditional belief that King Cadmus and Queen Harmonia were transformed into snakes. This folklore comes from the earlier belief that the souls of the departed rulers of Thebes trans-migrated into the bodies of serpents.

176. Relief from a
Roman villa shows
Jason and Medea
stealing the Golden
Fleece. Italy, ca. 50
C.E.

177. Snakes writhe
about the gifts of
Demeter as she
holds wheat and
poppy pods. Greece,
fifth century B.C.E.

176

177

Mexican Goddesses

In Mexico, the Aztec culture appears wholly patriarchal, but a deeper search reveals a strong feminine underside, which expresses itself mainly through the serpent, the most powerful and popular symbol in the culture. Mexican myth revealed the goddess as immensely strong, and always as the Terrible Mother, a negative figure who brought nocturnal darkness up from the underworld. Yet they believed the underworld was the place from which all nourishment ultimately springs. So the Earth Mother, for all her ferocity, was also the flower-covered earth in spring. The Aztecs showed ambivalence to all things feminine. They saw the snake as both a dark creature and a bringer of light and wisdom.

COATLICUE

Coatlicue, Aztec Mother of the Gods, embodies the earth. Her twelve-ton statue, dating from pre-Columbian times, displays a welter of tusks, scales, and claws with a double serpent head set upon a human torso. One of the few specific facts known about her concerns her decapitation, after which two serpent heads sprang from her severed neck.[1] Her hands are the talons of a bird of prey; her feet resemble those of a giant tortoise. Her necklace of hacked-off human heads and hearts and her serpent skirt make her utterly terrifying.

Coatlicue's girdle, an attribute of the Mother Goddess, originally covered with gold, is buckled with a skull. Distinctive in many traditions, the girdle relates to the deity's perennial virginity, despite childbirth, and sexual power.

In appearance and character Coatlicue resembles the Hindu goddess Kali, who embodies the idea that life must be destroyed to be reborn. The Aztec tribes believed that they emerged from "the womb of death" in the west, where the sun descended. Coatlicue is called "the flower-covered earth in spring" and "she from whom the sun is reborn each day." In the lower realm, Coatlicue is preeminent and preexistent, floating for eons in misty chaos, carrying within herself the seeds of all life, as creator and destroyer.[2] Coatlicue, as Vegetation Goddess, is Lady of the Plants and her aid was invoked to keep the exuberant jungle at bay. She remained close to her son Tlaloc, the Rain God. In Mexico City her principal temple stands next to Tlaloc's. It is not unusual that the goddess the Aztec people carried with them from Asia retained so many of the creative characteristics of the Old World's Mother Goddess.

Dual in nature, Coatlicue is both a source of disease and death and a goddess of healing and women's medical practice. The account of Coatlicue's pregnancies reveals a

178. Statue of Coat-licue, Aztec Mother of the Gods, with a double serpent head, a human torso, and a serpent skirt. Mexico, pre-Columbian. (See plate 20.)

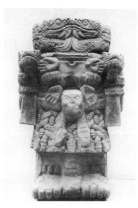

178

subordination of her original powers to the Sun God. After giving birth to the moon and stars, Coatlicue lives in solitude and chastity in the temple, clothed in white from her eagle-down headdress to her snakeskin sandals. One day, while sweeping the courtyard of the temple, Coatlicue, the Lady of the Serpent Skirt, sees a ball of hummingbird feathers in the dust at her feet. Admiring its iridescence, she picks it up and tucks it into her belt. It feels warm, as if heated by the sun. When she finishes sweeping, she seats herself to rest and reaches for the ball of feathers. It has disappeared. At that moment, she realizes that she is pregnant. When her children, the moon and the stars, discover this, they become angry and decide to kill her. Coatlicue weeps, but the child in her womb consoles her by indicating that he will defend her against all.[3] At the moment when Coatlicue's enemies come to slay her, the Sun Child Huitzilopochtli emerges from her womb fully grown. Using the sun's rays and the aid of the serpent of fire, the youthful Sun God overcomes his sisters and brothers and puts them to flight.

COYOLXAUHQUI

Mere chance has retrieved the majestic presence of yet another Serpent Goddess. One February day in 1978, around dawn, a municipal worker struck something hard as

he dug under the street near Mexico City's Cathedral Square. In the dim light, he bent down and found that he had stumbled upon a circular disk of carved stone. The disk, some ten feet in diameter, represented Coyolxauhqui, the Aztec Moon Goddess. It lay in its original position before the Great Temple where, centuries before (ca. 1428 C.E.), it had been the focal point of sacrificial religious ceremonies. Its discovery led to the excavation of the temple site.[4]

Coyolxauhqui's myth relates that while she and her war god brother, Huitzilopochtli, were quarreling over power at Coatepee, or serpent hill, he killed and dismembered her, cutting the body into fourteen pieces.[5] The number fourteen appears in mythologies throughout the world, referring to the distance in solar days between the waxing moon and the waning moon and, by analogy, to the cycles of birth and death. Like her mother, Coatlicue, Coyolxauhqui wears the skull at her waist. She is the third pre-Columbian deity to appear with serpents entwined as a girdle about her waist. Each severed arm and leg is engraved with two knotted serpents, and a single serpent peers from her feathery crown, as it does from the crown on Atargatis's head or from the tower crown of the Minoan goddess. Great powers emanated from this deity even after she was overthrown.

179. Discovered in
Mexico City in
1978, a ten-foot
stone disk of the
Aztec Moon God-
dess Coyolxauhqui,
wearing a girdle
of copulating
vipers. Mexico,
pre-Columbian.

179

180. The Mayan rainbow and lunar Snake Goddess Ix Chel promotes fertility and helps women through childbirth. Mexico, pre-Columbian.

181. Giant stone serpent guards the steps of the Mayan pyramid at Chichen Itza. Mexico, pre-Columbian.

Ix Chel, the Mayan rainbow deity and lunar Snake Goddess, promotes fertility. She also helps women through the labors of childbirth; they go to her sacred island, Cozumel, for parturition. She holds the jar, symbol of the womb, upside down so that childbirth may proceed. Her husband, the Sun, was wildly jealous and suspicious when, as Moon Goddess, she disappeared regularly from the sky three nights each month. Weary of his accusations, she left him to wander the night sky and subsequently made liaison with his brother, the Morning Star.

QUETZALCOATL AND CULCULCAN

The Aztec god Quetzalcoatl, or Green Feathered Serpent, corresponds completely to a neighboring Mayan god, Culculcan of Yucatan. Other parallels are found in the Snake God of the North American Hopis, who still use live rattlesnakes while performing their annual rain dance.[6] Aztec and Mayan gods share the spiral shell, another emblem of birth and resurrection. Rebirth is the central element of Mayan religious belief, and the Snake God is always its symbol.

The feathered serpent represents a tangle of mythological meanings and the reconciliation of opposites. The serpent of water and earth combines with the bird, a creature of light and air, suggesting the dichotomy of life and death.

Under various names, Quetzalcoatl stands for the dominant male element in the Aztec faith, visible as a savior-god throughout Central American religions. He symbolizes the generative, luminous aspect of the plumed serpent, who transforms himself through atonement,[7] not unlike the resurrected god of the Near East, the hero king and culture-bringer with the qualities and functions that formerly pertained to the Goddess. In Mexico, too, there appears to have been a patriarchal appropriation of her place.

A gigantic stone snake with a spiral at the hinge of its jaw serves as a dramatic guardian to the staircase of the Mayan pyramid at Chichen Itza, an ancient ruined city in Yucatan, Mexico. The pyramid, dedicated to the Snake King Culculcan, is an architectural expression of the Mayan calendar. The four stairways of ninety steps each add up to 360 days, to which were added the five sacred days that completed the Mayan year, as in the Egyptian calendar. Inscribed on the temple is the Mayan date that corresponds to 360 C.E. In another building, the Caracol of Chichen Itza, the serpent was represented by a tower with a spiral staircase.

180

181

The statues of Culculcan, the Feathered Serpent, often incorporate snakes; the God is shown in serpent form with a human head. The temple entrance resembles the gaping jaws of an enormous snake; within the shrine lived serpents tended by special priests of his cult. For the Toltecs of Teotichuacan, who ruled Mexico for a thousand years before the Aztecs came to power, a feathered serpent symbolized waters of the earth and the earth itself, with its plumelike vegetation.

Although the later Aztec worldview is strongly patriarchal, their earlier hidden history yields a different picture. A figure represented by a man rules side by side with the King and bears the name of the Terrible Mother: the Snake Woman. She is the executive peak of the internal affairs of the tribe. There can be little doubt that an originally matrifocal constellation was overlaid by patriarchal institutions.[8]

Serpent Deities of India and the Far East

The serpent, or some variation of the serpent, has appeared in the art and religion of the Far East and India since ancient times. In China and Japan one sees evidence of snake reverence despite subsequent patriarchal traditions. The serpent was a factor in the religions of India, Bengal, and Indonesia. In the Buddhist faith the Aitareya, a Brahman chant, quotes hymns to the Queen of Serpents who presides over all that moves. With some exceptions, the attributes of the serpent once considered symbolic of female deities have been usurped by patriarchal traditions and are now seen as symbolic of gods.

JAPAN: UGA-JIN

Little is known today of the secret fertility cult of Uga-Jin, and few images survive. But as one rare bronze statue demonstrates, the mysterious Japanese Snake God was strikingly similar to Quetzalcoatl. An earth and water deity, he is identified with the snake Uga, whose image decorates the chignon of the Japanese Love Goddess, Benzaiten, sometimes invoked as the Japanese Aphrodite. Uga-Jin was too barbaric for the Buddhist priesthood to tolerate, and the priests allowed his altars to disintegrate.

Uga-Jin's resemblance to Quezalcoatl may not be entirely accidental in view of the links that archaeologists and other scholars have established between Asia and Central and South America. The land bridge connecting Asia and Alaska that existed during the glacial period encouraged emigration to the New World, and water voyages followed as early as 8000 B.C.E. Furthermore, Uga-Jin's resemblance to the Snake God of Babylonia suggests a branch from the same root; antecedents for his cult have been traced in China as well, where Li Tsu describes ancient Chinese serpent divinities with human heads.

CHINA

The scarcity of human figuration in Neolithic China makes one terra-cotta head with its starry collar unique.[1] The lid's distinctive design differs from front to back: In the back the design is composed of twelve sections separated by heavy lines, each section containing three lozenges on a vertical axis; the design in front consists of twelve undulating snakes separated from one another by straight bold lines. The lozenges (womb) and the serpents (water) illustrate the influence of the feminine principle in agriculture and the magical cult ceremonies used to stimulate it.

The short, hollow horns may have been used to shake seeds from the vessel into ploughed furrows at planting time. Between the horns appears the sculpted head of a

182. Uga-Jin, a god with a snake's body, is associated with the Japanese Love Goddess, Benzaiten. Japan, Neolithic.

182

183. All that remains of this mother pot is the lid: a head with hollow horns for shaking seeds into the furrows of the fields. China, Neolithic.

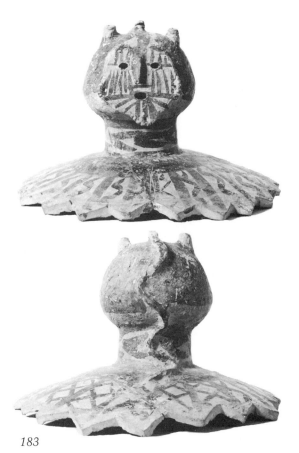

serpent whose body descends down the back, rippling over the lozenges in the manner of Atargatis, the Creation Goddess. The seeds pass the serpent, which imbues them with fertility.

The relationship of snake and goddess to the water cycle recurred as a theme in ancient China. The celestial snake is one of the signs of the Chinese zodiac, and as late as the eighth century B.C.E., many of the serpent deities of Chinese myth were participants in a cosmic plan for the sexual fertilization of the earth. The pot cover clearly identifies the head and star-shaped lid with the night sky, the rainlike undulation of the serpent with the Mother's watery lozenge, and the shimmering moon of vegetative power with the ritual objective of an early agricultural cult.[2]

From the Shang dynasty (ca. 1350–1027 B.C.E.) come various remnants of female snake deities. The rain cycle was composed figuratively of dragon goddesses, divinities of streams, lakes, and marshes whose archaic forms combine a scaly serpent below the waist with the torso of a lovely woman above. As rain-bringers, they exercised a mysterious power over fertilizing rain as well as mist, fog, and dew. The Dragon Goddess's shadow flits through ancient poems and stories, still visible in the delicate Dragon Ladies and Shamankas intended to replace her.

183

184. Nü Kua, a creatrix half snake, half woman, made humans from clay and with her brother-lover created order in the universe. China, T'ang Dynasty, ca. 618–907 C.E.

In the Late Chou (770–221 B.C.E.) and Han dynasties (202 B.C.E.–220 C.E.), Dragon Ladies, or Shamanesses, turn up as relics of serpent worship. But by that time female dragons and serpents were being nudged out of legend by the official, predominantly male cult of Confucianism.

NÜ KUA

One of the few archaic deities to survive this purge was Nü Kua, a powerful creator goddess who molded humans out of clay and put new order in the universe. She is pictured as half snake and half woman. Despite Nü Kua's disappearance from the official cult, she survives in poetry, art, and iconography of the period. A piece of cloth from a T'ang tomb (ca. 618–907 C.E.) shows her with her serpentine brother, Fu Xi. Both figures appear against a night sky studded with constellations. As Sky Goddess and Creator Spirit, Nü Kua carried musical instruments.[3] She sang and played the reed organ to create the music of the spheres.

In Han art, Fu Xi's snaky torso is entwined with Nü Kua's. The incestuous pair is honored as the first couple; in legends, Nü Kua created Fu Xi from her own body. Between their heads blazes the sun disk; around it rotate constellations of the twelve zodiacal signs. On her head she wears a net

184

that symbolizes her skill as a weaver of fabrics and her importance as a source of heavenly moisture. It is she who fabricates the world.

Throughout the later poets, Nü Kua retains her former dignity as Creator. One of the greatest of the T'ang poets, Li Po, recalls her, ironically, as Creatrix of humankind.

Nü Kua played with the yellow earth,
Patted it into ignorant inferior man.[4]

In a fragment of a poem by Ch'in Tao-yu, writing at the end of the ninth century C.E., she is seen doing what she does best: mending the blue sky wherever it has torn.

Suspended over the Hsiang and Kiang
Nü Kua's gauzy skirt, a hundred feet long,
Gives its color to the hills.[5]

SHAMANKAS

The Shamankas (Shamanesses) played an important spiritual role in the society of the Chinese Bronze Age (ca. 1350–1027 B.C.E.). They were mortals who had the power to travel the spirit world, bearing requests to the supernatural beings. Linguistic evidence reveals their close relationship to the fecund mother and the fertile soil. In Shang and Chou times, Shamankas were regularly employed at court to bring rain to the parched countryside and held official court appointments to serve as the mouthpieces of oracles. Much later, the T'ang court

employed as many as fifteen Shamankas at once.[6] Their spells were expected to work, and when they failed, the musicians, dancers, and oracle-givers were tortured with exposure to the blistering sun and were sometimes sentenced to a fiery death in ritual sacrifice.

INDIAN NAGAS

The link between serpent and moisture is worldwide, ranging from Europe to Asia to Africa and extending to the peoples of the Americas. The Nagas, rain and water deities of northern India, were probably imported from a place where the standard of the tribe was a serpent. Depicted as snake spirits, the Nagas assumed human form from the waist up but retained their snakelike extremities.

The snake and the rainbow are linked in myth throughout the world. The Kulu tribe of northern India called the rainbow *Buddhi Nagin*, meaning "old female snake." Here the rainbow is associated not only with a serpent but with a feminine serpent deity. Snake women are also common in myth. Powerful, fierce, energetic, and occasionally benevolent, snake maidens reign over the seas, whose pearls and other treasures are at their disposal.

DEVI AND KALI

The Vedic Aryans, remote cousins of the Homeric Greeks, conquered India about the middle of the second millennium B.C.E. They developed the Brahman tradition and sought to suppress the cult of the Great Mother Goddess that continued to flourish in the south among the dark-skinned Dravidians. That Devi came before Brahma is proved by many female figures found in the Ganges Valley (ca. 1500 B.C.E.).[7] These figures embody the Great Mother, who divides herself through the ages into goddesses such as Durga, Tara, and Kali. Analogous to such Near Eastern goddesses as Ishtar and Inanna, the Indian goddess Kali is identified in holy texts with the supreme deity of the Tantra.

Neither the succeeding millennia nor the many subsequent religions of India could eradicate or materially weaken the indigenous Indian concept of the supreme deity as a feminine power. Mahadevi is known as Kalika because she is without beginning or end; as sole creator, preserver, and destroyer of millions of worlds, her body is the all-pervading blue-black of the universe. Kali's nakedness, sometimes referred to as "sky-clad," denotes creation. There are two sides to the Goddess. Her right side shows her as transcendent benefactor, holding the abundant food bowl with the golden ladle; her dark left side personifies sorrow and death. In her, the divine is overwhelming, awesome, and terrible. As Lady of the Skulls, the benign Mother wears a necklace of skulls around her neck. As Mother of Death, she ends the lives of the very beings she bore in her Durga form. Despite her dark devouring nature, Indians love Kali; hers is the ultimate power of transformation.

The masculine form of Kali is Kala, meaning "time and death." Siva is known as Maha Kala, "great time." According to Mary Louise von Franz, Siva's *Shakti*, or active energy, manifests its destructive side in Kali, seen as the primordial soul of infinity and eternity.[8]

In an eighteenth-century C.E. Tantric painting the goddess Kali holds, among other symbols, a sword and a bowl of blood. Serpents surround her on all sides, and she wears a crown and garlands of serpents. Her symbolic thread, known as Kali's Snake, signifies the umbilical cord, basic to creation; broken, it means death. The twice-born Brahmins are invested with the sacred thread at initiation. The thread links Kali to the Three Fates who spin, weave, and cut the thread of life. As mentioned, many creation goddesses carry the Tablets of Fate and have the thread or the shuttle as emblem.[9] Kali's attributes and character reveal a goddess of great antiquity, as her prominence in Tantrism verifies.

185

186

KUNDALINI

In the Tantric practice of Kundalini Yoga, the dormant goddess Kundalini ("coiled up") symbolizes the female energy in the universe seen as a serpent:

The divine power,
Kundalini, shines
like the stem of a young lotus;
like the snake, coiled round upon herself,
she holds her tail in her mouth
and lies resting half asleep
at the base of the body.[10]

Kundalini's power, manifested in her ascent through the *chakras*, the seven centers of perception, vibrates upward along the spine. Rising above the crown of the head, the energy explodes into a flower of pure consciousness.[11] The concept of a force that erupts from the head seems to have been indigenous to the ancient goddess religion; that may be why serpents rear from the deity's head in many cultures.

MANASA

In a sculpture dating from the eleventh or twelfth century C.E., the favorite deity of the ancient Dravidians in western Bengal, Manasa, a much-beloved goddess, sits on a lotus throne wearing a tiara of seven cobras. Devotion to her arises not from a fear of snakes in this snake-infested land, but from the belief that the snake deity is a primeval

185. A Tantric painting shows Kali wearing a necklace and girdle of snakes. India, eighteenth century C.E. (See plate 31.)

186. The Serpent Goddess, Manasa, wearing a tiara of snakes. India, ca. eleventh or twelfth century C.E.

form of the goddess herself.[12] It is estimated that ninety-eight percent of the people in and around Bengal still worship the Mother Goddess, either in the form of a stone figure or a pot. In their homes, in her shrines, and under trees, her followers sing special songs to her and sacrifice goats and pigeons in return for her favors.

Manasa is worshiped with the goddess Shasthi as if they were one. In present-day Ksirahara, in India, there is a four-armed image of Shasthi that strongly resembles icons of Manasa. Shasthi holds a child in her lap; her right foot rests on a cat. In her right hand she holds the leafy branch, emblem of her relationship to vegetation and the fertilizing waters. The cult of snakes is also very popular in the lower Himalayas.

In the classical Indian epics, the snake is a magician, expert in all forms of magic. One aspect of Manasa's complex character, her magical power, is manifested in her complicated relationship with childbirth. Manasa can bestow the gift of fertility. Since rain, her identifying mark, resembles snakes, some believe her to have originally been a rain goddess. Manasa is worshiped in India today, although many of her public sanctuaries, neglected by a government to which serpent worship is officially embarrassing, have fallen into disrepair, as have those of Uga-Jin in Japan.

INDONESIA

Ancient Indonesian tradition states that the firstborn female of each generation serves, during her nubile years, as the priestess of a serpent cult. Her mother, her grandmother, and her little daughter help prepare her for the dangerous rite of the ceremonial kiss. A tray of offerings is decorated with fruit and flowers and placed on the priestess's head; she begins to ascend a long and narrow path, cut into a sheer cliff, ending at a slender vertical aperture in the rock. Placing the tray on the ground, the priestess begins to chant. A giant cobra slips from the cave; swaying rhythmically, it rises to its full height. The priestess bows, places the tray closer and darts back a split second before the cobra strikes. The snake recoils slowly and repeats the onslaught again and again; the priestess provokes and parries each attack. It is a terrifying performance. After many assaults, the great serpent grows weary and his strike becomes perceptibly slower. Although the risk is still great, the priestess steps forward at this point and deftly places a kiss on the great serpent's head. Three times she places the ceremonial kiss on its head between thrusts; with the third kiss, the ritual is completed. Thus did the immemorial tradition of a vegetation cult persist in detail until the very recent past in one country.

Evidence of
the Snake Cult in
Other Cultures

The use of the snake in a religious context extends beyond the regions already discussed. Other places showing evidence of snake cults include the Scandinavian countries, Britain, North America, Africa, and Australia. This widespread serpent veneration supports the theory that the ancients believed that because the serpent could slough its skin, it could command the mystery of rebirth. The similar meanings that widely distant cultures attached to the serpent could also indicate a migration of symbols. For example, various African tribes show evidence of having been influenced by the powerful, long-enduring cults of Egypt.

SCANDINAVIA

Many Bronze Age treasures have been discovered in the burial mounds and bogs of Denmark. The clothing, offerings, and human remains in the bogs are remarkably well preserved due to the high level of tannic acid in the soil. Authorities believe that most of the artifacts placed with the dead were religious offerings to the Great Goddess. As a result of recent finds, the Danish Goddess of the Snake has come to be regarded as very ancient; she is no longer considered simply a minor figure in Scandinavian myth.[1]

In northern countries, goddesses, prophets, and priestesses were commonly connected with serpents. A snake goddess or prophet was surely the central figure in an elaborate boat found on a steep slope at Fårdal, above the Norrear Valley. Although the different components of the piece were scattered, reconstruction was made possible by reference to an engraving on a razor and to rock carvings of the period.[2] The slope at the site repeats a pattern of water running downhill in the manner of a sinuous serpent.

A bronze goddess from the eighth century B.C.E., with shining, all-seeing eyes of gold, kneels with a great snake in the center of a cult boat. She wears a very short corded skirt similar to one worn by a young woman found buried in a Danish bog. Around the statue were feminine ornaments and three animal beads.

A second cult boat, similar to the first, is protected by two horned gods with axes; a deity or priestess with long hair stands in the center wearing a long robe and carrying a great serpent. The boat is decorated bow and stern with animal heads.

On a picture stone from the island of Gotland, Sweden (ca. 400 C.E.), a magical design dramatizes the relation of snake and woman. The scene is framed by a twisted cord, emblem of binding and connecting.

187. Bronze Snake Goddess kneels in a cult boat. Denmark, eighth century B.C.E.

188. Danish goddess stands in a cult boat carrying a serpent. Denmark, eighth century B.C.E.

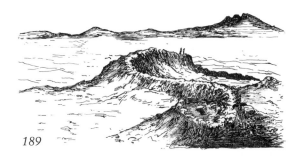

189

187

188

Within the cord's contours, snakes form a swastikalike triple knot; a spell against negative sorcery, it resembles the sign of infinity, the number 8 on its side. The knot, commonly connected with sexual relations and marriage ("tying the knot"), applies here to birth. The emergence into consciousness resembles the untying of a knot. Below, the deity sits in the childbirth position, a guardian snake in each hand.

SERPENT MOUNDS

In Scotland, a remarkable serpent constructed of stone stretches landward as if emerging from the dark waters of nearby Loch Nell. Situated on a grassy plain, it rises in height from seventeen to twenty feet and extends for some three hundred feet, forming a double-S curve. Sheltered within the curved tip of the tail stood a stone altar, destroyed by vandals in the nineteenth century.[3]

Beautifully articulated in all its anatomical features, the whole length of the raised spine is formed of finely matched stones placed symmetrically to shed rain. The long, narrow stone causeway along the top of the mound is set like the vertebrae of a huge beast, and the sloping ridges on each side suggest ribs. The care with which the site was chosen may be gauged by the precision of the alignment, visible from the

189. Giant stone serpent twists upward from Loch Nell, Scotland, date unknown.

190. Snake-holding deity, protector of women, in birth position. Gotland, Sweden, ca. 400 C.E.

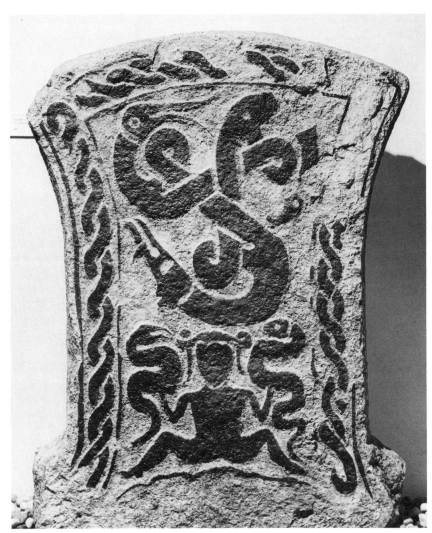

190

191. Large serpent
mound winds for
seven hundred feet
along a ridge in
Ohio. Locust Grove,
Ohio, 1000 B.C.E.–
700 C.E. (See plate
32.)

foreground. Standing at the site of the altar
at dawn on the vernal equinox and looking
along the length of the great serpent, one
sees the sun rising behind the triple peaks of
Ben Gruachan.

In view of its location and the universal
belief in the serpent's mystic powers,
there is little doubt that the mound was a
ceremonial or initiatory center with
significant religious and magical meaning
for the agricultural people who built it.

On the other side of the world, on the
Mississippi River system, thousands of
earthworks were built by the Adena people,
a civilization whose disappearance remains
a mystery. One of the most remarkable of
these constructions is the great Serpent
Mound, dated by carbon 14 to between 1000
B.C.E. and 700 C.E. This mound winds its
way nearly a quarter of a mile along a rocky
ridge in Locust Grove, Ohio. Seven deep
curves unwind from the tightly coiled tip of
the tail to the outlines of the head, where its
open jaws hold an oval shape that resembles
an egg.

The mound occupies the very summit of the
hill. The head lies close to the point, and
the body extends back seven hundred feet in
a manner that conforms to the shape of the
hill. The curves end in a triple coil at the
tail. The mound is 1000 feet long and, by all
accounts, the largest serpent image in the
world.[4] From the ridge on which the mound

lies, a spur of rock resembling a weird rep-
tilian head projects about 150 feet above the
waters of Bush Creek. This natural rock for-
mation may have inspired the prehistoric in-
habitants to elaborate upon and enhance it.[5]

THE NORTH AMERICAN INDIANS

The North American Indians invariably link
snakes with vegetation. The snake guardian
of the Hopi personifies the underworld life
that fertilizes the maize. The Hopi claim
that the Ohio snake mound was created by
their ancestors. The snake's name is
Tokchi'i, the guardian of the east who
protects the tribe from that direction. The
Hopi snake dance, specifically intended
to create rain, is performed each year in the
dry season. The performers dance for hours,
holding live rattlesnakes in their mouths.
The serpents very rarely bite the Hopi, and
the Hopi do not harm these creatures.
Theirs is a religion of spirits whose great
potency the dance focuses onto the serpent.
Like the Hopi, the Pawnee believe that
spirits bring the rain; they also believe that
thunder is the hissing of the great serpent.

In Algonquin myth, the swift darting of an
immense snake makes the path of lightning.
Algonquins hold that because the lightning
is vomited by the Creator, it leaves serpen-
tine twists and folds on the trees that it
strikes.[6] They also believe that the serpent
is a rain deity and holds dominion over

plants and crops. The snake's undulations are an emblem of the fertilizing rain so significant for agricultural tribes.

In later religions the life-giving phallic significance of the serpent accounts for its continued association with fertility goddesses and their priestesses. Their remote mountain home in the Chiriqui province in western Panama has helped the Cuna Indians of San Blas to escape Christian influence, and members of their tribe worship a divinity known as the Lumines-cent Giant Blue Butterfly Lady, whose sacred beast is a great serpent. The present-day Cuna sew vivid patchwork *molas* that depict the Goddess and her serpent in close and intimate communion. The snake, a vegetation spirit who guards the Tree of Life, helps the Earth Mother give birth to plants, animals, and people.[7]

The rites and myths of the Goddess reached the Americas in an infinite variety of guises and by a number of routes. Occasion-ally, as among the Cuna, the original ideas have been preserved in a relatively pure form, and chief among these is the associa-tion of woman and serpent. The Cuna's neighbors, the Mayans, say that humanity was created from a mash combining maize with the body of the Great Mother and the fertilizing blood of the serpent. The consort of the Cuna Earth Mother is her son, Olowaipipple, the Sun God, a link that

brings to mind many similar relationships in the Old World. The goddess Ishtar's lover was her son Tammuz, the Sumerian Shepherd God, and the rituals of both these myths duplicate the drama of the vegetation cycle, a continuous reenactment of death and resurrection.

AFRICA

Until recent times, the Baga tribe of Guinea worshiped Niniganni, a goddess in python form. Known as a deity of life, she appears elusive and treacherous; yet as a prophetic figure she presides over fortune and riches. Huge wooden figures of Niniganni have only recently been discovered by the West because of the care and zeal with which they were guarded by the Baga people. More than likely they were hidden by Baga women, whose life-giving function appears to be symbolized by a lozenge patterning on the python's body. Niniganni's statues are embellished with fourteen vertically linked lozenges, which traditionally represent not only heavenly moisture and fertility but stand for the fourteen days between the dark moon and the full moon.

Africa, the dark continent, has preserved its ancient wisdom: Throughout, different species of snakes are worshiped as deities and revered as tribal emblems. Along the Blue Nile the python is especially

192. The Baga tribe
of Guinea wor-
shiped the python
goddess, Niniganni,
until recent times.
Guinea.

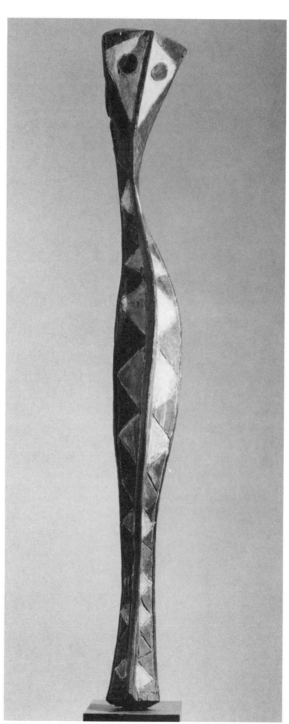

192

venerated. The Bari, a tribe that once kept tamed serpents in their dwellings, recognize the python Yukanye as the mother of their tribe. African snakes are frequently associated with women, who were believed to receive inspiration from them. Such is the case in Benin, where the women of the tribe receive the gift of prophecy from the omniscient, all-powerful serpent deity. When touched by the serpent, some Benin women are seized with convulsions and are consequently consecrated as priestesses.[8] Their queen is a rainbow deity, a patroness of waters, who appeared in serpent form under the name of All-Bringing-Forth. Her husband, Da, has become an incarnation of the eternal being, the never-ending great snake.

Pliny, on his trip to Egypt, collected details of rites from ancient Africa. Since Clea, the head priestess of Delphi, was Pliny's close friend, he was supplied with important introductions among the priesthood of Egypt. They told him that the West African isle of Fernando Po furnishes an example of a rite involving the killing of the Great God, a cobra. Cobras had the power to grant riches and fortune or death and destruction. Each year the cobra god is killed and his skin is hung from the highest tree in the center of the village. Infants are placed under its protection through guiding the child's hand to touch the creature's skin.

AUSTRALIA

The prehistoric paintings found all over the continent of Australia belong to a vital tradition. Just as we say we meditate on a subject, contemporary Stone Age aborigines say they "dream" the ancient myths, which is to say, they call them up. The myth of the All-Mother, the old woman of northern Australian myths, is one of the creator goddesses who rose from the sea in serpent form. Among the rock paintings at Arnhem Land, there is one of the All-Mother giving birth. It was she who gave birth to the First People. After they were born, she scraped them to lighten their skins and licked their bodies to life. In northern Kimberley the All-Mother appears in a cosmogonic role and, as a great snake in the sky, creates the Milky Way. Throwing water on the earth, she made the oceans. Called the Rainbow Serpent, Ngalijod, she not only birthed all people but made their feet, cut fingers for them, made their eyes for seeing, made their heads, gave them belly and intestines and energy to move about. The people would have died of thirst if the Rainbow Serpent had not made water for them by urinating. Later, she showed them how to dig for food and how to eat it.[9]

Judeo-Christian Serpents

Elements of the Genesis story were part of the collective mythology long before the books of the Old Testament were written. Despite the Judaic prohibition against graven images, use of the snake as a religious symbol was commonplace among the tribes of Israel. The Bible's brazen serpent and golden calf were the two main animal totems of a wandering people greatly influenced by other cultures. Ugaritic Anat and Babylonian Astarte are often shown with serpents in their hands, while Atargatis appears with a great snake wound around her body (see fig. 156). The snake or dragon was a pre-Israelite symbol of the Great Goddess; a serpent on a pole was a central image in her religion, which the latter-day Israelites were constantly trying to stamp out.

In Genesis, the talking serpent is undoubtedly a surviving element of animism.[1] The serpent may have been a divine being whose evil associations were added to its character by people of a later period in Judaic tradition.

An Old Testament codex from twelfth-century Munich shows Moses raising the brass serpent to relieve the plight of his people who were being bitten by snakes for sinning. Although it was denounced by the late prophets, witchcraft or shamanism was common among the early tribes of Israel, and in the Old Testament, Moses and Aaron had powers enough to overcome those of the pharaoh's magicians.[2]

In the age of Hezekiah, the brazen serpent, an emblem of Moses' family, was believed to be the same age as the Ark and probably to have been placed therein as a symbol of Yahweh. The worship of a brass serpent had its origin in the worship of a live serpent, and the substitution took place long before the age of Moses. Although the law of Moses was hostile to every kind of idolatry, the worship of the serpent was practiced by Moses himself, who transformed his magic wand into a serpent.[3] "The sacred serpent remained the God of Israel in the temple for five centuries and 'the children of Israel did burn incense to it,'" writes Robert Briffault.[4] Other remnants of goddess worship can be seen in the customs of the Levite priests, who often wore headdresses bearing the lunar crescent, and sometimes wore white turbans that represented the full moon.[5]

"High Place" is the term used in the Old Testament to designate goddess temples not yet eliminated, and archaeological excavation has revealed a Canaanite High Place at Gezer, in modern-day Israel, where the bronze image of a cobra was found amid broken pottery within a circular structure. These circular buildings usually housed live serpents.[6]

193. Returning with the commandments to find a plague of serpents, Moses sets up a counter charm. Illuminated manuscript. Germany, twelfth century C.E.

194. Bronze serpent from the Church of St. Ambrogio in Milan. Brought from Constantinople, ca. 1000 C.E.

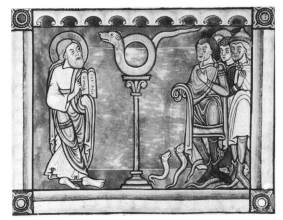

193

194

The many female figurines uncovered throughout Palestine indicate that the Israelites, both in Palestine and in Mesopotamia, were an agricultural people who originally worshiped the Goddess and looked upon the serpent and the bull as symbols of fertility.[7] In this area the snake is associated positively with woman, as in all matrifocal societies. This positive association stems from the long-standing reverence for the serpent in goddess religions. To the subsequent male-oriented society, of course, the snake is a subtle emblem of the fall.

In Israel, the serpent had served as a fertility emblem of the Mother Goddess. Says E. O. James:

It was not denied that Yaweh by his mighty hand and stretched-out arm had brought the captive tribes out of Egypt . . . to their promised land, but in Palestine the controlling forces were gods of the land, and their prescribed rites, to be neglected at grave peril. It was they who dealt with fertility rather than Yaweh. . . .[8]

In the center of the ancient church of St. Ambrogio, in Milan, a splendid brazen serpent, given a beard to make its masculinity clear, coils on a high column. Although its age and origin are mysteries, church officials say the serpent came from Constantinople in 1000 C.E. and is a metaphor from the Old Testament.

The Serpent
and the Tree of
Knowledge

The tree, widely venerated as a divine symbol of the Goddess,[1] embodies the mysterious procreative powers of the feminine. In ancient Greece it was revered as the Tree of Knowledge and so was related to the serpent, who possessed wisdom. The oracle at Dordona answered the questions of the communicants through the murmuring leaves in the groves of the deity. The perennial tree, which each year puts forth new blossoms, leaves, and fruit, remains a universal symbol of renewal and rebirth.[2] A connection between serpents and trees of wisdom is made in many ancient myths, including the Genesis story.

GULA-BAU

The underworld goddess Gula-Bau, one of the principal deities of the Akkadian and Babylonian peoples, lives in a garden at the center of the world. Her story illustrates another facet of the Middle Eastern genesis myth that preceded the writing of the Old Testament. A Chaldean cylinder seal from ca. 2500 B.C.E., reminiscent of the so-called temptation drama, shows the snake rearing itself behind the seated Vegetation Goddess. Gula-Bau and her horned lover-son Damuzi sit on either side of a palm tree from whose branches hangs a cluster of dates. Each extends a hand toward the tree, offering its bounty to those who would eat. Damuzi embodies a resurrected Redeemer, the Sumerian version of the mythic vegetation deity. Although there are similarities, the possibility that this could be an early version of the Adam and Eve story has been denied by archaeologists.[3]

As an underworld deity originally called Mama, Gula-Bau's name occurs frequently in incantation texts. She was worshiped particularly as goddess of the grain, and was a forerunner of Demeter and Persephone. Where trees are venerated, the snake often appears either coiled about the trunk or nearby. Like many other goddesses of the period, Gula-Bau was known as the great physician, a life-giver who cured disease with a touch of her hand and led the dead to new life. As an earlier dog deity, she was originally called Bau, from the dog's bark.

SMYRNA

A Greek coin from Myra (238–244 C.E.) shows a tree defended by serpents who dart out from its roots at two axe-wielding men. The nude goddess in the tree wears a veiled archaic headdress, a flowery lily-shaped basket known as a *calathus*, a name akin to the Greek verb "to spin." The calathus relates to the Greek idea of maidenhood and fruitfulness. Although the

195. On a cylinder
seal, a serpent rears
behind Gula-Bau,
Chaldean deity of
vegetation and the
underworld. Iraq,
ca. 2500 B.C.E.

196. On a Greek
coin from Myra, a
fertility deity
emerges from a tree
guarded by ser-
pents. Turkey, 238–
244 C.E.

195

196

divinity may be identified with Artemis-Aphrodite as goddess of fertility, her exact function is unclear. Some connect her appearance on this coin with the legend of the foolish wife of King Cinyras the Cyprian, who boasts that her daughter Smyrna is more beautiful than Aphrodite. Aphrodite avenges the insult by making Smyrna fall in love with her own father. One night Smyrna enters his bed after Cinyras has drunk himself into a stupor. Upon discovering that he is both father and grandfather of Smyrna's unborn child, he seizes a sword and chases Smyrna from the palace. Before he can overtake her, Aphrodite changes her into a myrrh tree, which Cinyras splits in half with his sword. Out of the tree tumbles Smyrna's child, the beautiful infant Adonis.[4]

The sacred tree, commonly recognized in the Western world as the Tree of Knowledge of Good and Evil, is not usually thought of as a magical tree. Yet it has all the properties of one. The tree and the serpent branch from the same root, and the snake who offers Eve the fruit is indeed a tree spirit, and Eve herself a Tree Goddess.

Several allusions to oracular trees are found in the Old Testament, the most memorable being the stories of the Lord speaking to Moses from a burning bush and to the prophetess Deborah from a palm tree. Additional evidence that divine life resides in the sacred tree appears in connection with oracles or with divination. The living tree, with its surrogates the post and the pole, possesses a unique life associated with epiphanies.[5]

EVE AND THE SERPENT

Most people are familiar with the story of creation as it is told in the Old Testament; few are aware that in Genesis there are two distinctly different, if not contradictory, accounts. In the first, Genesis 1:26–31, man and woman are created simultaneously and placed in a joyous garden full of flowers and singing birds. Paradise, then, is an enchanted world of plants and animals, a plantation enlivened by things that sprout from the earth. In the midst of this grove, the serpent, a creature of the earth, enjoys its natural habitat.[6] Eve is at the heart of the drama from the beginning, a Mistress of Vegetation and Lady of the Beasts.

The account in Genesis 2:4–23 presents a vastly different story. Here, in the more familiar version, we are told that Adam was created and, after him, all the lesser animals. The Lord decides that animals do not fulfill Adam's need for companionship. So, to please him, and to "further disguise Eve's original Godhead,"[7] as Robert Graves and Raphael Patai write, the Lord fashions Eve from one of Adam's ribs.

How can these divergent stories be explained? The first has a spontaneous, poetic quality common to the early oral tradition of matrilineal times. In this version, there is not one God but a pantheon, *elohim* in Hebrew. The order of creation begins with watery chaos; then comes land, followed by vegetation, followed by birds and beasts. Finally, man and woman are created together. This logical order of events can be recognized as conforming to creation myths from other cultures throughout the world. And it is a bountiful creation, given freely by the gods, with no conditions attached.

In the later version, the order of creation is quite bizarre. Land comes first, then water, followed by man, the animals, and, at the end, woman. She may be seen as the final triumph of God the Experimenter, or His mean and vengeful spirit whose first words are (as the serpent points out) a lie: He tells Adam he will die if he eats the fruit from the tree.

In his discussion of this passage, James Frazer points out that the Jahwist writer

hardly attempts to hide his deep contempt for woman. The lateness of her creation, and the irregular and undignified manner of it—made out of a piece of her lord and master, after all the lower animals had been created in a regular and decent manner—sufficiently mark the low opinion he held of her nature; and in the sequel,

his misogynism, as we may fairly call it, takes a still darker tinge, when he ascribes all the misfortunes and sorrows of the human race to the credulous folly and unbridled appetite of its first mother.[8]

By contrast, in the idyllic garden of the first narrative, a charming naïveté, almost a gaiety of tone is struck, though a veil of mystery shades the brightly colored picture of life in innocence. *The Woman's Bible*, a commentary prepared by a committee of women from the United States and Europe, assembled by Elizabeth Cady Stanton and first published in 1894, makes a corollary point:

Here is the first title deed to this green earth given alike to the sons and daughters of God. No lesson of woman's subjugation can be fairly drawn from the first chapter of the Old Testament.[9]

The theme of the second Jahwist account of the creation story is that of initiation: the secret knowledge of life shared by Eve and the serpent of wisdom. Usually an initiation involves rites undergone to introduce a change into a tribe or a religion or to promote the acquisition of magic powers. In this tale we can trace the archetypal scenario that includes the introduction into the mysteries and a symbolic death and rebirth:

In the midst of the garden grew the tree of knowledge of good and evil, and God had forbidden man to eat of its fruit saying "for in

197. In a manuscript illustration, Adam and Eve stand beneath the tree around which the serpent is coiled. Spain, 976 C.E.

the day that thou eatest thereof thou shalt surely die."[10]

The death of which God warns can be seen as the death of the old life that is experienced by the initiate approaching a new life on the path of knowledge. The serpent explains the symbolic death to Eve: "Ye shall not surely die. . . . Your eyes shall be opened."[11] This is a direct reference to the spiritual awakening that is a central element in the mystery religions.

The serpent, it should be remembered, always speaks to Eve, never to Adam. It is Eve who accepts the perils of the ritual transformation, the dangers attendant on the rite of passage, and the fear of death as a consequence of her choice. By following a dangerous path that promises a wondrous prize, Eve shows courage and initiative. She is neither timid, credulous, nor easily swayed.

In the patriarchal version, Adam is exonerated of the heavy burden of guilt heaped upon Eve. The idea that he is so easily beguiled by Eve does him little credit. Yet this fiction of the male as putty in the hands of the female is perpetuated to this day.

The archetypal fusion of woman and serpent is severed by Jahweh, who metes out punishment first to the serpent, then to Eve, and, finally, to Adam. His monotheistic

197

retribution is striking: For the first time in recorded history, enmity is established between serpent and woman. Jahweh addresses the serpent thus:

And I will put enmity between thee and the woman and between thy seed and her seed. . . . Unto the woman he said, I will greatly multiply thy sorrow and thy conception; in sorrow thou shalt bring forth children.[12]

Why does the Lord feel compelled to separate the serpent and the woman and their future generations? The answer may lie in the traditional aid and comfort the snake had given to woman in childbirth for untold generations. The belief among Jews that the binding of the belly with snakeskin assured easy delivery and that a snakeskin girdle worn during delivery was a protection against mishaps shows the persistence of this idea.[13]

As we have seen, the serpent girdle recurs often in images of the Goddess. The Minoan Snake Goddess wears this amulet prominently like the Cretan goddess Eileithyia, Goddess of Birth. The Medusa at Corfu, shown in childbearing position, wears a girdle of copulating vipers, and the Aztec Moon Goddess Coyolxauhqui also wears the serpent girdle.

The identification of Eve with the serpent depends on the serpent's embodiment of the life force. Eve is the heiress of the Great Mother, herself capable of assuming serpent form.[14] A great bond exists between woman and serpent in their shared experience of rebirth: woman through the menstrual cycle that, as the name implies, follows the lunar calendar and serpent through the shedding of skin that makes of it a new creature over and over again. Both represent a quintessential aspect of the Great Mother: her power of resurrection.

The second version of the creation story in Genesis demonstrates how hostility to natural symbols engenders unnatural symbols. The perverted notion that Eve was created from Adam's rib (an uncanny parallel to the patriarchal Greek myth that has Athena taken full grown from Zeus's head) forms a sharp contrast to the natural symbology of serpent as guide and initiator in the cycle of death and rebirth. The unnatural symbol became a trademark of the patriarchal spirit, but the harsh impulse it represents evolved into a stratagem that failed in the inner sense, for it allowed the matrifocal character of the natural symbol to reassert itself in the depths of the psyche. Outwardly, however, the stratagem was immensely successful. The persistence of the patriarchal attack finally suppressed the goddess religion and placed women in a position subservient to men. As Robert Graves and Raphael Patai write:

A main theme of Greek myth is the gradual reduction of women from sacred beings to chattels. Similarly Jehovah punishes Eve for

causing the Fall of Man. . . . The Greeks made woman responsible for man's unhappy lot by adopting Hesiod's fable of Pandora's jar, from which a Titan's foolish wife let loose the combined spites of sickness, old age and vice. "Pandor"—"all gifts"—it should be observed, was once a title of the Creatrix.[15]

The parallel with Eve is significant, and the very meaning of her name has been disputed by scholars. In Hebrew (Genesis 3:20) Eve is *Hawwah*, meaning "Mother of all Living."[16] According to W. Robertson Smith, the name is associated with a Semitic word meaning "clan" and is thus "a personification of the idea of kinship thought of as consisting in descent from a common mother."[17] A very early interpretation, still accepted by modern scholars, connects the name of *Hawwah* (Eve) with Semitic words for serpent, a possibility that is especially interesting in light of the fact that the hieroglyph for woman was also the hieroglyph for snake. This connection has been reinforced by the discovery of *Hawwah*'s name on a devotional tablet of Punic origin. Addressed to an underworld serpent deity, it begins, "O lady HVT [goddess], queen. . . ."[18]

Recent studies of ancient Gnostic texts have shed some light on the nature of this serpent-goddess-queen. In *The Gnostic Gospels*, Elaine Pagels provides abundant examples of Gnostic worship of a feminine deity.

In addition to the eternal, mystical Silence and the Holy Spirit, certain gnostics suggest a third characterization of the divine Mother: as Wisdom. Here the Greek feminine term for "wisdom," sophia, translates a Hebrew term Hokhmah. . . . Desiring to conceive by herself, apart from her masculine counterpart, she succeeded, and became the "great creative power from whom all things originate," often called Eve, "Mother of all living. . . ." To shape and manage her creation, Wisdom brought forth the demi urge, the creator-God of Israel, as her agent.[19]

The references to the divine mother as Sophia in the Gnostic texts establish this feminine being as omnipresent. However, as Pagels explains, careful editing eventually removed all hints of the Godhead's female nature:

The secret texts which Gnostic groups revered were omitted from the canonical collection, and branded as heretical. By the time the process of sorting the various writings ended—probably as late as the year 200—virtually all the feminine imagery for God had disappeared from orthodox Christian tradition.[20]

Although the Gnostics managed to explain away their elimination of a feminine God and to replace her with a male God who boasts his autonomy and power, they were never able to forget her completely. In these same accounts, the male God "is castigated for his arrogance—nearly always by a superior feminine power."[21]

It is in this light that one can view as a product of the Mother the male God of the Gnostic texts, the Creator-God of Israel, whose function it was to administer her wisdom. The Yahweh of Genesis is a jealous God who tries to conceal the Mother's wisdom by threatening death to those who eat the fruit of Paradise. Eve is aware of the serpent's role as guardian of wisdom and follows its advice despite the threats of Yahweh. There are many hidden references to the serpent's superior wisdom in the numerous Aramaic texts, appearing in the form of word play that

equate[s] the serpent with the Instructor ("serpent," hewya; "to instruct," hawa). Other Gnostic accounts add a four-way pun that includes Eve (Hawah): instead of tempting Adam, she gives life to him and instructs him.[22]

In other words, the account in Genesis of Eve's misdemeanors is simply a projection of, and cover-up for, Yahweh's extreme actions against his creator, *Hawwah*, and her holy serpent guardian. He steals her power and even her name, as the word Yahweh itself suggests.

At the dawn of literate times, therefore, the serpent appears as a supreme figure guarding the Tree of Life and the Tree of Knowledge. Later demoted, the snake became the envoy of negative destructive power as in the Old Testament. A hint of this is present in the Babylonian story of Gilgamesh who, given the plant of immortality, allowed a little snake to steal the plant so that humankind was deprived of it. The Mother Goddess, strongly connected with the Tree of Life, is in a sense the tree itself. At the same time she is outside the tree, vivifying it to bud and flower.

The Serpent Goddess survives today as the Caduceus of the medical profession, its rod representing the Tree of Life. Originally a wand with three budding leaves, it became the symbol of the god Hermes, and in Greek myth the emblem of health and happiness. Adorned with garlands, it was believed to induce a state of trance and could be used to call up the spirits of the dead. It also became the emblem of the late demi-god, Asclepius, the healer. Pausanius mentions that the terror of the Gorgon lies in the snakes on her head. She is sometimes shown with the serpents on her forehead forming a Caduceus. The face of the Medusa was in itself mild and beautiful; take away the human face and you have the sacred Egyptian emblem of the serpents and the winged circle (in Greek, the Caduceus).

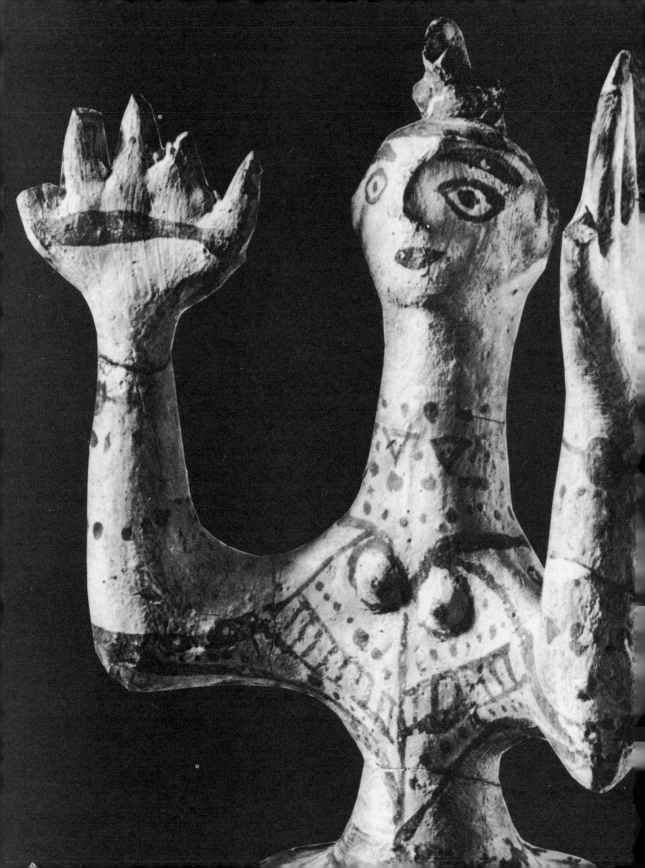

The Butterfly

Shrine figure with a
butterfly design
over her breasts.
Crete, late Minoan
III, ca. 1400–1100
B.C.E. Detail of fig.
199.

In myth, the human spirit often assumes the form of a butterfly fluttering and shimmering in the sun. The idea of the butterfly soul extends around the world and appears as a manifestation of the breath of life. In the autumn, the caterpillar becomes a nymph wrapped in a cocoon of its own weaving, sleeping until, in summer, it metamorphoses into a colorful moth or butterfly. It is scarcely possible to witness this awesome transformation without making an analogy to resurrection. From the Eastern point of view, the pupa provides a strict hieratic image of serene contemplation, a promise of new life.

CRETE

From the Palace of Knossos, Late Minoan III, a deity stands with arms upraised. The dove, a life sign, perches on her head. The deity's magic, outsized hands, raised in blessing, emanate power; each palm is painted with a dark band, perhaps to underline her creativity in the material world. The meaning of the hand varies; it often seems to be an indication of fertility. Her hair falls down the back of her long neck; four necklaces imply high status. The key to her personality lies in the transparent bodice, tied at the back: Its design mimics the spread wings of a butterfly, and her breasts appear on its wings as eyes.

The deity's large hands may connect her to the Idaean Dactyls. In early Crete, the Idaean Dactyls personified that divine tool, the hand. The Dactyls were shamans from Mount Ida who lived in secret sanctuaries and conducted rites of initiation and renewal. When the Mother, Rhea, brought forth Zeus in Crete, she thrust her fingers into the earth during her birth pangs, and the Dactyls sprang up.[1] The five female fingers on the left hand belong to the sorceress; the fingers of the right hand are male. This is consistent with the tradition of the right hand as the doer and the feminine left as the hand of wisdom.

THE AXE AND THE BUTTERFLY

Although one of the conspicuous images of Cretan religion, the double-axe, which resembles the butterfly with its wings spread, has proved resistant to interpretation. It is surely a cult object, since the material from which these axes were made, such as gold, thin sheet bronze, soft stone, and so forth, makes them unfit for practical use. A small straight-edged double-axe found in a sacred cave and engraved with a delicate butterfly is certainly a votive object. The straight edge that replaces the usual curved end of the axe may have been chosen to offset the butterfly's curved wings. Standing as it does for new birth, the butterfly is the perfect decoration for an

198. Butterfly engraved on a straight-edged double-axe signifies death and rebirth. Crete, date unknown.

199. Shrine figure crowned by a dove with a butterfly design over her breasts. Palace of Knossos, Crete, Late Minoan III, ca. 1400–1100 B.C.E.

198

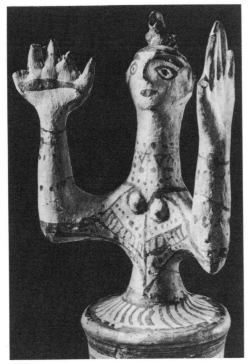

199

200. Mexican codex
depicts the Love
Goddess as a butter-
fly. Mexico, pre-
Columbian.

200

axe that cuts in two directions. Paired, the
directions suggest death and renewal.

SCOTLAND

Spirit and water in both alchemy and
religion, with fire, earth, and air, form
opposing, equally sacred elements. It is
difficult, when tracing the path of such
beliefs, to determine whether the symbols
rise spontaneously from the human psyche
or migrate from one place to another.
They appear as the basic elements through-
out the world.

In the west of Scotland, well into the early
part of this century, butterflies were fed
with honey to honor their sanctity. Mexi-
cans and Gaelic-speaking Scots share some
beliefs about butterflies that are strikingly
similar in detail. In both countries, the
butterfly is both deity and human soul and
at the same time fire. The butterfly may
appear at first scrutiny to be totally
unconnected with fire, yet once the link is
made, the resemblance between fluttering,
flickering flame and the pulsing, incandes-
cent winged insect becomes readily
apparent.[2]

The name of an ancient Scottish Fire God,
Daelan-De, meaning "Brightness of God,"
reflects his function. In Scottish Gaelic, one
of the names for butterfly is *teine-de*, "fire
of god"; the word *daelan* refers to a burning

coal, lightning, and the brightness of the
starry sky. At the same time, *daelan-de* is
the name of the burning faggot taken from a
ceremonial fire for the purpose of rekindling
an extinguished flame. Kept alight by
twirling while carried from house to house,
it gives an impression of stars in the night
sky.[3] Earlier, the same connection existed
between the Goddess and fire.

MEXICO

The Mexican codices, highly sacred
religious picture books, were almost
entirely destroyed by the Spaniards. A few
of the surviving paintings, brought to the
king of Spain as gifts, complete the link
between fire, butterfly, and deity. The most
relevant painting shows the Love Goddess,
Xochiquetzal, as a human-headed moth
holding fire sticks aloft.[4]

The delicate insect and the stone knife,
while superficially disparate, combine in
the Mexican cult of magical weapons. An
ancient, pre-Columbian hymn symbolizes
the butterfly goddess Itzpapolotl, whose
wings are tipped with obsidian, a knife-
sharp black volcanic glass.

In the cult of magical weapons, the double-
axe represents the womb of life associated
with early goddesses. These early deities
preside over death and the hunt, and their
double-axes are symbols of the butterfly

spirit,[5] the divine womb from which life and death spring. The sacrifices commanded by the goddess earned her the title of Goddess of Death. Yet, under the new pagan religion, she herself was put to death. This is obvious in Mexican myth in which the Moon Goddess, Coyolxauhgui, is dismembered by the Sun God. In Mesoamerican sacred art the Aztec goddess Itzpapalotl, the butterfly deity, was considered demonic, and had symbols of death on her face as well as a bifid tongue.

In ancient times, death was not regarded with horror. The attitude was closer to the familiarity and humorous camaraderie with which Mexicans of today view death, which nevertheless remains an awesome mystery. They know that the Mother of Death is not to be laughed at. Although frightening, she *is* still the Mother who will not abandon us; life, death, and rebirth all flow from her womb.

THE CUNAS OF CENTRAL AMERICA

Today, the Cuna tribe of Central America entertains similar ideas about the central figure of their religion, the Giant Blue Butterfly Lady, who preserves an age-old mystery, the kernel of their present-day religion.[6] While the Cuna worship the Earth Mother in the form of the Morpho butterfly seen everywhere in the constantly warm climate, their beliefs follow, to an amazing extent, the outline of the ancient religion brought from Eurasia across the land bridge of the Bering Straits during the Ice Age. The Cuna Indians adopted the butterfly from the new environment, and their cult somehow escaped the general changeover to the masculine religion.

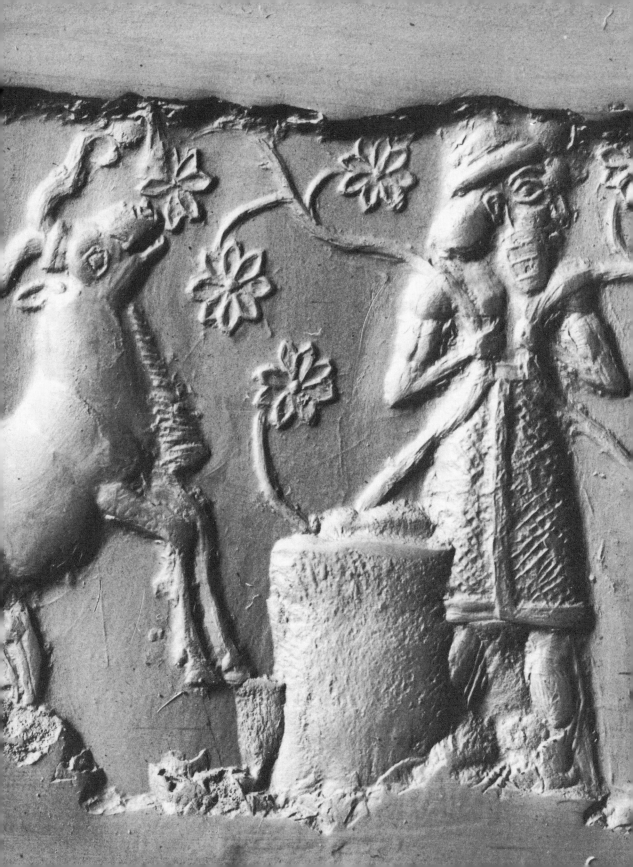

The Ewe and the Ram

A ram, his feet on the altar of the Goddess, chews on a golden blossom from the sacred branch. The priest who holds it wears a garment with her identifying net pattern. Sumer, 2500 B.C.E. Detail of fig. 203.

Although the prehistoric Sun Goddess was its mother, the ram deity, the symbol of strong sexuality, became a masculine solar emblem. Its fate provides an excellent example of the changeover in religious symbolism that took place around the middle of the Bronze Age.

The Egyptian hieroglyph for ram, transliterated as *ur-am*, means "solar heat." In myth, ram deities are virtually indistinguishable from bull gods; both appear as equivalents of the sun. There is, however, one important difference; the humid bull personifies the evening sun, which dying, loses strength. Before the Bronze Age when the sun belonged to the Goddess, the symbols were reversed.

NORTH AFRICA

During the Neolithic era the first domestic animal to be worshiped was a female sheep. A superb prehistoric rock engraving from the Sahara-Atlas mountains near Ksour Djabek Bes Seba, in Algeria (7000–4500 B.C.E.), shows a worshiper standing in veneration before a ewe whose collar bears the chevrons of the Goddess. Her lactating udders identify and reinforce her sex, as the sun disk on her head and collar confirm her divinity. (The sun disk was added at a later, Neolithic date.)[1] Nearby, a figure, with elbows bent and hands upraised, indicates power drawn from above.

Hundreds of years later, the Berbers of northern Africa believed the ram to be an embodiment of supernatural forces; even today their folklore centers around sheep. One of the greatest feasts in their religious calendar is a ram sacrifice. There are many stories about people consulting sacred rams, whose adoration appears to have filtered down from Asia Minor and Europe; in any case, the rock paintings of North Africa, in which rams figure, belong to a prehistoric culture that in some ways is continuous with the present.

FERTILE CRESCENT

High on the wall of a shrine at Çatal Hüyük from the sixth millennium B.C.E., a leopard goddess is portrayed giving birth to a ram. In another shrine in this town, a deity is similarly shown giving birth to a bull (see Part XI, "The Cow and the Bull").[2]

In the Fertile Crescent, the reed bundles of the goddess Inanna are analogous to the ram's spiral horns, considered to be springs of creative energy. The bond between ram and deity, embodied by spirals, is further strengthened by the connection between her looped reed clusters and the horned gate. On a cylinder seal from Sumer (2500 B.C.E.), the divine lamb stands on an

201

201. Goddess with leopard ears gives birth to a ram. Çatal Hüyük, Turkey, ca. 6000 B.C.E.

202. A male worshiper pays homage to a Sheep Goddess who wears a sun disk and a collar of chevrons, in a rock engraving from the prehistoric Sahara-Atlas mountains, Algeria, 7000–4500 B.C.E.

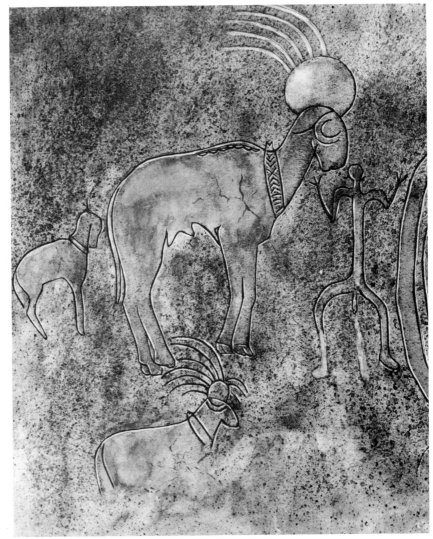

202

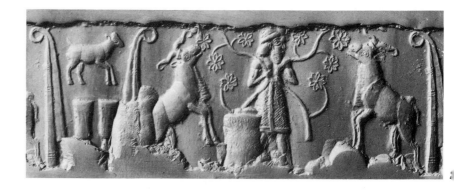

203. The deity's sacred reed bundles protect the lamb on the altar. Sumer, 2500 B.C.E.

altar flanked by these reed bundles. Nearby, Damuzi grasps the sacred tree protected by rams; their horns inspire the geometric design of the Ionic pillar capitals.

A magnificent Sumerian offering from the Queen's tomb at Ur (2500 B.C.E.), one of a pair of fabulous rams standing on their hind legs and thrusting their horns among the branches of a little tree flowering with golden blossoms, buds, and fruit, promises new life. A solid gold post rises behind the animal, doubtless a support for a deity. The lavish use of rich materials, gold, ivory, silver, and shell, is significant. Each material has its own symbolic meaning. Shells refer to the deity's womb; lapis lazuli, worn by Ishtar, symbolizes the starry night. Later, the ram became a surrogate victim who replaced Abraham's firstborn under his knife.[3]

An ivory Mistress of Animals, found at the ancient Ugarit city of Ras Shamra (Syria, ca. 1400 B.C.E.), is believed to have been made to order by Mycenaeans. The ram and the goat, almost interchangeable, are emblems of the deity, who stands on her altar and holds up sheaves of wheat.

THE AGE OF THE RAM

Astrology, an attempt at a mixture of myth and astronomy, is an organization of celestial knowledge undertaken by priests and priestesses called Mathematici, or Learned Mothers, toward the end of the matricentric era. The Babylonians gathered and codified the astronomical evaluations of Paleolithic and Neolithic observers. Later, the arrival of the great world eon, the Age of the Ram, opened the vernal equinox at the time of King Nabonassar (797–734 B.C.E.), initiating a new era.[4] The first sign of the zodiac, under the sign of the ram, symbolizes spring and overcomes the power of darkness and winter.

THE MYSTERIES

Originally a feminine ritual, the Greek and Roman secret religious cults, the Mysteries, were veiled in secrecy to prevent the dissipation of magical strength. In the scenario of the Mysteries, the head and horns of the ram constitute one of the symbols of enlightenment. A cinerary urn, found on Rome's Esquiline Hill, pictures one of the Mysteries' ceremonies of absolution. The veiled candidate sits surrounded by symbols; between his feet lies a ram's horn representing the fleece of purification. Above his head is held a *liknon*, the winnowing fan that separates the wheat from the chaff or the soul from the body; nearby, a dish of poppy pods induces the sleep that prepares him for rebirth. Meanwhile, a pig is dispatched to the underworld as his sacrificial replacement.[5]

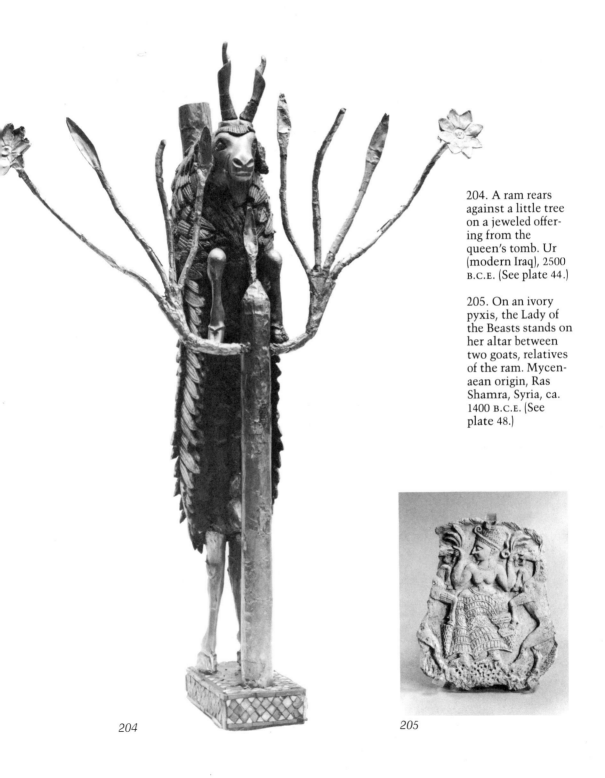

204. A ram rears
against a little tree
on a jeweled offer-
ing from the
queen's tomb. Ur
(modern Iraq), 2500
B.C.E. (See plate 44.)

205. On an ivory
pyxis, the Lady of
the Beasts stands on
her altar between
two goats, relatives
of the ram. Mycen-
aean origin, Ras
Shamra, Syria, ca.
1400 B.C.E. (See
plate 48.)

204

205

206

In the Brahman tradition of India, the individual who undergoes the rites of rebirth is figuratively reborn on a ram's skin. This ritual goes back at least to the eighth century B.C.E. and describes a practice that used images similar to the Mysteries.

THE CRIOBOLIUM

The criobolium, the sacrifice of a ram to honor the Great Mother and Attis, was analogous to the taurobolium, a bull sacrifice to the Great Mother alone. The purpose of both rites was purification and regeneration. The criobolium deeply influenced Christianity. For Christians, Christ is the lamb that dies for them. Since there is no sign of the existence of such a cult earlier, the criobolium appears to have functioned mainly to promote the rise of the god Attis. Widespread and celebrated, its doctrine of absolution and resurrection laid the ground for Christianity. The spread of the criobolium helped to end the Mother Goddess religion and banished the immemorial intimacy between humans and the goddess,[6] making way for a lamb symbolic of the resurrected Christ.

GREECE AND THE EASTERN MEDITERRANEAN

The deity sometimes takes the form of a ewe or stands on its skin. On a bronze medallion, Aphrodite Epitragia rides nude on the back of a running sheep; like Europa, she holds the animal's horn in one hand and a mirror in the other. In the field around her, the Pleiades whirl. Coins from Cyprus, her birthplace, bear a similar design. On that island, a sheep was sacrificed each year by sheepskin-clad worshipers, who thereby affirmed their kinship with both victim and deity.[7]

Aphrodite had a long love affair with Hermes, a magician and the Lord of Flock, who often took the form of a ram. The sculptor of figure 207 from the early fifth century B.C.E. shows him wearing a winged hat and winged boots, carrying a ram. As esoteric master of knowledge beyond death, Hermes conducts the souls of the dead to Hades.

Ram goddesses abound in the cultures of the ancient Near East; in Canaan and Palestine the Goddess was worshiped as the ewe Astarte. Sheep are appropriate to a country of dry steppes, whereas the people of the well-watered Phoenician mountains, hospitable to kine, worshiped a cow goddess. These hybrid goddesses symbolize an ancient form of ritual in which celebrants affirm kinship with the divinity through a

206. Surrounded by the Pleiades, nude Aphrodite rides a sheep. Greece, sixth century B.C.E.

207. The magician Hermes, Lord of the Flock and Aphrodite's lover, wearing a winged hat and winged boots, carries a lamb. Possible Greek origin, fifth century B.C.E.

207

sacrifice of the sacred animal.[8] The union of animal, human, and goddess is consummated by eating the animal's flesh and drinking its blood.

The panathenaea, a ritual related to Athena's statue, took place in the Parthenon on the Acropolis each year. A ram was sacrificed and its skin draped on her statue. This ritual makes it clear that at first the animal was considered a living deity; only later was it represented by a God in human form.

THE GOLDEN FLEECE

Parts of the legend of the Golden Fleece, already recounted (see "Greek Serpent Deities"), were taken from the much older myth of Athamas, king of Boeotia. His children by Nephale ("Cloud") escape being sacrificed by Ino, their stepmother, and ride off on a magical golden ram that plunges into the sea. Helle falls off and drowns in the Hellespont, which bears her name.[9] Phrixus is transported to Colchis, on the Black Sea, where he sacrifices the ram and presents it to King Aeetes. An oracle predicts that the king's life depends on its safekeeping, so he hangs the Golden Fleece on a tree and sets a dragon to guard it.

The events of the Argonautica, part mystery, part history, that took place in the thirteenth century B.C.E. were not recorded

208

209

210

208. Phrixus rides the Golden Ram. Greece, sixth century B.C.E.

209. Sculpture of Jason stealing the Golden Fleece. Syria, fourth to sixth centuries C.E.

210. The sorceress Medea rejuvenates the ram in her magic cauldron. Greece, sixth century B.C.E.

until one thousand years later, in the third century B.C.E. Filled with the greatest heroes of Greece, the ship Argo, captained by Jason, son of the Thessalonian king, sets out to capture the Golden Fleece. The Argonauts reach Colchis, an ancient Egyptian colony.[10] Jason meets the king, who puts him through terrifying trials in order to earn the fleece; the king, however, still withholds it. Jason searches and finds the fleece fastened to an oak tree. With the help of Medea, the king's daughter (niece of Circe, and sorceress), they drug the guardian serpent with her magic herbs. Jason grabs the fleece and escapes with Medea, who has fallen in love with him. Then all make their way back to Greece. For Jason, the ordeal of the Golden Fleece resembles an initiation trial.

The fascinating story ebbs and flows with the fortunes of Medea; it is her story. On an Attic amphora from the sixth century B.C.E. the sorceress is painted on the left practicing her magic spell. Jason's father, the old king, accompanied by his daughters, watches closely. One daughter lifts her hands in amazement as she watches a live ram boiling in an enormous cauldron. Instead of dying, the ram springs from the pot with renewed youth and energy, rejuvenated by Medea's spells.

The Golden Fleece illustrates the spiritual creative power of the ram, whose nature is essentially aggressive, blind to everything but its own driving will. The ram's hide is described in *The Iliad* as the aegis with golden tassels.[11] The aegis, or fleece, possessed such magical force that Zeus and Athena had only to shake it to terrorize enemies and put them to flight. Athena wore it on her breast or wrapped herself in it. Weather fleeces were shaken by early deities to produce rain, and Zeus used the Golden Fleece to frighten Penelope's wooers with a great storm.

The Spider

On a shell gorget,
the eyes and the
womb of Spider
Woman dominate
a design bordered
by her emblems.
Great Indian
Mound, Tennessee.
See fig. 212.

The spider weaves its web in the air, thus becoming an intermediary between the animals of the earth and the creatures of the sky.[1] As a goddess of fate, she weaves her home from her own body and spins the thread of life. The word *spider* comes from the Old English *spinan*, meaning "to spin." The modern word *spinster*, unwed woman, arises from the ancient idea that the spinners of fate were virgin goddesses who spun not only human life but the fate of the world. In Sanskrit, to sew is *siv*, the same root as thread. It is preserved in the Latin *suo*; in English, "to sew." Another Sanskrit root is *nah*; from it stems Latin *neo* and *necto* "spider," literally "the wool spinner." *Rak* in Greek corresponds to the Greek word meaning "to stitch together," "to weave"; hence Arachne, a fine weaver in Greek myth.[2]

The feminine attributes of fertility, magic, and witchcraft identify women with the spider, and this identification is apparent in many shared activities. As a creator connected with witchcraft, the spider may bring good luck or bad. A friend of humankind, she weaves webs of protection against stinging insects and embodies patience and industry.

Seen in a negative light, however, the spider is monstrous, its web dark and gloomy. For some, she personifies a mythical ogress,

a devouring female comparable to the dangers encountered in the labyrinth or on the night sea voyage to the netherworld.[3] Ananse, the male spider, is a trickster known on the Gold Coast and all over Africa as clever and malignant.[4]

GREECE

The relationship of the Fate Weaver, Athena, to the spider goes back to ancient times when Athena was called the Spider. In the myth of the virgin Arachne, Athena teaches the princess from Lydia to weave. Later, jealous of her pupil's celebrated skill, she strikes Arachne on the forehead, transforming her into a spider; hence the word *arachnid*.[5] This myth may be a late attempt to explain Athena's ancient relation to the spider.

In Homer's *Odyssey*, Penelope, like the spider, becomes a trickster. Each night she undoes the weaving of the day. Penelope destroys her web in the evening and weaves it again in the morning, never catching up with herself, as it were, thus remaining constant to her husband and her destiny. Both evening and morning aurora are compared to the spider and its web; during the night, the aurora of evening prepares next day's dawn. If the sun dies in the west without clouds and the luminous spider shows itself in the western sky, it augurs well for a fine tomorrow.

211

211. On a cylinder seal, a gigantic spider protects the granary of the Goddess Inanna from insects. Uruk, Iraq, 3000 B.C.E.

MESOPOTAMIA

A glyphic detail from Uruk, during the Jemdet Naar period (ca. 3000 B.C.E.), portrays the veneration of a large spider by two women with braided hair, each seated on a low divan. One extends her arms toward the spider; the other reaches out toward a triangular object, with a sphere on either side, that represents Inanna's Sumerian temple granary or animal byre.[6] The insect-eating spider guards the deity's storehouse.

INDIA

The *Rig-Veda* says the aurora is woven during the night and that *Raka*, the full moon, sometimes helps the spider to weave.[7] In Hindu myth, the spider symbolizes Māyā, the maternal aspect of the triple goddess who spins the Web of Fate.[8]

The spider appears in the initiation rites of the inhabitants of the Andaman archipelago in the Bay of Bengal. These tiny, egalitarian people have maintained, until the twentieth century, their Stone Age way of life. Each day after the chores are done, they dance their sacred legends. They live in fear of the terrible monsoons, the excessive rainstorms common to their part of the world, and one of their myths concerns the northwestern monsoon. Their spider ancestor was a powerful creatrix, a female spider named Biliku. According to the mythology, when the world was plunged into darkness, the benign Biliku taught the people how to bring back daylight after the dark monsoon with fire, song, and dance.[9]

In the East Indian *Mahabharatan*, two women spin and weave the days and nights in black and white threads on the loom of the year. In the fifth story of the second book of *Afanassieff*, concerning the passage of time, the spider sets its web to catch flies, mosquitoes, and wasps. A wasp, caught in the web, begs to be released in consideration of the many children she must leave behind her. The credulous spider lets her go; the wasp then warns all flies and mosquitoes to stay away. When the starving spider asks for help from the grasshopper, moth, and bug, nocturnal insects all, they spread the rumor that the spider is dead, having given up the ghost on the gallows (i.e., the evening aurora has disappeared into the night). The flies, mosquitoes, and wasps come out and fall into the spider's web (the morning aurora).[10]

NORTH AMERICAN INDIANS

Spider Woman represents an early creatrix for the Hopi. In myth, it is she who saw the empty, silent earth and, seeking to put joy into the world, took earth and water from her mouth (saliva) to mold the first beings. She covered them with a white cape

212. On a shell gorget, the womb of Spider Woman dominates a design bordered by emblems of the Goddess. Great Indian Mound, Tennessee.

213. Mimbre earthenware depicts a spiderlike vinegrone with triangles. American Southwest, ca. 900–1150 C.E.

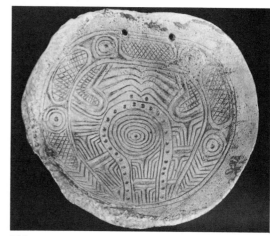

212

woven of wisdom, knowledge, and love, singing over them until they came to life as two sets of male twins. She taught them to prepare the world to receive humans, making it joyful, beautiful, and rich with songs and other sounds. In her creative wisdom, she gathered four different colors of clay and made four female beings to mate with the twins. This was the beginning of humankind.[11]

A handsome shell gorget found in the Great Indian Mound near Moccasin Bend in Tennessee's Hamilton County is incised with a border of the Mother Goddess's emblems: sacred chevrons, net patterns, and concentric circles. At the bottom, the border is interrupted by the intrusion of the spider's womb; fierce little eyes peep out above the circular form and bent legs surround Spider Woman's central uterine shape. Her aid to humans in myths has earned her the affection of many. Although the Hopi claim some of the mounds, the name of the ancient tribe responsible for the gorget is unknown.

In the southwestern United States, the spider figures as an image of the Earth Mother. Especially striking is the pottery (ca. 900–1150 C.E.) from an ancient Indian tribe, the Mimbre. The originality and freshness of their earthenware dishes and bowls comes in part from the great humor and affection with which they portrayed

213

their usual subject: animals. This spiderlike vinegrone (a species related to the arachnids) has a repeating triangle motif on her back. Since in this tribe all pottery was made by women, and most of the designs or paintings were probably made by women as well, this image is most likely from the hands of a woman.

Among the Navaho, Spider Man and Spider Woman teach the Earth People how to weave. At Taos Pueblo in New Mexico, Spider Grandmother, a positive personality, plays her usual role in folk tales, that of a resourceful helper.[12]

One of the activities most commonly ascribed to the moon is that of spinning and weaving. In a quaint myth of the Iroquois, an old woman gifted with the power of divination sits in the moon as it grows, weaving a forehead band. Every month, the cat who sits beside her unravels her work so she must continue till the end of time, weaving the never-finished web. In various parts of the world there are similar correspondences between moon, spinning, magic, fertility, and witchcraft.

THE SOUTH SEAS

In the rites of Malekula, the spider is visualized as the Monster Le-hev-hev, a negative feminine power, a type of devouring ogress. According to John Layard's interpretation of the Malekulan view, Le-hev-hev resembles the Mother of Death. She is often encountered in the netherworld as a spider at the center of her web.[13]

THE SPIDER AND THE MOON

In Borneo, the moon deity sets about the creation of the world by assuming the form of a spider. In Nias, Indonesia, when the moon dies, its soul appears as a spider spinning a web.[14] Perhaps because of the moon's weblike growth, the Parasi of central Brazil identify the moon with a spider; and among the Huitoto, the highest heaven belongs to a spider. In the Loyalty Islands, the spider represents the power that sends rain, since that is the task of the moon. This myth incorporates vestiges of the old sacrificial rites: Killing a spider is said to bring rain.[15]

In their unending weaving and killing, spiders symbolize the ceaseless alternation of forces upon which the stability of the cosmos relies.[16] That is why Jung sees the spider as a symbol of the self, that part of the personality that includes both the conscious and the unconscious.[17]

The Deer

As Moon Goddess,
Artemis is linked
with the deer.
Etruscan, Italy, 600–
500 B.C.E. Detail of
fig. 221.

ithe, tense, aloof, and incredibly fleet, the deer embodies the spirit of the wild. An ancient emblem of the birth-giving goddess, it belongs to both moon and water. On the other hand, the branching antlers are linked to the rays of the sun. The word *deer* means "shining fire," for when the sun shines through the antlers it is dazzling. Great power is attributed to horns and the animals possessing them. Because of their many uses and their sexual and cultic significance, antlers have a peculiar fascination for humans. Since horns belong to the most fecund animals, they were looked upon as an outcropping of excessive generative power, and they were used as tools to work the soil and at the same time make it fertile. Speaking analogically, as in early human thought, horns were a sign of wisdom. Hence they were later given to the Christian Lucifer. In early beliefs, horns conducted vital force according to their size, which determines the breadth and magnitude of their supernatural powers.

An intensity of feeling is conveyed by the art of the Paleolithic caves, particularly in that of Lascaux. Here a vigorous baying stag with fine antlers and outstretched neck conveys the very presence and movement of the wild animal.

At the ancient postglacial lake site of Stellmoor, near Hamburg, Germany, seasonal ritual offerings were made of young does and bucks. The megalithic worshipers submerged two-year-old does in sacred pools that silted up over the centuries and preserved the remains in tannic acid soil. In one pool, archaeologists discovered a complete reindeer skull with extensive horns, mounted on a seven-foot ritual pole. Erected on the shore above a sacrificial lake, pole and skull apparently toppled into the silt, where they remained buried until the twentieth century.[1] Alexander Marshack has noted that the skull belongs to a sixteen-year-old female, perhaps the pathfinder for a pack since, among ruminants, an old female always becomes the leader. It is this kind of old antlered doe who was held sacred by the ancient tribes.[2]

The imagination is fired by another deer skull, with eyes bored into the front so that it could be used by humans as a mask. It reveals hard usage and must have been worn on many ceremonial occasions to have become so badly broken. These rituals, usually featuring dancing, may have been the precursors to Dionysian revels; cavern walls are alive with leaping figures who represent those whose footprints are still preserved in the soft earth of remote chambers.

214. Female rein-
deer skull and horns
from a pole erected
beside a sacrificial
lake. Stellmoor,
Germany, Upper
Magdalenian.

215. Painting of a
baying reindeer
from the Cave of
Lascaux. France,
Magdalenian. (See
plate 40.)

216. Deer skull
with broken horns
used as a ritual
mask. Prehistoric.

214

215

216

217. Water vessel in the shape of a deer marked with moon crescents. Bulgaria, 6000 B.C.E.

218. Engraved on a bronze bowl, shamanesses with antlers dance their rituals. China, Chou period.

219

217

218

Five thousand years before the moon was associated with Artemis, the doe was marked with crescents that develop the metaphor: deer, moon, renewal.[3] The identification of the deer as an animal of rebirth is due largely to the amazing annual loss and regrowth of its antlers. From ca. 6000 B.C.E., a water vessel in the form of a doe stretches her neck as if to sniff the air. There is a small hole in the snout for pouring.

The fragment of a copper vessel found at Las Carolinas, near Madrid, shows a herd of deer standing under a rayed sun. Their horns repeat the rays in a way that illustrates superbly the relationship of antlers to sun. The use of copper goes back at least to 4500 B.C.E., which places it squarely in Neolithic times.

The symbol of Ninkursag, Sumerian goddess of birth and rebirth, was a doe.[4] A similar connection between the goddess and deer is made by an enormous copper plaque above the temple gateway at Al 'Ubaid, a town on the Euphrates, near Ur. This relief shows two deer guarding the divine being Imgudud, the lion-bird of earth and sky.[5]

In the late Chou period of China, lithe female shamans, wearing antlers as part of their magical paraphernalia,[6] danced their rituals in close-fitting, long-sleeved garments that suggest flight. The scene is

219. Sun rays and
deer antlers on a
fragment of a cop-
per vessel. Spain,
4000–3000 B.C.E.

220. Imgudud, the
lion-bird of Chaos
and Storm, guarded
by deer of the tem-
ple of Ninkursag,
Goddess of birth
and rebirth.
Al 'Ubaid, Sumer,
third millennium
B.C.E.

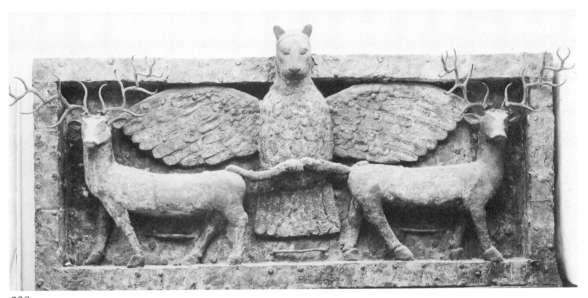

220

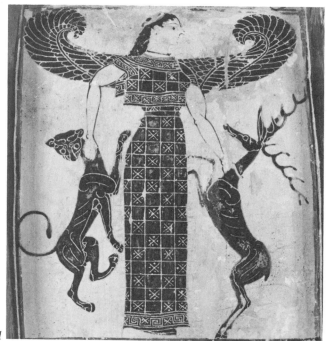

221

221. Artemis grips
a deer in one hand
and a lion in the
other. Etruscan,
Italy, 600–500 B.C.E.

222. Towering
above the others,
the Goddess stands
at the center of a
cart; at either end
stand deer with
enormous antlers.
Greek workman-
ship, Austria, sev-
enth century B.C.E.

223. Deer and danc-
ing priestesses from
the Indus Valley
civilization are
linked in a ritual
with sun symbols
and rosettes. Har-
appa, India, 2500–
1500 B.C.E.

223

engraved on a fragment of a sacred bronze bowl. The deer, an emblem of nobility, is the only animal able to find the fungus of immortality. From Bali to Mexico, the ancient deer dance survives in folk rituals in which horned masks or headdresses are worn. In all cases, the deer impersonates the lower world.

The Indus Valley civilization, with its main archaeological sites at Harappa and Mohenjo-Daro, is the earliest civilization so far discovered in India. Deer were here again linked with the afterlife. Dancing priestesses with a deer appear on a shard; the women's hair is blowing, and even the deer, marked with symbols of life, has narrowed her eyes against the wind. Around the rim spin the phases of the moon.[7]

Many years before Homer's interpretation of Artemis in the eighth century B.C.E., she was connected with water, trees, and woodland life. But it is as Moon Goddess that she is linked with the deer. A winged Artemis on an Etruscan vase (sixth century B.C.E.) grips a deer in one hand and a lion in the other. It is unlikely that a masculine animal would become the symbol of a female deity: In traditional symbolism such discrepancies do not occur. The whole fabric of civilization, supported by a stable maternal culture, formed a consistent web, until torn apart by herders on horseback from the Black Sea region. The inconsis-

tency of the stag (a male deer) as a symbol of Artemis (the birth deity) is an example of this gender confusion. The reindeer provides evidence for the original symbolism: It is one of the few species of cervidae in which the doe grows antlers.

A bronze Hallstatt processional wagon from a grave at Strettweg, Austria, mirrors a far earlier ceremony. The stiff geometric-style (early seventh century B.C.E.) figures are arranged in pairs; in the center towers a thin small-breasted goddess, nearly twice the size of the other figures. She carries on her head a large, yet shallow chalice cushioned by a small pillow that identifies her as the goddess. Two mounted warriors with lances guard the deity fore and aft, while between them stand ithyphallic men carrying axes. The deity's great antlered deer stand in the front and rear flanked by virgins who grasp the horns of the deer. The four corners of the wagon are decorated with doe's heads. All are naked except the goddess, who wears a girdle. The subject and style convey a curious numinousness. The workmanship of the piece is definitely Greek.

The Fish

Mother of the Mys-
teries with fish on
her skirt, symbol-
izes the three
worlds. Boeotia,
Greece, seventh
century B.C.E.
Detail of fig. 242.

The Paleolithic Fish

Denizen of water and first sign of animal life, the fish symbolizes powers of generation and rebirth. It stands guard beside the Tree of Knowledge, and its proverbial sagacity provides a metaphor for the wisdom of women. The feminine deities who came up from the sea as fish were the earliest culture-bringers, preceding the male gods who took fish form. In Irish tradition, the salmon inspired knowledge and abundance, as it does among the Finno-Ugrics and the North American Indians.

The yoni, as East Indians call the mons veneris, is symbolized by the lozenge, diamond, glyph, or rhomb. Used in both pagan and Christian religions, the vesica piscis ("vessel of the fish") reflects the idea of the feminine as vessel. Among pagans, the eating of fish on a certain day represented the deification of the yoni.

In early art and myth the fish glorifies the Great Mother and her womb. Its occasional figuration as phallus foreshadows the replacement of the goddesses by male deities. Today, the Italian word for fish is *pesce*, slang for penis; and the lozenge, or rhomb, is still the visual symbol for vagina. The word rhomb comes from spinning; the Greek verb means "to roll about." The fish has also been seen as a bisexual symbol, its cleft tail identifying it with the feminine, while the shape of the head and body suggests the masculine organ.

THE FISH AND THE WOMB

An amazing carved fish from the Paleolithic era was discovered by the Russians at Siberian Mal'ta. The center of its body bears a pecked spiral labyrinth design simulating a womb with the uterine passage. The piece considerably strengthens the fish-womb association. No less than twenty female figurines were found in the dwellings of Mal'ta, but only in the women's areas. Since the statuettes were regarded as sacred objects, it is probable that the fish found with them was also considered holy.

THE FISH AND THE LOZENGE

The carving and use of antlers were acts of ritual magic for Upper Magdalenian people. An engraved frieze of salmon, reindeer, and lozenges encircles, on the vertical axis, a reindeer antler discovered at Lorthet, in the foothills of the Pyrenees. The engraving traces the image of two salmon leaping toward the sexual parts of a reindeer. Above the backward-turned head of another reindeer appear two lozenges, schematized vulva signs, dotted in their centers like eyes. Because of the circular composition,

224. Reindeer, with fish between their legs, and lozenges, engraved on a tine. Lorthet, France, Magdalenian.

225. Fish pecked in stone by immigrants from French caves is marked with a womb. Mal'ta, Siberia, Paleolithic era.

224

225

226. On a shard
from Tiryns, a fish
jumps toward the
genitals of a horse
with a lozenge next
to it. Greece, 1400
B.C.E.

226

the lozenges reappear below the deer's feet.
This is the first known appearance of the
lozenge. Glyphs and fish, symbols of
fertility, reveal the Paleolithic hunter's
desire for fecundity among the reindeer.
The salmon's reputation for strength and
virility derives from its yearly journey
upriver when it repeatedly leaps high
waterfalls and traverses rapids to reach
its spawning ground. The superb linear
drafting of deer and fish, with their finely
detailed fur and scales, displays a precise
hand and a remarkable perception.

Carl Hentze corroborates the perception of
the lozenge as a symbol of the vulva.[1] In the
symbolic combination of fish, lozenge, and
deer, the deer stands for the mother deity.
The association of symbols suggests that
Magdalenian people were aware of the
relationship of sex and reproduction. With a
cranial capacity equal to that of contempo-
rary humans, they possessed a high order of
intelligence and were keenly observant.

FISH, HORSE, AND LOZENGE

Many thousands of years after the Paleolithic
era the vitality of the lozenge persists in
ancient Greece. It appears on a shard from
Tiryns, the town of Heracles, where a
celebrated rite implies an invocation of
fecundity identical to that of the Lorthet
engraving. The comparison points to

the conservatism of fertility ceremonies in
general. The shard dates from ca. 1400
B.C.E., and by this time the fertile attributes
of fish and lozenge seem to have been
transferred to the horse. Tamed and reined,
the horse could offer its master freedom and
power; therefore its fertility was much
desired, inspiring numerous scenes in
which a horse is depicted with a fish
jumping toward its phallus, with the
lozenge nearby. Simultaneously, the fish's
forked tail, as another representation of
the vulva, transforms the symbol into a
bisexual one.

On another Greek shard (mid-eighth
century B.C.E.), a fish jumps between the
animal's legs. The vignette is surrounded by
abstract symbols: Two bands of lozenges
encircle the lid; another band of dots
decorates the pot below the figures.

A fine Argive vase (1400 B.C.E.) has as its
central scene two salmon leaping toward
the phalluses of two horses. Rows of
lozenges circle the top and bottom of the jar.
Near the fish on the left, two more lozenges
appear. The combination of lozenge and
fish is not intended to be erotic; rather, it is
symbolic of a powerful generative force.[2]

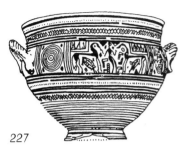

227

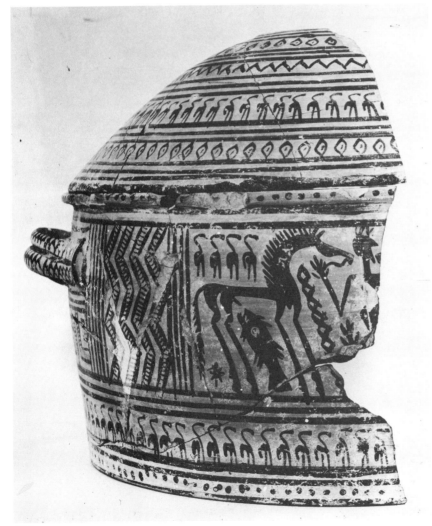

228

227. Detail shows central magical scene on an Argive vase with salmon leaping toward horses' genitals. Full vase portrays horse and fish united by two bands of lozenges, representing fertility. Greece, ca. 1400 B.C.E.

228. Horse and fish are united by two bands of lozenges that encircle the vessel's lid. Greece, ca. mid-eighth century B.C.E.

229. Reindeer horn incised with dolphin emphasizes the forked tail. France, Magdalenian.

230. From La Vache, a bone fragment with the head of a doe and two fish. Ariège, France, Magdalenian, 18,000–14,000 B.C.E.

230

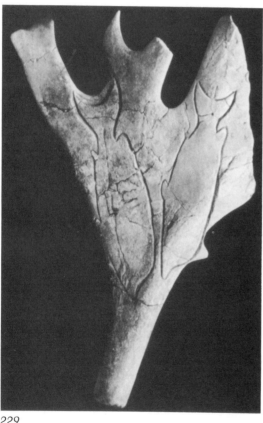

229

THE FISH AND THE DEER

The importance of the fish-reindeer connection in the Ice Age religion of northern Europe is so insistent that it requires a detailed inquiry. For example, two dolphins incised on an antler from the Magdalenian culture are cunningly placed as a visual pun so that the forked tail of one dolphin fits neatly into the forked tines of the horn. Each fork emphasizes the numinous quality of the other, since both dolphins and antlers were sacred.

The dolphin's womb, wisdom, and compassion for humans connect it to the Great Mother; later, the relationship is transferred to Aphrodite and Tanit. In ancient Greece, the word *dolphin* relates closely to the Goddess: Known as the navel of the world and a center of Greek religion long before Apollo, Delphi takes its name from dolphin, itself derived from *delphe*, the Greek word for womb.[3]

The fish-deer connection appears often in Upper Magdalenian cave art. From the hill site of La Vache, France, an engraved bone fragment presents the sketchily rendered head of a doe followed by two fish. The tips of two ears and the line of a neck disclose the remnant of another animal who leads the doe. Depicting the male as well as the female sex of the animal, the fish establishes that both sexes can represent fertility.[4]

Later Fish and Lozenges

Unlike words, symbols do not carry explicit meanings. They cannot be pinned down or defined, but strike chords of recognition in the unconscious, bypassing the more rational proesses of the conscious. The lozenge shape conjures up fertility and water. It is constructed by placing the open ends of two chevrons together. The lozenge combines the two sexes to spell fertility; the downward pointing triangle is feminine and the upward pointing one masculine. When used in fish images, this reinforces the bisexual symbolism of the fish.

LEPENSKI VIR

Lepenski Vir, in northwestern Yugoslavia, was an early site of worship, situated on a rocky ledge overlooking the Danube at its most dramatic wild gorge. Hewn from stone, a monumental Neolithic sculpture, dated to ca. 6000 B.C.E., was found there, again linking the fish and the lozenge motifs.

According to Dragoslav Srejović, the religion of Lepenski Vir seems to have been an ancestral cult of the Great Goddess centered around hearth and fire. Reindeer and fish, universal sun symbols, were worshiped for their significant roles in the genesis myth of the culture.[1]

Lepenski Vir existed in cultural isolation, unrelated to the neighboring villages. Its hexagonal stone-walled buildings contained fifty-four egg-shaped sandstone sculptures. One depicts a fish goddess from whose eyes flow columns of lozenges, embodiments of the life force. Watery chevrons of the bird goddess, designating a special link between fish and bird, turn downward on her left cheek; on her right cheek, the symbols are inverted.

ISHTAR AND AN.ZU

From early times the lozenge is also identified with Ishtar. One of the chief figures of the Assyrian pantheon, she appears first as Goddess of Love and Creativity. In later times she is shown as a destructive chaos monster probably called An.Zu, according to Dr. Edith Porada.

On an Assyrian cylinder seal from ca. 1000 B.C.E., An.Zu is accompanied by a fish and a lozenge. The two symbols are often linked on cylinder seals of the period to reinforce the fertility role of the Goddess.

The seal depicts the god Ninurta beneath his emblem, the winged sun disk. He aims his star-studded bow into the mouth of his mother, the chaos monster, whose body he divides to form earth and water. The goddess An.Zu is surrounded by her symbols, too. Above her head hangs the

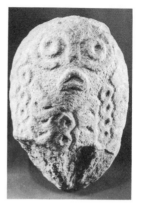

231. Neolithic sculpture of Fish Goddess with life columns on her face. Lepenski Vir, Yugoslavia, ca. 6000 B.C.E. (See plate 36.)

231

sickle moon with the seven-pointed star; beneath her claw grows the sacred tree; before her swim the fish and lozenge. In this culture, the lozenge takes a softer, more vaginal shape.

From Ishtar's divided body, the firmament and the earth were born and all living things formed. An expression of the origin of the universe from chaos, this myth also describes the seasonal fruitfulness of the land where spring flood waters (Ishtar) are dispersed by the sun and winds. It may also be understood as a metaphor for the destruction of the old order.

Difficult as it may be to see the beautiful goddess Ishtar in this chaos monster, this monster, An.Zu, and Ishtar represent the same character. In the divine An.Zu, the character of the divinity is clarified, distilled into Creator-Destroyer. An.Zu may be a creature of chaos and of darkness, but her chaos precedes the ordering of the universe. She is the primordial water, the earth, and Genetrix of all seeds, destroying life so that it may be born anew.[2] An alternate name for Ishtar, Tiamat, has as its root the Semitic word *tehom*, meaning "the deep of the ocean," which links her to the fish.[3]

THE HALOA FESTIVAL

The Haloa in ancient Greece formed part of the ritual harvest festival known as the Thesmophoria, and included a feast, a procession, and ritual dances. Only women were allowed to participate since they alone understood the processes of fertilization and the maturation of the seed. During the procession, women carried enormous scallop shells, emblems of the vulva, to honor Demeter of the Grain, and giant phalli to celebrate Dionysos of the Vine. Sacred cakes shaped like the shells and the phalli were fondled and eaten by the women. Broad sexual jokes were often acted out, as illustrated in two red-figured Attic vases from the fifth century B.C.E. Two women dance around a giant phallus. One woman aims a playful kick at the sex of the younger woman. The second illustration makes a visual pun: fish equals phallus. Carried with ease by a woman in the procession, the gigantic fish with its flaring tail and exquisitely drawn eye depicts the double image. The entire festival was meant to excite erotic feelings. To this end the priestesses passed among the women, whispering in their ears "words that might not be uttered aloud."[4] At the end of the celebration, men and women gathered in the fields to stimulate the earth's fecundity by making love on the ground.

232. Cylinder seal shows Ninurta shooting the goddess An.Zu. Assyrian, ca. 1000 B.C.E.

233. The Haloa harvest festival involves erotic rites in which women dance around a giant phallus. Athens, fifth century B.C.E.

234. In the Haloa procession, one woman carries an enormous fish-phallus through the streets. Athens, fifth century B.C.E.

232

233

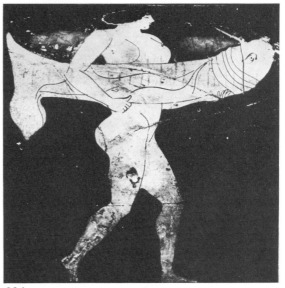

234

235

VISHNU

A far cry from the merrymaking of the
Grecian women with the phallic fish is the
mystical adoration in India of the Hindu
god Vishnu. From the western Himalaya of
the ninth century C.E. comes a finely carved
and proportioned stone image of Vishnu in
his first incarnation as a fish. The hand-
somely chased pillar directly behind
the figure represents the deity as a cosmic
tree. As a fish, Vishnu is specifically
identified with the feminine moon, ruler
of the rainy season, and it is as a fish that
he plays a central role in the deluge myth
of the *Sataphatha Brahamana*.

In the sacred text, Vishnu appears as a little
golden fish cared for by the wise Manu, who
is unaware that the little fish is a manifesta-
tion of the deity. In payment for Manu's
patient care Vishnu appears and warns him
that a flood is coming. He directs Manu to
construct a strong boat and to place in it the
seeds of all things, a pair of every kind of
animal, and seven sages.[5] For the duration of
the deluge, Vishnu guides the boat to
safety. Sacred fish are still kept in pools in
India, and Vishnu is worshiped in fish form.

The Indian myth bears a strong resemblance
to the much later biblical story of Noah.
The great flood has a widespread mythical
tradition since it suggests the primordial
source of the cosmos, water chaos, and

236

237

235. Vishnu, in his fish incarnation, shown against the deity as cosmic pillar. India, ninth century C.E.

236. In a brick from a Chinese tomb, both fish and lozenge signify rebirth. China, Han Dynasty, 202 B.C.E.–221 C.E.

rebirth. In deluge myths, a view of time and space as cyclical in nature is implied. The flood effects instantaneous dissolution; water, the devouring primeval principle, the Mother, takes her children back into herself.[6]

CHINA

A Chinese Han brick of gray earth, part of the decorative frieze of a Chinese tomb (202 B.C.E.–221 C.E.), joins a border of fish and lozenges and presents the theme of resurrection. The entire lower half of the brick is devoted to this motif; the upper and lower panels are linked to a horizontal row of dragons whose loosely coiled, spiral tails extend the idea. On the upper panel, on the treetop, perches the great Firebird, the Sun; below the Tree of Life a horseman descends from his mount.

JUDEO-CHRISTIAN TRADITION

The mosaics of the Beth Alpha synagogue in Galilee, from the sixth century C.E., provided an unusual archaeological find. The design is composed of three linked lozenges; the upper spaces between the large lozenges hold smaller lozenges, and the spaces below contain images of abundance. In the space on the lower right, a vine is laden with grapes; on the left, a fish extends a red tongue, inviting rain. In

237. Mosaic lozenge designs from Beth Alpha Synagogue include fish. Israel, sixth century B.C.E.

the large central lozenge a fertile partridge leads four chicks. A tree bears three pomegranates in the lozenge on the left. Pomegranates were the sacred fruit of the divinity, and their abundant seeds have been picked out on the outside of each fruit's womblike shell. The desire for plenty is developed further in the mosaic by the pecking bird enclosed in the third large lozenge and by the cluster of grapes. These images all point to fecundity and prosperity. They seem to represent offerings to the higher being responsible for generation and regeneration.

An extraordinary mosaic, late fifth century C.E., from a Christian church on the Sea of Galilee, unites fish and lozenge with a basket of bread. The church is located at Zabgha, where Christ miraculously fed the multitude with five loaves of barley bread and two fishes.

In the Judaic tradition, the fish stands for the Messiah. When Christ's followers accepted him as their Savior, they began to use the fish as his symbol. In both religions, fish was a sacramental food, and the faithful were called little fish. His miraculous feeding of the multitude expresses the idea that the faithful will be given spiritual nourishment. As a Christian symbol, the fish stands for faith as well as purity since it can pass through salt water and remain fresh.[7]

The function of woman, as giver and transformer of nourishment, is assumed by Christ, a god of the grain according to James George Frazer.[8] Baking bread was one of the primeval mysteries formerly in the hands of the grain-gathering women. Accordingly, in the Greek Mysteries of Demeter the adoration of a dramatically revealed sprig of wheat was a central rite in her worship.[9]

A much later version of the miracle of the loaves and fishes is carved with simple charm on the base of a Celtic stone cross of uncertain date from Castledermot, in Kildare, Ireland. The standing Christ holds one of the five round loaves of bread, below which lie the two fish. At the top a design of interwoven spirals, signs of becoming, is completed with floating lozenges.

As a symbol of Christ, the fish came to represent the eaten god's mystic body. In the ceremony of the Eucharist, the bread and wine represent the body and blood of the Savior; this image, common in the Roman catacombs, alludes to the feeding of the multitudes.

Thus the Christian symbol of the fish is evidently related to the older symbols of the Mother Goddess. Her hovering presence, denoting fertility by combining fish and lozenge, is apparent in this later symbolism despite the patriarchal character of Judeo-Christian tradition.

238. Mosaic from a Christian church on the Sea of Galilee makes a parallel between the lozenge and the miracle of the loaves and fishes. Israel, fifth century C.E.

238

239. Another version of the miracle is carved in relief on the base of a Celtic cross. Ireland, date unknown.

239

THE SWASTIKA, THE FISH, AND REBIRTH

The swastika symbol has been, since ancient times, a sign of the life force. The four arms of the swastika suggest the four primary elements: earth, air, fire, and water. The swastika has a double significance that goes back to Paleolithic times: It represents the sacred womb and new life. The earliest known swastika, found in Mal'ta, Siberia, is engraved on the under-wings of a flying bird of mammoth ivory.[10]

A lead goddess from Troy, excavated by Heinrich Schliemann, has, in addition to five sacred necklaces, a prominent swastika. Its position on her sexual triangle should be conclusive proof of the swastika's meaning. Ram's horns, indicative of strong sexuality, decorate her head.

From the artistic jewelry of pagan France, a golden belt buckle displays a figure whose skulllike face is indicative of the Goddess of Death. The most striking characteristic of the ornament is the great fish engraved on the figure's body. The theme is remarkably similar to a Greek terra-cotta vase of Artemis (see fig. 242).

ARTEMIS AND REBIRTH

Artemis is a deity of lakes, marshes, and streams;[11] therefore the sacred fish, inhabitant of the underwater world, appears on her ritual apron. The scene on a funerary amphora from Boeotia, Greece (seventh century B.C.E.), indicates by signs and symbols a descent to the underworld and rebirth thereafter.

Surrounded by familiar emblems, the Goddess appears as Mother of the Mysteries, characterized by a leaf-shaped face, watery hair, and life streams falling from her waist. The female triangles on her bodice indicate her generative powers. With her outstretched arms raised in the traditional sign of blessing, she divides the upper regions from those below. Bird, horned cow, and fish symbolize the worlds of air, earth, and water. The lions, guardians of the Life-Giver, stand on either side, paws outstretched toward her. The tail of the one on her left descends in a spiral, whereas the tail of the lion on her right ascends in a similar spiral.

Below the Goddess's sheltering left arm lies the path to the underworld, marked by the bull's leg that Gilgamesh tore from the sky bull and hurled into the constellations. The lowered spiral tail of the lion on her left indicates a descent to the underworld, from which leaf forms sprout. The path emerges between the world mountain and the lion

240

241

240. A goddess from Troy with many necklaces and a swastika placed on her sexual triangle. Turkey, third millennium B.C.E.

241. On a gold belt buckle, the Goddess of Death carries a fish on her body. France, 530–753 C.E.

242. Artemis as Goddess of the Mysteries presides over the three worlds. Boeotia, Greece, seventh century B.C.E.

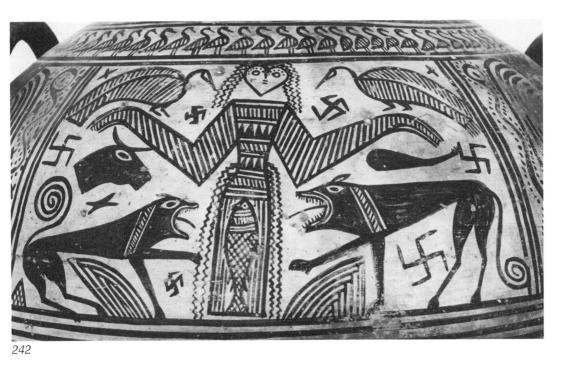

242

243. Death and renewal in a work by Paul Klee entitled *Around the Fish*. Switzerland, 1926. (See plate 38.)

243

whose raised spiral tail leads to the shuttle of destiny. Over the lion, beneath the Goddess's right arm, presides the head of a nourishing cow with crescent moon horns. The vase records the age-old initiation pattern, the difficult journey that mimes death and rebirth.

Nearly three thousand years later, Paul Klee (1879–1940), in a painting describing an underworld adventure, presents a more contemporary version of the idea of dying to be reborn. Klee's scholarly understanding of ancient symbols is handled with great finesse in *Around the Fish*. His juxtaposition of masculine and feminine elements creates a symbolic fusion of opposites. The lunar crescent recalls the cyclical influence of the sun and moon in the sky. Out of the two fishes, embodiments of opposing principles, comes an arrow underlined by an exclamation point, a combination indicating the beginning of the transformative underworld journey. The arrow points to the candidate in whose neck is embedded the forked flame of the male-female principle, the trisula. The tines of the trident, emblematic of the three worlds, represent the beginning, middle, and end, or birth, death, and renewal.

A line indicating the initiate's descent leads down to the underworld, a transparent cylinder marked with a red flag for danger. There the neophyte encounters the five-seeded apple, which, like the five-pointed star of Ishtar, stands for the Mother Goddess. The apple, sacred to Aphrodite, and eaten by Eve in the Garden, represents consciousness (wisdom), the fruit of the Tree of Knowledge of Good and Evil. In Scandinavia, too, the apple stands for rebirth.[12]

The novice encounters the four-sided archetypal representation of the womb, the lozenge. Next to this glyph lies the trefoil or fleur-de-lys, the Flower of Light that is an embodiment of the trinity. Klee's initiate, like his counterpart in antiquity, must trace his way through the red, labyrinthine path to the center, where he finds the seed of life and the trisula, sign of creative power.

The adventurer, carrying the germinating seed, then enters a longer passage, more difficult of access, whose ascending path leads to the upper world. Emerging, he finds the trisula has grown and fused with the trefoil, or cloverleaf, to treble the psychic force.[13] (In German the word *klee* means "cloverleaf" or "trefoil.") There, too, is the seed and the cross. As the initiate's entrance into the threadlike labyrinth represented a symbolic death, so does his emergence signify a rebirth.

Resurrection, Water, and the Fish

In the beginning the earth came out of the sea; that water produces all life, is an ancient as well as a current observation. *Mari* means both womb and sea in Sumerian. Significantly, Aphrodite-Mari, the goddess known as the Mother of Us All at Hierapolis, produced all things out of moisture, as she herself was born out of the sea. A fish legend is understandably part of her myth, which creates a link between Aphrodite-Mari and Jonah. Jonah's rebirth from the belly of the whale is a prototype of the resurrection of Christ. Jonah's name means dove, Aphrodite's most sacred bird. There is a long line of deities identified with water and resurrection; in addition to Aphrodite, there are Tiamat, Atargatis, Themis, Kali, and the Virgin Mary.

THE GREEKS—APHRODITE

The term *goddess of love* in Sanskrit means "she who has a fish as her emblem"; as Aphrodite Pandemos, one of her early Greek forms, she stands on a dolphin. Believed to be a fish by the early Greeks, the dolphin possesses a womb and breasts so it became one of Aphrodite's special symbols. A terra-cotta from eastern Greece (sixth century B.C.E.) is less the image of a gentle deity born in foam than the expression of the goddess who rules what has been called the irresistible and harrowing domain of love.[1] She is an alluring and seductive figure of fatal enchantment leading others to doom.[2]

The sites of temples often express the characters of the deities to whom they were consecrated, and many of Aphrodite's temples and shrines have been described as haunting and terrible, expressing a nature that appears to be beyond the reach of reason or control.[3]

A far more forceful personage than classical tradition presents, Aphrodite inherited some of the most potent aspects of the early Mother Goddess and has many points in common with the Lady of the Wild Things, as may be seen in her appropriation of the most fertile animals in each realm: dove, pig, and fish. In Greece, her association with air, as Ourania Aphrodite, the Heavenly One, is more pronounced than her associations with water or earth and identifies her with the Syrian Goddess of Heaven, Astarte. Originally a Cretan modification, Aphrodite was a relatively late addition to the Olympian pantheon. There, as has been discussed earlier, her many powers were reduced to a single function: her reign over human passion.[4]

Aphrodite was worshiped as the Fish Goddess, Atargatis, in the Syrian temple at Ascalon, which is her most ancient shrine yet discovered. Herodotus calls this sanctuary the Temple of the Celestial

244. Aphrodite, mounted on a dolphin, carries a casket representing life, death, and rebirth. Greece, sixth century B.C.E.

Venus. At Hieropolis, the fish cult of Atargatis was characterized by splendor: her fish-tailed statue was covered with gems and gold, and the sacred fish in the temple ponds wore jewels in their fins, lips, and gills. Another temple, in the extreme north of Syria, lies close to Ninevah, which means "House of the Fish" and where the fish deity had many followers.

Although the dolphin came to symbolize the new solar god, it was originally an emblem of the Moon Goddess. According to pre-Hellenic belief, the dolphin and the moon carried the souls of the dead into the underworld. Aphrodite, identified with the moon and the dolphin, sometimes took over the role of psychopomp, guide of souls to the underworld.

In addition to having specific associations with the womb, the fish represents the Mother Goddess herself and often appears as her mount. The animal incarnation on which the transformed deity rides is not merely the vehicle but actually an alternate form, or epiphany of the divinity. The earliest images of the deity were often in animal form and only later assumed anthropomorphic shape. At times the actual process of transformation is recorded; on tablets from the ancient Near East, the goddess is described as part fish, part maiden—the fabulous mermaid of more recent times.

244

245. Kwannon
mounted on a giant
carp. Japan, seven-
teenth century C.E.

JAPAN AND CHINA

In Japanese mythology, a giant carp was
responsible for the creation of the islands of
Japan. When this great creature, asleep
under the sea, arose from its slumber, it
thrashed about so violently it caused a great
tidal wave from which the islands appeared.[5]

The carp represents fertility, and, like the
salmon, goes back as a symbol to the Stone
Age (see fig. 224). Belief in the virile
properties of this fish is evident in contem-
porary Japan, where boys carry paper carps
as banners on the day of the boys' festival to
express the hope that mothers will bear
males.

An emblematic pattern of lozenges
ornaments the kimono in a seventeenth-
century Japanese print in which Kwannon,
the popular Buddhist Bodhisattva (future
Buddha) of Mercy and Fecundity, stands
poised on a giant carp. As Goddess of Mercy,
Kwannon parallels the Virgin Mary, who in
turn is identified with the Chinese Guanyin,
a bodhisattva. The fish assumes a promi-
nent place in the mythologies surrounding
these figures.

In China the fish is, in general, a charm
against evil. At one time, Guanyin, a
Chinese bodhisattva, was the most powerful
being in the Chinese pantheon. A protector
of women, honored in every dwelling, her
powers include the ability to induce

245

246. The celestial Tanit, to whom the fish, particularly the dolphin, is sacred. North Africa, Punic period, 264–146 B.C.E.

246

pregnancy in sterile women (she began as a male). Guanyin hears the cry of the world and sacrifices her Buddhahood for the sake of suffering humanity.[6] Her transformation from male to female deity is unusual—in most instances, male gods began as goddesses.

NORTH AFRICA AND THE MIDDLE EAST

The Semites of North Africa identified Tanit with Astarte and Aphrodite.[7] She journeyed on shipboard with sailors from the Near East. There are striking similarities between Tanit, Hera, and Aphrodite—all share the dove, the dolphin, and the sacred pillar. In addition, Tanit's geometric emblem is similar to the Egyptian life sign, the ankh, which itself resembles the sacred knot of the Cretan goddess and the reed bundle of the Sumerian deity Inanna, all symbols of the womb.

The great Phoenician goddess Tanit, known as the Heavenly Virgin, has not only the bird as her emblem but the fish as well. An androgynous figure, Tanit is the partheno-genic Mother of the Gods.[8] Punic inscriptions (ca. third to second centuries B.C.E.) testify to her presence on the North African coast, and stone monuments show her as a stylized deity with a triangular body and arms upraised to disseminate the life force. In one gable, a geometrically styled sun

and moon evidence cosmic intention. The protecting hand on Tanit's right signifies grace, while the ancient sign of the caduceus, two intertwining snakes, was used on Punic stelae to assure fertility.

A glimpse of the Goddess to whom the fish was sacred illuminates the ancient Sassanian practice of hanging her emblem, the fish, on the foreheads of horses. When a horse died, its golden fish was buried with it. In present-day Greece, ornamental fish still can be seen dangling on the foreheads of horses, along with the ubiquitous blue beads that symbolize the eyes of the Goddess. Both are used in the Near East to ward off evil.

The horse-riding Scythians considered their mounts their most valued possession, directly under the protection of the Persian Anahita. She was known as the Immaculate One, a fountain of never-ending water and semen flowing from the stars. She appears as a late female sun deity in charge of the solar orb. Anahita is described as richly clad in clothes of gold and shining beaver pelts. Her statues were dressed in gold-embroidered garments and a great golden cloak that covered all.[9]

18

20

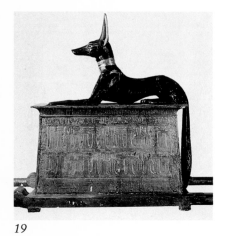

19

21

Plate 17. Aphrodite poised on the shell. Greece, third century B.C.E. (See fig. 86.)

Plate 18. Ring seal depicting the descent of the deity. Isopata, Crete, Second Palace Period. (See fig. 162.)

Plate 19. The king in the form of the god Anubis during the course of his transformation. Egypt, ca. 1325 B.C.E. (See fig. 132.)

Plate 20. Statue of Coatlicue, Aztec Mother of the Gods, with a double serpent head, a human torso, and a serpent skirt. Mexico, pre-Columbian. (See fig. 178.)

Plate 21. Gate of the Lions at the acropolis of Mycenae. Greece, 1250 B.C.E. (See fig. 123.)

Plate 22. Winged Isis, protector of the Gods. Egypt, after 1570 B.C.E. (See fig. 150.)

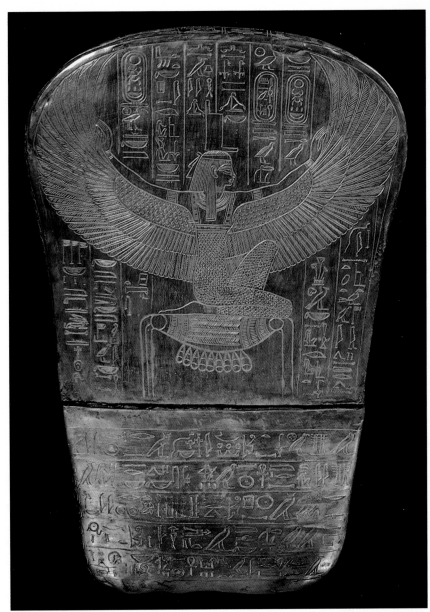

23

Plate 23. Neith as golden cobra wears the shuttle on her breast. Tomb of Tutankhamen, Egypt, ca. 1325 B.C.E. (See fig. 147.)

Plate 24. Bird-headed deity, with diagonal stripes, holds snake child. Mycenae, Greece, 1400 B.C.E. (See fig. 143.)

Plate 25. One of two sister deities (or perhaps mother and daughter) from the Palace of Knossos, brandishes sacred adders. Crete, sixteenth century B.C.E. (See fig. 158.)

Plate 26. The Black Virgin, symbol of wisdom and the resolution of opposites. Salzburg, Austria, eighteenth century C.E. (See fig. 99.)

Plate 27. Mother Goose, a modern vestige of the Bird Goddess, rides on a whittled-down version of the Sacred Tree. North America, nineteenth century C.E. (See fig. 96.)

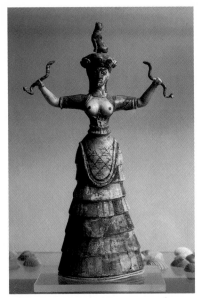

25

26

24

27

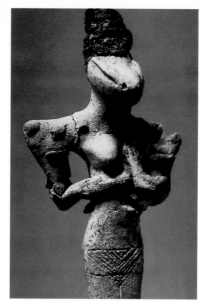

29

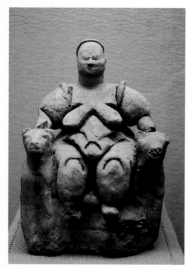

28

30

Plate 28. Birth scene with mother deity on a birth throne flanked by leopards. Çatal Hüyük, Turkey, 7100–6300 B.C.E. (See fig. 115.)

Plate 29. Serpent-headed Madonna from Ur, suckling her infant. Iraq, fourth millennium B.C.E. (See fig. 153.)

Plate 30. Enshrined Minoan serpent divinity with banded body wears three necklaces. Crete, 1100–1000 B.C.E. (See fig. 142.)

Plate 31. A Tantric painting shows Kali wearing a necklace and girdle of snakes. India, eighteenth century C.E. (See fig. 185.)

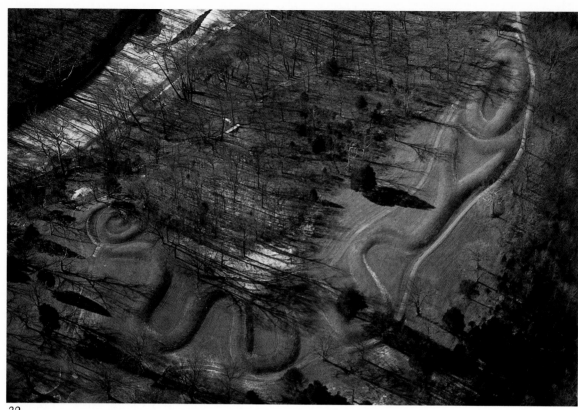

32

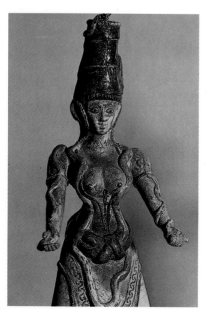

Plate 32. Large serpent mound winds for seven hundred feet along a ridge in Ohio. Locust Grove, Ohio, 1000 B.C.E.–700 C.E. (See fig. 191.)

Plate 33. Primal serpent divinity from the Palace of Knossos. Crete, ca. sixteenth century, B.C.E. (See fig. 157.)

33

Ceremonies of the Fish

Rites and ceremonies evolved into myths and legends. It is difficult to find instances in which myths have given birth to rites. People invent myths to explain their behavior. The ceremonious treatment of fish is often noted; the arrival of the first fish of the season occasions a great celebration in tribes who subsist largely on fish. For example, the Tlingit of Alaska hold a great festival when the first halibut arrive.

THE GODDESS OF THE FLOWING VASE

Rebirth through water is a common theme in the early religions of the Near East. The belief did not, as was formerly believed, begin in the Euphrates Valley, an important site of fish worship. Both Egypt and Mesopotamia may have had a common source for this idea in Old Europe.

The recent finds at Lepenski Vir (see "Later Fish and Lozenges") establish an early Neolithic date, and material from the Paleolithic era suggests that the idea may go back even further. At Mari, Iran, in the center of the throne room of King Zimri-Lim, a splendid limestone statue known simply as the Goddess of the Flowing Vase was discovered, dating from the eighteenth century B.C.E. Adorned with six necklaces and a horned crown, she figures as a deity of considerable prestige. She holds before her a vase that gushed water over the front of her dress from a pipe hidden in the vase. Little fish engraved down the length of the dress create the illusion of fish swimming upstream. Etched lozenges cover the area of her breasts. She may be a remote ancestor of the Celtic Lady of the Fountain, mentioned in the tenth century C.E. manuscript *Mabinogion*. Rituals of rebirth spring from the early view of woman as the container of the seed. To them she is the vessel, the sacred water basin, and the pollen-filled pail; she embodies the life-giving water.[1]

The result of the transfer of worship from goddess to god appears approximately one millennium later. In the great Assyrian temple of Assur at Guzana (early seventh century B.C.E.) stood a large stone ritual basin dedicated to the god Oannes, who had appropriated the water rites of the Goddess. The exterior of the basin is decorated with a handsome frieze in which a central god wears a horned diadem and holds a flowing vase. He has, in fact, taken her title and become the God of the Flowing Vase. Flanking him are four fish-clad priests carrying situalas (pails) containing pollen for fertilizing plants. The rites performed at the basin were probably of a lustral, purifying nature, resembling those of Minoan Crete. His legend is borrowed entirely from hers; the Goddess has not

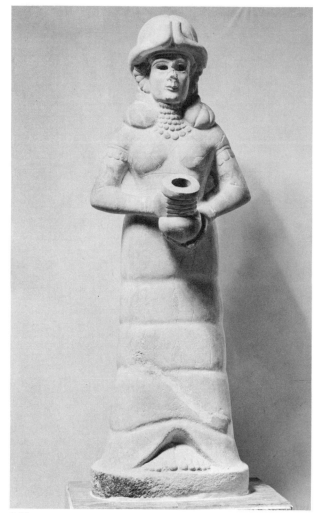

247. Dominating the throne room of an Iranian king, the Goddess of the Flowing Vase wears six necklaces. Mari, Iran, eighteenth century B.C.E.

248. On a baptismal font, the God of the Flowing Vase usurps the Goddess's role; he holds a vase of running water. Assyria, seventh century B.C.E.

247

248

249. Fish-clad priests replace the Mother in the rites of the dead. Assyria, seventh century B.C.E.

250. Bronze mirror incised with fish and spirals encircle the sun. Naxos in the Cyclades, 2400–2200 B.C.E.

survived since he is now presented as the creator of humankind and source of agricultural knowledge.

Often the fish acts as a guide to the souls of the dead, and in one image fish-clad priests replace the Mother in the rites of the dead. In Egypt, the link between the God's origin and solar myths becomes explicit in the solar night-sea journey, which is based on the belief that when the sun sets in the sea it returns to the Mother's womb.[2]

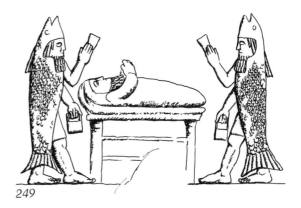

249

THE FISH AND THE SUN

Vision and truth are symbolized by the mirror, an emblem of the sun. It also corresponds to water, as reflector of the universe. Incised on a Bronze Age mirror (2400–2200 B.C.E.) from Naxos in the Cyclades, fish and spirals circle the sun in a graphic relationship between fish and sun, life and death. The Greeks thought the sun's nightly journey traversed the waters below the earth, through "the doors of Helios and the land of dreams," according to Homer. These waters constitute Oceanus, the origin of gods and men, ever ebbing and flowing.[3] The circular surface of the polished bronze mirror reproduces the solar disk, reflecting the sun's rays from its highly polished face. Mirrors often figure in the magical equipment of a king's tomb. For example, in Egypt, an elegant mirror case

250

in the form of an ankh, feminine sign of eternal life, was included among the sacred furnishings in the tomb of Tutankhamen.[4]

Ancient cosmology divided the firmament into the earth, the sea, and the sky. In Egypt, the sun passes across the sky either as the Goddess in a sunboat or as a fish. The fish accompanied the dead through the underworld and the sun's voyages through the water of the underworld in a fish vessel.

The myth of rebirth exemplified in the strong relationship between solar deities and the fish is not coincidental. It evolved through the goddess rituals and was transferred to the sun gods Ea, Osiris, and Christ, all of whom experienced rebirth through water.[5]

ASTROLOGICAL RELATIONSHIP

The Great World Year is a cosmic concept, a division of eons into periods of roughly two thousand years. According to Rupert Gleadow, the British authority, the vernal equinoctial point of the northern hemisphere entered the constellation of Taurus, the Bull, in 4139 B.C.E. and left Taurus to enter the sign of Aries, the Ram, in 1953 B.C.E. At this point, the cult of the Ram God, Ammon, was rising in Egypt. We have just passed through the Great World Year of Pisces, during which Christ became personified by the fish.[6]

Since astrology is not a science but represents our beginnings in the codification of knowledge, there is some disagreement as to the date beginning the Great World Year of Pisces. Some put it at the birth of Christ, others at approximately 220 C.E. Although we have come to the end of the Age of Pisces, there is some disagreement as to exactly when we enter the Age of Aquarius, which promises a reconciliation of opposites.

The great antiquity of zodiacal signs is demonstrated by the Stone Age rock paintings at Cueva de Arce, Spain. But it was the early Akkadian astronomers of King Sargon of Agade (2750 B.C.E.) who organized what was then understood of astronomy and astrology into the zodiac as we know it. Codified in Mesopotamia and Babylonia, the zodiac migrated to Europe, Africa, and Asia, and finally the Americas, without undergoing any significant change. Wherever the zodiac was adopted, it was held sacred and ultimately was incorporated into the religion.

Astrology is widely criticized as unscientific since the ancient astrologers did not properly understand the progression of the equinoxes; the present division of the year into twelve astrological signs, with the change from a moon calendar of thirteen months to a sun calendar, has a discrepancy of one month due to this progression. It

should not be judged from the scientific point of view, however. In many cultures—India for one, where couples still routinely have their charts compared before they marry—this entirely intuitive and remarkably sensitive system remains a central element of a living faith.

Pisces is represented on star maps by the figure of two fish headed in opposite directions. The southern fish was the sky sign for the Syrian Man-Fish God, Dagon, and for the oxyrhynchus, one of the largest fish in the Nile, worshiped in Egypt.[7] Another view sees the fish of the zodiac as male and female twins, the offspring of Aphrodite and her son Eros.[8]

The stained-glass Pisces appears at Chartres, that magical cathedral from the thirteenth century C.E., dedicated to the Virgin whose son epitomizes Pisces.[9] The astrological aspect for the birth of Christ comes directly from Matthew: "The Magi from the East were stargazers who, beholding an extraordinary constellation, inferred an equally extraordinary birth under the sign of the fish."[10] The birth took place at the conjunction of Jupiter and Saturn. Thus, even at the time of the Apostles, Christ was viewed from an astrological standpoint, and his birth was seen in terms of astrological myths.

251

251. Stained-glass fish from a window in Chartres Cathedral. France, thirteenth century C.E. (See plate 37.)

252

THE WATERS

The ancient Peruvians called themselves children of water and worshiped springs and lakes.[11] They set up their altars in groves near fountains or pools where their offerings were presented by the high priest. He dove deep into the water to give them to the goddess living there. To Peruvians a vase or water container became a religious symbol. One pre-Inca cup of dark wood comes from a grave in Peru. The fish-shaped section of the cup is carved in wood and inlaid with colored shells. Orange, the sacred color in Peru, is used in the shell inserts. The early Peruvians, like many primitive peoples, believed their ancestors suffered a thirst peculiar to the dead. Funerary libations were offered to satisfy this thirst and had the simultaneous function of cleansing the deceased. Purification through water links the Peruvians with ancient European cults.

NORTH AMERICAN INDIANS

The prehistoric people known as the Mimbre, from the southwestern U. S., remain a mystery, but their terra-cotta bowls are full of wit and charm. One bowl displays a crane with a multiple lozenge on its stomach, carrying five fish on an elongated undulating neck. In China and Japan the crane is a mother figure, and in Siberian myths it signifies the Triple Goddess.

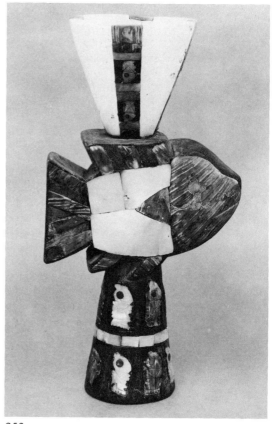

253

254

THE CELTS

The Celtic worship of wells is tied to the universal reverence for fish and water. Celtic equivalents of the Greek Fountain of the Nymphs were consecrated as holy wells. St. Columba blessed more than three hundred springs in Britain, exorcising demons from the waters. The River Dee, meaning divinity, worshiped by the Celts as the goddess Aerfon, was also called Dyfridwy, meaning "Water of the Divinity."

The holiness of the fish is further demonstrated on Gallo-Roman altars, where its appearance signifies its wisdom and prophetic abilities. One altar presents a fish apparently talking into the ear of a disembodied human head. According to Anne Ross, the stone relief depicts a Celtic hero, Finn MacCool, and his Salmon of Wisdom.[12] The salmon has otherworldly knowledge most useful to a hero, and protects him. He honors the fish by raising the salmon on his banner, so during battle the salmon whispers advice in his ear.

In Irish legend, a powerful goddess named Boann, She of the White Cows, creates the River Boyne and gives it her name. Formerly a well, the stream is shaded by nine magic hazelnut trees; in the well lives the divine salmon of knowledge, which swallowed the magic hazelnuts and thus became the wisest creature in the world.[13]

Rites of the Dead

According to Assyrian tradition, individual souls plunge into the waters of the Goddess's sacred fish pond in a baptism that promises rebirth. The fish acts as the bearer of the soul through the dark waters, and thus figures in funerary rites around the world. In many traditions the connection is repeatedly made between death and initiation; one must undergo some loss in a rite before one can gain wisdom. The concept is cyclical; the seed must go underground to be reborn.

THE EGYPTIAN THRONE AS LAP OF THE GODDESS

The Fish Goddess belonged to the netherworld in Egypt; Isis incarnate was the Great Fish of the Abyss. A striking bronze of an enthroned fish goddess, Hat-Mehit (from whom the cat, Mehitibel, took her name), comes from the New Kingdom (1580–1100 B.C.E.). She is crowned with a large fish and bears Hathor's symbols: horns and solar disk. The deity sits with the infant Horus on her lap, creating a throne for the young god. She offers Horus her breast in the manner of Hathor or Isis.

Although there is only iconographic evidence of a real matrifocal society in Egypt, kingship was determined by matrilineal descent through marriage with the sister. Word derivations offer clues to the rest of the story. In the oldest Egyptian form Isis's name, Ast or Auset, means "seat" or "throne."[1] The lap of the Goddess is enormously significant. The venereal mountain figures as the original throne. A coronation in Egypt was not effective until a king had literally mounted the throne and sat in the lap of the Goddess. The woman's mothering quality resides not only in her womb but also in the lap upon which her newborn child sits protected, surveying its kingdom. The lap as expanse of thigh relates to labia and lip and through them to the mouth of the mother vessel, the mouth of the river, and the mouth of the womb. In India, the king sits ceremonially on a throne representing the lap or womb. In Sicily, thrones are connected to the cult of the dead.

ISIS AND OSIRIS

The legend of the dismemberment of the Egyptian god Osiris by his brother Set is the story of a ritual battle between opposing forces that has its roots in early agricultural myth. After the god's dismemberment, Isis, his wife and twin (with whom he was destined to fall in love and mate while still in the womb), recovers from the water all the pieces of Osiris's shattered body except his phallus, which has been swallowed by

255. Bronze of Hat-Mehit, wearing a fish on her lotus crown and carrying Horus on her lap. Egypt, New Kingdom, 1580–1100 B.C.E.

255

a fish. Having bound the pieces together she fashions a golden phallus, lies upon the reconstructed body of her husband, and through her divine sorcery conceives their child Horus. Osiris is thereafter called the risen Osiris, although he remains below as God of the Underworld. Plutarch says the part Isis did not recover, the phallus, was carried about in festival processions similar to the Grecian Phallephoria and Haloa Festival (see fig. 234).[2]

The fish symbol has both positive and negative sides. In Egypt it becomes the emblem of Set, the brother and murderer of Osiris. But it can also be an emblem of triumph, as when the fish that crowns the Goddess stands for a victory over death.

The double twins, Isis and Osiris, and Nephthys and Set, symbolize the androgyny found typically in divinities of cosmic fertility. The two sets of twins, originally seen as a unit, represent a dark side and a light side, eventually reunited by sexual love.[3]

Osiris repeats the pattern of a god sacrificed to create new life, doomed to die like the corn and be resurrected again and again. In the same way, the lover-sons of the Great Goddess die every seven years, in imitation of the vegetation cycle. Mystery plays that reenacted the sufferings, death, and resurrection of Osiris took place at the town of Abydos, where Isis resurrected the God

256

and, therefore, the most ancient site of his worship. Osiris's shrine contained a splendidly ornamented statue of the deity, dressed afresh each month for the festivals of the new and full moons.

A fish shrine was discovered in the surface rubbish by a tomb near the Nile at Abydos. The object of devotion was the oxyrhynchus fish, and the emblems on its head show that the fish was identified with Hathor. As a deity interchangeable with the Fish of the Abyss, she symbolizes resurrection. The name Abydos is derived from the Greek form of the Egyptian hieroglyphic for fish, *abtu.*

EGYPTIAN FUNERARY RITES

An Egyptian tomb fresco of 1304–1237 B.C.E. shows Anubis, Guide of the Dead, initiator and opener of the way,[4] embalming a fish-shaped mummy. Flanking him are tiny guardian figures, the deities Isis and her dark twin, Nephthys, each on the bud of a lotus.

Christine Desroches-Noblecourt, of the Louvre, suggests that the mummy is the abjou, among the largest of the Nile fish. It can approximate human size and therefore was considered appropriate to represent the dead, who must make their way through the waters of the underworld. This fish is one of four taking part in different phases of

the ritual, each representing the soul in a separate stage of its voyage to a new life. Since the deceased is shown as one of the fish in which his soul will travel, we can assume that the ritual journey through the underworld has begun. Taking the symbolic fish-womb correlation a step further, fish, womb, and tomb are clearly emphasized.[5]

Observation of the daily movements of the sun gave rise to funerary rites meant to solve the mystery of the star's setting in the west and rising in the east. Believing that the sun traversed the waters of the underworld each night, the Egyptians assumed that the soul of the pharaoh, son of the sun, followed the same path to his own resurrection. Gradually the rites were democratized, and one did not have to be a king, noble, or priest to follow the pharaoh's night-sea journey to a renewed life.

On an Egyptian sarcophagus of the Hellenistic period (330–323 B.C.E.) the fish takes the place of the soul-bird that usually hovers protectively over the mummy stretched out on the lion couch. Traveling to its rebirth in the form of the oxyrhynchus fish, the soul navigates the waters of the underworld and visits pilgrimage sites along the Nile that represent stages of initiation. Like the oxyrhynchus, the phargus eel was considered an incarnation of the god. Therefore taboo, it was not to be eaten in these towns.

256. Sacred oxy-
rhynchus fish with
Hathor's symbols
on her crown.
Egypt, 1580–1100
B.C.E.

257. Fish mummy
guided by Anubis.
Egypt, ca. 1304–1237
B.C.E.

257

258. Stone Age
tomb in the form of
a shark affords pro-
tection for the spirit
of the Malekulan
man who built it.
Vao Island,
contemporary.

259. In Egypt, the
Tree Goddess pro-
vides food and drink
for the departed at
the tomb's garden
pool. Egypt, New
Kingdom, 1580–1100
B.C.E.

258

259

In Egypt and the Near East, the garden and pool stand for transcendental elements. Happy is the individual who has a garden and pool before his or her tomb, providing cool shade, fish, birds, fruit, and flowers. Ancient texts describe the deceased walking there, souls at peace, with hunger satiated and thirst slaked. On one Egyptian mural, the Tree Goddess lends religious significance to a calm garden and pool scene.[6] The fish in the temple pools of the ancient Syrian goddess Atargatis, to whom the fish was sacred, wore jewels in their gills and fins.

MALEKULAN RITES

Since the fish carries the soul after death through the underworld in many ancient traditions, the fish is an element in funerary rites worldwide. Despite its primitive aspect, the fish tomb on the Malekulan island of Vao, in the Pacific Ocean, was built in this century. Its builder, though our chronological contemporary, lived in a Stone Age culture. The sarcophagus of fieldstone rises some six feet and is thirty feet long, with fantastic monolithic stone slabs used for fins and tail. The shark tomb is an emblem of the Mother of Life and Death. Far from dynastic Egypt in time and space, the fish here retained its significance as a vessel of renewal.

The shark, chief devouring monster in this part of the Pacific, doubles for the Malekulan Guardian Ghost. John Layard speaks of this Guardian Ghost, Le-hev-hev, as being of uncertain sex and living in a cave in the realm of the dead.[7] Some clues, however, suggest that this supposedly neuter being is, in fact, regarded as female by the people.

The Malekulan symbolic rites of initiation suggest a return to the womb. These rituals are performed by entering a representation of the Earth Mother's womb, sometimes through a simulated sea monster. The symbolic womb serves a function similar to the initiatory hut of other cultures.

This symbolic return to the womb evokes the idea of being torn to pieces by the vaginal teeth of the Earth Mother or of being swallowed by a beast. One can see the goddess symbols at work in the rituals of New Guinea, near Malekula. In one ritual, the novice enters an artificial aquatic monster. Although the ritual is marked with terror and risk, the emphasis is on the mystery rather than the danger. The initiate acts out a ritual death in his quest for the sacred and mysterious forces that assure regeneration.[8]

260. At Palenque, in
a rare tomb within
a pyramid, a fish-
shaped sarcophagus
was designed for a
priest-king dressed
in jade. Mexico,
pre-Columbian.

261. Doors of a
Chinese tomb show
animal symbols of
the three worlds:
bird, tiger, and fish.
China, Han period,
226 B.C.E.–221 C.E.

THE MAYAN PYRAMID TOMB

Although amazingly similar in structure
to those of Egypt, the pyramids of Mexico
were not intended as tombs. However, the
Mayan pyramid at Palenque, unlike any
other Central American pyramid, houses a
true tomb. A few decades ago, the Temple of
the Inscriptions at Palenque yielded a
cunningly concealed stairway leading to a
superb tomb, a secret crypt dating back
to the seventh century C.E. The excavators
found rich funeral offerings of jewels placed
at intervals on the stair down to the tomb.

260

The walls of the burial vault were painted a
brilliant vermilion, and in the middle of the
tomb lay a great sarcophagus. When the
deeply carved cover was removed, it
revealed a highly polished inner lid carved
with an opening in the shape of a fish. One
end of the cover is flared like a fish's tail;
the other has round openings, placed as
eyes, that act as lifting holes. If the fish on
the lid represents rebirth, then the tomb
shares the same symbolism of the Egyptian
pharaohs and the builder of the Malekulan
shark tomb.

Inside the sarcophagus lay the priest-king,
covered with fabulous jade jewels in a
manner to suggest the volume and contours
of the flesh supporting them. Over his face
was a magnificent mask of green jade, the
sacred color, with eyes of white shell and

261

dark obsidian. This shimmering green mask lay against a glorious contrasting red ochre powder that covered the bottom of the sepulchre. Red ochre burials go back to 35,000 B.C.E., in Paleolithic Europe. As noted, images of the Goddess, of her followers, and many of her sacred objects have been painted red throughout history to symbolize blood and its life-giving qualities. All in all, the tomb suggests a theocratic system akin to Egypt's in which the king is also high priest and, both during life and after death, a god. Engraved on the stone that covers the tomb are stars that, in the magnificent phrase of Luis Ruz, the secret crypt's archaeologist, "mark the impeccable rhythms of time."[9] Above the body appears a crosslike motif that in Egypt indicates stars; life reborn after death.

CHINESE RITUALS

Two tombs recently uncovered in China reveal similarities between the rites and the art of China and of Central America. One tomb is from Mancheng, in Hobei Province. Inside the tomb, clothed in a suit of jade, lay a man of high rank, his features hidden behind a jade mask. The splendid tomb of a noblewoman of the Han dynasty was recently discovered. She was similarly clothed. Prepared in successive coffins, her body was lowered finally into a vermilion bath, which was still liquid when it was found.

The stone doors of a funerary chamber of the Han period (226 B.C.E. to 221 C.E.), from Honan Province, are carved with a triad of animals that symbolizes the three worlds of traditional Chinese thought. Each door is divided into three sections. On top is a bird, perhaps a pheasant, signifying the sky; in the middle field is a tiger's mask that represents the earth; and at the bottom is a fish that represents water. The door is the gateway through which the dead depart life to be reborn.[10]

Although China was not greatly affected by outside influences during the period preceding the introduction of Buddhism, the notion of the three worlds of the Triple Goddess, universal, corresponding to the cyclical pattern of human experience, seems to have been appearing in widely separated cultures at roughly the same time. The three-pointed hat on the tiger's mask is reminiscent of the Buriat shamans of Siberia, and further examples have been found at Lackin in Scotland and at Piska in Bulgaria, where a figure wearing such a hat stands between two serpents.

The Fish in
Christian Ritual

The fish is, as it was in ancient times, a symbol of Christ. The famous acrostic for Jesus (*i*), Christ (*ch*), God's (*th*), Son (*y*), Savior (*s*)—the Greek *ichthys* meaning "fish"—deepened the meaning of the fish symbol. From the second to the fourth century the fish symbol often appeared on amulets, carved rings, stones, and sarcophagi. Because of persecution, early Christianity was a hidden faith. Baptism and the Eucharist were well-guarded secrets. In the latter part of the second century an early Christian, Abercius, formerly a bishop of Hieropolis (Phrygia, Greece), had an inscription, couched in symbolic language that only a Christian would understand, engraved on his tombstone. In part it reads: "My name is Abercius. . . . Faith was my guide, and gave me everywhere for food the Ichthys from the spring, the great, the pure, which the spotless Virgin caught and ever puts before the Friends to eat."[1]

From the earliest times, water, a feminine element, has been a medium of regeneration. During the years when Christianity flourished as an underground religion, the fish was an emblem Christians used to recognize one another. The first Christians, being Jews, may have taken the symbol of the Messiah as fish directly from the Assyrians or the Egyptians.

The celebration of the Last Supper by Christ and his Apostles was in fact the observation of a Passover seder. Communion, like the seder, signifies a giving of thanks, and the word *eucharist* in Greek means "thanksgiving." According to Saloman Reinach, in the Eucharist, fish have been replaced with bread and wine.[2]

In Mesopotamia, fish fulfilled fertility and funerary functions at the same time that they represented the eaten god. As a vegetation god, Christ parallels the sacrificial victims of many pre-Christian cultures whose bodies, like that of Osiris, were dismembered and scattered in the fields to ensure revival of the crops. Communion celebrations derive from early pagan rites at which human flesh and blood were eaten as a sacrament.

If these acts seem remote from present-day religion, it is because they have been obscured by the neater rituals performed today. According to the Roman Catholic and Orthodox Church doctrine of transubstantiation, the bread and wine of the Eucharist are actually changed into the body and blood of Christ, thus creating a less cannibalistic version of the original religious practice.[3]

Christ's cross and the fish are combined on a bronze amulet from southern France, dated to an early period of Christianity (300

C.E.). The origin of the cross as a Christian symbol is obscure, although pre-Christian crosses in various forms are found throughout the world, representing two opposing principles, the spiritual (vertical) and the material (horizontal).[4] The cross may symbolize the four earthly directions. It takes the form of the maternal tree, an instrument of death and resurrection. And so it evokes the myth of the eternal return.

262. Christ's cross combined with the fish. Southern France, 300 C.E.

262

The Pig

Boar-headed Mother
Goddess, seated on
a lotus throne,
stands for the
changing moon that
constantly dies to
be reborn. India,
seventh century
C.E. See fig. 267.

In early Neolithic pottery, the Earth Goddess appears in the guise of a sow. The pig was worshiped whenever women were entirely in charge of agriculture, that is, until the invention of the plow. The pig's habit of rooting around in the soil with its snout made the identification with sowing and reaping natural and led to its worship. Its sanctity also arises from its fast-growing body and multiplicity of offspring. No later than the seventh millenium B.C.E., the sow became part of the vegetation ceremonies.[1] During the Neolithic, a sow oracle existed, according to Robert Graves; hence the animal's association with wisdom and prophecy.[2]

The pig is and was used as a sacrificial animal around the world. The sow as the Goddess of Death persists as an intercessor between the living and the dead, used to reenact the mystery of dying to be reborn. To this day the powerful Rajput clan of northern India worships the Corn Mother, Gauri (abundance), in the form of the wild pig, which suggests a very early beginning date for these ceremonies.

The pig shares its symbolic value with the boar. In Mesopotamia, at Çatal Hüyük, in shrine EVI 8, rows of breasts molded over the jaws and tusks of boars express the idea that life comes from death.

In Neolithic sculpture from Old Europe, women represent the Goddess by wearing sow masks. Sometimes the whole animal is preserved; figures of pigs have grain impressed in their bodies so that the pig becomes one with the life-sustaining grain.[3] From Leskavic in Macedonia (mid-fifth millennium B.C.E.), a terra-cotta head of fine quality expresses the twinkling merriment of a pig's face and, at the same time, the Mother Goddess. To make the relationship explicit, copper earrings or a necklace often adorn the deity; here both ears are broken exactly where they would have been pierced. The jeweled earrings embedded in the fins and lips of the sacred fish of Atargatis, in Dea Syria, reflect a similar religious intention four thousand years later.

CRETE

Because they were less expensive to feed and care for than bulls, sows appear as lesser sacrificial animals in vegetative festivities. Afterward they were eaten by worshipers who thus partook of the essence of the divinity. In Crete the pig was a favorite sacrificial animal at the Peak Sanctuary on Mount Juktas and other mountaintop shrines consecrated to the Lady of the Beasts. In Crete the Crone, as the Goddess of Wisdom, takes the form of the sow.

263. Sow's head personifies the Mother Goddess in a Neolithic terra-cotta. Leskavica, southeast Yugoslavia, mid-fifth millennium B.C.E.

GREECE

A legend helps to explain the curious rite of the Thesmophoria, a three-day harvest festival dedicated to Demeter and celebrated exclusively by women. At the time when Hades abducted Demeter's daughter Persephone, a swineherd was tending his pigs nearby. As the earth opened, the man and his flock were engulfed by the chasm down which Hades and Persephone vanished. This incident became part of the ritual of the Thesmophoria, following the main event: little pigs and phallic symbols were cast into a natural crevice of the earth, symbolic of the Earth Mother's vagina.[4]

The Sow Goddess gained significance through the cult of Demeter-Persephone; the cult of Demeter evolved through vegetation rites, which in Europe used the sacred pig. Much of the spirit of the religion with its blend of savagery and spiritual aspiration came down through the Thesmophoria. After the festivities were concluded, the women went off with the men and made love in the furrows of the fields to ensure the success of the crops. This ritual establishes a direct connection between human sexuality and agricultural fertility.

The Sow Goddess acts as an epiphany of the Lady of the Plants. Demeter often carries a torch and under her arm a small terra-cotta pig; so her connections to the underworld are made explicit. On the coins of Eleusis, a

263

264. Woman in the
birthing position
seated on the pig
symbol of fertility.
Southern Italy,
Hellenistic.

264

pig stands on a torch, which can only represent Demeter's Eleusinian Mysteries.[5]

Lewis Carroll's *Alice's Adventures in Wonderland* is an allegory of the mystery drama. It recounts Alice's descent through a rabbit hole to the underworld. There she encounters all the beasts; they gather about her, anxious to receive a prize. Alice then meets the disciplinary duchess who holds a baby in her arms. She gives the baby to Alice to nurse and it turns into a pig. Alice thus becomes Demeter-Persephone, Queen of the Underworld. Growing small and tall is a life-altering experience. The baby represents new life after the ordeal. If one reads with wit, the story becomes one of transformation.

One Hellenistic statuette from southern Italy plays off the pig's attribute of fecundity. An archetypal nude female sits sideways, holding the transcendental ladder, legs spread wide in the birthing position, on the back of a boar. The figure mirrors rites of earlier times when fertility, death, and resurrection partake of each other.

The seed follows the seasonal drama of vegetation; it must go underground like Demeter's beloved daughter, who, as noted, was carried down to the underworld by Hades. This springlike child, Persephone, represents the blossoming side of nature, the youthful aspect of Demeter herself; the

Harvest Goddess, who through her wisdom, became the Crone. Offerings associated with Demeter, usually natural products of the earth such as uncooked grains, honeycombs, and unspun wool, filled Persephone's altars. The pig, however, the animal sacred to both Mother and Daughter, represented the great sacrifice, for its blood was charged with a portion of their divinity.[6]

Purification rites, in which the pig played a central role, were essential to drive out evil. Representing the spiritual force of the feminine, the pig was beloved by Greeks to cleanse both spirit and body. Its special cathartic values were charged with the powers of the underworld that play a large part in the stories of Demeter and Persephone. At the Thesmophoria, the evil expelled sometimes took the form of demons, and the boughs and sprays of certain strong-smelling trees, such as laurel and withy, were used by Attic women for purification. First they beat themselves with the boughs and then anointed themselves with pig's blood. To purge oneself of a greater offense required more effort and ceremony, as when Apollo killed the python at Delphi. In one vase painting, Apollo himself administers the purification rites to Orestes, holding over his head a pig dripping with blood.

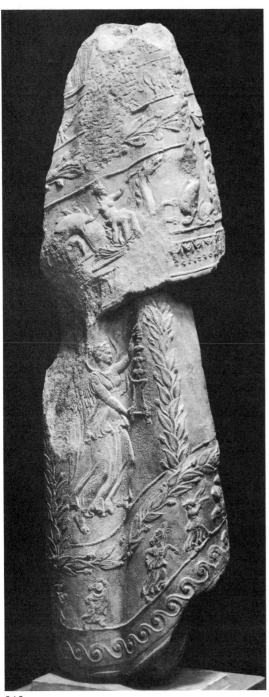

265. On the lower left of a fragment of marble drapery, a dancing figure wears hooflike sandals and a pig's mask. Greece, Hellenistic.

Phorcys became the father of Hesperides, whose prophetic wisdom was inherited from earlier sow oracles.[7] The belief in the pig's gift of divination spread, and the inhabitants of the northern Celebes believed that oracular power could be induced by drinking pig's blood.

In Athens, the memory of the pig's worship persisted. As late as the second century C.E., priestesses danced in ritual masked as sows and wore cloven hoofs. Found in the temple dedicated to the Despoina, the Kore (Kore is another name for Persephone), at Lycosura, a piece of marble drapery shows dancing figures engraved around the hem. One of them, in the lower left, wears a sow's mask and hooflike sandals, reflecting the actual rite of earlier times.

EGYPT

The god Set, as boar, plays the role of death-dealing beast who kills his brother Osiris, the vegetation god of Egypt, beloved of his sister, Isis. Grainne, the Irish goddess, undergoes the same tragedy with her lover, Diarmid; and the pattern repeats itself with the Syrian Tammuz and other deities.

Taboo in Egypt, the pig was considered unclean, and even swineherds were despised. Yet pork was eaten once a year, during a full moon, and Osiris was associated with the pigs sacrificed for these moon

266. In present-day Stone Age Maleku-la, a labyrinthine lozenge design traces the path to rebirth. New Hebrides, contemporary.

266

rituals. Meanwhile, the sow continued to be a sacred beast of the Sky Goddess, Nut. A dramatic text quoted by Henri Frankfort contributes another view of the sow: it describes the goddess Nut swallowing the stars at dawn to birth them again at dusk. In this aspect, Nut is called "the Sow who eats her piglets" and is represented as a sow.[8]

PALESTINE

It was difficult for Greeks to understand why the pig was abhorred by Israelites, Muslims, and, for that matter, Egyptians. Left on its own, the pig is as clean as any other animal. Is the pig forbidden because of its "uncleanliness" or because of its sanctity? The Jewish taboo on pigs' flesh was certainly not a reasonable and sensible effort to avoid trichinosis, as the modern rationalization would have us believe. Saloman Reinach writes:

In the whole of the Bible there is not a single instance of an epidemic or a malady attributed to eating of unclean meats. . . . The pious Jew abstains from pork because his remote ancestors, five or six thousand years before our era had the wild boar as their totem.[9]

Although some Jewish sects ate it secretly as a religious rite, much evidence suggests that it was not eaten in Palestine because it was divine.[10] This ambivalent attitude toward pigs has been constant through the ages; within most cultures the animal usually has both positive and negative connotations.

INDIA

Although repressed, the Sow Goddess lives on. A high relief from northern India (seventh century C.E.) shows a boar-headed mother goddess with great breasts seated on a sacred lotus throne, a child in her lap.[11] Later, when hunting became a game, Phorcis, the Sow Goddess, was masculinized into Phorcys.

OCEANIA

Rites of initiation from the Stone Age were models for the Greek and Egyptian vegetation mysteries that reenacted the sacred drama of death and rebirth. The mortuary rites of the Greek Thesmophoria festival parallel those of modern Malekula (in the New Hebrides off New Guinea), where the burial rites include throwing a live pig into the grave to placate Le-hev-hev, the Guardian Ghost. The Malekulans regard the pig as the most sacred of animals. "Every native, however poor, possesses a pig destined to be sacrificed and eaten on the day of his death."[12] In this way, a rite can live on even after its original meaning is lost.

267. Boar-headed
Mother Goddess
with a child in her
lap, seated on a
lotus throne. India,
seventh century
C.E.

Rituals of this present-day Stone Age
culture refer to the labyrinth and the
devouring monster in a manner similar to
the myths of Greece and the ancient
Near East. An intricate Malekulan dance in
which the participants thread their way
through rows of dancers "corresponds with
the path followed by the dead man through
a mazelike design drawn in the sand by
the Guardian Ghost."[13] Drawn by women,
the ritual sand tracings are complex
labyrinthine webs whose central figure,
frequently in a lozenge, represents the
tomb. In parts of Scotland and northern
England today, women draw tangled thread
designs on thresholds and hearthstones to
ward off witches and evil influences.
Labyrinthine designs abound throughout
Europe and Asia.

In the New Hebrides, the island group to
which Malekula belongs, the pig is often
represented by a cowrie shell, and cowrie
shells commonly connect the pig with the
divine vulva through which birth and
rebirth take place. The Romans called the
shell both Little Sow and Alma Mata ("Soul
Mother"). Cowries are still much used and
valued by primitive cultures.[14]

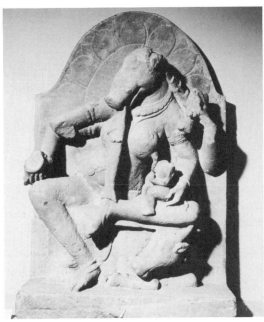

267

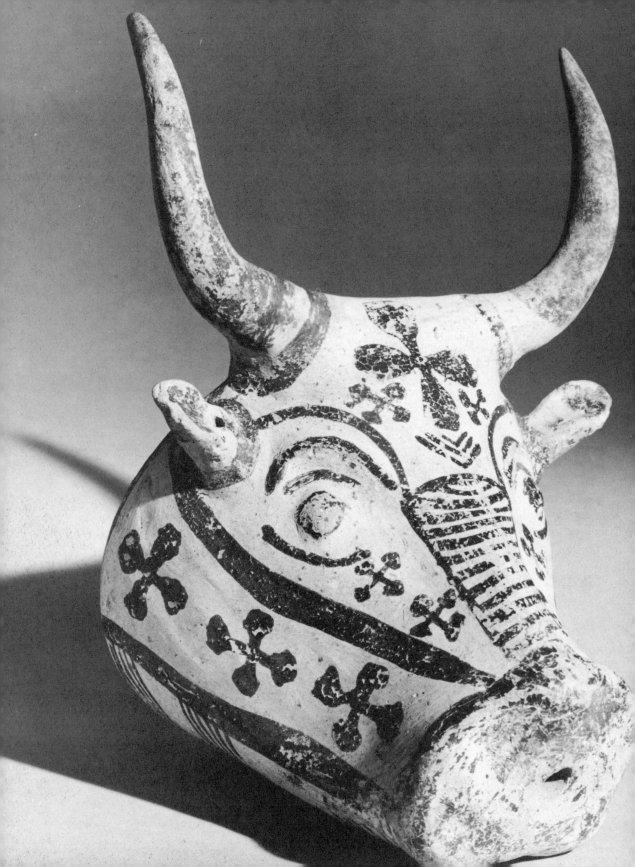

The Cow and the Bull

Quatrefoil and
chevron symbols of
the goddess on the
face of a bull. Crete,
1600 B.C.E. See fig.
292.

The Cow Goddess

In some ancient mythologies, the cosmic cow, Mother of All, creates the universe. With a flick of her udder, the horned moon cow creates the starry firmament; out of her flows the Milky Way in an abundant, never-ending stream. She gives birth daily to the life-giving sun.

The Sanskrit *gau*, and Egyptian *kau*—both meaning "cow"—appear in the names of goddesses such as the Hindu Gauri and Kuri; they are also related to the cowrie shell, a universal symbol of the womb.[1]

In the ancient world where cattle were raised, the worship of a cow deity was practiced in association with the worship of a Mother Goddess. Her symbol in this context was the reed bundle, and it was raised over every cattle byre in the Fertile Crescent, to protect the cattle's health and well-being. In India today the worship of the cow remains a living faith that can be traced back through neighboring Mesopotamia to predynastic Egypt, where the cow form of Hathor was adored.

In the myths of India, the universe, born from the milk of the Goddess, becomes solid through the churning of the milky ocean. The celestial milk flows from the cow, Surabhi. In addition to being the raw material for dry land, it is the nectar of the gods, whom Surabhi thus nurtures. It is because of Surabhi that the cow in India is

sacred to this day and may not be disturbed in her wanderings in town or country.[2] The identification of Hathor with the cow, a bond omnipresent in the Egyptian consciousness, is reflected in the art of Egypt and Spain.

From Japan to the lands of northern Europe, myths of cow reverence persist. They are less conspicuous than the bull myths because they are far older, dating from preliterate times, and have been altered almost beyond recognition by the subsequent religions.

THE WILD COW OF THE CAVE PAINTINGS

In the painted caves of the Paleolithic era, cattle and horses are often found close together, though in nature the species do not mingle. In Lascaux especially, the grouping of cow, bull, and horse is recurrent. The famous cow with foreshortened legs (an amazing early technical achievement, not to be revived until the Renaissance) is pictured plunging over a procession of horses.

Annette Laming proposes a possible explanation for the strange togetherness of cows and horses. She believes prehistoric pictures were intended as compositions, not as random isolated figures. In the minds of these early people, she suggests, cattle were

268. The cow as a symbol of the female. Lascaux, France, ca. 17,000–12,000 B.C.E. (See plate 43.)

269. Paleolithic cow leaps over a procession of horses. Lascaux, France, ca. 17,000–12,000 B.C.E.

268

269

270. Proto-Elamite cow deity. Iran, ca. 2,900 B.C.E. (See plate 42.)

270

feminine symbols and horses were male symbols.[3] Pairing the sexes might therefore be the reason for the animals' unnatural juxtaposition.

THE COW IN THE MIDDLE EAST

In one artifact from Iran (ca. 2900 B.C.E.) the Mesopotamian Mother Goddess, in human form with a cow's head and hoofs, kneels. The vessel she presents embodies herself.

In present-day southern Iraq, reed huts thirty to forty feet long are still being built and used as living quarters for the more prosperous families of the Marsh Arabs. Many thousands of years ago, in the fourth millennium B.C.E., such reed huts and byres were used to house the sacred herds of Inanna. As sanctuaries of the deity, marked by looped reed bundles, they were the property of the Goddess. These bundles resemble the sacred knotted scarf of the goddess in Crete two thousand years later. They were also used in the temple of the Cretan Goddess. Inanna and the Eye Goddess share as their symbols the dove, the snake, and the double-axe. Joseph Campbell suggests that the number of symbolic connections between the goddesses point to either early migrations to Crete from Sumer or, more probably, to a common source.

From Sumer to Babylonia in the eastern Mediterranean, the carved relief called "the little calf with the milky mouth" is found as a sacred motif. Since a primary concern of Neolithic religion and art was fertility, a cow nursing her young was a well-known fertility symbol in cattle-raising cultures.

Although the bull was held in high esteem, it apparently did not represent a sexual partner of the Great Goddess. Her reproductive capacities were presumably of a parthenogenic order. Despite its maleness, it symbolized the Goddess herself. In fact, because the bull's head closely resembles the female reproductive organs, writes D. O. Cameron, it is a metaphor of the womb and of birth.[4]

Modern medical journals show the shape of uterus and fallopian tubes: the rosettelike openings of the tubes may be turned up or down. Textbooks did not exist in 6000 B.C.E., but the inhabitants of Çatal Hüyük seem to have been familiar with female anatomy. One opportunity for this knowledge came when they followed the custom of secondary burial. As the vultures fed on the bodies, they laid open the internal organs. A mural at Çatal Hüyük shows a woman driving off the birds, perhaps to study the structure of the partially dissected corpses.[5]

271. Cow nursing a
calf functions as a
fertility symbol.
Iran.

272. Looped reed
bundles of Inanna
resemble the sacred
knotted scarf of the
goddess in Crete,
2000 years later.
Iraq and Crete.

273. Bull's head and
horns from Çatal
Hüyük, covered
with lozenges,
resembles medical
drawing of the
uterus and fallopian
tubes. Turkey, 6500–
5700 B.C.E.

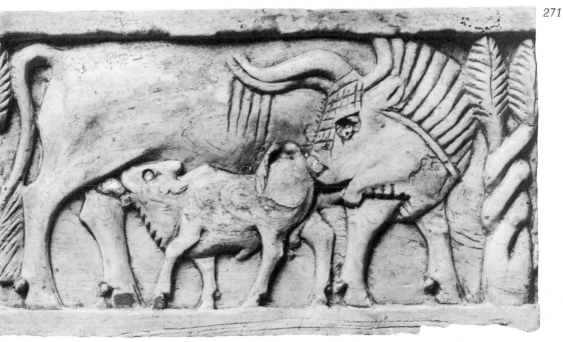
271

272

273

274. Star-headed female with raised arms suggests a bovine-headed deity whose horns end in stars on an Amratian slate pallet. Egypt, before 3100 B.C.E.

275. Hathor in cow form emerges from the hillside through papyrus flowers. *Book of the Dead*, Egypt, 1320–1200 B.C.E. (See plate 39.)

275

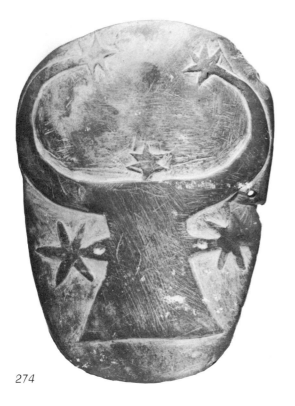

274

EGYPT

A mysterious slate palette from the Amratian culture of prehistoric Egypt creates a provocative double image: in one view it is a celestial bovine-headed deity whose horns and ears end as stars.[6] It can also be seen as a star-headed female figure whose raised arms end in starry, flowerlike hands and around whose waist stars circle. A remarkable relationship exists in this double image and the one Emmanuel Anati called the Lady of the Cave, discovered in the Magourata caves in Bulgaria (ca. 1850 B.C.E.).

HATHOR, ISIS, AND NUT

In Egyptian art, Hathor appears in a variety of guises, most often wholly in cow form. Hathor is the face of the sky, the deep, and the deity who dwells in a grove at the end of the world. One of her names was Lady of the Sycamore, and the tree was considered her living body. Hathor's fruit provided the seeds of renewal. Beyond the grave as a cow, she suckled the newly dead. "Seek the Cow Mother" is the legend written on the walls of the tombs of the early kings.

In one illustration of earthly delights the Goddess emerges, covered with stars, from the papyrus flowers of the Western Mountain, place of the dead. She is adorned with a collar, a saddle cloth decorated with the net

276. Hathor's cow-eared head appears beneath a headdress of a sistrum. Egypt, Saite period, 663–525 B.C.E.

277. Hathor's head, with cow's ears and horns, commands the funeral pallet of the first dynastic king, Narmer. Egypt, ca. 3100 B.C.E.

pattern, and ostrich feathers between her lyriform horns.

So far as we know, Hathor is the first divinity depicted in Egyptian art that has come down to us.[7] Her cow-headed image dominates the predynastic funeral pallet of King Narmer (ca. 3100 B.C.E.), a reminder, perhaps, that the throne was inherited through the female line. A similar image of her face appears on the great pillar capitals of her temple in Dendera, where special reverence was paid to her sacred cows.

Crowned by a damaged sistrum, the cow-eared Hathor, from the Saite period (663–525 B.C.E.) has a strange but handsome face marked by a cow's ears. From the center of her headdress rears Neith as cobra, coiled to strike. Along the base of the sistrum, a row of twelve uraeus snakes guard her forehead. The music of the sistrum accompanied the dances performed in the worship of Hathor. The instrument was called the fertility awakener and symbolized the deity. The sound of its music is still heard in Nubia, up the Nile, where it continues to be used in local fertility rites.

A creation myth preserved in a text from Gebelein describes the first creation:

My majesty precedes me as Ihy, the son of Hathor. . . .
I slid forth from the outflow between her thighs in this my name of Jackal of the Light.

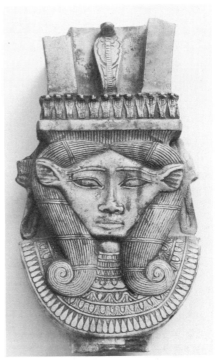

276

277

278

278. King Ameno-
phis II stands pro-
tected beneath
Hathor's head and
also kneels to drink
from her udder.
Egypt, ca. 1450–
1425 B.C.E.
(See plate 46.)

I broke forth from the egg, I oozed out of her
 essence,
I escaped in her blood. I am the master of the
 redness.
I am the Bull of the Confusion, my mother Isis
 generated me . . .
[this happened] . . . before the disk had been
 fastened on the
horns, before the face of the Sistrum had been
 molded—
The flood it was that raised me up while the
 waters gave me—. . .
I built a house (in Punt) there on the hillside
 where my mother resides beneath her
 sycamores.[8]

Until Isis appeared, a late deity of the
Egyptian religion, Hathor reigned supreme.
In one story, Isis's son Horus, whose name
means "House of Hathor," cuts off his
Mother's head and replaces it with the head
of a cow.

In a statue the sacred Cow Goddess, Hathor,
has a golden body covered with trefoils and
quatrefoils that resemble the myriad stars.
Between her horns she bears the sun disk,
wreathed by soaring flowery plumes as she
steps through a papyrus thicket. She pro-
tects the king, Amenophis II (ca. 1450–
1425 B.C.E.), who stands beneath her head.
A simultaneous side view shows the young
king kneeling to drink from her udder. Her
nourishment, the passport to kingship,
provides the sustenance that protects him
on his journey to the next world, where she

alone presides. Her maternal care confers
eternal divinity on the kings. The bull's tail
that hung from the belts of the pharaohs
was a reminder of their debt to Hathor and
remained part of the pharaonic ceremonial
garb for over three millennia.

Hathor's lighter side, shown in her role as
Goddess of Sensuality—art, joyful singing,
music, the delight of dancing and love—
embodies all the pleasures of touch.[9] It was
likely that the priestesses of her temple
gave themselves to strangers, a custom in
Asia Minor where the sexual act was
considered a form of adoration of the deity.

Other goddesses, such as Neith and Isis,
also were worshiped in cow form in Egypt.
Nut, the Goddess of Death, who created the
universe and ruled the heavens, appeared
as a great cow with stars on her belly. She
gave birth to the sun each day in the eastern
sky; the Bull of Heaven impregnated her
every morning and the rising sun was her
calf. Although the bull of morning died with
the sunset each night, he was born again
each day. This intimacy is yet another
reason Nut's image adorns the tombs and
coffins of the kings, expressing hope for
renewed life.

THE SACRED HORN—GREECE AND CRETE

The sacred marriage rites of the cow-horned moon priestesses and the bull-masked sun kings of ancient Cretan dynasties symbolize the mating of sun and moon. In the myth of the Moon Goddess, Pasiphae, ("She Who Shines on All"), the architect Daedalus builds a hollow wooden cow for her. He covers it with a cow's hide, and tells Pasiphae how to slip inside and draw the attention of the splendid white sun bull. From this curious mating came the Minotaur.[10]

The abduction of the Moon Goddess, Europa (the full moon, She of the Broad Face), echoes the tale of Pasiphae and describes the union of cosmic forces. Zeus successfully woos Europa in his disguise as a gentle bull, and with her on his back he speeds through the sea from Phoenicia to Knossos. Mother of the race, she bears Minos in Crete. On the metope of a Greek temple in Sicily, Europa is the central character in the abduction drama. With her left hand she holds the bull's horn, revealing her control over its magical powers. The journey from her native Phoenicia can be interpreted as an initiatory sea journey in which the bull, as psychopomp (soul bearer), carries her through the watery depths to bring about rebirth.

Hera, the powerful Moon and Earth Goddess described throughout Homer's *Iliad* as ox-eyed, was worshiped as the Goddess of the Yoke at Argos, where many votive images of cows have been uncovered, all of them dedicated to the Goddess in whose temple (Heraion) sacred herds were kept. She is the counterpart of the Moon Cow, Io, from whom the Ionians took their name. Herodotus tells us that the Greek Cow Goddess, Hera, Io, or Latona is the equivalent of the Egyptian deity Buto. The holy city of Buto, named after that goddess-queen, was the oldest oracular shrine in Egypt. In addition, Hera is identified with Hathor in Egypt and with Ishtar-Astarte in Mesopotamia. Worshiped first in Babylonia and then in Persia, Anahita was revered with offerings of white heifers and green branches. All of these cosmic deities share the cow's fruitful attributes.

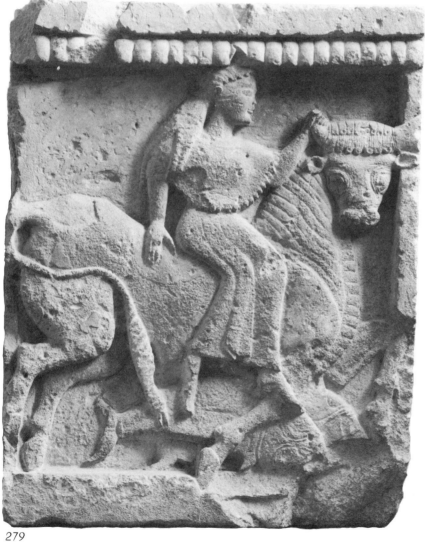

279. Metope of a Greek temple in Sicily pictures Europa riding Zeus the bull and holding his horn. Sicily, ca. 600 B.C.E. (See plate 41.)

Fertility

Although cow and bull share many symbols, the two animals are fundamentally different. Since the cow is a divine epiphany of the Goddess herself, in the new religion the bull is raised to the status of a deity. Over time, the ancients connect the bull image with both goddesses and gods. With a life force so strong that it springs forth as horns, the sacred bull expresses the mystery of birth. Later, as the great fecundator of nature and incarnation of the Corn Spirit, the bull plays an important role in ritual as a symbol of phallic power (though not as the sexual partner of the goddess who, as mentioned, is parthenogenic). In Greece, he embodies the moist sun beneficent to plant life. Like the cow, the bull is so holy that he imbues others with his sanctity. He is called "The Sanctifier."

A symbolic fusion of horns and moon is characteristic of a people who constantly observed the sky. Among bull-worshiping peoples, lunate horns are a cult object emblematic of the moon's influences on growth and the power of the Goddess over nature.[1] When women planted according to the lunar calendar, the bull was worshiped above all other animals.

The belief that women and earth were similarly nubile persisted long after primitive horticulture developed into more sophisticated techniques of sowing and reaping. Women alone participated in the late vegetation festivals of classical Greece and devoted themselves to the female divinities of the soil.

Until recently there was no known bridge from the bull and goddess link that existed in Paleolithic times to its flowering in Neolithic cults millennia later. The findings by Gimbutas in Old Europe and at Çatal Hüyük in Anatolia established a religious continuity between the European art of the Upper Paleolithic era and the fertility cults of Crete and the Near East.

As the matrifocal influence waned, the son-lover of the Goddess gained in power until he achieved kingship. In earlier fertility rites, kingly powers were sealed by marriage to a bovine Moon Queen or a priestess of the Goddess. As has been mentioned, cow queens were necessary for the renewal of kingship in Egypt, and divine right was ordained by matrilineal descent.

THE WAGON AND FERTILITY IN GREECE

As soon as the wheel was invented, the ox-drawn wagon became an emblem of the vegetation deity. In some places she drives a chariot drawn by bulls; in others her image stands in the sacred wagon-cart. Patriarchal cults evolved as goddess-oriented rites were absorbed into masculine rituals. In the

280. Rhyton used to
fertilize the fields
by sprinkling them
with blood. Crete,
1100–1000 B.C.E.

early phases of the Greek cult of Dionysus
(ca. fifth century B.C.E.), his rites are clearly
superimposed over the existing goddess-
centered religious order. With the new
Moon God of Vegetation, represented by the
sacred bull, the masculine role as insemina-
tor is stressed. At the summer solstice, his
cult wagon was wheeled over the fields to
bless the land in the manner of the ancient
Fertility Goddess in past millennia.

A small terra-cotta rhyton from Bronze Age
Crete (1100–1000 B.C.E.), in the form of a
vehicle with a driver and three bulls' heads
in front, illustrates the ceremonial use of
a cult vessel in the promotion of the soil's
productivity. Its sieve-like bottom permits
the sacrificial blood to fall through and
stimulate the earth. The vehicle may have
been visualized as a three-step altar.

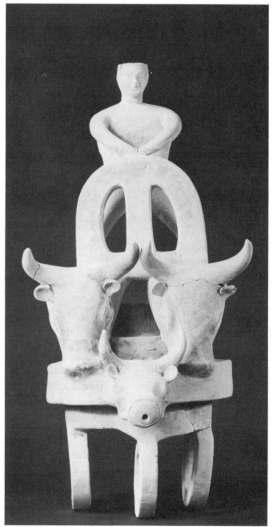

280

THE WAGON AND FERTILITY IN SCANDINAVIA

The connection between fertility, the goddess, and the wagon also exists in Scandinavia, in association with the deities Nerthus and Freyja. According to a lucid Roman account (first century C.E.) of the sacred rites of Nerthus, the Nordic Earth Mother, villagers trundle her image through the towns in a wagon drawn by cows. Her visits are greeted with days of celebration and feasting, which end in human sacrifice.[2] The contents of the northern peat bogs testify to a dark side to the magic divinations of the *volva* (priestesses). Hundreds of extraordinarily well-preserved bodies have been unearthed in the marshy peat bogs of Denmark and other parts of northern Europe. Most of the mummies date from the Danish Iron Age (100 B.C.E. to 500 C.E.); isolated finds go back more than five thousand years.

Nerthus remained in power until the second half of the Bronze Age. Sacrifices uncovered in the bog graves reveal many features of her worship, including offerings of humans with ropelike sacred neck rings of gold or iron, as well as sacrificed draft animals and buried wagons. The worship of Freyja, divinity of fertility and death, was modeled on that of Nerthus and included a sacred wagon-cart in which she and her priestesses were pulled about the countryside.

Credited with the introduction of witchcraft, Freyja practices a form of soothsaying known as *seior*, actually closer to the powers of yoga than sorcery. This magic enables women with special mantic gifts to predict the future of newborn children, the matrimonial destinies of young people, and the success or failure of coming crops. Journeying from village to village and feast to feast in their wagon-carts, the shamanesses travel alone or in groups, their peripatetic way of life an imitation of the moon's wanderings. Apparently, they acted as priestesses of the Vanir, a group of matriarchal and agricultural deities led by Freyja. Through magic they could cure the sick, divine the hidden, and control unseen events in the life of the community. Elaborately bedecked in animal skins and wearing cat-skin gloves, the seeress sits on a cushion stuffed with hen's feathers. She performs animal sacrifices while the other participants sing a spell to lull the *Volva* into a state of ecstatic trance. According to H. R. Ellis Davidson, during the formalities of the ceremony, questions are put to her by the villagers, and little that she predicts goes unfulfilled.[3]

The *Volva* survived the conquering patriarchal deities longer than other symbols, to become the final representative of the fertility goddess in the north. The woman of high rank found in a ninth century C.E. Danish ship-burial at Oseberg is believed

281. Kachina cow
head with human
body. Zuni, North
America, ca. 1850
C.E.

282. George Catlin
painting of the
Mandan warriors
performing the
Sacred Buffalo fer-
tility dance. North
America, ca. 1835
C.E. (See plate 45.)

to have been a priestess of the Vanir; she
was buried with a beautifully ornamented
and carved ceremonial wagon. These
strange cultic rites, forerunners of the
medieval Lenten carnivals, celebrate the
coming of spring. Their exact origin is
uncertain, but the periods of riotous
vegetation rites and farewells to the flesh
are ceremonies for the expulsion of
death (winter) and demons destructive to
the crops. The word carnival is believed to
come from *carrus navalis*, or "cart of the
sea," a boat-shaped vehicle on wheels like
those used in the ship-cart pageants of
Egypt, the Near East, and the processions
of Dionysus.

Sacred noise-producing instruments such as
bells, sistra, drums, and bull-roarers were
employed in the religious mysteries of the
ancient world to summon worshipers and
ward off evil spirits. Thunderous noise
making, dancing, and the wearing of animal
masks are still central features of carnivals,
such as the Lenten Mardi Gras of New
Orleans and Carnaval in Brazil.

THE CORN MOTHER AND THE BUFFALO— AMERICAN INDIAN RITES

Universally connected with corn through
their role in planting, pounding, and
cooking, women perform the maize rituals.
The sowing and reaping of corn were

united by association with rites of fertility
and sacrifice. Corn is the generic term not
only for maize but also for oats, peas, wheat,
and barley. Since the Stone Age, rituals to
accompany the cultivation of barley had
existed in Europe, and the Corn Mother
played a central part in the harvest customs
there. The last sheaf of the harvest is the
Mother of the Wheat, the Harvest Mother,
or the Great Mother, and the harvest is not
officially over until the last wagon carries it
from the field to the barn.[4]

The worship of maize is among the oldest
of American Indian traditions, dating back
to prehistoric times. In the spring festivals
of the Mandan and Minnitaree tribes,
reverence was paid to the Old Woman Who
Never Dies, a corn spirit responsible for the
growth of crops. At the autumn buffalo
festivals, every woman carries a maize plant
while performing the dance of the corn
maidens. The later incorporation of
the buffalo, an animal similar to the bull,
into maize rituals allowed meat and grain to
be honored and was made possible by the
animal's symbolic tie to vegetation. By 1000
C.E., dances and ceremonies centering on
the buffalo flourished among the Plains
Indians.

For the Mandan Indians, the buffalo was an
animal of ritual importance and a source
of food, clothing, and shelter. Warriors
of the Sacred Buffalo Society, wearing great

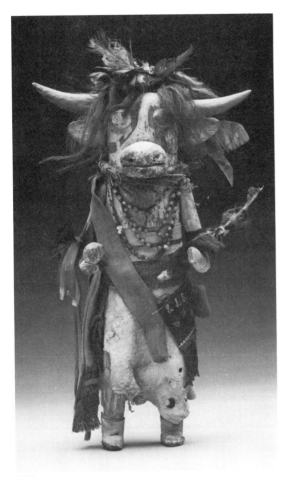

281

282

buffalo heads and skins and imitating the animal's movements, performed ceremonial dances for the success of their crops.[5] As recently as a century ago on the Great Plains, the buffalo's hide was used, as the cow's hide was in Egypt, to enfold the newborn and to cloak the dead for their journey.

A statue of a Kachina cow with human form from the Zuni tribe is altogether unique. Dressed in a buckskin skirt with a woven sash and moccasins, it wears a four-strand necklace. Its head is covered with hair and feathers, and it carries a carved wooden rattle and wand in its moveable arms. Its bulbous eyes and prominent nose make it comically fierce for so small a figure.

THE INDUS VALLEY CIVILIZATION

On a seal from the Harappan Bronze Age, the non-Aryan, pre-Vedic source of East Indian tradition (ca. 2500–1750 B.C.E.), the Goddess stands between the branches of a sacred fig tree. A horned god or divine king kneels before her, offering for sacrifice a sphinxlike combination of human, bull, and ram. Seven horn-crowned priestesses attend the Goddess, long braided hair flowing below their tiaras. The subject of the Harappan seal suggests the presentation of a gift by a divine king to a goddess whose generative powers will be triggered

283. Seal from
Harappa presents
the nude Goddess
standing in a pipal
tree and receiving as
sacrifice a combina-
tion of human, ram,
and bull. India, ca.
2500–1750 B.C.E.

by the sacrifice. There can be little doubt
that the seal represents renewal through the
female deity since the sacred fig, or the
large, long-lived variety known as the pipal,
is venerated in India. Women make votive
offerings to it by tying rags to its branches
and painting the bark with red ochre.[6]

The all-pervading presence of a Mother
Goddess cult is apparent in the archaeologi-
cal finds of the two major urban sites of
Harappa and Mohenjo-daro in the Indus
River Valley. Nearly three-quarters of all the
terra-cotta animals there depict hump-
backed bulls. The human forms are
predominantly female; their crude modeling
suggests that large numbers were manufac-
tured as household deities.[7] The small clay
pigs unearthed with the bull figures recall
the prehistoric bull boat engraved on a rock
face in the Nubian desert to promote
fertility.

The influence of Mesopotamia and the
Fertile Crescent, Persia, and Afghanistan
may have filtered into the nearby Baluchis-
tan hills and hence into the settlements of
the Indus Valley during the Neolithic period
(ca. fourth millennium B.C.E.). The numer-
ous terra-cotta figures of mother goddesses
and bulls and the repetitive geometric
pottery motifs display the familiar simpli-
fied dot-in-circle eyes, rosettes, and hatched
triangles. This evidence of early goddess
worship in the Baluchistan Kulli culture

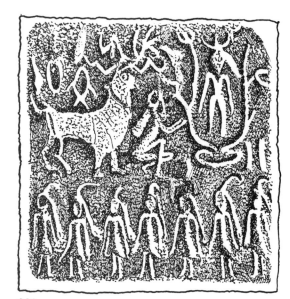

283

provides a connecting link between India and the ancient Near East.[8]

The collapse of the matrifocal civilization and the recession of its goddess queen resulted from the arrival of the patriarchal warrior-herders and the installation of their gods. Grazing denudes the land of vegetation. When plant life is consumed, roots shrivel and no longer hold soil; with years of rain the earth washes away, creating dust bowls. The prestige of women, cultivators of the land, declined when the volume and quality of the crops that sustained life in the Neolithic period dwindled. In keeping with the emerging universal pattern of masculine power, worship of the Mother was obliterated in the north. On the islands of Malta and Crete, however, her worship was maintained for many more centuries with no signs of a masculine god. The sanctity of the cow in modern India, a tradition of the goddess cult of the pre-Aryan Indo-Iranians, has managed to assert itself, as mentioned, despite centuries of dominance by the meat-eating pastoral Vedic peoples.

TAOISM

The Chinese religion of Taoism, like its Asian counterparts, involves a deeply nature-oriented approach to life. One theory suggests that the origin of the *Dao De Ving* (*Tao Te Ching*), Lao-tzu's collection of

Taoist thought, was originally rooted in the worship of the Mother Goddess. All of the images of the Universal Mother are described in the *Tao Te Ching*;[9] symbols of the Great Mother appear throughout. *Tao Te Ching* can be viewed as a hymn to the love and power of Divine Motherhood. Arthur Waley suggests that both the *Yi Jing* (*I Ching*), or *Book of Changes*, and the *Tao Te Ching* originated in moon worship. The very language of the Taoist text, with its constant celebration of the transformative life of the Mother, confirms the likelihood of these theories.[10]

Although the emphasis of the Confucian *Yi Jing* is decidedly masculine, there is evidence that an earlier version, the *Kun Qian*, in which the feminine power was given priority, was discovered by Confucius during the Chou dynasty. In the later Confucian text, the receptive *Kun* is the opposite of the creative, masculine principle *Qian*.

The trigram Yin represents all aspects of the feminine as Earth, Mother, and Belly or Womb, sometimes symbolized by the gentle cow. The spirit of the Tao moves toward a balance through humility, flexibility, and gentleness, and by the constant renewal of the tension between the polar forces of yin and yang, represented in the image of two interlocking spirals.

284. Lao-tzu, the wild one, astride a bronze water buffalo. China, Sung dynasty, 960–1279 C.E.

284

A Sung dynasty bronze incense burner shows Lao-tzu, the wild one, founder of Taoism, riding a water buffalo. The representation of the great Taoist philosopher on his animal vehicle expresses the reverence for life in the *Tao Te Ching* and submission to the cycles of change as seen in the feminine quality of nature. The theme is similar to "The Return on Oxback," part of the Parable of the Ten Oxen, an allegory of the process of enlightenment that is one of the few written texts of Chinese Zen Buddhism.[11] Jung called this process of enlightenment "individuation," the urge of the self for its own realization. In the allegory, which is accompanied by ten pictures, the ox in the paintings changes gradually from dark to light. In the last pictures, the work is done, all is forgotten in laissez-faire, the ox fades away, and the individual is alone with the solitary moon. Finally both vanish; the ox and the herder disappear.

In both China and Europe the midwinter solstice is celebrated as a feast of ghosts and spirits, a festival of the dead, and a burial of the sun that ends in resurrection. As elsewhere, in China the fertility goddess is the goddess of death as well. Even today Chinese wedding and funeral feasts echo the fruitful celebrations of ancient times.[12]

Death and Rebirth

In early times death was closely connected with the fertility rites of the Great Mother. The bogs of Denmark and northern Europe hold proof of the many individuals sacrificed to the divinity. A man with a rope around his neck, remarkably preserved by a Danish bog, attests to a purposeful death. A daring miniskirt of fringe worn by a young woman found in another bog supplies further evidence; the skirt duplicates the one on the priestess from the Danish bronze boat (see fig. 187). This side of the goddess is concerned with rot and decay, blood, death, the grave, and the close and holy darkness. They are, after all, part of the life cycle. Death, however unpleasant, was felt to be followed by renewal. Since such is the life cycle of plants, ancient people maintained the sophisticated idea that all animate life must keep this basic pattern. Rebirth was symbolized by the cycling moon and the luminous star. This transformation was not abstract in any sense; it was considered to literally take place. In the early Stone Age, people were buried with food, drink, and the wherewithal to make fire to provide for the life to come.

ÇATAL HÜYÜK

Predating other forms of decoration in the buildings, intricate geometric designs and three-dimensional images of bulls ornament the walls of the shrines at Çatal Hüyük (ca. 6500 B.C.E.). Textiles found in the shrines are decorated with a kilim pattern of lozenges whose complex maze design is similar to that of the kilim rugs woven in Anatolia today. Visual references to the Great Goddess include numerous suggestions of death and rebirth. Her presence is apparent, too, in flower forms, quatrefoils, breasts, horns, rosettes, rhombs, and triangles. There is no indication of animal sacrifice, only small deposits of grain and other offerings.

In addition to the huge bulls' heads and horns, modeled in plaster and sometimes decorated with red paint, plaster reliefs of goddesses in the birth-giving position, with arms and legs outstretched or turned upward, often dominate the walls. The birth of the Bull God from the body of the Goddess is the subject of some of the murals.

Further evidence of goddess worship permeates the ancient site. Women received preferential burial in the houses. The main sleeping platform was assigned to the mistress of the house and to her children. The rare red-ochre burials, given to eleven of the four hundred skeletons recovered, reveal bones of the female sex alone. Women's grave goods are generally identified by a sacred necklace.[1]

The west wall of one shrine bears a high relief of the Mother Goddess in the childbirth position. A large bull's head with widespread horns emerges from her womb. Over the burial platform on the east wall of the shrine a triad of elaborate, three-dimensional bulls' heads is mounted between two pillarlike posts on the central panel.

Some five thousand years later, a naked goddess mounted on a bull opens her flowery robe to reveal herself to her prostrate worshipers. Patroness of fields and crops, the Syrian divinity of fertility and death rides the powerful animal partner that, over a period of thousands of years, embodied the male principle almost never represented in human form. The male role in procreation did not go unrecognized in the later phases of culture; as the gender focus changed, the bull became identified as the royal partner to the deity. Around the Mediterranean during the astrological Age of the Bull (roughly 4000–2000 B.C.E.), the ruling king claims kinship with the sacred beast and so becomes guardian of vegetation. He magically assimilates the bull's fertilizing influences. The implications of this totemism were so far reaching, writes E. O. James, that few cultures in the Near Eastern and Aegean regions remained untouched by its influence.[2]

THE UNDERWORLD JOURNEY

Rites of initiation describe the difficult transition of humans from one stage of life to the next. The Goddess of Death, whose power of resurrection is evident in the oldest account of the rites of passage, tells of Inanna's descent to the abyss to intercede with her sister Eriskegal.

According to the myth, Inanna was stripped of her symbols of power at each of the seven gates, until she stood naked and splendid before her sister Eriskegal, the Lady of the Underworld. When Eriskegal looked at her, Inanna lost all life; as a corpse, she hung on a hook three days and three nights. Her father finally restored her to life, although a substitute had to be found to take her place in the underworld. When Inanna ascended to her realm, she discovered that her lover Damuzi had usurped her throne; angry, she sent him down to Eriskegal as her replacement. Finally, Inanna repented and allowed Damuzi to return periodically. As a Vegetation God, he ascends annually to earth for half the year, permitting the earth to bloom.[3]

At Ur, where the bull was known as the beloved of Inanna, the Cow Goddess, Ninhursag, is known as the guardian of fields and herds. She is worshiped as Mother of All, or She Who Gives Life to the Dead. A reclining cow or young bull decorates

285

285. In her shrine, the Mother Goddess gives birth to a large bull's head with widespread horns. Çatal Hüyük, Turkey, ca. 6500 B.C.E.

286. Divinity of fertility and death rides her partner the bull. Syria, ca. 1500 B.C.E.

287. Reclining cow or bull on a copper relief decorates the lintel of First Dynasty temple. Al'Ubaid, Iran, ca. 2500 B.C.E.

286

287

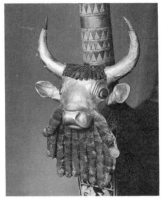

288. Figurehead of a
bull on a harp, from
Queen Shub-ad's
tomb chamber. Ur,
Iraq, ca. 2400 B.C.E.
(See plate 47.)

288

a copper relief on the lintel of the First
Dynasty temple at Al 'Ubaid, near Ur (ca.
2500 B.C.E.).

Also discovered in the royal graves of Ur
were the bodies of Queen Shub-ad and her
entire court. Human sacrifice of some
sort took place in the funerary rites,
although no signs of a death struggle are
evident: the remains of the exquisitely
dressed ladies of the court, attendants, and
musicians, some ninety bodies in all, are
carefully arranged in the tomb of the
resplendent queen. Her finely decorated
wooden chariot stands nearby, with the
bones of an ass on each side of the shaft. At
the pit's entrance lie the king's wagons;
beside them, laid out in orderly fashion, are
the skeletons of three rows of oxen and
drivers.[4]

In Queen Shub-ad's chamber, among the
rich array of grave goods, stands a harp of
gold and lapis lazuli adorned by the fabulous
figurehead of a bull that gazes at us across
nearly forty-five hundred years. His splendid
head possesses a face and horns of gold, a
curling spiral beard and eyes of sacred lapis
lazuli. Beside the harp lie the bones of the
gold-crowned harpist.

Although the grave pit of the king was
plundered of everything except the remnants
of two model boats, designed to carry the
king on his underworld journey; in the
chambered vault behind the king's room,

the treasures of the queen remained intact.
Her body lies on a simple wooden bier with
one woman attendant crouching at her head
and another at her feet. The entire upper
portion of the queen's body is covered with
beads carved from precious stones; three
fish-shaped amulets decorate her cloak;
lapis charms of a seated bull and calf hang
from her hair. The silver head of a cow lies
among the offerings, with many womb
symbols: large natural cockle shells, and
imitation shells fashioned in silver and
gold. An elegant headdress of leaves and
flowers is not only beautiful but points to
the queen's role in the vegetation cult.[5]

Ritual vessels of every description surround
Shub-ad's bier. The gold goblet near her
hand, like the simple clay cups held by the
women of the court in the outer chamber,
contained a strong sedative and hints
that hers, too, was a sacrificial death.

Forerunners of the rites celebrating the
underworld meeting of Inanna and her lover
date back to the early Neolithic rituals
held in tomblike caves. The Cave of the
Bats, in Spain, contained a Stone Age burial
remarkably similar to that of the queen of
Ur. The skeleton of a woman in skin robes,
with necklace and diadem of teeth and
shells, reclines in the inner chamber before
a semicircle of clothed and adorned
women's bones and woven baskets of grain
and poppy seeds, the latter possibly the

cause of their quiet deaths.[6] She probably died willingly, choosing to share a delightful hereafter with royalty rather than be cast into the dreary underworld of ordinary people. Later in the burials of kings and common people, female skeletons or emblems of the womb point to the ancient idea of the female as the instrument of rebirth.

The huge Nubian necropolis at Kerma in Upper Egypt is roughly contemporary with the burials at Ur (Old Kingdom, ca. 2850–2190 B.C.E.), and many males interred there appear to have been accompanied by sacrificed females. In these burials, the male dignitary lies on a bier whose legs are bull-shaped down to the hooves, his body covered with the hide of an ox. The peaceful posture of the dignitary's body is in sharp contrast to the tightly cramped female bodies, whose hands cover their faces or are wrung together. Sometimes they clutch their hair. One of the women, well supplied with jewelry and grave gear, was placed either directly in front of the bed or with the man beneath the hide.

The motif of the bull as carrier of the funerary vessel, or as the vessel itself, firmly unites him with the concept of regeneration. The Egyptian *Book of the Dead*, begun about 4000 B.C.E., describes a rite in which the deceased is wrapped in a bull's skin, a magical vehicle of purification, and placed in the Mesquet chamber. "Mesquet" refers both to the actual bull skin and to the chamber in which the deceased "passes through" the skin of a bull.[7] The goddess Meskhenet presides over the place of new birth, cutting the umbilical cord to this world and allowing the soul to enter the underworld. In one version of the myth of Osiris's resurrection, Isis gathered the pieces of his scattered body in a wooden box covered with ox hides.

Until fairly recent times, bull-related regicides, timed to a lunar calendar, were practiced by the African tribes of Zimbabwe and by the Shilluks of the Upper Nile. The strangled king was buried with a living virgin; after the two bodies had rotted, they were wrapped together in the hide of a black bull with a white mark on its forehead.[8] The African kings traced their descent from a divine ancestress, and a dramatic similarity exists between these ceremonies and the Egyptian rites of the dead.

Far to the east of Egypt, on the Indonesian island of Bali, the dead were traditionally, and are still, placed in tight-fitting cult vessels shaped like standing bulls. The elaborately carved and painted sarcophagi were placed in little open-air pavilions, along with offerings of rice and the head of a freshly slaughtered buffalo. Bulls, pavilion, and offerings were consumed in the funeral fire, the most sacred rite in the

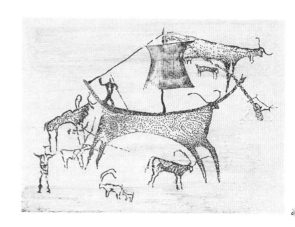

289. Balinese sarcophagi resemble standing bulls, emblems of protection and containment. Bali, Indonesia, contemporary.

290. The bull with boat on his back. Boat is used for celestial navigation, traversing the waters of the underworld. Holdein Magol, Egypt, ca. 3000 B.C.E.

289

Hindu-influenced Balinese religion. The ashes from the cremation were then scattered from boats at sea, the dwelling place of the demons, to ensure the soul's release for reincarnation. The nature of the cult vessel's protection and containment stresses the maternal relationship symbolized in the allegorical rite. Both womb and tomb are seen as nest, cradle, bed, ship, wagon, and coffin. All are wooden vessels that stand for the Earth Mother who brings forth life from herself.

CULT BOATS

The widely diffused and age-old use of cult boats in funerary rites is further substantiated by a curious and striking petroglyph (ca. 3000 B.C.E.) discovered at Holdein Magoll, a region in the Nile valley, south of Egypt. On the rocks near a burial site, an engraving shows a running bull with a serpent boat mounted on his back. In the imagery of the ancient Near East, the solar barge traverses the heavenly ocean; in Egypt from the First Dynasty on, sun boats were employed in the symbolic navigation of the soul to other worlds.

One boat transported the sun disk across the ocean of the daytime sky; the other carried it through the night-darkened waters of the underworld.[9] This explains the finely worked boats of silver and copper discovered

in the predynastic tomb of A-bar-gi at Ur and the two life-sized sailing vessels unearthed close to the Great Pyramid at Giza.

Extremely long-lived in Egypt and the Near East, the use of the ship as an emblem of rebirth existed in varying forms throughout the world, from about 2500 B.C.E. to Christian times. The excavation of the Indus Valley site of Mohenjo-daro unearthed miniature vessels of faience, clay, and stone.

Nordic countries used ships for burial of the dead: solar ships figure on Scandinavian rock paintings of the Bronze Age. By the early Iron Age, ship burials were a common method of inhumation, and ship models from peat bogs comprise some of the earliest remnants of civilization in the north. In England, where ship burials had existed since the Bronze Age, boat-shaped graves were frequently lined with stones, and barrows have yielded boat-shaped coffins made from tree trunks. Thanks to the fabulous ship burial at Sutton Hoo, we know that the custom continued in the Christianized Anglo-Saxon countries until the seventh century C.E.[10]

In Denmark during the Middle Ages, the ships carried in Christian church processions were modeled on those used in ceremonies to bless the fields when Freyja was worshiped, and the ox-drawn cart belonged to her as chief Fertility Goddess of the Vanir. To this day in Abydos and Luxor in Egypt similar boat processions are still enacted.

THE TAUROBOLIUM

The Taurobolium, a sacrifice ritualized to honor the Great Goddess, became popular during the last centuries of paganism. In one ritual, the high priest of the Great Mother, wearing a gold crown on his head and a white toga, descends into a dark abyss covered by a pierced platform. Led onto the platform is a great bull bedecked with flowers, his breast gleaming with gold. A knife flashes and the hot blood streaming from his slit throat rains in a purifying shower over the priest below, who then emerges and presents himself, dripping with blood, to the worshipers. The rite purifies the entire realm and all the people. Consecrated to Artemis in the East, and widespread in Asia Minor, the ritual of the Taurobolium traveled to Rome about the second century C.E. and was popular in Europe as late as 394 C.E.[11]

The Bull in the Labyrinth

The labyrinth, a magical maze constructed of stone, wood, turf, or hedge, affords a path of entry between worlds. Although many famous labyrinths exist, the Palace of Knossos was by far the best known. Its acclaim may be due to the popularity of the myth of the Minotaur, a bull-headed man. The coins of Crete, which carry a representation of a formal labyrinth on one side and the Minotaur on the reverse, were disseminated by trade through the known world.

The labyrinth, over which a female always presides, symbolizes death and rebirth; it depicts a journey to the center and out again. G. Rachael Levy traces the first depiction of the maze back to the Paleolithic age, where it is painted as a sort of macaroni scrawl placed, as became the custom, at the entrance of a cave.[1] The labyrinth is still drawn today by Hindu women of southern India before the threshold of their houses at the time of the winter equinox, or death of the sun.

LABRYS AND LABYRINTH

According to Greek myth, festive yet terrifying bovine rites took place at the Palace of Knossos, where King Minos had instructed his legendary architect, Daedalus, to build a labyrinthine structure in which to conceal the king's wife, the Moon Queen, Pasiphae, and her monstrous bull-headed progeny, the Minotaur.

The Palace of Knossos itself was called *labyrinthos*, meaning "the palace of the double-axes." Both the maze, a symbol of the uterus, and the double-axe, called the labrys, derive their meaning from the word *labrys* ("lip"), which refers to the female labia protecting the passage to the womb. The double-crescent-shaped axe, a holy instrument of sacrifice, symbolized the womb and the butterfly of rebirth.[2]

The terra-cotta head of a cow from Crete lacks a nose and a mouth, but its face, ears, and horns are covered with symbols of the Goddess in a manner similar to that of the Egyptian cows. The thirteen quatrefoils symbolize the number of the four quarters or fourfold world. One large quatrefoil occupies the place of central importance, on the cow's forehead; and a triple chevron is painted between the horns. The image helps substantiate the sacredness of the bull in Crete.

The labrys or double-axe, mounted between bovine horns, is among the holiest symbols of the Minoan goddess cult. Votive double-axes appear throughout the palaces of Crete, ranging in size from delicately worked golden jewelry to bronzes nine feet high.

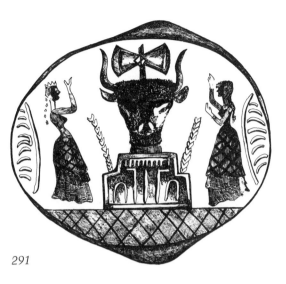

291

292

291. Engraved on a gold Minoan ring, a double-axe rises from a triple altar. Crete.

292. Quatrefoil and chevron symbols of the goddess on the face of a bull. Crete, 1600 B.C.E.

On a ring of beaten gold, a colossal bull's head with a double-axe between its horns crowns a triple altar. It establishes the bull as a significant image in the cult of the Cretan goddess. On either side stand two figures—queen, priestess, or Goddess; one figure is crowned. Stalks of wheat for the Grain Mother rise on either side of the altar. We can surmise that the scene takes place on holy ground, since it is criss-crossed with the net pattern.

Much later, among certain African tribes, a double-headed axe that represents thunder appears on the symbolic headdress of cultic figures. Buffalo masks of the Upper Volta's Bobo Oule tribe designate a protective guardian spirit. The masks bear the double-axe symbol between their lunar horns.

Stalks of wheat or barley continue to figure in sacred tableaux of the Mediterranean world. To the worshipers of the Greek Nature Goddess, a sheaf of wheat or barley personifies the deity of vegetation. At the harvest festivals honoring Demeter and Dionysus, the presentation of a single sprig of barley at the climax of the ritual was sufficient to send devotees into hypnotic trances. At Argos, where Hera was worshiped in cow form, ears of wheat were called the flowers of Hera. In a rite derived from Crete, the later Greeks sprinkled barley grains on the altar prior to the slaying of the sacrificial bull.

THESEUS AND ARIADNE

Set in the Palace of the Double-Axes, the familiar myth of Theseus and the Minotaur describes a ritual duel imposed on the candidate for kingship: combat with a bull or human in bull's guise. Magical contact with the bull's horns enables the sacred king to make rain and fertilize the land for the Moon Goddess. The prehistoric association of the horn with the life force is demonstrated by the Venus of Laussel (see fig. 311), who raises a bull's horn with one hand and touches her belly with the other. The gesture survives on the metope of a Greek temple in Sicily. The figure of Europa (see fig. 279) sits astride the sacred bull, holding firmly to its horn.

Although Theseus is the acknowledged hero of the Cretan legend, credit for his success belongs to Ariadne, daughter of Pasiphae and Minos and half-sister of the Minotaur. Having fallen in love with the Athenian youth, Ariadne gives him a ball of golden thread that enables him to retrace his steps and find his way out of the labyrinth. This thread is called the thread of initiation, as the labyrinth is the way, a passage leading to the center, the path to consciousness. As Goddess of the Labyrinth, Ariadne provides the clue to the path.[3]

An Attic vase shows Theseus gripping the horn of the Minotaur in his struggle for kingship; Ariadne stands by his side, the thread of initiation spiraling from her tunic. At the Palace of the Double-Axes, where he has been sent as a sacrifice to the mighty Minotaur, Theseus embarks upon an initiatory ordeal that begins with his entry into the labyrinth. His triumph over the Minotaur suggests the ritual slaying of the old hero-king, just as his emergence from the labyrinth suggests the initiation of a new king.

At the Athenian Thesmophoria, a fertility festival, fourteen of the women who took part were mothers of youths and maidens saved by Theseus's victory over the Minotaur. Theseus is linked with the late autumn celebration of sowing that honored Demeter (Ariadne) and her daughter, Persephone.

The journey of the male through the passage of the labyrinth furnishes a contact with forces of the Dark Mother, which finally leads to wisdom or enlightenment. The labyrinth becomes a symbol of the self, a mandala through which one approaches the sacred center. It is not surprising, in a patriarchal society, to find a monster like the Minotaur there at the center of the maze. He unites the conscious and unconscious forces in a masculine dichotomy: the conscious desire for male power and male

293

293. On an Attic vase, Theseus struggles with the Minotaur while Ariadne holds the thread they must follow to escape the labyrinth. Greece, early fifth century B.C.E.

294. Cypriot figure in bull mask, engaged in a sacred dance. Cyprus, ca. 1200 B.C.E.

selfhood can only be satisfied by turning to the female, and acknowledging the bull's head on the man, by going into the feminine labyrinth. The Minotaur seems a natural product of patriarchal thinking endemic in the mythology of later times.

CYPRIOT RITES

A sacred mimetic dance for the growth of vegetation is the likely context for a small Cypriot terra-cotta figure. Her bull mask shows how the connection between bulls and sacred rites existed on Cyprus as well as Crete. This skirted and bull-masked votary of the Goddess was discovered at the ancient site of Citium, at the seaside temple of the goddess Paralia, protectress of the seashore (ca. 1200 B.C.E.).

294

295. Both young
men and women
participated in the
sacred bull games of
Middle Minoan III.
Crete, ca. 1700–1400
B.C.E. (See plate 49.)

THE *TAUROKATHAPSIA*

In a fresco of the *Taurokathapsia*, the bull
game of Crete, the participating young men
and women run directly at the bull, seize its
long horns and somersault over its back.[4]
The white-skinned figures represent
females, the dark-skinned figures, males.
The name *Taurokathapsia* comes from
tauros, meaning "bull," and *kathar*,
"to purify." Apparently the games served a
purifying function prior to the possible
blood sacrifice of the animal. Underlying
the sport is a traditional Cretan rite of the
Bull God, which originally consisted of
ripping up a bull and eating it, a ritual
that in turn may have replaced one involving
human sacrifice.

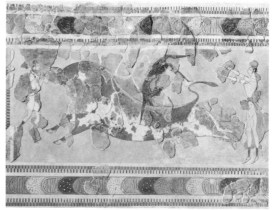

295

However, the purpose of the games has
never been certain: no weapons were used
and no scenes of the animals' death have
ever been found.[5] A part of the spring
festival, the bull games were dedicated to
the goddess Ariadne. Her sacred knot
and her pillar shrine are found on frescoes
and gems of the ritual. In some instances,
her shrines overlook the arenas in which
the acrobatic feats were carried out.

The Bull God

The close connection between the bull and the Goddess having been established, it is worth pointing out the immense prestige of the bull during the Upper Paleolithic era, as manifested in the bull figures painted on the cave walls and found in sculpture. First and foremost, the bull represents the earth; later, as Weather God, he symbolizes the sun and the moon. Although the strong morning sun belongs to the ram, the gentler setting sun of evening is represented by the bull.

THE PALEOLITHIC BULL GOD

The five huge animals in the Hall of Bulls at Lascaux, outlined in black, are wonderfully accurate in detail and even exhibit a sophisticated sense of chiaroscuro. One especially handsome image, painted on the cave walls there, emphasizes the physical majesty and power of the beautiful animal. It somehow conveys a sense of the tragic in life.

HADAD

By 2400 B.C.E., the bull and the thunderbolt were connected with deities of sky and weather. The bull's bellowing reminded archaic people of thunder. Throughout the Fertile Crescent, the bull, as Weather God, personifies Baal, or Lord. A stone relief from the ruins of the Assyrian temple of Arslan-Tashi (1500 B.C.E.) shows Hadad (Adad or Baal) holding thunderbolts, and mounted on a charging bull.

In Syria, Hadad was worshiped as the protector of harvests and especially feared and revered as a deity of storm, rain, and wind.[1] From about 1500 B.C.E., the double tridents carried by the God symbolized the double flash of lightning associated with the storm deity in Mesopotamia. Inexplicably, Hadad's lightning is sometimes shown in the shape of ritual horns, while that of other gods is pictured as the double-axe.

In Assyria as elsewhere, the Earth Mother had been the primary spiritual inspiration until the shadowy figure of the Sky Father mounted his mighty bull. The figure of the Goddess gradually faded as the patriarchal order grew in strength and the Sky God assumed leadership in the pantheon.

THE ROSETTE

Mycenae marks an earlier order. The rosette of the Goddess, worn on the Bull God's headdress there, establishes his identification with her. The foreheads of the Bull Gods of other lands frequently carry the same symbol. The bull's head from the shaft graves at Mycenae is marked with a large gold rosette between its golden horns. In Crete it became the mark of Asterios, the

297

296

296. The majesty and physical power of the bull depicted on the cave walls of Lascaux. France, Magdalenian, ca. 15,000 B.C.E.

297. Golden rosette identifies a bull, exhibiting gold horns, with the Goddess. Mycenae, ca. 1450 B.C.E.

298. The god Hadad mounted on a charging bull, from the temple of Arslan-Tashi. Assyria, Mesopotamia, 1500 B.C.E.

298

Minotaur. The rosette of the Goddess came to be identified with the son of Shamash in Mesopotamia, the apis bulls of Egypt, and the stellar ox in China. By this time in history the rosette was a symbol of the sun. Earlier it had belonged to the Eye Goddess, and simulated the vulva.

The Moon God, Sin, appears in Babylonia and Assyria riding a crescent moon. His chariot rolls on rosette-shaped wheels, drawn by humpbacked bulls, as depicted on a silver Sassanian plate (224–640 C.E.). Sin represents the past glories of the fire cult of the Zoroastrian religion and often assumes a bull-like shape. At his new moon festivals, a magical time fraught with danger, kettle drums were beaten to keep away evil spirits. At the waxing phase of the moon, Sin, Lord of the Calendar and of Wisdom, became a benign increaser of flocks.

DIONYSUS

On a Bacchic vase of the fifth century B.C.E., the bearded, vine-crowned Dionysus rides his white-horned bull. He holds the grape-covered vine in one hand and pours a cup of wine into the earth with the other. The idea of Dionysus as an actual bull is indicated by his many epithets—bull-faced, bull-horned, and the like.[2] Dionysus has a strong watery side, yet symbolizes earth. The bull-shaped Poseidon and the bull-

299. Embossed on a Sassanian silver plate, the Moon God, Sin, is drawn by humpbacked bulls. Assyria, 224–640 C.E.

300. The Wild God, Dionysus, pours wine on the earth as he rides his symbol, the bull. Greece, fifth century B.C.E.

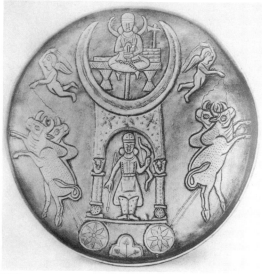

299

300

headed river gods helped make the bull form acceptable for Dionysus.

Dionysus was the deity of generation and the sap of life as well as the spirit of wine, his most celebrated role. His rare tree form refers to his role as a vegetation divinity and a god of transformation; intoxication and orgy were most important to his cult. His votaries were possessed with his spirit. In the wild, nocturnal Dionysiac feasts that followed, his disciples lost themselves in ecstasy and danced for the bull-shaped Dionysus.

Whatever the beginnings of the Dionysiac cult, it clearly followed the same form of ritual that characterized the earlier vegetation cults. The worship of Dionysus was marked by the celebration of mother and son; the sacred Son-King of the Earth Goddess was destined to be the victim at her orgies.

As the embodiment of the corn spirit, Dionysus became a sacrifice.[3] His close association with the Mother and her ancient rites eventually brought him into the women's harvest celebrations honoring Demeter and Persephone, the Corn Mother and the Corn Maiden. His ties with the feminine are supported by the fact that his assimilation into the Attic calendar did not change its essentially female nature. In the Haloa festival, it became quite

natural to offer the first fruits of the field to the God of the Vine as well as to Demeter, the Barley Mother. The ecstatic revelry of the Wine God's followers added to the erotic heat of the spectacle.

In Greece in the springtime, when the Goddess's sacred willows turn green, the bull was entreated by the priestesses to appear and was driven to his temple by the holy women, as described in the spring song quoted by Plutarch, the first systematic anthropologist:

In the Spring-time, O Dionysus
To thy holy temple come,
To Elis with thy graces,
Rushing with the bull-foot, come,
Noble Bull, Noble Bull.[4]

The bull accompanies Dionysus, or the God takes bull form. The Graces, the three Greek goddesses who personify beauty, charm, and grace, attended the great beast and covered him with garlands and fillets. The bull-driving ritual, a joyous spring festival of dancing and song called the Dithyramb, meaning "Song of Birth," commemorates the spring birth of Dionysus. This festival, the origin of Greek drama, ends in the death of the Bull God; his sacrifice for the fertility of the fields and for human life makes the drama a tragedy.[5]

The wild orgiastic cult of Dionysus gradually transformed Greek religion. Despite its frenetic propensities, the cult eventually put an end to cannibalism and ritual murder in most of Greece. The partaking of wine became a substitute for the bloody communion with the God, and no more blood was shed for the appeasement of deities and spirits. In his new role as one who inspires, Dionysus joined Demeter as the God of Mysteries. The arrival of this new order was the wedge that helped drive the people apart from the Goddess, signifying the end of goddess worship. Following close on its heels was the masculine, rational religion of Apollonian light and order.

The Goddess and
Her Partners

THE HIEROS GAMOS—SUMERIA

The Mother Goddess played a prominent role in the celebration of the sacred marriage rites, the Hieros Gamos, of Mesopotamia. In Sumer, as elsewhere, kings secured their position on the throne by marriage to the queen or Mother Goddess. An early cylinder seal from the city of Uruk suggests a journey of the Moon God of Ur to the temple of the Fertility Goddess to celebrate the Hieros Gamos, the sacred marriage. The Bull God stands in the sacred cult boat; it carries the Goddess' throne. The accompanying man belongs to the deity since he is marked with her net pattern. Blossoms decorate the prow and stern, and the deity's looped reed bundles rise from her throne.

In later Sumerian epics, the Earth Goddess is said to have sailed along the river to meet her husband, the Moon God of Ur, but the ancient hymns claim it was the opposite. They relate that the God, laden with gifts, made the yearly journey by water to the divinity's temple, where the Hieros Gamos was performed and the union consummated. Amid flowering boughs they came together on a bull-hoofed nuptial couch, spread with animal skins. Details of the story vary from town to town; some versions describe the actual place of the rite as a modest hut-shrine whose earliest representations bear the looped reed emblem of the Goddess; others picture an elaborate temple. In Babylonia, the summit of the ziggurat, a temple, that suggests a stairway to heaven, was frequently the site of these annual nuptials. Later, in "civilized" Athens, the Bull God, Dionysus, received his bride in the Boukolion, or bull's shed.

An erotic Sumerian mythic poem speaks of the passionate lovemaking of the Fertility Goddess, Inanna, with the Shepherd King, Damuzi, in a manner that conveys the intensity of the fertility rite. Damuzi, the sacred partner, is described as a wild bull with a beard of lapis lazuli; Inanna's vulva is compared "to a horn, 'the boat of heaven,' to the new crescent moon, and the fallow land." She entreats the bearded bull to "plow her vulva."[1] When the queen and her bovine consort finally consummate their marriage, vegetation springs up around them.

Usually, the Bull God is the consort of Ishtar's double, Asherah, a goddess whose inscription is on the altars of Palestine. Asherah, "She of the Womb," sometimes appears as Anath or Ashtoreth (Astarte), variants of the Hebrew Fertility Goddess of Love and War and identical with the Goddess of a Thousand Names of the ancient Near East. Anath was transformed into the lover and sister of the Bull God, Baal, a weather deity.[2]

301. In a boat, the altar of the Goddess, marked by her reed bundles, is mounted on the back of a bull. Sumer, ca. 4000–3500 B.C.E.

302. The God Mithra sacrifices himself as a bull. Germany, Roman period, ca. second century C.E.

It is possible that the biblical story of Esther may have evolved from the Tammuz-Ishtar cult, the name Esther thus deriving from the deity's name. Esther is also the Hebrew form of Oestre, the Celtic goddess of fertility, whose spring festivals were later adopted by the Christians and named Easter, the day of resurrection.

CYBELE AND MITHRA

Mithra, the ancient god of Persia and India, was a minor deity until about the fifth century B.C.E. But by the end of the first century C.E., the new religion of Mithra had emigrated from Persia to Rome, where it became one of the most popular sects of the empire and a special favorite of the Roman legions, for whom Mithra was the ideal divine comrade and fighter.[3] Monuments to the god were erected in many parts of the old world, on the shores of the Black Sea, in the great Scottish Highlands, and on the fringes of the Sahara Desert. Like Dionysianism, Mithraism helped to eradicate worship of the Goddess by superimposing its Mysteries on those of the Goddess.

The central story of the religion described Mithra's capture and sacrifice of a sacred bull, from whose body came all good things on earth. The most familiar ritual of the Mithraic Mysteries honoring this event, the sacrifice of the bull, is carved in relief on a

301

302

stone altarpiece from the Roman period (ca. second century C.E.). The Sun God, Mithra, acts out the theme of his religion by slaying his own bull-form. The new Bull God was regarded by his followers as the originator of the terrestrial life; he sacrifices himself so that life can be renewed. The grains that spring from his self-inflicted wound show him as a personification of the corn spirit and connects the ritual with offerings of bull kings in ancient times.[4]

Reversing the tradition that excluded males from the Mysteries in ancient Greece, Mithraism excluded females from participation in its rites. Women were permitted, however, to dedicate themselves to the God by denying themselves sexual pleasure in his honor.

At that time, the goddess temples, particularly those of Isis, were thronged with female devotees who worshiped the Goddess of Many Names. Isis drew converts from every walk of life; emperors and plebeians groveled in the streets when the image of Isis passed. A temple of Astarte stood in Rome, and the noisy rites of the Mother Goddess Cybele and her lover Attis drew much attention. The oldest Mithraeum was contiguous to the Metroon, the temple of Cybele, in Ostia; there is every reason to believe that the worship of the Iranian god and the Phrygian goddess were performed together throughout the empire.[5] The name of Cybele's temple stems from the Greek: *metra* and *metro* mean "uterus," and *meter* means "mother."

Cybele's name, in Latin, links her with the labrys and with caves: *cybela* means "cave" and *sybelis* stands for double-axe. The cave, magical chamber of childbirth and frequently the site of initiation and oracular divination, is identified from prehistory with the body of the Goddess herself.

From the third century B.C.E., the orgies and mutilating rites in the ecstatic cults of Cybele, the Magna Mater, and Attis and Adonis were especially popular in Rome, as well as those of Isis and Osiris and the Mysteries of Mithra. Often, the temples of these gods and goddesses stood side by side. In the West, the Mysteries of Mithra and those of the Great Mother eventually merged, only to give way to Christianity, which was similar in many ways to Mithraism.

ISIS, OSIRIS, AND THE APIS BULLS

In Egypt, and eventually throughout the Mediterranean region, the Apis bull was the sacred bull, primarily associated with Osiris and Ptah. At Memphis in Egypt, sixty-four mummified Apis bulls with remarkably identical markings were buried to honor the Ptolemaic god Serapis (formerly Osiris-Apis). They bear witness to the

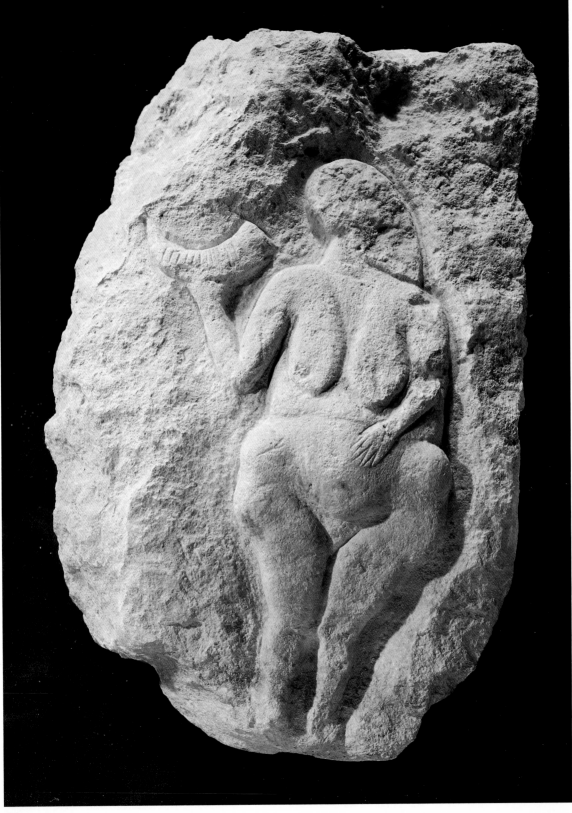

35

36

37

Plate 38. Death and renewal in a work by Paul Klee entitled *Around the Fish.* Switzerland, 1926. (See fig. 243.)

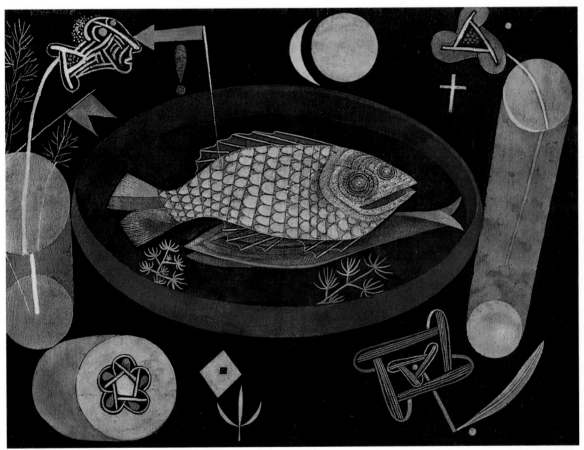

Plate 39. Hathor in cow form emerges from the hillside through papyrus flowers. *Book of the Dead*, Egypt, 1320–1200 B.C.E. (See fig. 275.)

Plate 40. Painting of a baying reindeer from the Cave of Lascaux. France, Magdalenian. (See fig. 215.)

Plate 41. Metope of a Greek temple in Sicily pictures Europa riding Zeus the bull and holding his horn. Sicily, ca. 600 B.C.E. (See fig. 279.)

Plate 42. Proto-Elamite cow deity. Iran, ca. 2900 B.C.E. (See fig. 270.)

Plate 43. The cow as a symbol of the female. Lascaux, France, ca. 17,000–12,000 B.C.E. (See fig. 268.)

40

43

41

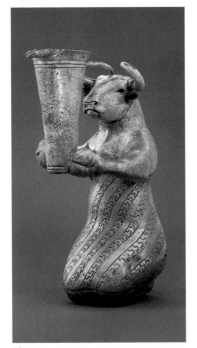

42

Plate 44. A ram rears against a little tree from the queen's tomb. Ur, Iraq, 2500 B.C.E. (See fig. 204.)

Plate 45. George Catlin painting of the Mandan warriors performing the Sacred Buffalo fertility dance. North America, ca. 1835 C.E. (See fig. 282.)

Plate 46. King Amenophis II stands protected beneath Hathor's head and also kneels to drink from her udder. Egypt, ca. 1450–1425 B.C.E. (See fig. 278.)

45

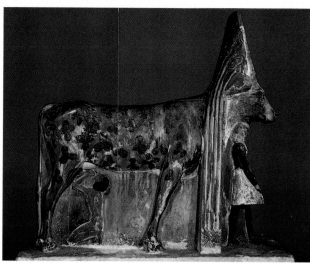

46

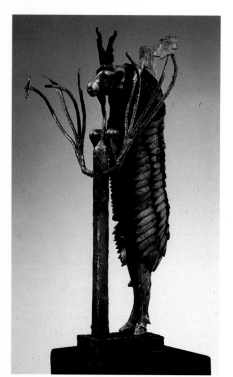

44

Plate 47. Figurehead of a bull on a harp, from Queen Shub-ad's tomb chamber. Ur, Iraq, ca. 2400 B.C.E. (See fig. 288.)

Plate 48. On an ivory pyxis, the Lady of the Beasts stands between two goats, relatives of the ram. Mycenaean origin, Ras Shamra, Syria, ca. 1400 B.C.E. (See fig. 205.)

Plate 49. Both young men and women participated in the sacred bull games. Crete, ca. 1700–1400 B.C.E. (See fig. 295.)

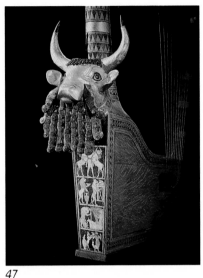

47

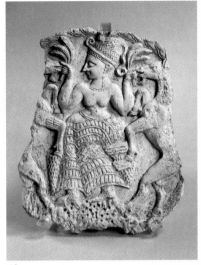

48

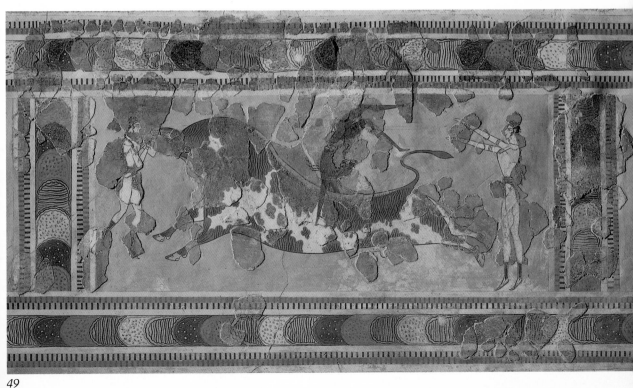

49

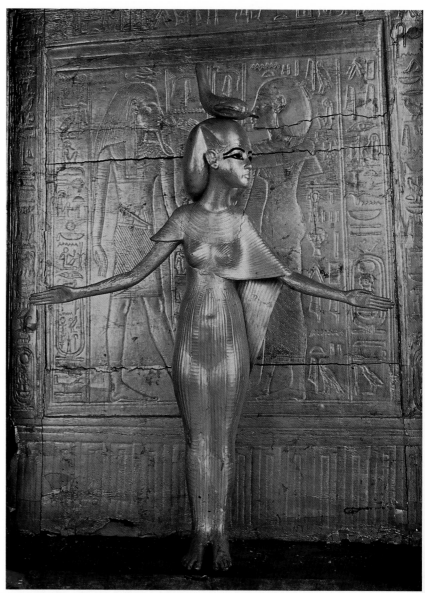

Plate 50. On a gilded shrine from the tomb of Tut-ankhamen, a life-size figure of Selket wears a scorpion on her head. Egypt, ca. 1325 B.C.E. (See fig. 323.)

303. The body of
the Apis bull, in
elaborate cata-
falque, is the focus
of his funeral
procession. Egypt.

duration and intensity of bull worship. The
Apis bull was a giver of oracles; those who
inhaled his breath received the gift of
prophecy. At Memphis, each bull lived out
his allotted years in a special place of honor
before being drowned in his own sacred
spring.

The Apis Bull God's funeral was celebrated
with splendid rites. His catafalque was
drawn through streets crowded with
lamenting worshipers, and all Egypt was
searched for a calf with similar markings—
a white triangle on its forehead and half-
moon on its breast—to be its successor.
Once found, this reincarnation of the
drowned bull was led with rejoicing to
Memphis.

The sacrificed bull was an incarnation of
Osiris-Apis, guide of the dead.[6] On one
painted coffin, the Apis bull, with a
mummy on his back, stands in an attitude
of reverence before an obelisk. The mummy
cover is marked with the diamond-shaped
net (sacred water or womb symbol); obelisk
and bull convey the idea of illuminating
creative energy and, by extension, the
continuity of life. A symbol of the phallus,
the obelisk was sacred to Isis, since
phallus worship originated in Egypt in
remembrance of Osiris's golden member.
Isis had been worshiped at Saqqara and
honored from the time of the First Dynasty;
in Roman times obelisks were set up to

303

304. A god in his
own right, the Apis
bull bows before an
obelisk. Egypt.

304

305. Parvati, the
Dark Goddess, rides
her bull, Nandi.
India.

commemorate Isis as Cow Goddess of
Memphis and mother of the Apis bull. It
may well be that the obelisk to which the
bull pays homage earlier embodied his
mother, Isis, as pillar. Symbols of the sun,
the monolithic obelisks were, by the
Fifth Dynasty, called Petrified Rays of
Sunlight, a name that identified them with
Osiris, the Sun God.

PARVATI, NANDI, AND SHIVA

An Indian miniature painting from Rajas-
than shows the Dark Goddess, Parvati,
reclining comfortably on her milk-white
bull, Nandi, an epiphany of her divine
consort, Shiva. Parvati is one of the four
forms of the Great Goddess Mahadevi, or
Devi. She has a benevolent aspect, repre-
sented by Sati and Parvati, and a destructive
side, shown in Durga and Kali. In her
gentle role, the Indian Mother Goddess,
source of life, became equated with the
divine cow.[7] Like her counterparts in the
West, Parvati bears the emblem of the
crescent moon, and as a figure of lunar
fertility she evolved into a protector
of women and children. Both as Nourishing
Mother and Lady of the Beasts, Parvati is
linked to the virgin goddesses Isis and
Artemis.

Shiva descended from the Lord of the Beasts,
the ancient pre-Aryan partner of the

Mother Goddess, Pasupati, and attained
popularity as a god of fertility with the bull
as his sacred vehicle.[8] According to his
mythology, he is both frightening and
auspicious. He may combine his masculine
creative attributes with *shakti*, female
energy, to appear as the hermaphrodite
Ardhanarisvara. More often, he is accompa-
nied by Parvati, and both are invoked as
partners in the process of generation.[9] Even
today in parts of India, when seeds of the
field burst forth, the farmers place the new
sprouts among small terra-cottas of Shiva
and Parvati, whom they worship together.

Despite the Brahmanic tradition, there are
still many vestiges of an earlier pre-Vedic
mother goddess cult there. The village
deities of south India with few exceptions
are female, although the Hindu triad of
Brahma, Vishnu, and Shiva form the basis of
Indian religion. Also indicative is the
widespread adoration of the *lingam* and the
yoni, and the universal reverence for cows.
Worship of bull and phallus in connection
with rites of the Mother Goddess was a
dominant feature of early Indus Valley
civilization.[10]

DURGA AND THE BUFFALO MONSTER

On an Indian miniature from the eighteenth century C.E., the Hindu goddess Durga, immensely popular especially in Bengal, heroically attacks the buffalo monster Mahisha. An early version of the Corn Mother Durga myth centers on her bravery in battle. Defeated by the unconquerable buffalo demon, Mahisha, and driven from their heavenly kingdom, the helpless gods are confronted by the flaming, fierce, and beautiful Durga. Arming herself with the weapons and symbols of all the deities to become the epitome of cosmic forces, she defeats the evil Mahisha in battle. Durga's victory is significant, for the gods admit that the divine energy of the universe, the one primal force, the *shakti*, comes from the World Mother.

Durga's purpose, as a fertility deity, is to establish the link between human fertility and vegetative fertility. In Rajasthan, the earth goddess Gauri brings the crops to harvest; she is colored yellow, the color of ripe corn. The women carry her image to the water's edge and dance around it.[11]

Hindu males regard women as vessels of fertility. As embodiments of the maternal energy in nature, they are human duplicates of the Great Mother of All. Unlike her female counterpart in Western tradition, the Hindu Mother Goddess as *shakti*, or universal power, is regarded as the personification of "the activating energy,"[12] while the male is the passive aspect. In occidental mythology, the slaying of the monster is carried out almost exclusively by masculine heroes.

The buffalo is the animal traditionally offered as sacrifice to the benign yet terrible Black Earth Mother who incorporates aspects of the mild Parvati and the fearsome Kali. Her three aspects are wed to the three principal Hindu gods: Shiva, Brahma, and Vishnu. As the demon-slayer, she becomes a form of the goddess Kali, from whose temples a river of blood from beheaded offerings has been pouring continuously for millennia. As a result of the bloody offerings, the womb of Kali, the Goddess of Death, gives birth forever to all things.[13] As in the West, the assortment of Indian female deities is associated with the primary image of Mother Womb.

THE NECKLACE

The necklace is intensely sacred, binding the Mother Goddess from the beginning of time and symbolizing the many in one. Kali wears a grotesque string of human skulls, while Durga's breast is adorned with a necklace of pearls from the milky ocean. The protective necklace often serves to identify the nude deity. Indian goddesses sometimes combine a chaplet with a bull's

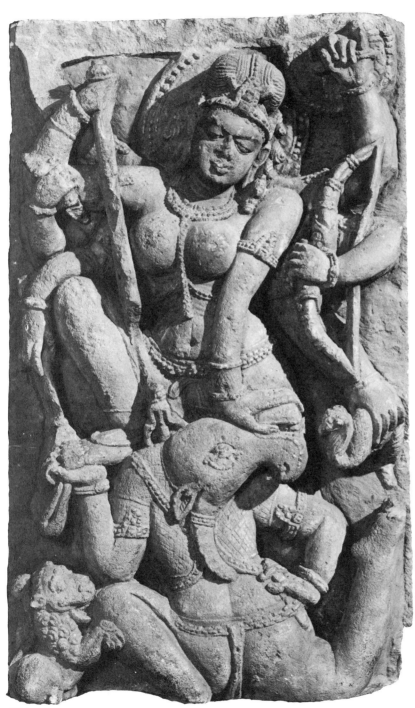

306. To save the male gods, the Hindu Goddess Durga attacks the monster buffalo Mahisha. India, eighteenth century C.E.

306

307. One of the hundred bull capitals from the Palace of Persepolis. Persia, first millennium B.C.E.

308. Mistress of Vegetation with volutes. Mycenae, ca. 1550–1500 B.C.E.

head worn as an amulet. In the West, pillars of rough stone called menhirs were sometimes given a necklace to mark them unequivocally, and the naked fiddle-idols of the Cyclades wear necklaces as identification. The importance of the necklace may be gathered from the fact that Ishtar swore by it. Many of the austere votive figures dedicated to Ishtar at Tell Brak wear the necklace, and the vast numbers of crude goddesses of the Harappan type, from the early Indus Valley civilization, are similarly distinguished. Bronze Age female fertility figures bearing the golden torque neck ring of Freyja and dating from about 2500 B.C.E. have been unearthed from Scandinavian peat bogs.

THE BULL AND THE PILLAR

In Persia, the pillar representation of the Goddess fuses with the symbol of the sacred bull at the palaces of Susa and Persepolis, where pillar capitals formed by double kneeling bulls serve as roof supports. Thirty-six such pillars ran along the halls of the winter palace of Artaxerxes II in Susa, and one hundred bull-columns stood majestically in the larger palace at Persepolis.[14] Although enormous, the animals convey a sense of delicacy and elegance; their harnesses, adorned with rosettes and a design of tiny running spirals, join the bovine necks to form a crescent moon. The

columns themselves combine the motifs of rosette and spiral on a much larger scale.

This starry rosette, which appears on the earliest cylinder seals of Mesopotamia, was the symbol of Ishtar. In later times it became a frequent emblem of the Sun God, and as such it was worn on the bull's forehead (see fig. 297). The rosette unites sun, star, and uterus in a single iconographic statement.

After suffering invasions, Persian culture and religion regained its high level of the second millennium B.C.E. under the rule of Artaxerxes II (405–361 B.C.E.). The king set up images of the Great Goddess, Anahita, throughout his empire.[15] Worship of the bull sacred to the Persian goddess soon extended to the religious melting pot of ancient Rome, where Anahita became fused with the other deities of the Asiatic cultures. As a Mistress of Beasts, she was identified with Artemis Tauropolis and the Phrygian Cybele. She was the most popular of all the deities in Armenia,[16] where sacred herds of white heifers branded with her mark were sacrificed to her in fires fed with green branches.

The special relationship between the Persian goddess and the cow is reminiscent of a vast number of similar associations in art, such as the images of Hathor, the Cow Goddess, that crown the pillar capitals of her temple at Dendera. Bull-horned

307

308

columns also appear in the Cretan palace at Knossos, where tiny models of triple-pillared altar shrines with roosting doves testify to the connections between pillar, goddess, dove, and bull. In these shrines, the central stone pillar is worshiped as a sacred tree, the dwelling place of the deity.[17] Tree and pillar cults, deeply rooted in the Minoan religion, survived into classical Greek times. In a late tribute to the Bronze Age Pillar Goddess, the graceful Kore-pillars of the Erechtheum lend human form to the previously abstract representations of the divinity (see fig. 57).

A prototype of the Cretan columns may be found in the omega-shaped pillar designs on ancient Babylonian boundary stones. The omega is a stylized form of the deity's womb. Both the Mesopotamian Lady of Birth and the very ancient Sumerian Ninhursag, the Cow Goddess and Lady of the Mountain, are sometimes simply called Uterus.

THE VOLUTE

A volute, a spiral- or scroll-shaped form, on the Ionic and Corinthian pillar capital, closely resembles the rosette and omega and is probably derived from them. Originally columnar architectural supports, volutes resemble the curved, outward-turned reed bundles of Inanna. A golden Lady of the Plants, of Cretan workmanship, exhibits the

volute symbol and holds a double garland in her hands (ca. 1550–1500 B.C.E.). Two pairs of volutes, which support sacred papyrus fronds, spring from her head.

Later associated in art with the downward-curled palm fronds of the Tree of Life, the spiraling volute initially evolved into the Anatolian column capitals that preceded the Ionic order. These feminine shapes form the triple pillars of the Babylonian stones and echo the tree-pillared altar of the Cretan goddesses.

STONE

The universal veneration of the pillar may derive in part from the megalithic belief that the godhead resides in stone. According to Erich Neumann, the ancients experienced the Earth Mother as the Mountain Mother, She of the Cave and the Rock.[18] It is no accident that stones are among the oldest of her symbols.

In India, the stone phallic *lingam* and the stone vulvic *yoni*, representations of the divine, are to this day among the most popular objects of worship along the wayside and in Hindu sanctuaries. As a symbol of generative male energy, the mysterious phallus, which increases and dwindles like the moon, was an emblem of the autonomous Great Goddess long before the worship of male gods.

The Hebrew word *Beth-el* means "House of God." The temple was a late development of the cave and, as such, a symbol of the Great Goddess. The caves of Ajunta and Ellora in India partake of both. Many haunting stone forms throughout the world make this connection clear; Delphic omphalos, Indian *lingam* and *yoni*, Irish dolmen, and Islamic black stone—all embrace the divinity. The megalithic temples of the Celts, such as Stonehenge, standing in perfect symmetry on the plains of England, are among the most dramatic and powerful expressions of belief in the sanctity of stone.

The Bull
and Judeo-Christian
Rites

To judge from the numerous warnings against goddess worship in the Old Testament, it seems the destruction of goddess cults was a preoccupation of the early Hebrew patriarchs and their neighbors. We tend to think of the Hebrew tradition as a strictly monotheistic one. Yet it would be strange if, evolving for centuries in a region of flourishing goddess cults, the Jewish religion had remained immune to them. Indeed, at times it is difficult to determine whether a certain cult was entirely Yahwistic; countless biblical references contradict the claims of monotheism and indicate a lingering fidelity to the earlier pagan religions.

THE GODDESS IN ISRAEL: ASHERAH

We know that the Goddess was still worshiped in Israel in ca. 609 B.C.E. Jeremiah found children gathering firewood in the streets for their mothers to make sacrificial cakes for the festival of the Queen of Heaven. When he remonstrated with them, the people declared they would continue to burn incense and pour out offerings to her as their kings and princes had always done. Since her worship had been neglected, they pointed out, terrible catastrophes had visited the Israelites,[1] and those left in the capital had been obliged to flee to Egypt.

Especially popular in Palestine was the cult of the Canaanite goddess Asherah, worshiped in carved wooden pillars that bear her name. Placed near Asherah's altars on mountains and groves, these anthropomorphic pillars have naturally disintegrated over time, but the Bible suggests that some of the destruction may have been intentional:

And ye shall overthrow their altars and break their pillars, and burn their groves with fire; and ye shall hew down the graven images of their gods, and destroy the names of them out of that place.[2]

Fortunately, a stone image of Asherah has survived the ravages of the Yahwists. The female head, found in the ruins of Dan, where the golden calf was worshiped, in what is now northern Israel, dates from the eighth century B.C.E. The Goddess strongly resembles her neighboring deities Anat, Astarte, and Ashtaroth.

BAAL, THE BULL GOD, AND YAHWEH

The second commandment handed down to Moses implies that idols were made in the shape of bulls and other animals, many sacred to the Great Goddess in other religions of the time.

While Moses was absent on the mountain above, his brother Aaron placed an image of

309. In an illustration from an English psalter, Israelites worship the golden calf. England, thirteenth century C.E.

309

the god Baal, a golden calf, at the foot of Mount Sinai. A vignette from an English psalter shows the Israelites worshiping a golden calf mounted on a column, while Moses, unaware of the blasphemy, receives the law from the Lord on the mountain. The orthodox Moses was angered on his return to find the golden image, whose worship testified to the survival of totemism and the presence of the goddess cult.³ The Canaanite bull gods, or Baals, are equivalents of Hadad and personifications of the storm, the wind, and the clouds. They control the rainfall and the growth of crops and share the amorous affections of the same Goddess.

A representative of a newer and more puritanical outlook, Moses scorned the ritual sexual license that was a feature of the veneration of the divine powers of life; the lying together in the fields that accompanied the revelation of an image of the deity of vegetation, for example. When Aaron presented the golden calf of Baal, writes Raphael Patai, the people responded in a similar fashion. After offering a burnt sacrifice, they shared a sacrificial meal with the god and then, according to custom, engaged in copulation in the fields.⁴

Despite negative associations, the bull remained a potent symbol in early Jewish religion. In the temple of Solomon stood a great basin known as the Sea, which rested

on the images of twelve oxen and was probably used as a drinking font for animals. According to the Book of Kings, portable images of bulls were consecrated by Jeroboam at temple sanctuaries in the northern kingdoms of Beth-el and Dan. The chief cult objects at the shrines, the golden bulls, were worshiped as symbols of the god who had delivered Israel from Egypt.

Some of the nature and attributes of the indigenous Baal were transferred to Yahweh when his worship was introduced to Israel. In the sanctuaries devoted to him, Yahweh's cult was sometimes indistinguishable from that of the earlier occupants, and Yahweh probably owed much of his original appeal to the bull gods.[5]

Having established itself firmly on pagan ground, Judaism then sought to rid itself of associations with paganism such as the sacred prostitutes who accompanied the worship of the Lady. The king in Mesopotamia had shared the couch of the Goddess, and Palestinian shrines were used for the same purpose by the priestesses and their lovers. But Josiah destroyed the houses of the sacred prostitutes. Early Jewish history is a chronicle of struggles against the invasions of pagan idolatry in a composite nation. The story of these battles reveals that Abraham's covenant, which proclaimed the monotheistic faith and established a common religious lineage among followers, was only one tactic in a strategy intended to revise the meaning of the local history.

CHRISTMAS

All new religions superimpose themselves upon old ones, projecting earlier beliefs onto new gods, and the triumph of Christianity was assured partly through its absorption and continuation of age-old beliefs. It is no coincidence that December 25, Christ's birthday, was a day of universal celebration among earlier people, a day sacred to such virgin-born sun gods as Osiris, Horus, Dionysus, Adonis, Mithra, Buddha, and Freyr. During this time, most people celebrated the increase of the sun symbolized by the confinement of the Queen of Heaven (or the Celestial Virgin), and the birth of the Sun God.

The solar vegetation god of Christianity appears on a Byzantine marble relief (ca. fourth to fifth centuries C.E.) in one of the earliest known representations of the nativity of Christ. Wrapped in swaddling clothes, the Christ child lies in a manger guarded by an ox and an ass, with the Tree of Life at his head and the Tree of Death at his feet.

310. Byzantine
relief of the nativity
shows the Christ
child attended by
the ox and the ass.
Greece, ca. fourth
to fifth centuries
C.E.

310

In Egypt, the ass was regarded in one aspect as a solar animal because of his great virility; the long-eared animal was one of the symbols of Set. The ox, sacred to Osiris, signified the soul of the Sun God, believed to reside in the bodies of all oxen. In the Christian world of the fourth century C.E., the ox and the ass still denoted the contending brothers, Set and Osiris (Horus), and their appearance together represents a reconciliation of good and evil.[6]

Christmas, or Noel, the day of regeneration in Druidic belief, was originally a festival that announced the winter solstice. This greatest festival of the year was called the Mother Night. Among the heathen Nordic races, the ancient festival of Jul (Yule) acknowledged the sun as the promoter of fertility, an idea that stretches back to even earlier times when the sun was ruled by the Great Mother.

The evergreen tree is the chief symbol of Christmas in many parts of the world; its branches are placed about the house or woven into wreathes. Traditionally, people spread straw over the fields or on the cottage floor and slept there on Christmas Eve to encourage the harvest in the year to come. This gesture can be traced to the sacred harvest rites of ancient times, characterized, as noted, by copulation in the fields, shared sacrificial meals, and excessive eating.

Although the reason for the practice is long forgotten, excessive eating is still characteristic of Christmas celebrations in which ham frequently substitutes for the whole pig or boar that, along with goose, adorned Christmas tables of the past. The fertile pig, sacred to Demeter, was sacrificed in the harvest festivals of ancient Greece, and at the Thesmophoria, as an aspect of her worship, cakes shaped like sexual symbols were served.[7] These cakes may be the forerunners of the animal-shaped cookies eaten in Europe and America at Christmas. The sown cakes baked in central Europe provide another parallel; the flour comes from the last gathered sheaf of grain, which in ages past embodied the spirit of the Goddess.

THE NUMBER FOUR

As feminine influences in religion decreased, the Virgin Goddess from whom the pantheon of male gods sprang was thrust aside. Thus, the Virgin Mary, who represents the earth and its darkness, the Great Mother Goddess, is excluded from the Christian Trinity of Father, Son, and Holy Ghost. As a result of the elimination of the female element, the number three, formerly feminine, as in the Triple Goddess, became identified as masculine; the number four, traditionally the number of the earth, remained associated with the feminine.

The medieval alchemists' idea of perfection was based in part on an axiom stated by Maria Prophetissa: "From the third comes the one as the fourth. . . ."[8] This may be interpreted to mean that unity will result when the third produces the fourth.

Another number four in Christianity is the four gospels. An interesting link is found between the iconography of these four, and Egyptian practices. Luke's ox, John's eagle, Mark's lion, and Matthew's angel (or "man") are analogous to the four Canopic jars used in Egypt for the rites of the dead. Each of the jar's lids represents one of Horus's four sons; three have animal heads and the other a human head.[9]

The Bull, the Moon,
and the Calendar

The bull is primarily revered for having the power to make vegetation grow. The mythic bull is associated with the moon, which, by its mysterious waxing and waning, moves the tides, controls thunder, lightning, and rain, rules the growth of flora, and influences the rhythm of the womb. The bull's association with water comes through the moon, and crescent horns are a natural emblem of his weather-controlling power. The bull's horns, emblems of the crescent and considered a source of life-giving fluid, account for the animal's magical powers of fertilization.

THE PALEOLITHIC ERA

Little is known about goddess worship among the seminomadic cave dwellers of prehistoric times, although proof that her cults flourished continues to accumulate. The evidence of magical or mythological beliefs has convinced many anthropologists that goddess worship is so old that it was probably the first religion. Numerous sophisticated and fascinating stone carvings of women from ca. 30,000 all the way up to 8000 B.C.E., a truly awe-inspiring time span, comprise the earliest clues to goddess worship.

The first documentation of the enduring symbolic relationship between the bull and the Great Goddess was a stone relief found carved on the wall of an Upper Perigordian (ca. 20,000–18,000 B.C.E.) rock shelter near Les Eyzies, in the Dordogne.[1] The great life force of the bull, guardian of vegetation, was thought to be concentrated in his horns. The naked Venus of Laussel, as she is known, raises a bison horn in her right hand to signify her reign over the generative. Her featureless face, shaped like the full moon, turns toward the horn. To emphasize her fruitfulness, the Goddess places her left hand on her belly, in a gesture similar to Aphrodite's.

Found on the wall of the same shelter were a belted male and a second female holding a bull's horn; all three of the figures are about seventeen inches high, which is large for the period. The carefully executed bas-reliefs probably do not pertain to the myths and rites of hunting magic exclusively, since such art was usually hastily done, whereas these are fully developed, mature works.

Modeled with great sensitivity, the shrine's central goddess reveals traces of red ochre, and nearby rocks are incised with feminine sexual symbols. The red color indicates the goddess's wider cosmic significance, representing life. Many primitive taboos are

311

311. The Paleolithic
Venus of Laussel
raises a bull's horn
whose thirteen
notches refer to the
cycle of the moon.
Les Eyzies, Dor-
dogne, France, ca.
20,000–18,000 B.C.E.
(See plate 34.)

312. Mary, Queen of
Heaven, seated on
the horned moon,
holds the Christ
child in her lap.
Spain, ca. seven-
teenth century C.E.

related to feminine mysteries and rise from
the awe connected with the magical
properties of blood and faith in its ability to
avert evil. These beliefs have descended
from the Paleolithic era all the way to
Christian times. In antiquity, sacrifices of
human or animal blood were precious
offerings to the deities of vegetation; among
certain tribes, men and women were
sacrificed so the land could be fertilized
by their blood.

Probably an example of one of the earliest
known time reckoners, the horn in the
deity's hand has thirteen marks that
represent the calendrical divisions of the
lunar year, or the time between the moon's
quarters. Each incision corresponds to the
days between the first sliver of the crescent
moon and the orb of the full moon. Robert
Menghin first established a connection
between the crescent moon and the horn,
and Alexander Marshak has made important
contributions concerning its use for calen-
drical calculations.

The relationship between the female blood
cycle and the lunations of the moon
underlies the symbolic use of crescent
horns into the Christian era. Because the
Virgin Mary reigns as the Queen of Heaven,[2]
she is sometimes depicted cradled by the
crescent moon.

312

THE IRON AGE

Of two bronze statues from Iron Age Russia, one with a male figure, one with a female, the masculine statue pictured here is by far the finer piece. An ithyphallic male deity of storms crouches atop a three-tiered row of bucrania flanked by curled horns. The bell-holder probably was used for magical rain-making and vegetation rites, and the bells and clappers clearly refer to the female-male relationship. Both pieces come from the period of the changeover from matrifocal worship. To satisfy both religions, both pieces were made so that neither deity would be offended.

But even the masculine piece contains aspects reminiscent of the goddess. The number of tiers and the number of horned heads that decorate each tier are significant: the number three is tripled to make nine, the supreme number of the Triple Goddess. It also stands for the phases of the moon when seen in conjunction with representations of oxen. Nine is the number of times the moon goes around the earth in each of its phases and was also the sacred number of the orgiastic moon-priestesses who presided over the Lenaean festivals of Greek Semele.[3]

In art, even Christian art, the bull seldom appears without a branch nearby to remind the viewer of its power over vegetative growth. On the bronze bell-holder the branch is symbolized by the club, a stand-in for the tree. Many late weather gods appear with axes, hammers, or clubs, magical boughs transformed from fertility symbols into weapons. The wooden club of the sun hero Heracles and the magical hammer of the Norse Thunder God, Thor, may serve similar functions. The scepter of kingship carries the same symbolic power.

THE WEATHER GOD OF ASSYRIA

A number of mythological themes are splendidly embossed on the surface of the golden bowl of Hasanlu, a province of Iran under the influence of Assyria. One scene on the bowl shows a bull spewing a stream of refreshing water as a weather god drives it through the star-studded sky. Elsewhere on the bowl is a portrait of the naked goddess. The sacked palace where it was found dates from the ninth century C.E. The bowl, evidently an heirloom, came from an earlier period (ca. 1800 B.C.E.) and was saved for posterity only because a burning ceiling fell on three young people trying to save the bowl. One princeling died with his arms around it; his gold-handled sword lay at his side.[4]

In the religions of Europe, Asia, and Africa, the divinities of the sky were related primarily to the great deities of vegetation. Their vigor as weather gods finds expression through the bull symbol. Far from being

313. Male weather deity crouches on a row of bucrania. Bells and clappers refer to male and female sexual relationship. Russia, Iron Age, ca. 1200 B.C.E.

314. Mythological themes embossed on golden bowl of Hasanlu. Assyria, 1800 B.C.E.

313

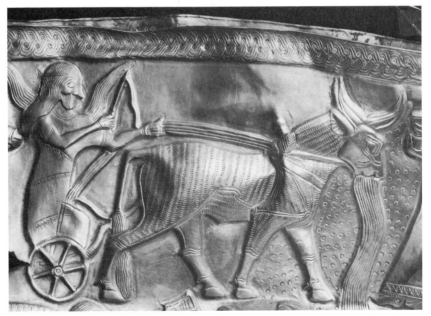

314

autonomous, self-evolved gods, each is accompanied, and often governed, by a goddess upon whom the fecundity of the universe depends. As a result of this union, the sky gods absorb both her lunar and her chthonic attributes. The sacred marriage of sky and earth was in no way confined to a small cultic circle; for at least six millennia and across three continents, the water bull remained the consort of the fertile Mother.

CHINA

The phases of the moon are the theme of a massive ritual food bowl from the Chou dynasty (1122–221 B.C.E.). The Chinese bronze is an imitation moon calendar, with mathematical relationships given symbolically in number and form. Opposing each other in four directions, the handles are decorated frontally with three water buffalo heads, delicately engraved in relief. The three buffalo heads represent the moon's chief phases: waxing, full, and waning. The prominent bronze nodules imitate the movable wooden pegs used in more ancient calendars; their circular arrangement in groups of twelve refers to the solar year.

In China, the bull measured the year. The festival called the Meeting of Spring, or the Beating of the Spring Ox, included colorful and jubilant processions that took place all over the country. Celebrated on the first day of spring, i.e., the beginning of the new year, the festivities culminated in the beating with sticks of an ox effigy, filled with grain, that stood on an altar. Broken amid the crowd, the figure spilled the grain, disseminating fertilizing power and the promise of an abundant year. A buffalo was killed and his flesh eaten while sacrifices were made to the Divine Husbandman, a legendary human figure with a bull's head.[5] The similarity of early Chinese astrology myths to those recounted in the great Babylonian cuneiform texts indicates that many rites and myths migrated from the Near East to the Far East. This festival dates back to Sumerian times and originated in ancient Egypt. The beginning of the Egyptian year, with the accompanying inundation of the Nile, was the Day of Hathor, the Cow Goddess, recorded in ancient texts.[6]

SEASONAL BULL SACRIFICES

Many bull gods of the ancient Near East and Greece were ritually dismembered and scattered over the fields as fertility offerings. A festival nearly identical to the Beating of the Spring Ox was called the Bouphonia, or Ox Murder. It was held in classical Athens at the full moon during the last month of the harvest. An ox approached the altar to eat the offering of wheat and barley placed there for him. His belly filled with

315. On a Chou dynasty bronze, the lunar calendar uses buffalo heads to depict its phases. China, late eleventh to early tenth century B.C.E.

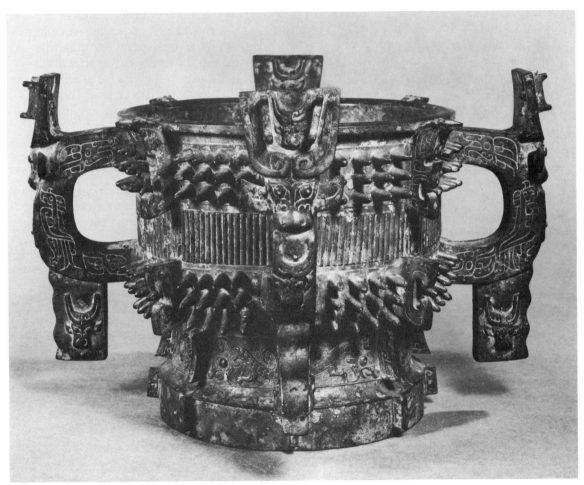

315

the harvest grains (like the bellies of the human sacrifices in the northern bogs), the animal was slaughtered and skinned, the raw flesh distributed to the harvesters and his hide stuffed with grasses.[7]

In the Mexican Christmas celebrations, blindfolded children beat a *piñata* (paper bull) with sticks in order to be showered with its hidden gifts. The Ainus of the northernmost Japanese islands, whose skull structure reveals them to be immigrants from the Paleolithic caves of Europe, practiced similar rites. However, they retain the original bear in place of the bull. Comparable, too, is the Bedouin camel sacrifice; the animal is attacked with knives and wholly devoured between the rising and setting of the morning star, Ishtar-Venus, to whom the offering is made.

One detail unites the Chinese ox festival, in Greece called the Bouphonia, the camel sacrifice, and the *piñata* party. In all four, blindness was an essential part of the ritual. The Chinese effigy, made of multicolored paper, was pasted on a framework of a blind man or according to the instructions of a necromancer in a closed-eye trance. In Mexico, the *piñata* hung high in the air, out reach of the blindfolded children who struggled to hit it. The Bedouins performed their murderous act in the dark of early morning, obliged to complete the ritual before the sun rose. The Greek ox was slain by butchers in full view of everyone; afterward, at their mock trial, everyone claimed to have seen nothing, and the guilt was passed around until finally the axe and knife were accused, found guilty, and condemned. The mock trial to determine the identity of the murderers took place amid laughter and amusement.[8]

Prayers are often said with closed eyes, in the belief that eliminating the external will facilitate communication with the numinous spirit. In Morocco a bride's eyes are blindfolded for three days before her wedding. Blindness is a requisite of initiation, too: the initiate enters into the realm of darkness to gain knowledge of the Mysteries, and the eyes are opened only after he or she has emerged from the dark, having "seen" the light. In Genesis, the serpent says to Eve, "Your eyes shall be opened."[9]

ASTROLOGY AND THE CALENDAR

Egypt and Sumer-Babylonia share not only myths but a nearly identical calendar of great complexity. Each has thirty-six weeks of ten days with five days added at the end. One assumes a common origin is responsible. The calendar was based on the rising of the stars at twelve-hour intervals. The most important star, Sirius, is associated with Isis.[10]

316. In a page from an astrological treatise of Albumasar, Venus the celestial queen rules the sign of the bull, Taurus, and the scales of Libra. France, ca. 1403 C.E.

Many veiled allusions to the cult of the goddess survive from early times. Acknowledging the fertile union of the Goddess and the bull, the Sumerian astrologers who devised the zodiac placed the sign of Taurus under the rule of the planet Ishtar (Venus), where it remains today. A leather page from the astrological treatises of Albumasar (an Arabian astronomer of the ninth century C.E.), presented to the Duc du Berry in France about 1403 C.E., shows Venus playing a harp and wearing a crown of gold. The celestial queen of the planet that bears her name sits on her throne, ruling over two astrological signs, Taurus the Bull and the Scales of Libra.

Before the formation of the zodiac and the evolution of the written word, Venus was identified as the morning star, the one that sheds its light before the rising of the sun, after all the other stars have ceased to shine. The astrological influence of Venus is expressed in fruitfulness, generosity, beneficence, warmth, and moisture. In star worship, the virgin goddesses of the Near East were frequently personified as the planet Venus, the evening and the morning star.

The famous Egyptian architect Senmut's ceiling, designed for his own tomb, portrays Horus as the morning star, pointing his spear at the bull whose constellation sinks in the morning sky as the Goddess adds her

316

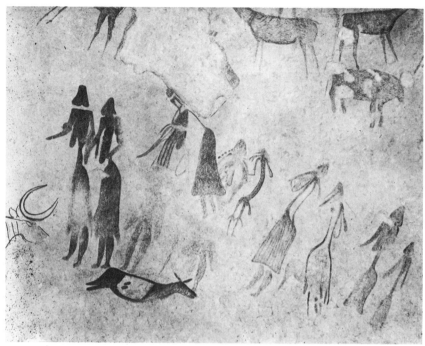

317. Upper Paleolithic cave painting from Cogus pictures women performing the Dance of the Hours. Spain, Upper Paleolithic, after 10,000 B.C.E.

318. On the ceiling of architect Senmut's tomb, Horus as morning star points at the constellation Taurus. Egypt, after 1490 B.C.E.

317

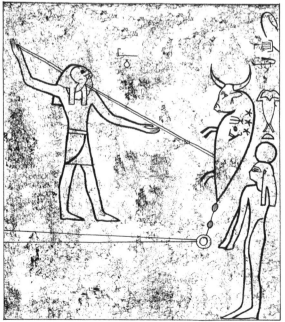

318

weight. Over time, the galaxy of the Great Bull became known as that of the Great Bear.

THE MOON

For the ancients, the powers of the moon were not established by a succession of scientific experiments; these powers revealed themselves through intuition and analogy. The sun remained for them relatively steady and unvarying, while the moon waxed and waned and sometimes disappeared altogether. Its perpetual return made it a symbol of rhythmic change and fertility.

In early civilizations everywhere, time was measured by the moon. Its changing phases determined the months of the first calendars, and the word *moon* may be seen in related words such as *month, measure,* and *menses.* In addition, the moon divides the lunar month in half, while the four quarters make up the weeks. The reproductive functions of women seem to be regulated by the moon, since lunar and menstrual cycles coincide, so babies are carried for nine lunar cycles. In the Pacific Island cultures, the cause of women's menses is believed to be sexual intercourse with the moon god during their sleep.[11] The moon rules the tides, and its domination extends to all liquids and hence the weather, which appears to change in response to the progress of the lunations. Held responsible for all vegetative growth, the moon became the fountainhead of plant life from seed to sacred tree. Finally, the moon waxes to full yet wanes and dies at the end of the cycle. After three days of darkness it is reborn, a universal symbol of hope for individual renewal.

THE DANCE OF THE HOURS

Magdalenian rock paintings of Spain and North Africa show women with bows and arrows hunting with men. But at Cogus in Catalonia, at roughly the same time as the painted caves on the other side of the Pyrenees, a scene was portrayed in a different artistic style, and with completely different content. On a rock-shelter fresco, nine maidens dance in a circle wearing form-fitting, narrow-waisted dresses and triangular caps.[12] The inclusion of the bison places the scene in the Upper Paleolithic era. Added at a later date, the small brown male has a phallus that is not erect. This affirms that the ceremony was not intended as a fertility rite. The scene may have been a Dance of the Hours, originally mimicking the movement of the stars and the great orbs. This mirroring of the eternal cosmic dance by the participants may be the first recorded version of the celestial circle dance.

The Scorpion

Deity of the under-
world, Selket wears
a large golden scor-
pion on her head.
Egypt, ca. 1325
B.C.E. See fig. 323
and plate 50.

The Scorpion expresses the vital spirit in humans which, transformed, becomes the divine pneuma. One of its symbols is the scorpion which stings itself to death.[1]

The association between serpent and scorpion, both sudden and dangerous stingers, appears in the Babylonian and Greek astrological sign of Scorpio, which corresponds to the Egyptian sign of the autumn equinox, the serpent. In esoteric traditions, the scorpion is recognized as a spiritual insect through its gift of self-immolation and rebirth. The venom of the scorpion is said to contain its own antidote.

MESOPOTAMIA

A Sumerian bowl from the Hassuna Sawarra period (ca. 5350–5050 B.C.E.) depicts four aspects of a naked, windblown divinity with hair flying. Eight scorpions swirling about her in a double swastika pattern suggest rebirth and the ceaseless flow of time.

An early expression of the sanctity of the scorpion appears on the square face of a stamp seal from 3300 B.C.E., where the rosette of the Great Goddess, Inanna, is protected by the pincers of two scorpions.

From Ur, a fascinating figure in the position of birth accompanied by two scorpions, expresses the terrifying ambivalence of the Mother Goddess.

SOUTH AMERICA

According to Patricia Monaghan, the great Scorpion Goddess of the Amazon River, Ituana, lives at the end of the Milky Way. There she rules the afterworld, reincarnating souls to new life and nursing earth's children from her innumerable breasts.[2]

EGYPT

Venerated in Egypt from an early time, the scorpion scuttles into *The Book of the Dead* as a deity of great antiquity. An ancient text recounts the story of a journey Isis made with seven of these insects. When her son Horus was bitten by one scorpion of the most deadly species, her scorpion friends saved her son for love of Isis. Furthermore, they bit the son of a woman who had refused to help Isis. Through her magic, Isis then saved that bitten boy.

A bronze now in the Louvre, of Selket, Goddess of Magic, pictures her as a sphinx. Shaped like a woman whose lower body is that of a scorpion, Selket married a snake deity with monstrous human limbs. At times she is frightening and at others quite friendly. Selket's friendly relationship with Isis, recounted on a boundary stone known as the Metternich Stele, is a result of her maternal diligence. Selket wears Isis's horns and sun disk on her head. Despite her fearsome power over death, Selket appears beneficent when associated with Isis.[3]

319. The upper body of Selket, the Scorpion Goddess, has the form of a woman while the lower torso takes the shape of a scorpion with raised tail. Egypt, New Kingdom, 1570–332 B.C.E.

319

320. Goddess giving birth, guarded by scorpions. Ur, ca. 2400 B.C.E.

320

321. Stamp seal shows two scorpions protecting the rosette of the goddess Inanna. Sumer, ca. 3300 B.C.E.

322. Protected by eight scorpions, four aspects of the Goddess dance in a swastika pattern on a bowl. Sumer, ca. 5350–5050 B.C.E.

321

322

323. Standing before a gilded shrine from the tomb of Tutankhamen, a life-size figure of Selket wears a scorpion on her head. Egypt, ca. 1325 B.C.E. (See plate 50.)

323

Selket symbolizes resurrection into the new life beyond earthly existence. Gathering the setting sun into her outstretched arms, she becomes the link between the living and the dead and helps the dead accommodate themselves to their new land. In another aspect, Selket is united with Sirius; as a consequence the star is placed in her crown.

Selket's most significant task is the guardianship of the Canopic jars beneath the funeral bier.[4] One holds the intestines within which is the white chyle. Thence flows a curious string of connections. First, the greater part of the white chyle produced in the intestines circulates by osmosis. Second, the offspring of the scorpion, born under a thin membrane, crawl out after the mother breaks the caul; the little scorpions climb up and cling to her back. Third, since the scorpion mother has no breasts, her babies feed on her back by osmosis. The intestines have to be very sensitive to separate nourishment from waste products effectively, and this hypersensitivity involves the development of an entire defensive reflex of the sympathetic and cerebro-spinal systems. Scorpion venom attacks precisely this nervous system in what is, among other things, a remarkable instance of symbolic analogy. Without benefit of scientific instruments, the early Egyptians understood the process of osmosis in the living intestines well enough to relate the idea to the way young scorpions feed.

Selket is the Scorpion Goddess, an ethereal woman of awesome beauty. On the magnificent gilded shrine of Tutankhamen, her striking golden figure protects the king. Three other guardian goddesses accompany her, one on each side of the shrine. Deity of the underworld, Selket wears on her head a large golden scorpion.

NORTH AMERICA

The Mimbre people of the American southwest drew many animals, including the scorpion. Since Mimbre women created most, if not all, of the pottery and its decoration, symbols from the ancient traditions have been preserved with their pre-patriarchal meanings intact. The scorpion is always associated with fertility, both among humans and in the fields. In Mesopotamia the scorpion was a beneficent cosmic symbol connected to the Hieros Gamos (sacred marriage); it insured the fertility of the nation for the year.

An insect from a Mimbre dish is drawn with four of the classic symbols of the goddess: spiral, chevron, net pattern, and lozenge. It is a refreshingly new presentation of these familiar signs. At the top of the scorpion figure, the spiral of life and death is placed, indicating the central theme. Below,

324. Ancient Mimbre scorpion design displays many symbols of the goddess. American Southwest, 900–1150 C.E.

324

325. Bronze dancing Shiva balances on a circular pedestal that represents the earth, his dance floor held up by three scorpions. India, eighteenth century C.E.

325

water, as rain, has an important place as striated chevrons. Beneath the snakey tail a huge dew drop shape encloses the net pattern, surrounded by a checkerboard design.

INDIA

Chamunda, scorpion deity of the central Indian tradition, is a form of Durga and personifies one of the Seven Mothers.[5] In statues, she sits upon a corpse. She is decorated with skulls, and her long bone scepter is topped with another skull. The marks of the scorpion on her emaciated belly mean hunger. In a mysterious gesture that may allude to death, she often holds her finger to her lips. Her endowment of poison indicates that she has death in her power and, at the same time, indicates her connection with rebirth.

An articulated bronze of the eighteenth century C.E. portrays Shiva dancing on a circular platform that stands for the earth. Shiva balances a long curved rod with an elephant at each end so that he may easily spin without falling. His dance floor is held up by three large scorpions, chosen to denote that the earth depends on the Great Mother's round of birth, death, and rebirth.

The Bear

An ancient statue of
the Bear Goddess,
Dea Artio. Switzer-
land, second cen-
tury B.C.E. Detail of
fig. 332 and plate 35.

The bear inspires awe and fascination, embodying as it does the spirit of the wild and of the Goddess as Mother. It acts as the very incarnation of nature. Despite its immense size and strength and its rugged appearance, the bear reminds humans of themselves; without its fur, its body closely resembles our own. Quick, clever, and agile, the bear's correspondence to humans does not stop at its appearance. It walks upright, is purposeful, methodical, and dextrous; close study of its habits in the primordial forest must have taught early humans a good deal about survival in an abundant but formidable environment. Furthermore, the bear's hibernation is a strong symbol of rebirth. With an abundance of appropriate characteristics, the bear served the ancients well as a sacred presence.

Analysis of the word *bear* provides insight into the creature itself. It is one of the richest and most basic words in our language, an irreducible noun or verb. The verb, as in "to bear," reveals a deep substratum of significant connections. In English it means "to carry," "to give birth," "to produce," or "to hold up." *Bairn* is Scottish for "child." The word for bear in other European languages is equally provocative.[1]

THE PALEOLITHIC ERA

Opinions as to the date and place of humankind's birth change constantly. The oldest known mark made by a human being was scratched on an animal bone about 300,000 years ago in southern France, at a site called Pech de l'Age. Marshack believes that the rib was used for some kind of calendrical calculations.[2] The first discernible evidence of interaction between the human and the bear dates to ca. 50,000 B.C.E.

Bear ceremonies began in the prehistoric Old World. Their significance reflects the days of the Great Hunt of Neanderthal times. The cave bear inhabited both the lowlands and the high mountain areas of the Alps and took refuge for hibernation in caves as high as eight thousand feet. For thousands of years, Neanderthal hunters followed the bear through the deep wooded mountains to its high winter habitat. The bones of more than five hundred cave bears killed by hunters were found in a cavern near Erd, Hungary, and radiocarbon-dated to 49,000 B.C.E. Thirteen thousand years ago, thirty thousand bears had been killed at the Swiss cave of Wilden Mannistock, where some forty-two skulls were placed in a line.[3] The time necessary to kill so many animals must have been considerable. It took at least nine men to kill a cave bear who was nine feet tall. Since a good deal of communication would be necessary to

326. Crypt altar of
stone set in floor
and covered with a
limestone slab.
Drachenloch, Swit-
zerland, 50,000
B.C.E.

kill such a large, ferocious animal, some
form of speech must be as old as the earliest
bear hunts, which can be traced by the
tools made to kill the bear.[4]

One of the most astonishing finds of a ritual
character was made at Drachenloch, a cave
high in the Alps. It apparently served for ten
thousand years as a seasonal home for
bears. In one of its chambers stood a crypt-
altar of carefully dressed stone slabs set in
the floor and covered with a thick slice of
limestone 4½ inches thick. Discovered
inside the chest were seven well-preserved
cave bear skulls and a number of long
bones, dated to about 50,000 B.C.E. Other
skulls were ceremoniously placed around
the wall in niches.[5] The bear's soul appears
to have been considered more closely
connected with its skull than with any
other part. It was often placed on a pole
probably as the ritual object of a distinct
type of bear cult.

Similar caches of cave bears' skulls protected
by stone slabs were found in eastern
Switzerland in a cave called the Wilden-
mannlisloch, and another in Franconia,
Germany called the Petershohle.[6] Many
archaeologists favor religious interpretations
of the deposits. They can hardly be under-
stood otherwise since they were placed
in the most remote parts of the caves to
protect them from desecration.

326

327. Incised silhouette of bear on exposed outcropping of rock. Norway, Megalithic.

327

On a bare outcropping of rock exposed by the retreat of the glaciers, the incised silhouette of a megalithic bear embodies the perpetuation of the magical traditions of Ice Age art. Found in Finnhagen, Norway, these rocks became highly polished by the grinding action of the ice, so their smooth surfaces have been able to resist erosion. This hunting art of the north suggests not only the rock carvings from Paleolithic times, but a survival of the bear cult among the Lapps of northern Scandinavia, the Gilyaks of Siberia, and the Ainu of Japan.

Ancient ceremonies make clear that human contact with the bear was not without gaiety. After the hunt, in addition to the feasts and ceremonies that developed around then, there was dancing. In the cave of Pechialet in the French Dordogne Valley, the figures of two men are etched, dancing beside a huge bear. Another engraving, from Mas D'Azil, portrays a masked dancer before the enlarged paw of a bear. The imprint of the bear's paw is close in size to the imprint of the human hand; when gigantic, the paw evidently had a sacred meaning. Hunting itself was a holy activity, ending in celebration, during which bear imitations were played out in dance.

In the Magdalenian rock engraving from Les Combarelles in the Dordogne, two bears display the arched forehead and determined

328. Two Paleo-
lithic bears
engraved on rock
from Les Comba-
relles, Dordogne.
France, before
14,000 B.C.E.

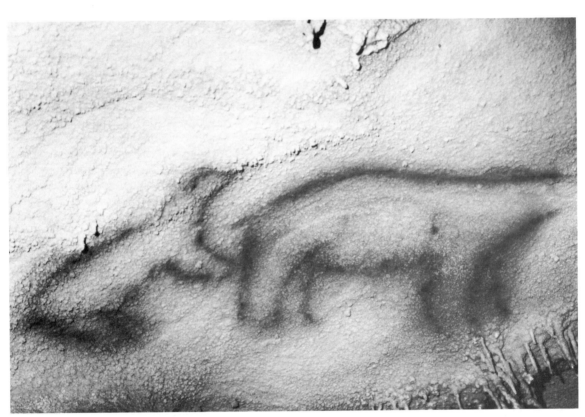

328

329. Small amber bear. Resen Mose, Denmark, Mesolithic era.

330. Bear vase from the Dinilo culture, marked with lozenge shapes and zigzag lines. Zadar, Yugoslavia, late sixth millennium B.C.E.

329

gait distinctive of bears. They are rendered with deep artistic feeling.

The Mesolithic era produced a small amber bear from Resen Mose, Denmark, evidently designed to be fondled; the sculpted nose and ear have been worn thin from handling. The engraved marks along the snout were made over many years with different points.[7]

THE BEAR VESSEL

Marija Gimbutas writes that the Neolithic terra-cotta bear figures in the form of water vessels are distinctly feminine.[8] This idea is supported by a wealth of material connecting the feminine and water found in "Lady of the Waters."

From a site near Zadar, Yugoslavia, created by the Danilo culture in the second half of the sixth millennium B.C.E., a bear vase is marked with diamond shapes and zigzag lines (torrents of water). Her paws are marked with watery lines.[9] As noted, the bear's paw apparently had a separate sacred meaning.

THE BEAR MOTHER

Close to humans in its habits and personality, the female bear is a tender mother who nurtures her cubs attentively for a long period.

330

331. Bear as
madonna nursing
an infant. Fafos II at
Kosovska Mitro-
vica, Yugoslavia,
fifth millennium
B.C.E.

The bear has been described as nurse and
mother and is often shown erect nursing a
child or carrying a child on its back.[10] The
bear as Madonna, nursing an infant, is
illustrated by a touching figure of a Bear
Goddess with an infant in her arms: both
wear masks. Found in Fafos II at Kosovska
Mitrovica, Yugoslavia, it dates from the
Late Vinca culture, after 4,800 B.C.E.

BEAR REVERENCE IN LATER TIMES— JAPAN AND NORTH AMERICA

The cult of the bear spread northward from
the caves of France to Mal'ta, Siberia. Bear
cults persisted until as late as the last
century among the Ainu of northern Japan,
and the Eskimos and Indians of North
America.[11]

The Ainu set the skulls of slain animals
along the east walls of their huts and bow in
the direction of the sunrise. Their well-
known bear rituals began by nurturing the
bear for a year in the village, during
which time it is petted, fed, teased, and
much revered. At the end of the year the
bear is sacrificed. At the elaborate ceremony,
the Ainu thank the bear and apologize to it
for its death, explaining that they need its
flesh for food and its fur for clothing.[12]

Like most ancient hunters, the Eskimos of
the North American continent, for reasons
of faith, do not eat the brains or marrow

331

(a gourmet treat) of an animal. For the Eskimos, the practice is connected with reverence for a female deity. Here we have a taboo practice associated with a belief in a female deity, the "mother of the beasts." Yet its role corresponds to that of the supreme being worshiped by the most ancient Eskimos, who is also conceived of as a divine dispenser of hunting luck.[13]

The affinity between contemporary sacrifices and the prehistoric sacrifices commemorated by skulls is striking:

The objects found at Drachenhole and other sites are proof positive that the bear hunters of the last interglacial were already making such sacrifices and that they must therefore believe in a supreme being . . . belief in a supreme being must have been current even among their predecessors.[14]

In the world of the Haida of northwest Canada, the bear is a figure close to the Indian community; several tales explain how bears become part human, or humans become part bear. According to myth, the whole clan descends from a Bear Mother. Hunting is considered a holy activity. The bear is believed to exact atonement from the hunter for its death.

Each winter the Utes and Paiutes, Indian tribes of the North American plains, perform a bear dance in imitation of the animal's awakening from its annual sleep.

Inside their lodges, women and men dance together. The celebration draws a parallel between the bear's winter sleep and its reawakening in the springtime, and the participant who dies to be renewed.

BEAR REVERENCE—GREECE AND EUROPE

In Greece the people also thought highly of the Bear Goddess. As Jane Ellen Harrison writes, "The well-born, well-bred little Athenian girls who danced as Bears to Artemis of Brauronia, the Bear Goddess, could not but think reverently of the great might of the Bear."[15] Throughout classical Athens, bears were worshiped as sacred to Artemis.[16]

The Celts venerated Dea Artia, a bear goddess. The name of the Celtic Fire Goddess, Bridgit, stems from the word for bear. Another Celtic deity, Andarta ("Strong Bear"), is worshiped throughout Gaul. The names Arthur and Artio mean "bear."

In similar fashion, the city of Bern, Switzerland, arose from the center of a cult of the bear as Mother. The people there still take her as their symbol.[17] In 1832 in Muri, near Bern, an ancient statue of Dea Artio, the Bear Goddess, was unearthed from the vegetable patch of the local parson. The arresting bronze statue shows the seated deity offering fruit in a paterna dish to her bear—which is another aspect of herself.

332. On a bronze statue found near Bern, the Bear Goddess, Dea Artio, offers fruit to another aspect of herself. Switzerland, second century C.E. (See plate 35.)

ASTRAL BEASTS

Since prehistory the menagerie of the Mother's beasts has been projected into the sky as astral constellations. In European culture we have Cygnus (the swan), Leo (the lion), Canis (the dog), Draco (the serpent), Aries (the ram), Pisces (the fishes), Taurus (the bull), Scorpio (the scorpion), and Ursa Major and Minor (the bears). The name of the Ursa constellation came through the Greek myth of Callisto. A beautiful young nymph of Artemis, Callisto one day caught the eye of Zeus. When he pursued her, Callisto kept changing her form, but he assumed the same guise each time and finally caught her in the form of a bear. When Artemis realized that Callisto was pregnant, she instantly killed her. Repentant, she then placed Callisto and her child as bears among the stars: the constellations Ursa Major and Ursa Minor.

The bear's presence in the stars is not surprising, since it acts as an avatar of forces that rule all life. The two endmost stars in the Great Bear are always in a line with the pole star, Polaris or North Star, in the Little Bear. Polaris is the most constant star in this hemisphere, and therefore indispensable for orientation. The configuration of the two bears, the most conspicuous of the northern constellations, illuminates the northern sky.

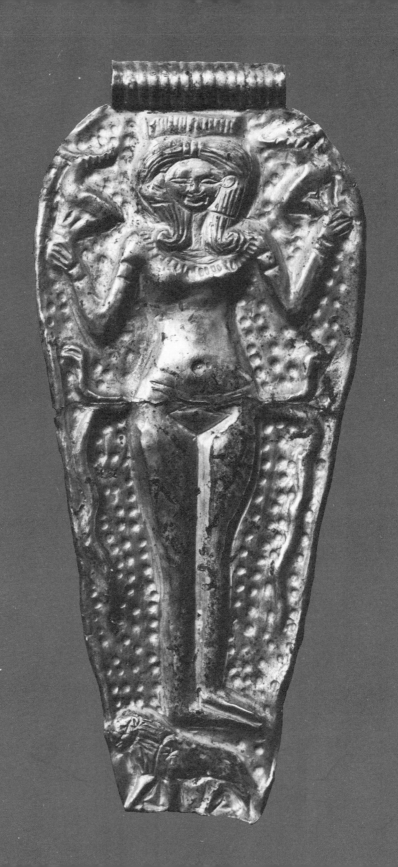

Afterword

Gold amulet of
Anat holding
snakes and standing
on a lion. Ras
Shamra, Syria, thir-
teenth century
B.C.E. See fig. 152.

Early people saw themselves at the center of the universe and understood all things in relation to themselves. Their art and symbols expressed this; much importance was given to their environment—positions of the stars in the sky, colors, numbers, the elements, plants, and animals all had meaning. The connections among these images had significance as well. For example, animals appeared in the sky as constellations; the moon's crescent stood for the bull's horn; the red ochre used for burial symbolized the life blood; the omphalos, cave, mountain, and labyrinth all suggested the womb.

The great question that has always shadowed humanity is that of death. All religions have grown out of attempts to explain and explore this mystery. Early people looked to the world around them for clues to the answer. Through observing nature, they concluded that, just as vegetation dies and is reborn each year, so all humans must experience rebirth.

From the beginning of the Pleistocene epoch, before 70,000 B.C.E., there is evidence that humans struggled with the idea of death. Archeologists have unearthed a Near Eastern cult of the dead from this time that practiced ceremonial interments. In these red ochre burials, the dead were laid in either extended or contracted positions and surrounded by symbolic objects. The lavish quantities of shells, flint fire-making implements, animal bones, and flowers indicate a funeral ritual that implies belief in a continued existence after death; a place where food, tools, and warmth would be needed. The effort taken to paint the bodies with sacred red ochre implies significance attached to the act; perhaps a desire to make the body ready for its new life.

Explanations for the mysteries of life and death often included the idea of a supreme being, one who might govern both birth and death. This supreme being was logically female; if one looked at nature, it was clear that the power over birth, human and animal, belonged to the female. By extension therefore, the goddess controlled birth and fertility on a larger scale. Thus creation myths developed with female deities as those who gave birth to the universe.

Through archeological evidence and myth, it is clear that the Great Goddess was worshiped by the ancients from the Paleolithic era on. The array of art and ritual objects in this book is only a small sampling of the worldwide proliferation of such archeological evidence. In the time before history, Paleolithic and Neolithic people recognized the Great Goddess as the universal principle that precedes form and worshiped her manifold powers. She was the

primal ancestress, the one who sustained the people and the earth. Her spirit lived in all things.

Women were believed to be closely related to the divine. Their prestige in these ancient cultures was an indication of the reverence with which the goddess was held, but it may also be that woman's high position in early society prompted a portrayal of deity in her image.

Scholars do not agree whether the deity, sometimes called "The Goddess of Many Names," remained a single entity in the minds of the people, or was thought of as numerous individual deities. Possibly the various goddesses functioned as aspects of the same divinity, just as the various animals symbolize different aspects of her powers. The Great Goddess may have united a variety of other sacred beings, such as the Moon Goddess, the Goddess of Death and Transformation, the Earth Mother, and the Mountain Mother. She would likewise be the Lady of the Plants and Mother of the Beasts.

Of the animal epiphanies, the bird, particularly the water bird, expresses the character of the Great Goddess more succinctly than any other creature. With the great cosmic egg, the Bird Goddess gave birth to individuals as well as the cosmos. The water bird emphasized water's practical and sacred significance. Water was essential for life.

Eliade places water as the basic element of life, typifying the formless potential of all physical and cosmic matter.[1] The seeds of all things emerge from it and return to it. With the invention of pottery in the early Neolithic era, women were visualized as water containers (obvious during pregnancy). Divinities and females were both represented in the huge water jars that stood on the altars.

Of all the goddess's symbols, the moon was perhaps the most culturally pervasive, since it could be seen from all continents. The moon was sacred to the goddess partially through its magic power over water and all liquids, including women's menses. The moon's influence over water and the observation that plants grow at night gave rise to the mistaken notion that the moon alone caused growth. Thus, the moon was also important for fertility. In part, the cow and bull were revered as symbols of the goddess because the shape of their horns paralleled that of the crescent moon.

The pagan life-view can be seen as one predicated on repetition and recollection. Rituals, maintained through recollection, permit the perpetuation of an idea over time; an idea thereby can maintain or even gain in power. The reverence in rituals for the goddess and her symbols may have fostered the widespread, transcontinental migration of her symbols.

The concept of a male God and patriarchal social structures are both comparatively recent developments. As Robert Briffault states in *The Mothers*, human society formed itself around the mother and her young, not the father.[2] In 1956 the eminent anthropologist Ashley Montagu reintroduced Briffault's radical ideas by writing the preface for Briffault and Bronislaw Malinowski's book, *Marriage: Past and Present*. It laid out in clear fashion the human race's actual history by including the 70,000 years before the most recent 2,000. No traces of patriarchal organization, either in marriage or morality, existed in early culture. On the contrary, the male was the one who came from the outside to join the family of the female, severing his own family ties. Even in the animal world the female and her offspring generally constitute the family unit.[3]

The precepts of Goddess worship reflect the eternal cyclic movement of life from birth to rebirth. It is therefore appropriate that fascination with the Goddess has been reborn, on both the scholarly and the popular levels. Even the Roman Catholic Church consented in a small way in recognizing the Virgin's godliness through the acceptance of the doctrine of the Assumption of Mary in the 1940s. The new goddess-centered energies and emotions may embody a profound inner drive toward achieving a cultural position of balance, such as that between yin and yang. Only very recently have we consciously addressed the imbalance to try to regain that natural equilibrium. And we are discovering that, despite patriarchy's efforts to wipe out the goddess religions, the ancient patterns shimmer through.

Religious experience, says William James, is convincing precisely because it is, simply, overwhelming. Through it, life is given splendor and meaning.[4] As Gerald Sykes has pointed out, we are all born with an intuition of the sacred, which we can either develop or ignore. Most of us, even our artists, prefer to ignore it.[5] Yet the arts, perhaps especially the arts, are not alien to religion. The high level of ancient religious art attests to an affinity.

The story of *Lady of the Beasts* relies on symbolism and the connections drawn between one idea or object and another. There are thirteen animals in the book; it was not planned that way, but it is fitting. In the past the number thirteen was revered for its connections to the goddess; it has been feared or denounced by patriarchal society for the same reason. To matrifocal cultures it stood for death and rebirth. The number became sacred because of the thirteen months in the lunar year, originally calculated by women by tracking their menses.[6]

Why the ancients have used animals as symbols so extensively in their art and religion is not an easy question to answer. Perhaps, as Carl Jung writes, they were considered more beautiful and certainly more powerful than human beings.[7] Perhaps the creatures touched off a primary response, deep in the psyche; they are that part of the surrounding environment most similar to humans. They are more approachable and immediate, even as symbols, than are deities. People turned to them to explain life and death and to give both physical and spiritual nourishment. Their presence and power was mysterious, yet ultimately affirming. Buoyed by their symbolic significance, people sang and danced, celebrated, lived, and made love with the glory of the Goddess in their hearts.

It is time for the recovery of the sacred. The animals are our guides on this quest. Along with the myths, symbols, and rituals associated with them, they point the way, inspiring our unconscious. It is, ultimately, always the inner being that directs us in both the outer and the inner worlds. The search for the hidden, the power of the sacred, begins within ourselves. It is not locked away, but completely accessible, open to everyone; it couldn't be closer. Fear is the only limitation; evil and darkness can be overcome as we search for the center. A teacher may give us a clue, but the journey essentially is made alone. We use any means at our disposal: our spiritual ancestors, fantasy, dreams, or the animal guides. The Goddess herself is, all at once, the impetus for, a mentor during, and the goal of the journey. So the Goddess presides at the birth of consciousness, bestowing the gift of renewal on all seekers.

Notes

Introduction: The Primal Female

1. Siegfried Giedion, *The Eternal Present: The Beginnings of Art*, Bollingen Foundation Series XXXV.6.1 (New York: Pantheon Books, 1962), 136.

2. Carl G. Jung, *The Collected Works of C. G. Jung*, vol. 6, Bollingen Foundation Series XX (Princeton, NJ: Princeton University Press, 1971), 443.

3. Marija Gimbutas, *Gods and Goddesses of Old Europe, 7000–3500 B.C.* (London: Thames and Hudson, 1974), 195.

4. Erich Neumann, *The Great Mother: An Analysis of the Archetype*, Bollingen Foundation Series XLVII (New York: Pantheon Books, 1963), 43–45.

5. Robert Briffault, *The Mothers*, vol. 1, (New York: Johnson Reprint Corp., 1969), 471.

6. James Mellaart, *Çatal Hüyük: A Neolithic Town in Anatolia* (New York: McGraw-Hill Book Company, 1967), 209.

Part One: The Bird

BIRD DEITIES OF THE PALEOLITHIC ERA

1. Jane Ellen Harrison, *Themis: A Study of the Social Origins of Greek Religion* (New Hyde Park, NY: University Books, 1962), 100–101.

2. Daniel E. Brinton, *Myths of the Americas* (Blauvelt, NY: Multimedia Publishing, 1976), 106.

3. E. O. James, *The Beginnings of Religion* (Westport, CT: Greenwood Press, 1973), 108.

4. Jane Ellen Harrison, *Prolegomena to the Study of Greek Religion* (New York: Meridian Books, 1955), 111.

5. Karl Sofus Lumholtz, *Unknown Mexico*, vol. 1 (New York: Charles Scribner's Sons, 1902), 313.

6. Porphyry, *De Abst II*, 48.

7. E. A. Westermark, *Ritual and Belief in Morocco*, vol. 2 (New York: Macmillan, 1968), 338–39.

8. Alexander Marshack, *The Roots of Civilization* (New York: McGraw-Hill Book Company, 1972), 147.

9. Marija Gimbutas, *Gods and Goddesses of Old Europe, 7000–3500 B.C.* (London: Thames and Hudson, 1974).

10. Siegfried Giedion, *The Eternal Present: The Beginnings of Art*, Bollingen Foundation Series XXXV.6.1 (New York: Pantheon Books, 1962), 526.

11. Amédée Lemozi, *La Grotte-Temple du Pech-Merle* (Paris: Editions August Picard, 1929), 183.

12. Gertrude R. Levy, *The Gate of Horn* (London: Faber and Faber, 1948), 123.

13. Giedion, *Eternal Present*, 503.

14. Marshack, *Roots of Civilization*, 286–88.

15. Giedion, *Eternal Present*, 456.

16. Ibid., 440–41.

17. Gimbutas, *Gods and Goddesses*, 140, fig. 124.

18. Harrison, *Themis*, 100.

19. Walter Torbrugge, *Prehistoric European Art* (New York: Harry N. Abrams, 1968), 18.

20. R. de Saint-Perier, "Statuette de Femme Stéatopyge Découverte à Lespugue, Haute-Garonne," *L'Anthropologie* 32 (1922), 1.

21. Giedion, *Eternal Present*, 438.

22. Paolo Graziosi, "Addaura," *Bullettino di Paleontologia Italiana* n.s. 8 (1952–53): 5–22.

23. Z. A. Abramova, "Paleolithic Art in the U.S.S.R.," *Arctic Anthropology* 4 (1967): 84.

24. Alfred Salmony, "Die Künst Des Aurignacien Im Mal'ta (Sibirien)," *IPEK* 1 (1931): 1–6.

25. Carl Hentze, *Mythes et Rituales Lunaires* (Anvers, Belgium: Editions de Sikkel, 1932), 47.

26. Giedion, *Eternal Present*, 445.

THE CREATRIX

1. Mircea Eliade, *The Forge and the Crucible* (New York: Harper & Brothers, 1962), 80.

2. Robert Briffault, *The Mothers*, vol. 1 (New York: Johnson Reprint Corp., 1969), 466.

3. Ibid., 473.

4. Mircea Eliade, *The Quest* (Chicago: University of Chicago Press, 1969), 140.

5. Carl G. Jung, *The Collected Works of C. G. Jung*, vol. 5, Bollingen Foundation Series XX

(Princeton, NJ: Princeton University Press, 1976), 354.

6. Z. A. Abramova, "Paleolithic Art in the U.S.S.R.," *Arctic Anthropology* 4 (1967): 68.

7. Erich Neumann, *The Great Mother: An Analysis of the Archetype*, Bollingen Foundation Series XLVII (New York: Pantheon Books, 1955), 211.

8. Alfred Salmony, "Die Künst Des Aurignacien Im Mal'ta (Siberien)," *IPEK* 1 (1931): 1.

9. Marija Gimbutas, *Gods and Goddesses of Old Europe, 7000– 3500 B.C.* (London: Thames and Hudson, 1974), 163.

10. Colin Renfrew, *Before Civilization* (New York: Alfred A. Knopf, 1973), 104.

11. Briffault, *Mothers*, vol. 2, p. 252.

12. Marek Zvelebil, "Postglacial Foraging in the Forests of Europe," *Scientific American* 254 (1986): 90.

13. Gimbutas, *Gods and Goddesses*, 167.

14. N. K. Sanders, *Prehistoric Art in Europe* (Harmondsworth, England: Penguin Books, 1985), 190.

15. R. T. Rundle-Clark, *Myth and Symbol in Ancient Egypt* (London: Thames and Hudson, 1978), 56.

16. Rundle-Clark, *Myth and Symbol*, 213.

17. Alexander Piankoff and Natasha Rambova, *Mythological Papyri*, vol. 1, Bollingen Foundation Series XL–3 (New York: Pantheon Books, 1957), 49.

18. Donald A. MacKenzie, *Myths of Pre-Columbian America* (London: Gresham, [1924?]), 17.

19. Gertrude R. Levy, *The Gate of Horn* (London: Faber and Faber, 1948), 101.

20. Vincent Scully, *The Earth, the Temple and the Gods: Greek Sacred Architecture* (New Haven, CT: Yale University Press, 1963), 209.

21. Ibid., 134.

22. Ibid., 75.

23. Michael Dames, *The Silbury Treasure: The Great Goddess Rediscovered* (London: Thames and Hudson, 1976), 93.

24. Daniel E. Brinton, *Myths of the Americas* (Blauvelt, NY: Multimedia Publishing, 1976), 211.

25. James George Frazer, *Folklore in the Old Testament* (New York: Tudor Publishing, 1923), 13.

26. Carl G. Jung, *The Collected Works of C. G. Jung*, vol. 14, Bollingen Foundation Series XX (Princeton, NJ: Princeton University Press, 1963), 338.

27. Brinton, *Myths*, 212.

28. Florence Waterbury, *Bird Deities in China* (Ascona, Switzerland: Artibus Asiae, 1952), 72.

29. Heinrich Schliemann, *Ilios: The City and Country of the Trojans* (New York: Harper & Brothers, 1880).

LADY OF THE WATERS

1. Robert Briffault, *The Mothers* vol. 3 (New York: Johnson Reprint Corp., 1969), 6, 19.

2. Alexander Marshack, *The Roots of Civilization* (New York: McGraw-Hill Book Company, 1972), 284.

3. Stylianos Alexiou, *Minoan Civilization*, trans. Cressida Ridley (Heraklion, Greece: Spyros Alexiou Sons, 1969), 145, pl. Ia.

4. Marija Gimbutas, *Gods and Goddesses of Old Europe, 7000– 3500 B.C.* (London: Thames and Hudson, 1974), 116.

5. Ibid., 132, 254.

6. Ibid., 95.

7. Ibid., 136. See also Marija Gimbutas, editor, *Neolithic Macedonia*, in *Monumenta Archaeologica*, vol. 1 (Los Angeles: The Institute of Archaeology, University of California at Los Angeles).

8. James Mellaart, *Excavations at Hacilar*, vol. 1 (Edinburgh, Scotland: University of Edinburgh Press, publ. for the British Institute

of Archaeology at Ankara, 1970), 181.

9. Peter Warren, *Myrtos* (London: Thames and Hudson, 1972), 209–10.

10. Erwin R. Goodenough, *Jewish Symbols in the Greco-Roman Period*, vol. 8, Bollingen Foundation Series XXXVII (New York: Pantheon Books, 1958), 97.

11. Bernhard Karlgren, "The Date of Early Don-So'n Culture," *Bulletin of the Museum of Far Eastern Antiquities*, vol 14.

12. Florence Waterbury, *Bird Deities in China* (Ascona, Switzerland: Artibus Asiae, 1952), 95.

13. Ibid., 87.

14. Marcel Granet, *Danse et Legendes de la Chine Ancienne* (Paris: Librairie Felix Alcan, 1926).

THE NOURISHING MOTHER

1. Alexander Marshack, *The Roots of Civilization* (New York: McGraw-Hill Book Company, 1972), 290.

2. Ibid., 291–93.

3. Marija Gimbutas, "The Shape of the Past: Vulvas, Breasts and Buttocks of the Goddess," essay from *Creatrix: Studies in Honor of Franklin D. Murphy*, edited by Giorgio Buccelatti and Charles Speroni (Los Angeles: Institute of Archaeology and Office of the Chancellor, the University of California at Los Angeles, 1981), 32.

4. Siegfried Giedion, *The Eternal Present: The Beginnings of Art*, Bollingen Foundation Series XXXV.6.1 (New York: Pantheon Books, 1962), 211.

5. Robert Briffault, *The Mothers*, vol. 1 (New York: Johnson Reprint Corp., 1969), 473–74.

6. Giedion, *Eternal Present*, 212–13.

7. Barbara Walker, *The Woman's Encyclopedia of Myths and Secrets* (San Francisco: Harper & Row, 1983), 150–51.

THE BIRD AND THE TREE

1. Mircea Eliade, *The Myth of the Eternal Return*, Bollingen Foundation Series XLVI (New York: Pantheon Books, 1954), 17–18.

2. Ibid., 18.

3. Mircea Eliade, *Myths, Dreams and Mysteries* (Glasgow: William Collins Sons, 1977), 62.

4. Erwin R. Goodenough, *Jewish Symbols in the Greco-Roman Period*, vol. 4, Bollingen Foundation Series XXXVII (New York: Pantheon Books, 1968), 73.

5. H. Kirschner, "Ein Archäologischer Beitrag zur Urgeschichte des Schamanismus," *Anthropos* 47 (1952).

6. Siegfried Giedion, *The Eternal Present: The Beginnings of Art*, Bollingen Foundation Series XXXV.6.1 (New York: Pantheon Books, 1962), 511.

7. Ibid., 508.

8. Florence Waterbury, *Bird Deities in China* (Ascona, Switzerland: Artibus Asiae, 1952), 67.

9. Carl Kerényi, *Goddesses of Sun and Moon* (Irving, TX: Spring Publications, 1979), 10–11.

10. Gertrude R. Levy, *The Gate of Horn* (London: Faber and Faber, 1948), 235.

11. Ibid., 236.

12. E. A. Wallis Budge, *The Book of the Dead* (New Hyde Park, NY: University Press, 1960), 285.

13. E. A. Wallis Budge, *Osiris and the Egyptian Resurrection*, vol. 2 (New York: Dover Publications, Inc., 1973), 129.

14. E. A. Wallis Budge, *The Gods of the Egyptians*, vol. 2 (New York: Dover Publications, Inc., 1969), 102.

15. Giedion, *The Eternal Present*, vol. 2, 443.

16. Carl Hentze, *Das Haus als Weltort der Seele: Ein Beitrag zur Seelensymbolik im China, Grossasien, Altamerika* (Stuttgart: E. Klett, 1961), Tafel I, 2.

17. Carl Hentze, *Bronzegerät, Kultbauten Religion im Ältesten China der Shang-Zeit* (Antwerp: De Sikkel, 1951), Tafel XXVIII, 81.

18. Robert Graves, *The White Goddess* (New York: Creative Age Press, 1948).

19. N. N. Bhatiacharyya, *Indian Mother Goddess* (Calcutta: R. K. Maitra, R. D. Press, 1971), passim.

SHRINES

1. E. O. James, *From Cave to Cathedral* (New York: Frederick A. Praeger, 1965), 16.

2. Marija Gimbutas, "The Temple of Old Europe," *Archaeology* (November-December 1980): 42.

3. Ibid., 43.

4. Ibid., 42.

5. Ibid., 43.

6. Marija Gimbutas, *The Gods and Goddesses of Old Europe, 7000–3500 B.C.* (London: Thames and Hudson, 1974), 131.

7. Arthur J. Evans, "The Minoan and Mycenaean Element in Hellenic Life," *Annual Report of the Smithsonian Institution, 1912–1913* (Washington, D.C.: Government Printing Office, 1914), 617–637.

8. D. O. Cameron, *Symbols of Birth and Death in the Neolithic Era* (London: Kenyon-Deane, 1981), 23.

9. Sibylle Von Cles-Redon, *The Realm of the Great Goddess* (Englewood Cliffs, NJ: Prentice-Hall, 1962), 70–108.

10. Colin Renfrew, *Before Civilization* (New York: Alfred A. Knopf, 1973), 108.

11. O. G. S. Crawford, *The Eye Goddess* (London: Phoenix House, 1957), 25–28.

12. Leonard Woolley, *History Unearthed* (New York: Frederick A. Praeger, 1963), 139.

13. Pausanias, *Description of Greece: Volume III* (Boston: Harvard University Press, 1918–1935), XXXii4.

14. John Garstang, *The Syrian Goddess* (London, 1913), 13.

15. C. G. Seligman, "Further Note on Bird-Chariots in Europe and China," *Journal of the Royal Anthropological Institute of Great Britain and Ireland* 58 (1928): 247–54.

16. Hanna Rydh, "On Symbolism in Mortuary Ceramics," *Bulletin of the Museum of Far Eastern Antiquities* 1 (1929): 51ff.

APHRODITE: LOVE AND DEATH

1. Hesiodus, *Hesiod: Theogony, Works and Days, Shield*, trans. Apostolos N. Athanassakis (Baltimore, MD: Johns Hopkins Press, 1983), 68.

2. Jane Ellen Harrison, *Prolegomena to the Study of Greek Religion* (New York: Meridian Books, 1955), 307.

3. Paul Friedrich, *The Meaning of Aphrodite* (Chicago: University of Chicago Press, 1978), 75.

4. Patricia Monaghan, *The Book of Goddesses and Heroines* (New York: E. P. Dutton, 1981), 23.

5. Edward A. Armstrong, *The Folklore of Birds* (London: Collins Press, 1958), 48.

6. Anne Ross, *Pagan Celtic Britain* (New York: Columbia University Press, 1967), 267, fig. 145.

7. Ibid., 261; quoting Carmichael in Benbecula, Scotland, II, p. 182 of an unpublished manuscript.

8. Henri Frankfort, *Kingship and the Gods* (Chicago: University of Chicago Press, 1948), 43.

9. James George Frazer, *The Golden Bough*, vol. 5 (New York: Macmillan, 1935), 34.

10. *Mabinogian*, trans. Charlotte Guest (London: J. M. Dent & Sons, 1924), 46.

11. Harrison, *Prolegomena*, 640.

12. Ibid.

13. Carl Kerényi, *The Gods of the Greeks* (London: Thames and Hudson, 1951), 194.

14. Ibid., 49.

15. Alfred Salmony, *Antler and Tongue* (Ascona, Switzerland: Artibus Asiae, 1954), 50.

16. Diane Wolkenstien and Samuel Noah Kramer, *Inanna: Queen of Heaven and Earth* (New York: Harper & Row, 1983), 7–9, 145.

17. Robert Graves and Raphael Patai, *Hebrew Myths: The Book of Genesis* (New York: McGraw-Hill Book Company, 1966), 65.

18. Ibid.

19. Raphael Patai, *The Hebrew Goddess* (Philadelphia: Ktav Publishing House, 1967), 207, 239–40.

20. Ibid., 244–45.

21. Barbara Walker, *The Woman's Encyclopedia of Myths and Secrets* (San Francisco: Harper & Row, 1983), 972; see also Christine Downing, *The Goddess: Mythological Images of the Feminine* (New York: Crossroad, 1981), 206.

22. Carl G. Jung, *The Collected Works of C. G. Jung*, vol. 9i, Bollingen Foundation Series XX (Princeton, NJ: Princeton University Press, 1977), 107–109.

23. Friedrich, *Meaning of Aphrodite*, 71.

24. Geoffrey Grigson, *The Goddess of Love* (New York: Stein and Day Publishers, 1977), 186.

25. Patai, *Hebrew Goddess*, 16.

26. Ean Begg, *The Cult of the Black Virgin* (Boston: Arkana, an imprint of Routledge & Kegan Paul, 1985), 28.

27. Ibid., 130–31.

BIRDS OF TRANSFORMATION

1. Mircea Eliade, *From the Stone Age to the Eleusinian Mysteries*, vol. 1 of *A History of Religious Ideas* (Chicago: University of Chicago Press, 1978), 45.

2. Kathleen Kenyon, *Excavations at Jericho* (London: British School of Archaeology in Jerusalem, 1960–83), 53ff., 84ff.

3. Stuart Piggott, *Prehistoric India*, (Harmondsworth, England: Penguin Books, 1950), 126–7.

4. Marthe de Chambrun-Ruspoli, *L'Epervier Divin* (Geneva, Switzerland: Editions du Mont-Blanc, 1969), fig. 26.

5. Mary Hamilton, *Incubation* (Laurinburg, NC: St. Andrews University Press, 1906).

6. Steven Lonsdale, *Animals and the Origins of Dance* (London: Thames and Hudson, 1981), 180.

7. Carl Hentze, "Le Symbolisme des Oiseaux dans la Chine Ancienne," *Sinologica* 5 (1957–58): 2–31.

8. A. Roess, "Der Hallstatt Vogel," *IPEK* 14 (1939): 75.

9. Florence Waterbury, *Bird Deities in China* (Ascona, Switzerland: Artibus Asiae, 1952), 87–88.

10. John Pollard, *Birds in Greek Life and Myth* (London: Thames and Hudson, 1977), 143.

11. James Mellaart, *Çatal Hüyük: A Neolithic Town in Anatolia* (New York: McGraw-Hill Book Company, 1967), 49.

12. Ibid., 167–68.

13. Ibid., 167.

14. D. O. Cameron, *Symbols of Birth and Death in the Neolithic Era* (London: Kenyon-Deane, 1981), 29.

15. Ibid., 30.

16. Ibid., 31.

17. Ibid., 36.

18. Alan W. Shorter, *The Egyptian Gods* (London: Routledge & Kegan Paul, 1981), 135–36. See also D. O. Cameron, *The Ghassulian Wall Paintings* (London: Kenyon–Deane Ltd., 1981).

19. Cameron, *Symbols of Birth and Death*, 40.

20. Ibid., 32.

Part Two: The Lion

1. Erich Neumann, *The Great Mother: An Analysis of the Archetype*, Bollingen Foundation Series XLVII (New York: Pantheon Books, 1963), 45.

2. Siegfried Giedion, *The Eternal Present: The Beginnings of Art*, Bollingen Foundation Series XXXV.6.1 (New York: Pantheon Books, 1962), 501.

3. Ibid., 52.

4. James Mellaart, *Çatal Hüyük: A Neolithic Town in Anatolia* (New York: McGraw-Hill Book Company, 1967), 181–82.

5. Ibid.

6. James Mellaart, *Excavations at Hacilar* (Edinburgh, Scotland: University of Edinburgh Press, 1970).

7. Gertrude R. Levy, *The Sword from the Rock* (London: Faber and Faber, 1953), 20.

8. Ibid., 21.

9. E. A. Wallis Budge, *The Egyptian Language: Easy Lessons in Egyptian Hieroglyphics* (New York: Dover Publications, Inc., 1976), 61; see also E. A. Wallis Budge, *The Gods of the Egyptians*, vol. 1 (New York: Dover Publications, Inc., 1969), 512–18.

10. Budge, *Gods of the Egyptians*, 444–48.

11. James Hastings, ed., *Encyclopedia of Religion and Ethics*, vol. 5 (Edinburgh, Scotland: T&T Clark, 1912), 244.

12. Neumann, *Great Mother*, 220.

13. Hastings, *Encyclopedia*, vol. 12, 451.

14. Alfred Salmony, *Antler and Tongue* (Ascona, Switzerland: Artibus Asiae, 1954), 50.

15. Ibid., 49–50.

Part Three: The Dog

1. Marija Gimbutas, *The Gods and Goddesses of Old Europe, 7000–3500 B.C.* (London: Thames and Hudson, 1974), 169.

2. Ibid., 171.

3. Ibid., 169.

4. Robert K. G. Temple, *The Sirius Mystery* (London: Sidgwick and Jackson, 1976).

5. E. O. James, *Cult of the Mother Goddess* (New York: Frederick A. Praeger, 1959), 152–53.

6. E. A. Wallis Budge, *The Book of the Dead* (New Hyde Park, NY: University Press, 1960), 182–83.

7. E. A. Wallis Budge, *The Gods of the Egyptians* (New York: Dover Publications, Inc., 1969), 264–65.

8. Lewis Spence, *Myths and Legends of the North American Indians* (Blauvelt, NY: Multimedia Publishing, 1975), 123–24, 351.

9. Donald A. MacKenzie, *Myths of Pre-Columbian America* (London: Gresham Publishing Co., [1924?]), 247.

10. Ibid.

11. E. A. Westermark, *Ritual and Belief in Morocco*, vol. 2 (New York: Macmillan, 1968).

Part Four: The Serpent

THE PALEOLITHIC SERPENT

1. Siegfried Giedion, *The Eternal Present: The Beginnings of Art*, Bollingen Foundation Series XXXV.6.1 (New York: Pantheon Books, 1962), 308–9.

2. Balaji Mundkur, *The Cult of the Serpent: An Interdisciplinary Survey of Its Manifestations and Origins* (Albany, NY: State University of New York Press, 1983), 17.

EARLY SNAKE GODDESSES

1. Joseph Campbell, *Occidental Mythology*, vol. 3 of *The Masks of God* (New York: Viking Press, 1964), 10.

2. Steven Lonsdale, *Animals and the Origins of Dance* (London: Thames and Hudson, 1981), 35.

3. Charles F. Herberger, *The Thread of Ariadne: The Labyrinth of the Calendar of Minos* (New York: Philosophical Library, 1972), 84.

4. Stylianos Alexiou, *Minoan Civilization*, trans. Cressida Ridley (Heraklion, Crete: Spyros Alexiou Sons, 1969), 102.

5. Carl Hentze, *Bronzegerät Kultbaten Religion Im Altesten China der Shang-Zeit* (Antwerp, Belgium: De Sikkel, 1951), 79–81.

6. Marija Gimbutas, *The Gods and Goddesses of Old Europe, 7000–3500 B.C.* (London: Thames and Hudson, 1974), 203.

7. Ibid., 208.

THE GREAT EGYPTIAN DIVINITIES

1. E. A. Wallis Budge, *Egyptian Language: Easy Lessons in Egyptian Hieroglyphics* (New York: Dover Publications, Inc., 1976), 33.

2. R. T. Rundle-Clark, *Myth and Symbol in Ancient Egypt* (London: Thames and Hudson, 1978), 198.

3. Erich Neumann, *The Great Mother: An Analysis of the Archetype*, Bollingen Foundation Series XLVII (New York: Pantheon Books, 1963), 220–21.

4. E. A. Wallis Budge, *The Gods of the Egyptians*, vol. 1 (New York: Dover Publications, Inc., 1969), 451.

5. Ibid., 460–61.

6. Alan W. Shorter, *The Egyptian Gods* (Boston: Routledge & Kegan Paul, 1981), 138.

7. Donald A. MacKenzie, *Egyptian Myth and Legend* (New York: Bell Publishing, 1978), 2.

8. Henri Frankfort, *Kingship and the Gods* (Chicago: University of Chicago Press, 1948), 43–44.

9. Ibid.

10. MacKenzie, *Egyptian Myth*, 2–6.

NEAR EASTERN DEITIES

1. A. A. Barb, "Diva Matrix," *Journal of the Warburg and Courtauld Institute* 16 (1953): 199–200.

2. E. O. James, *The Cult of the Mother Goddess* (New York: Frederick A. Praeger, 1959), 75.

3. E. O. James, *Myths and Rituals in the Ancient Near East* (New York: Frederick A. Praeger, 1958), 58–59.

4. Seton Lloyd, *The Archaeology of Mesopotamia: From the Old Stone Age to the Persian Conquest* (London: Thames and Hudson, 1978), 117–18.

5. Lucian, *De Dea Syria: The Syrian Goddess*, attributed to Lucian, trans. Harold W. Attridge and Robert A. Oden (Missoula, MT: Scholars Press, 1976), 51.

6. Pliny the Elder, *Natural History*, vol. 1–10, trans. H. Rackham (Cambridge, MA: Harvard University Press, 1938–62), xxx, 2(8), 17.

SERPENT GODDESSES OF CRETE

1. Marija Gimbutas, *Gods and Goddesses of Old Europe, 7000–3500 B.C.* (London: Thames and Hudson, 1974), 12, 18.

2. Arthur Evans, *The Palace of Minos*, vol. 1 (London: Macmillan, 1921), 501.

3. William Shakespeare, *Anthony and Cleopatra* (New York: Harper & Brothers, 1847), 48.

4. Robert Graves, *The Greek Myths*, vol. 1 (Harmondsworth, England: Penguin Books, 1955), 58.

5. Lewis Richard Farnell, *The Cults of the Greek States*, vol. 2 (London: Oxford University and Clarendon Press, 1896), 609.

6. H. W. Park, *Greek Oracles* (London: Hutchinson, 1967), 38.

7. Jane Ellen Harrison, *Themis: A Study of the Social Origins of Greek Religion* (New Hyde Park, NY: University Books, 1962), 433–34. She asks: "What was Apollo the bright and beautiful doing with the old snake?"

8. Gimbutas, *Gods and Goddesses*, 93.

SERPENT-HAIRED DEITIES

1. Marija Gimbutas, *Gods and Goddesses of Old Europe, 7000–3500 B.C.* (London: Thames and Hudson, 1974), 78.

2. Carl Kerényi, *Gods of the Greeks* (London: Thames and Hudson, 1951), 46.

3. Robert Graves, *The Greek Myths*, vol. 1 (Harmondsworth, England: Penguin Books, 1955), 239.

4. Ibid., 129.

5. Kerényi, *Gods of the Greeks*, 49.

6. Jane Ellen Harrison, *Prolegomena to the Study of Greek Religion* (New York: Meridian Books, 1955), 196.

7. Graves, *Greek Myths*, 129.

GREEK SERPENT DEITIES

1. Robert Graves, *The Greek Myths*, vol. 1 (Harmondsworth, England: Penguin Books, 1955), 129–30.

2. Jane Ellen Harrison, *Primitive Athens as Described by Thucydides* (Cambridge: Cambridge University Press, 1906), 47.

3. Ibid., 48, citing Herodotus.

4. Lewis Richard Farnell, *The Cults of the Greek States*, vol. 1 (London: Oxford University and Clarendon Press, 1896), 260–61.

5. Carl Kerényi, *Eleusis: Archetypal Image of Mother and Daughter*, Bollingen Foundation Series LXV.4 (New York: Bollingen Foundation, 1967), preface, xix.

6. Jane Ellen Harrison, *Prolegomena to the Study of Greek Religion* (New York: Meridian Books, 1955), 10, 17, 20.

7. Ibid., 288.

8. E. O. James, *The Cult of the Mother Goddess* (New York: Frederick A. Praeger, 1959), 152.

9. Kerényi, *Eleusis*, 32, 33.

10. James George Frazer, *The Golden Bough*, vol. 4 (New York: Macmillan, 1935), 84.

MEXICAN GODDESSES

1. Laurette Séjourné, *Burning Water: Thought and Religion in Ancient Mexico*, (New York: Grove Press, 1960), 160.

2. Erich Neumann, *The Great Mother: An Analysis of the Archetype*, Bollingen Foundation Series XLVII (New York: Pantheon Books, 1963), 182.

3. Séjourné, *Burning Water*, 159.

4. Eduardo Motas Moctezuma, "New Finds in the Great Temple," *National Geographic* 158 (December 1980): 767.

5. Ibid., 770.

6. James Hastings, ed., *Encyclopedia of Religion and Ethics*, vol. 11 (Edinburgh, Scotland: T&T Clark, 1937), 401.

7. Neumann, *Great Mother*, 203.

8. Ibid., 185; citing Vaillant, *The Aztecs of Mexico*, 122.

SERPENT DEITIES OF INDIA AND THE FAR EAST

1. Bernhard Karlgren, "Preliminary Report on Archaeological Research in Kansu Province," *IPEK* (Cologne, Germany, 1925): 32.

2. Carl Hentze, *Mythes et Symboles Lunaires* (Anvers, Belgium: Editions de Sikkel, 1932), 136–38.

3. Edward H. Schafer, *The Divine Woman: Dragon Ladies and Rain Maidens in T'ang Literature* (San Francisco: North Point Press, 1980), 40.

4. Ibid., 92.

5. Ibid., 98.

6. Ibid., 13–14.

7. Ananda Coomaraswamy, "Archaic Indian Terracotta," *IPEK* (Cologne, Germany, 1928): 64.

8. David R. Kinsley, *The Sword and the Flute* (Berkeley and Los Angeles: University of California Press, 1977), 110–11.

9. Buffie Johnson and Tracy Boyd, "The Eternal Weaver," *Heresies* (Spring 1978): 64–69.

10. Ajit Mookerjee, *Kundalini: The Arousal of the Inner Energy* (New York: Destiny Books, 1972), passim.

11. Ibid.

12. P. K. Maity, *Historical Studies in the Cult of the Mother Goddess Manasa: A Socio-Cultural Study* (Calcutta: Punthi Pustak, 1966), 331; citing specimen of a completed questionnaire translated from Bengali.

EVIDENCE OF THE SNAKE CULT IN OTHER CULTURES

1. P. V. Glob, *The Mound People: Danish Bronze-Age Man Preserved* (Ithaca, NY: Cornell University Press, 1970), 163–64.

2. Ibid., 165.

3. Emerson F. Greenman, *Guide to Serpent Mound* (Columbus, OH: Ohio Historical Society, 1964), 8.

4. Ibid., 9.

5. W. S. Webb and R. S. Baley, *The Adena People* (Columbus, OH: Ohio State University Press, 1957).

6. Lewis Spence, *Myths and Legends of the North American Indians* (Blauvelt, NY: Multimedia Publishing, 1975), 112.

7. Clyde E. Keeler, *Secrets of the Cuna Earthmother: A Comparative Study of Ancient Religions* (New York: Exposition Press, 1960), 67.

8. Robert Briffault, *The Mothers*, vol. 2 (New York: Johnson Reprint Corp., 1969), 663; citing C. G. Seligman, *The Melanesians of British New Guinea*, 282.

9. Joseph Campbell, *The Way of the Animal Powers* (San Francisco: Alfred Van der Marck Editions, 1983; distributed by Harper & Row), 140, fig. 245.

JUDEO-CHRISTIAN SERPENTS

1. H. J. Dukinfield Astley, *Biblical Anthropology* (London: Oxford University Press, 1929), 15–18.

2. Holy Bible, Exod. 7:9, KJV.

3. Saloman Reinach, *Orpheus: A*

Study of Religions (New York: Horace Liveright, 1942), 193.

4. Robert Briffault, *The Mothers*, vol. 3 (New York: Johnson Reprint Corp., 1969), 108.

5. Ibid., 109.

6. Merlin Stone, *When God Was a Woman* (New York: Dial Press, 1976), 209; citing R. A. S. Macalister, *Bible Sidelights from the Mound of Gezer* (London: Hodder and Stoughton, 1906).

7. Robert Graves, *The White Goddess* (New York: Creative Age Press, 1948), 273–74.

8. E. O. James, *Myths and Rituals in the Ancient Near East* (New York: Frederick A. Praeger, 1958), 63.

THE SERPENT AND THE TREE OF KNOWLEDGE

1. W. Robertson Smith, *The Religion of the Semites* (New York: Shocken Books, 1972), 185.

2. (Mrs.) J. H. Philpot, *The Sacred Tree, or the Tree in Religion and Myth* (New York: Macmillan, 1897), 15–23.

3. Joseph Campbell, *Occidental Mythology*, vol. 3 of *The Masks of God* (New York: Viking Press, 1964), 14; citing William Hayes Ward, *The Seal Cylinders of Western Asia* (Washington, D.C.: Carnegie Institute of Washington, 1960), 138.

4. Robert Graves, *The Greek Myths*, vol. 1 (Harmondsworth, England: Penguin Books, 1955), 69–70.

5. E. O. James, *The Tree of Life: An Archaeological Study* (Leiden, Netherlands: E. J. Brill, 1966), 33–34.

6. Carl G. Jung, *The Collected Works of C. G. Jung*, vol. 9ii Bollingen Foundation Series XX (Princeton: Princeton University Press, 1977), 245.

7. Robert Graves and Raphael Patai, *Hebrew Myths: The Book of Genesis* (New York: McGraw-Hill, 1966), 15.

8. James George Frazer, *Folklore in the Old Testament: Studies in Comparative Religion, Legend and Law*, vol. 1 (London: Macmillan, 1919), 5.

9. Elizabeth Cady Stanton with the Revising Committee of 1894, *The Woman's Bible* (reprint, Seattle, WA: Coalition Task Force on Women and Religion, 1974), 16.

10. Mircea Eliade, *Birth and Rebirth: The Religious Meanings of Initiation in Human Culture*, trans. Willard R. Trask (New York: Harper & Brothers, 1958).

11. Genesis 3:4–5, KJV.

12. Genesis 3:15–16, KJV.

13. James Hastings, ed., *Encyclopedia of Religion and Ethics*, vol. 6 (Edinburgh, Scotland: T&T Clark, 1937), 229, "Girdle."

14. Michael Dames, *The Silbury Treasure: The Great Goddess Rediscovered* (London: Thames and Hudson, 1976), 75.

15. Graves and Patai, *Hebrew Myths*, 15.

16. Ibid., 69.

17. James Hastings, ed., *Encyclopedia of Religion and Ethics*, vol. 5, 607.

18. Ibid., 608.

19. Elaine Pagels, *The Gnostic Gospels* (New York: Random House, 1979), 53–54.

20. Ibid., 57.

21. Ibid., 58.

22. Ibid., 59.

Part Five: The Butterfly

1. Carl Kerényi, *The Gods of the Greeks* (London: Thames and Hudson, 1951), 83–84.

2. Donald A. MacKenzie, *Myths of Pre-Columbian America* (London: Gresham, [1924?]), 321.

3. Ibid., 215.

4. Ibid., 216–17.

5. Marija Gimbutas, *The Gods and Goddesses of Old Europe, 7000–* 3500 B.C. (London: Thames and Hudson, 1974), 186–87.

6. Clyde E. Keeler, *Secrets of the Cuna Earthmother: A Comparative Study of Ancient Religions* (New York: Exposition Press, 1960), 66.

Part Six: The Ewe and the Ram

1. Joseph Campbell, *The Mythic Image*, vol. II (Princeton, NJ: Princeton University Press, 1975), 208.

2. James Mellaart, *Çatal Hüyük* (London: Thames and Hudson, 1967), 127.

3. Genesis 22:13, Scofield Reference Bible (New York: Oxford University Press, 1917).

4. E. O. James, *Myths and Rituals in the Ancient Near East* (New York: Frederick A. Praeger, 1958), 226.

5. Jane Ellen Harrison, *Prolegomena to the Study of Greek Religion* (New York: Meridian Books, 1955), 546–48.

6. James Hastings, ed., *Encyclopedia of Religion and Ethics*, vol. 4 (Edinburgh, Scotland: T&T Clark, 1935), 314.

7. W. Robertson Smith, *The Religion of the Semites* (New York: Shocken Books, 1972), 470.

8. Ibid., 310.

9. Robert Graves, *The Greek Myths*, vol. 1 (Harmondsworth, England: Penguin Books, 1955), 226–27.

10. Herodotus, vol. 1–4, trans. D. A. Godley (Cambridge, MA: Harvard University Press, 1966–69), 2, 103.

11. Homer, *The Iliad*, trans. George Chapman, Bollingen Foundation Series XLI (New York: Pantheon Books, 1956).

Part Seven: The Spider

1. Angelo de Gubernatis, *Zoological Mythology or the Legends of Animals*, vol. 2 (Detroit,

MI: Singing Tree Press, Book Tower, 1968), 165.

2. Max Müller, *Comparative Mythology* (London: George Routledge & Sons), 53.

3. Erich Neumann, *The Great Mother: An Analysis of the Archetype*, Bollingen Foundation Series XLVII (New York: Pantheon Books, 1963), 177.

4. Susan Feldman, *African Myths and Tales* (New York: Dial Publishing, 1963), 51–56.

5. Robert Graves, *The Greek Myths*, vol. 1 (Harmondsworth, England: Penguin Books, 1955), 98.

6. André Parrot, *Sumer* (New York: Golden Age Press, 1961), 379.

7. de Gubernatis, *Zoological Mythology*, 163.

8. Heinrich Zimmer, *The King and the Corpse*, Bollingen Foundation Series XI (New York: Pantheon Books, 1948), 240.

9. Steven Lonsdale, *Animals and the Origins of Dance* (London: Thames and Hudson, 1981), 50–51.

10. de Gubernatis, *Zoological Mythology*, 164.

11. Frank Waters, *Book of the Hopi* (New York: Viking Press, 1963), 5.

12. Gladys Reichard, *Navaho Religion: A Study of Symbolism*, Bollingen Foundation Series XVIII (Princeton, NJ: Princeton University Press, 1974), 467–69.

13. John Layard, *Stone Men of Malekula* (London: Chatto & Windus, 1942), 221–22.

14. Robert Briffault, *The Mothers*, vol. 2 (New York: Johnson Reprint Corp., 1969), 624.

15. Emma Hadfield, *Among the Natives of the Loyalty Group* (London: Macmillan, 1920), 227.

16. J. E. Cirlot, *A Dictionary of Symbols* (New York: Philosophical Library, 1962), 290.

17. Carl G. Jung, *The Collected Works of C. G. Jung*, vol. 9i, Bollingen Foundation Series XX (Princeton, NJ: Princeton University Press, 1977), 187.

Part Eight: The Deer

1. Johannes Maringer, *The Gods of Prehistoric Man* (New York: Alfred A. Knopf, 1960), 95.

2. Alexander Marshack, *The Roots of Civilization* (New York: McGraw-Hill, 1972), 267.

3. Marija Gimbutas, *Gods and Goddesses of Old Europe, 7000–3500 B.C.* (London: Thames and Hudson, 1974), 172–74.

4. Gertrude R. Levy, *The Gate of Horn* (London: Faber and Faber, 1948), 101.

5. Florence Waterbury, *Bird-Deities in China* (Ascona, Switzerland: Artibus Asiae, 1952), 24.

6. Ibid., 96–97.

7. Madho Sarup Vats, *Excavations at Harappa* (Delhi: Bhartiya Publishing House, 1974), pl. LXII.

Part Nine: The Fish

THE PALEOLITHIC FISH

1. Carl Hentze, *Mythes et Rituelles Lunaires* (Anvers, Belgium: Editions de Sikkel, 1932), 19–20.

2. Siegfried Giedion, *The Eternal Present: The Beginnings of Art*, Bollingen Foundation Series XXV.6.1 (New York: Pantheon Books, 1962), 192.

3. Robert Graves, *The Greek Myths*, vol. 1 (Harmondsworth, England: Penguin Books, 1955), 59; see also Mircea Eliade, *A History of Religious Ideas* (Chicago: University of Chicago Press, 1978), 271.

4. Alexander Marshack, *The Roots of Civilization* (New York: McGraw-Hill, 1972), 212, 218.

LATER FISH AND LOZENGES

1. Dragoslav Srejović, *Europe's First Monumental Sculpture: New Discoveries at Lepenski Vir* (New York: Stein and Day Publishers, 1972), 123–24.

2. Erich Neumann, *The Great Mother: An Analysis of the Archetype*, Bollingen Foundation Series XLVII (New York: Pantheon Books, 1963), 213–15.

3. Robert Graves and Raphael Patai, *Hebrew Myths: The Book of Genesis* (New York: McGraw-Hill Book Co., 1966), 26.

4. Jane Ellen Harrison, *Prolegomena to the Study of Greek Religion* (New York: Meridian Books, 1955), 148.

5. Alain Daniélou, *Hindu Polytheism*, Bollingen Foundation Series LXXIII (New York: Pantheon Books, 1964), 166–67.

6. Neumann, *Great Mother*, 217.

7. Gertrude Jobes, *Dictionary of Mythology, Folklore and Symbols*, vol. 1 (New York: Scarecrow Press, 1961), 574.

8. James George Frazer, *The Golden Bough*, vol. 5 (New York: Macmillan, 1935), 306–7, n. 5.

9. Ibid., vol. 6, p. 90.

10. Joseph Campbell, *Primitive Mythology*, vol. 1 of *The Masks of God* (New York: Viking Press, 1959), 257.

11. Graves, *White Goddess*, 323.

12. H. R. Ellis Davidson, *The Gods and Myths of Northern Europe* (Harmondsworth, England: Penguin Books, 1973), 165–66.

13. Elisabeth Edwards Goldsmith, *Ancient Pagan Symbols* (New York: G. P. Putnam's Sons, 1929), 100–102.

RESURRECTION, WATER, AND THE FISH

1. Vincent Scully, *The Earth, the Temple and the Gods: Greek Sacred Architecture* (New Haven, CT: Yale University Press, 1963), 97.

2. Erich Neumann, *The Great Mother: An Analysis of the Archetype*, Bollingen Foundation Series XLVII (New York: Pantheon Books, 1963), 81.

3. Scully, *The Earth, the Temple and the Gods*, 93.

4. Jane Ellen Harrison, *Prolegomena to the Study of Greek Religion* (New York: Meridian Books, 1955), 308.

5. Juliet Piggot, *Japanese Mythology* (New York: Paul Hamlyn, 1969), 13.

6. Bunyiu Nanjio, *Catalogue of the Chinese Tripitaka* (London: Oxford University Press, 1883), no. 282 (A.D. 148–170).

7. Saloman Reinach, *Orpheus: A Study of Religions* (New York: Horace Liveright, 1942), 42; see also Scully, *Earth*, 93, 99.

8. James Hastings, ed., *Encyclopedia of Religion and Ethics*, vol. 6 (Edinburgh, Scotland: T&T Clark, 1937), 675.

9. E. Benveniste, *The Persian Religion According to the Chief Greek Texts* (Paris: P. Geuthner, 1929), 61–62.

CEREMONIES OF THE FISH

1. Erich Neumann, *The Great Mother: An Analysis of the Archetype*, Bollingen Foundation Series XLVII (New York: Pantheon Books, 1963), 42–43, 47.

2. Carl G. Jung, *The Collected Works of C. G. Jung*, vol. 5, Bollingen Foundation Series XX (Princeton, NJ: Princeton University Press, 1976), 198–99.

3. Carl G. Jung, *Collected Works*, vol. 9ii, Bollingen Foundation Series XX (New York: Pantheon Books, 1959), 209; see also Homer, *The Iliad*, trans. George Chapman, Bollingen Foundation Series XLI (New York: Pantheon Books, 1956).

4. Christine Desroches-Noblecourt, *Tutankhamen* (New York: New York Graphic Society, 1965), 84.

5. Jung, *Collected Works*, vol. 5, 198, 234, 242.

6. Rupert Gleadow, *Your Character in the Zodiac* (New York: Funk & Wagnalls, 1968), 136.

7. Jung, *Collected Works*, vol. 9ii, 121, 144–45.

8. Robert Eisler, *The Royal Art of Astrology* (London: Herbert Joseph, 1946), 107.

9. Jung, *Collected Works*, vol. 9ii, 92, 111.

10. Jung, *Collected Works*, vol. 9ii, 89–90.

11. Lewis Spence, *Myths and Legends of Mexico and Peru* (Boston: David D. Nickerson, 1913), 292, 298, 306.

12. Anne Ross, *Pagan Celtic Britain* (New York: Columbia University Press, 1967), 350–51.

13. Ibid., 21, 219.

RITES OF THE DEAD

1. Henri Frankfort, *Kingship and the Gods* (Chicago: University of Chicago Press, 1948), 43–44.

2. James George Frazer, *The Golden Bough*, vol. 6 (New York: Macmillan, 1935), 10; quoting Plutarch, *Isis et Osiris*, 8, 18.

3. Carl G. Jung, *The Collected Works of C. G. Jung*, vol. 5, Bollingen Foundation Series XX (Princeton, NJ: Princeton University Press, 1976), 233–34.

4. E. A. Wallis Budge, *The Gods of the Egyptians*, vol. 2 (New York: Dover Publications, Inc., 1969), 263–64.

5. Christine Desroches-Noblecourt, "Poissons, Tabours et Transformations du Mort," *Kemi* 13 (1954), 34–37.

6. Ibid., 42; see also Budge, *Gods of the Egyptians*, vol. 2, 103.

7. John Layard, *Stone Men of Malekula* (London: Chatto & Windus, 1942), 218–20.

8. Robert Briffault, *The Mothers*, vol. 2 (New York: Johnson Reprint Corp., 1969), 688–89.

9. Alberto Ruz Lhuillier, "The Mystery of the Temple Inscriptions," *Archaeology* (1953); idem, "The Pyramid Tomb of the Prince of Palenque," *London Illustrated News* (1953); idem, "The Mystery of the Mayan Temple," *Saturday Evening Post* (29 August 1953).

10. Carl Hentze, "Le Poisson Comme Symbole du Fecundité dans la Chine Ancienne," *Bulletin de Musée Royale*.

THE FISH IN CHRISTIAN RITUAL

1. Walter Lowrie, *Art in the Early Church* (New York: Pantheon Books, 1947), 76.

2. Saloman Reinach, *Orpheus: A Study of Religions* (New York: Horace Liveright, 1942), 21.

3. Carl G. Jung, *The Collected Works of C. G. Jung*, vol. 12, Bollingen Foundation Series XX (New York: Pantheon Books, 1953), 295–99.

4. E. A. Wallis Budge, *Amulets and Talismans* (New Hyde Park, NY: University Books, 1968), 306.

Part Ten: The Pig

1. Marija Gimbutas, *Gods and Goddesses of Old Europe, 7000–3500 B.C.* (London: Thames and Hudson, 1974), 211.

2. Robert Graves, *The Greek Myths*, vol. 1 (Harmondsworth, England: Penguin Books, 1955), 129.

3. Gimbutas, *Gods and Goddesses*.

4. James George Frazer, *The Golden Bough*, vol. 6 (New York: Macmillan, 1959), 19.

5. Jane Ellen Harrison, *Prolegomena to the Study of Greek Religion* (New York: Meridian Books, 1955), 153.

6. Ibid., 124–25.

7. Graves, *Greek Myths*.

8. Henri Frankfort, *Kingship and the Gods* (Chicago: University of Chicago Press, 1948), 381.

9. Saloman Reinach, *Orpheus: A Study of Religion* (New York: Horace Liveright, 1942), 19–20.

10. James Hastings, ed., *Encyclopedia of Religion and Ethics*, vol. 12 (Edinburgh, Scotland: T&T Clark, 1937), 133.

11. Carl G. Jung, *The Collected Works of C. G. Jung*, vol. 5, Bollingen Foundation Series XX (Princeton, NJ: Princeton University Press, 1976), pl. IVa.

12. John Layard, *Stone Men of Malekula* (London: Chatto & Windus, 1942), 234.

13. Ibid., 340.

14. Barbara Walker, *The Women's Encyclopedia of Myths and Secrets* (San Francisco: Harper & Row, 1983), 182; citing C. G. Leland, *Gypsy Sorcery and Fortune Telling*.

Part Eleven: The Cow and the Bull

THE COW GODDESS

1. E. O. James, *Myths and Rituals in the Ancient Near East* (New York: Frederick A. Praeger, 1958), 31.

2. E. O. James, *Cult of the Mother Goddess* (New York: Frederick A. Praeger, 1959), 125–26.

3. Annette Laming, *Lascaux: Painting and Engraving*, trans. E. E. Armstrong (Harmondsworth, England: Penguin Books, 1955).

4. D. O. Cameron, *Symbols of Birth and Death in the Neolithic Era* (London: Kenyon-Deane, Ltd., 1981), p. 4; see also Michael Dames, *The Avebury Cycle* (London: Thames and Hudson, Ltd., 1977), 5.

5. Ibid., 7.

6. Siegfried Giedion, *The Eternal Present: The Beginnings of Art*, Bollingen Foundation Series XXXV.6.1 (New York: Pantheon Books, 1962), 116.

7. E. A. Wallis Budge, *The Gods of the Egyptians*, vol. 1 (New York: Dover Publications, Inc., 1969), 428.

8. R. T. Rundle-Clark, *Myths and Symbols in Ancient Egypt* (London: Thames and Hudson, 1978), 88.

9. Budge, *Gods of the Egyptians*, vol. 1, p. 435.

10. Robert Graves, *The Greek Myths*, vol. 1 (Harmondsworth, England: Penguin Books, 1955), 293.

FERTILITY

1. Marija Gimbutas, *Gods and Goddesses of Old Europe, 7000–3500 B.C.* (London: Thames and Hudson, 1974), 91.

2. Tacitus, *Germania*, trans. H. Mattingly (Harmondsworth, England: Penguin Books, 1948), 134–35.

3. H. R. Ellis Davidson, *The Gods and Myths of Northern Europe* (Harmondsworth, England: Penguin Books, 1965), 117–21.

4. James George Frazer, *The Golden Bough*, vol. 7 (New York: Macmillan, 1959), 135.

5. Lewis Spence, *Myths and Legends of the North American Indians* (Blauvelt, NY: Multimedia Publishing, 1975), 134–35.

6. E. O. James, *Cult of the Mother Goddess* (New York: Frederick A. Praeger, 1959), 35; see also E. O. James, *Myths and Rituals in the Ancient Near East* (New York: Frederick A. Praeger, 1958), 133.

7. James, *Cult of the Mother Goddess*, 34.

8. James, *Myths and Rituals.*

9. Sandra A. Wawrytko, *The Undercurrent of Feminine Philosophy in Eastern and Western Thought* (Washington, D.C.: University Press of America, 1981), 60–61.

10. Arthur Waley, *The Way and Its Power: A Study of the Tao Tê Ching and Its Place in Chinese Thought* (Boston and New York: Houghton Mifflin, 1935), 174.

11. Mokuse Miyuki, "Self Realization in the Ten Oxherding Pictures," *Quadrant* (Spring 1982): 25–44.

12. Dorothy Norman, *The Hero: Myth, Image, Symbol* (New York and Cleveland: World Publishing, 1969), 180–94.

DEATH AND REBIRTH

1. James Mellaart, *Çatal Hüyük: A Neolithic Town in Anatolia* (New York: McGraw-Hill, 1967), 207.

2. E. O. James, *Myths and Rituals in the Ancient Near East* (New York: Frederick A. Praeger, 1958), 135.

3. Diane Wolkstein and Samuel Noah Kramer, *Inanna: Queen of Heaven and Earth* (New York: Harper & Row, 1983), 52–89.

4. Leonard Woolley, *Excavations at Ur* (New York: Thomas Y. Crowell, 1954), 64.

5. Ibid., 66–67.

6. Gertrude R. Levy, *The Gate of Horn* (London: Faber and Faber, 1948), 105–6.

7. E. A. Wallis Budge, *The Book of the Dead* (New Hyde Park, NY: University Press, 1960), 370.

8. Joseph Campbell, *Primitive Mythology*, vol. 1 of *The Masks of God* (New York: Viking Press, 1959), 165; quoting Frobenius, *Monumenta Africana*, 318–22.

9. E. A. Wallis Budge, *Dwellers on the Nile* (New York: Dover Publications, Inc., 1977), 101.

10. H. R. Ellis Davidson, *The Gods and Myths of Northern Europe* (Harmondsworth, England: Penguin Books, 1964), 133.

11. James Hastings, ed., *Encyclopedia of Religion and Ethics*, vol. 12 (Edinburgh, Scotland: T&T Clark, 1934), 214–15.

THE BULL IN THE LABYRINTH

1. G. Rachel Levy, *The Gate of Horn* (London: Faber & Faber, 1948).

2. Marija Gimbutas, *Gods and Goddesses of Old Europe, 7000–3500 B.C.* (London: Thames and Hudson, 1974), 186–87.

3. Levy, *The Gate of Horn*, 248.

4. Stylianos Alexiou, *Minoan Civilization*, trans. Cressida Ridley (Heraklion, Greece: Spyros Alexiou Sons, 1969), 109–10.

5. Ibid.

THE BULL GOD

1. E. O. James, *The Ancient Gods* (New York: G. P. Putnam's Sons, 1960), 306.

2. Carl Kerényi, *Dionysos: Archetypal Image of Indestructible Life*, Bollingen Foundation Series LXV.2 (Princeton, NJ: Princeton University Press, 1976), 54–55.

3. James George Frazer, *The Golden Bough*, vol. 7 (New York: Macmillan, 1935), 12–13.

4. Jane Ellen Harrison, *Prolegomena to the Study of Greek Religion* (New York: Meridian Books, 1955), 437; quoting Plutarch, *Greek Questions*.

5. Kerényi, *Dionysos*, 316–18.

THE GODDESS AND HER PARTNERS

1. Diane Wolkenstein and Samuel Noah Kramer, *Inanna: Queen of Heaven and Earth* (New York: Harper & Row, 1983), 37.

2. Raphael Patai, *The Hebrew Goddess* (Philadelphia, PA: Ktav Publishing House, 1967), 64, 187–90.

3. Franz Cumont, *The Mysteries of Mithra* (New York: Dover Publications, Inc., 1956), 36–37.

4. Ibid., 136–37.

5. Maarten J. Vermaseren, *Cybele and Attis: the Myth and the Cult* (London: Thames and Hudson, 1977), 46–48.

6. E. A. Wallis Budge, *Osiris and the Egyptian Resurrection*, vol. 1 (New York: Dover Publications, Inc., 1973), 60.

7. E. O. James, *Cult of the Mother Goddess* (New York: Frederick A. Praeger, 1959), 123–24.

8. Heinrich Zimmer, *The Art of Indian Asia*, vol. 1, Bollingen Foundation Series XXXIX (New York: Pantheon Books, 1955), 22.

9. James, *Cult of the Mother Goddess*, 123–24.

10. N. N. Bhattacharyya, *Indian Mother Goddess* (3 Shambhunath Randit St., Calcutta: Indian Studies, Past and Present, 1971), 28.

11. Heinrich Zimmer, *Myths and Symbols in Indian Art and Civilization*, Bollingen Foundation Series VI (New York: Pantheon Books, 1946), 69.

12. Ibid., 139.

13. Erich Neumann, *The Great Mother: An Analysis of the Archetype*, Bollingen Foundation Series XLVII (New York: Pantheon Books, 1963), 152.

14. André Parrot, *The Arts of Assyria* (New York: Golden Age Press, 1961), 193–94.

15. Saloman Reinach, *Orpheus: A Study of Religions* (New York: Horace Liveright, 1942), 70.

16. James, *Cult of the Mother Goddess*, 94–96.

17. Gertrude R. Levy, *The Gate of Horn* (London: Faber and Faber, 1948), 120–21.

18. Neumann, *Great Mother*, 44.

THE BULL AND JUDEO-CHRISTIAN RITES

1. E. O. James, *Cult of the Mother Goddess* (New York: Frederick A. Praeger, 1959), 81.

2. Deut. 12:3 KJV.

3. Raphael Patai, *The Hebrew Goddess* (Philadelphia, PA: Ktav Publishing House, 1967), 39, 44; see also Reinach, *Orpheus*, 193.

4. Ibid., 124.

5. Ibid., 39–44.

6. E. A. Wallis Budge, *The Gods of the Egyptians*, vol. 2 (New York: Dover Publications, Inc., 1969), 242–43.

7. Jane Ellen Harrison, *Prolegomena to the Study of Greek Religion* (New York: Meridian Books, 1955), 122.

8. Carl G. Jung, *The Collected Works of C. G. Jung*, vol. 12, Bollingen Foundation Series XX (New York: Pantheon Books, 1953), 22–23.

9. E. A. Wallis Budge, *The Book of the Dead* (New Hyde Park, NY: University Books, 1960), 130–31.

THE BULL, THE MOON, AND THE CALENDAR

1. Alexander Marshack, *The Roots of Civilization* (New York: McGraw-Hill, 1972), 334–36.

2. Carl G. Jung, *The Collected Works of C. G. Jung*, vol. 9i, Bollingen Foundation Series XX (Princeton, NJ: Princeton University Press, 1980), 107–8.

3. Robert Graves, *The Greek Myths*, vol. 1 (Harmondsworth, England: Penguin Books, 1955), 57.

4. Edith Porada, *L'Art dans le Monde: Iran Ancien* (Paris: Editions Albin Michel, 1963), 83.

5. James George Frazer, *The Golden Bough*, vol. 8 (New York: Macmillan, 1935), 10–12.

6. E. A. Wallis Budge, *The Gods of the Egyptians* (New York: Dover Publications, Inc., 1969), 435.

7. Jane Ellen Harrison, *Themis: A Study of the Social Origins of Greek Religion* (New Hyde Park, NY: University Books, 1962), 143.

8. Jane Ellen Harrison, *Prolegomena to the Study of Greek Religion* (New York: Meridian Books, 1955), 111–12.

9. Gen. 3:5 KJV.

10. Robert K. G. Temple, *The Sirius Mystery* (London: Sidawick and Jackson, 1976), 64.

11. Robert Briffault, *The Mothers*, vol. 2 (New York: Johnson Reprint Corp., 1969), 432–33.

12. Gertrude R. Levy, *The Gate of Horn* (London: Faber and Faber, 1948), 79–81.

Part Twelve: The Scorpion

1. Carl G. Jung, *The Collected Works of C. G. Jung*, vol. 2, Bollingen Foundation Series XX (Princeton, NJ: Princeton University Press, 1973), 236.

2. Patricia Monaghan, *The Book of Goddesses and Heroines* (New York: E. P. Dutton, 1981), 157.

3. E. A. Wallis Budge, *The Gods of the Egyptians*, vol. 2 (New York: Dover Publications, Inc., 1969), 377–78.

4. Henri Frankfort, *Kingship and the Gods* (Chicago: University of Chicago Press, 1948), 382, n. 49.

5. Alain Daniélou, *Hindu Polytheism*, Bollingen Foundation Series LXXIII (New York: Pantheon Books, 1964), 286–87.

Part Thirteen: The Bear

1. Paul Shepherd and Barry Sanders, *The Sacred Paw* (New York: Viking Penguin Press, 1985), xvi–xvii.

2. Alexander Marshack, *The Roots of Civilization* (New York: McGraw-Hill, 1972), 15–16, 30.

3. Shepherd and Sanders, *Sacred Paw*, 190.

4. Johannes Maringer, *The Gods of Prehistoric Man* (New York: Alfred A. Knopf, 1960), 269.

5. Ibid., 42.

6. Ibid., 44.

7. Marshack, *Roots of Civilization*, 354.

8. Marija Gimbutas, *Gods and Goddesses of Old Europe, 7000–3500 B.C.* (London: Thames and Hudson, 1974), 113.

9. Ibid., 116, fig. 80–81.

10. Gimbutas, *Gods and Goddesses*, 190.

11. Maringer, *Gods of Prehistoric Man*, 102; quoting Wilhelm Koppers.

12. James Hastings, ed., *Encyclopedia of Religion and Ethics*, vol. 6 (Edinburgh, Scotland: T&T Clark, 1937), 879.

13. Maringer, *Gods of Prehistoric Man*, 52.

14. Ibid., 52–53.

15. Jane Ellen Harrison, *Themis: A Study of the Social Origins of Greek Religion* (New Hyde Park, NY: University Books, 1962).

16. Vincent Scully, *The Earth, the Temple and the Gods: Greek Sacred Architecture* (New Haven, CT: Yale University Press, 1963), 88.

17. Anne Ross, *Pagan Celtic Britain* (New York: Columbia University Press, 1967), 349.

Afterword

1. Mircea Eliade, *A History of Religious Ideas* (Chicago: University of Chicago Press, 1979).

2. Robert Briffault, *The Mothers* (New York: Johnson Reprint Corp., 1969).

3. Robert Briffault and Bronislaw Malinowski, *Marriage: Past and Present* (Boston, MA: Porter Sargent, 1956).

4. William James, *Varieties of Religious Experience* (New York: Macmillan, 1961).

5. Gerald Sykes, private conversation.

6. Barbara Walker, *The Woman's Encyclopedia of Myths and Secrets* (San Francisco: Harper & Row, Publishers, 1983), 648.

7. Carl G. Jung, *Psychology and Religion* (New Haven: Yale University Press, Inc., 1938), 114.

Bibliography

Abramova, Z. A. "Paleolithic Art in the U.S.S.R." *Arctic Anthropology* vol. 4 no. 2. Madison, WI:University of Wisconsin Press, 1967.

Ackerman, Phyllis. *Ritual Bronzes of Ancient China*. New York: Dryden Press, 1945.

Alexiou, Stylianos. *Minoan Civilization*. Translated by Cressida Ridley. Heraklion, Greece: Spyros Alexiou Sons, 1969.

Al-Sufi, Abd Al-Rahman. *Book of Fixed Stars*. Unpublished manuscript. C.E. 1632.

Armstrong, Edward A. *The Folklore of Birds*. London: Collins Press, 1958.

Astley, H. J. Dukinfield. *Biblical Anthropology*. London: Oxford University Press, 1929.

Bachofen, J. J. *Myth, Religion, and Mother Right: Selected Writings of Johann Jakob Bachofen*. Translated by Ralph Manheim. Princeton: Princeton University Press, 1967. (Bollingen Foundation Series, No. 84.)

Barb, A. A. "Diva Matrix." *Journal of the Warburg and Courtauld Institute* 16 (1953):199–200.

Begg, Ean. *The Cult of the Black Virgin*. Boston: Arkana, an imprint of Routledge & Kegan Paul, 1985.

Briffault, Robert. *The Mothers*. 3 vols. New York: Johnson Reprint Corp., 1969.

Briffault, Robert, and Bronislaw Malinowski. *Marriage, Past and Present*. Boston: Porter Sargent, Publisher, 1956. Preface by Ashley Montagu.

Brinton, Daniel E. *Myths of the Americas*. Blauvelt, NY: Multimedia Publishing, 1976.

Budge, E. A. Wallis. *Amulets and Talismans*. New Hyde Park, NY: University Books, 1968.

———. *The Book of the Dead*. New Hyde Park, NY: University Books, 1960.

———. *Dwellers on the Nile*. New York: Dover Publications, Inc., 1977.

———. *The Egyptian Language: Easy Lessons in Egyptian Hieroglyphics*. New York: Dover Publications, Inc., 1976.

———. *The Gods of the Egyptians*. 2 vols. New York: Dover Publications, Inc., 1969.

———. *Osiris and the Egyptian Resurrection*. 2 vols. New York: Dover Publications, Inc., 1973.

Cameron, D. O. *The Ghassulian Wall Paintings*. London: Kenyon-Deane Ltd., 1981.

———. *Symbols of Birth and Death in the Neolithic Era*. London: Kenyon-Deane, 1981.

Campbell, Joseph. *The Masks of God*. 4 vols. New York: Viking Press, 1959–68.

———. *The Way of the Animal Powers*. San Francisco: Alfred Van der Marck Editions, 1983; distributed by Harper & Row.

Cirlot, J. E. *A Dictionary of Symbols*. New York: Philosophical Library, 1962.

Coomaraswamy, Ananda. "Archaic Indian Terracottas." *IPEK* (1928).

Crawford, O. G. S. *The Eye Goddess*. London: Phoenix House, 1957.

Cumont, Franz. *The Mysteries of Mithra*. New York: Dover Publications, Inc., 1956.

Dames, Michael. *The Avebury Cycle*. London: Thames and Hudson, 1977.

———. *The Silbury Treasure: The Great Goddess Rediscovered*. London: Thames and Hudson, 1976.

Daniélou, Alain. *Hindu Polytheism*. Bollingen Foundation Series LXXIII. New York: Pantheon Books, 1964.

Davidson, H. R. Ellis. *The Gods and Myths of Northern Europe*. Harmondsworth, England: Penguin Books, 1965.

de Chambrun-Ruspoli, Marthe. *L'Epervier Divin*. Geneva: Editions du Mont-Blanc, 1969.

de Gubernatis, Angelo. *Zoological Mythology or the Legends of Animals*. 2 vols. London: Truber, 1972.

de Saint-Perier, R. "Statuette de Femme Stéatopyge Découverte à Lespugue, Haute-Garonne." *L'Anthropologie* 32 (1922).

Desroches-Noblecourt, Christine. "Poissons, Tabours et Transformations du Mort." *KEMI* 13 (1954).

———. *Tutankamen*. New York: New York Graphic Society, 1954.

Downing, Christine. *The Goddess: Mythological Images of the Feminine*. New York: Crossroad, 1981.

Eisler, Robert. *The Royal Art of Astrology*. London: Herbert Joseph, 1946.

Eliade, Mircea. *Birth and Rebirth: The Religious Meanings of Initiation in Human Culture*. Translated by Willard R. Trask. New York: Harper & Brothers, 1958.

———. *The Forge and the Crucible*. New York: Harper & Brothers, 1962.

———. *A History of Religious Ideas*. 3 vols. Chicago: University of Chicago Press, 1979.

———. *The Myth of the Eternal Return*. Bollingen Foundation Series XLVI. New York: Pantheon Books, 1954.

———. *Myths, Dreams and Mysteries*. Glasgow: William Collins Sons, 1977.

———. *The Quest*. Chicago: University of Chicago Press, 1969.

Evans, Arthur J. "The Minoan and Mycenaean Element in Hellenic Life." *Annual Report of the Smithsonian Institution, 1912–1913*. Washington, D.C.: Government Printing Office, 1914.

———. *The Palace of Minos*. 4 vols. London: Macmillan, 1921–36.

Farnell, Lewis Richard. *The Cults of the Greek States*. 5 vols. London: Oxford University and Clarendon Press, 1896.

Frankfort, Henri. *Kingship and the Gods*. Chicago: University of Chicago Press, 1948.

Frazer, James George. *Folklore in the Old Testament*. New York: Tudor Publishing, 1923.

———. *The Golden Bough*. 13 vols. New York: Macmillan, 1959.

Friedrich, Paul. *The Meaning of Aphrodite*. Chicago: University of Chicago Press, 1978.

Giedion, Siegfried. *The Eternal Present: The Beginnings of Art*. Bollingen Foundation Series XXXV.6.1. New York: Pantheon Books, 1962.

Gimbutas, Marija. "The First Wave of Steppe Pasturalists into Copper Age Europe." *Journal of Indo-European Studies* 5 (Winter 1977).

———. *Gods and Goddesses of Old Europe, 7000–3500 B.C.* London: Thames and Hudson, 1974.

———. *Goddesses and Gods of Old Europe, 6500–3500 B.C.* Berkeley-Los Angeles: University of California Press, 1982. Paperback edition of *Gods and Goddesses of Old Europe*.

———. *The Language of the Goddess: Images and Symbols of Old Europe*. New York: Alfred van der Marck Editions, 1988.

———. "The Shape of the Past: Vulvas, Breasts and Buttocks of the Goddess." Essay from *Creatrix: Studies in Honor of Franklin D. Murphy*, edited by Giorgio Buccelatti and Charles Speroni. Los Angeles: Institute of Archaeology and Office of the Chancellor, the University of California at Los Angeles, 1981.

———. "The Temples of Old Europe." *Archaeology* (November–December 1980).

———. ed. *Neolithic Macedonia*, in *Monumenta Archaeologica*, vol. 1. Los Angeles: Institute of Archaeology, University of California at Los Angeles.

Gleadow, Rupert. *Your Character in the Zodiac*. New York: Funk & Wagnalls, 1968.

Glob, P. V. *The Mound People: Danish Bronze-Age Man Preserved*. Ithaca, NY: Cornell University Press, 1974.

Goldsmith, Elisabeth Edwards. *Ancient Pagan Symbols*. New York: G. P. Putnam's Sons, 1929.

Goodenough, Erwin R. *Jewish Symbols in the Greco-Roman Period*. 13 vols. Bollingen Foundation Series XXXVII. New York: Princeton University Press, 1953–69.

Granet, Marcel. *Danse et Legendes de la Chine Ancienne.* Paris: Librairie Felix Alcan, 1926.

Graves, Robert. *The Greek Myths.* 2 vols. Harmondsworth, England: Penguin Books, 1955.

——. *The White Goddess.* New York: Creative Age Press, 1948.

Graves, Robert, and Raphael Patai. *Hebrew Myths: The Book of Genesis.* New York: McGraw-Hill, 1966.

Graziosi, Paolo. "Addaura." *Bulletino di Paletnologia Italiana* vol. 8 (1952–53):5–22.

Greenman, Emerson F. *Guide to Serpent Mound.* Columbus, OH: Ohio Historical Society, 1964.

Grigson, Geoffrey. *The Goddess of Love.* New York: Stein and Day Publishers, 1977.

Hadfield, Emma. *Among the Natives of the Loyalty Group.* London: Macmillan, 1920.

Harrison, Jane Ellen. *Primitive Athens as Described by Thucydides.* Cambridge: Cambridge University Press, 1906.

——. *Prolegomena to the Study of Greek Religion.* New York: Meridian Books, 1955.

——. *Themis: A Study of the Social Origins of Greek Religion.* New Hyde Park, NY: University Books, 1962.

Hastings, James, ed. *Encyclopedia of Religion and Ethics.* 13 vols. Edinburgh, Scotland: T&T Clark, 1935–37.

Hawkins, Gerald S. *Stonehenge Decoded.* Garden City, NY: Doubleday, 1965.

Hentze, Carl. *Bronzegerät Kultbauten Religion Im Altesten China der Shang-Zeit.* Antwerp: Editions de Sikkel, 1951.

——. *Das Haus Als Weltort Der Seele Ein Beitrag Sur Seelensymbolik Im China, Grossasien, Altamerika.* Stuttgart: E. Klett, 1961.

——. *Mythes et Rituels Lunaires.* Antwerp: Editions de Sikkel, 1932.

——. *Mythes et Symboles Lunaires.* Antwerp: Editions de Sikkel, 1932.

——. "Le Poisson Comme Symbole du Fecundité dans la Chine Ancienne." *Bulletin de Musée Royale.*

——. "Le Symbolisme des Oiseaux dans la Chine Ancienne." *Sinologica* 5 (1957–58):2–31.

Herberger, Charles F. *The Thread of Ariadne: The Labyrinth of the Calendar of Minos.* New York: Philosophical Library, 1972.

Herodotus. 4 vols. Translated by D. A. Godley. Cambridge, MA: Harvard University Press, 1963–69.

Hesiodus. *Hesiod: Theogony, Works and Days, Shield.* Translated by A. N. Athanassakis. Baltimore, MD: Johns Hopkins Press, 1983.

Homer. *The Iliad and the Odyssey and the Lesser Homerica.* Translated by George Chapman. Bollingen Foundation Series XLI. New York: Pantheon Books, 1956.

James. E. O. *The Ancient Gods.* New York: G. P. Putnam's Sons, 1960.

——. *The Beginnings of Religion.* Westport, CT: Greenwood Press, 1973.

——. *Cult of the Mother Goddess.* New York: Frederick A. Praeger, 1959.

——. *From Cave to Cathedral.* New York: Frederick A. Praeger, 1965.

——. *Myths and Rituals in the Ancient Near East.* New York: Frederick A. Praeger, 1958.

Johnson, Buffie, and Tracey Boyd. "The Eternal Weaver." *Heresies* (Spring 1978):64–69.

Jung, Carl G. *The Collected Works of C. G. Jung.* 20 vols. Bollingen Foundation Series XX. Princeton, NJ: Princeton University Press, 1955–78.

——. *Psychology and Religion.* New Haven, CT: Yale University Press, 1940.

Karlgren, Bernhard. "The Date of Early Don-So'n Culture." *Bulletin of the Museum of Far Eastern Antiquities* vol. 14.

——. "Preliminary Report on Archaeological Research in Kansu Province." *IPEK* (1925).

Keeler, Clyde E. *Secrets of the Cuna Earthmother: A Comparative Study of Ancient Religions.* New York: Exposition Press, 1960.

Kenyon, Kathleen. *Excavations at Jericho.* London: British School of Archaeology in Jerusalem, 1960–83.

Kerényi, Carl. *Dionysos: Archetypal Image of Indestructible Life.* Bollingen Foundation Series LXV.2. Princeton, NJ: Princeton University Press, 1976.

————. *Eleusis: Archetypal Image of Mother and Daughter.* Bollingen Foundation Series LXV.4. Princeton, NJ: Princeton University Press, 1967.

————. *Goddesses of Sun and Moon.* Irving, TX: Spring Publications, 1979.

————. *The Gods of the Greeks.* London: Thames and Hudson, 1951.

————. *Zeus and Hera.* Bollingen Foundation Series LX.5.5. Princeton, NJ: Princeton University Press, 1975.

Kingsley, David R. *The Sword and the Flute.* Berkeley and Los Angeles: University of California Press, 1977.

Kirschner, Horst. "Ein Archäologischer Beitrag zur Urgeschichte des Schamanismus." *Anthropos* 47 (1952).

Laming, Annette. *Lascaux: Painting and Engraving.* Translated by E. E. Armstrong. Harmondsworth, England: Penguin Books, 1955.

Layard, John. *Stone Men of Malekula.* London: Chatto & Windus, 1942.

Lemozi, Amédée. *La Grotte-Temple du Pech-Merle.* Paris: Editions August Picard, 1929.

Levy, Gertrude R. *The Gate of Horn.* London: Faber and Faber, 1948.

————. *The Sword from the Rock.* London: Faber and Faber, 1953.

Lloyd, Seton. *The Archaeology of Mesopotamia: From the Old Stone Age to the Persian Conquest.* London: Thames and Hudson, 1978.

Lonsdale, Steven. *Animals and the Origins of Dance.* London: Thames and Hudson, 1981.

Lucian? *De Dea Syria: The Syrian Goddess.* Translated by Harold W. Attridge and Robert A. Oden. Missoula, MT: Scholars Press, 1976.

Lumholtz, Karl Sofus. *Unknown Mexico.* 2 vols. New York: Charles Scribner's Sons, 1902.

Mabinogian. Translated by Charlotte Guest. London: J. M. Dent & Sons, 1924.

MacKenzie, Donald A. *Egyptian Myth and Legend.* New York: Bell Publishing, 1978.

————. *Myths of Pre-Columbian America.* London: Gresham, 1924?

Maity, P. K. *Historical Studies in the Cult of the Mother Goddess Manasa: A Socio-Cultural Study.* Calcutta: Punthi Pustak, 1966.

Maringer, Johannes. *The Gods of Prehistoric Man.* New York: Alfred A. Knopf, 1960.

Marshack, Alexander. *The Roots of Civilization.* New York: McGraw-Hill, 1972.

Mellaart, James. *Çatal Hüyük: A Neolithic Town in Anatolia.* New York: McGraw-Hill, 1967.

————. *Excavations at Hacilar.* 2 vols. Edinburgh, Scotland: University of Edinburgh Press, 1970; published for the British Institute of Archaeology at Ankara.

Miyuki, Mokuse. "Self Realization in the Ten Oxherding Pictures." *Quadrant* (Spring 1982):25–44.

Moctezuma, Eduardo Motas. "New Finds in the Great Temple." *National Geographic* 158 (December 1980).

Monaghan, Patricia. *The Book of Goddesses and Heroines.* New York: E. P. Dutton, 1981.

Montagu, Ashley. *Man: His First Million Years.* New York: Signet Science Library, New American Library, 1962.

Mookerjee, Ajit. *Kundalini: The Arousal of the Inner Energy.* New York: Destiny Books, 1972.

Müller, Max. *Comparative Mythology.* London: George Routledge & Sons.

Mundkur, Balaji. *The Cult of the Serpent: An Interdisciplinary Survey of Its Manifestations and Origins.* Albany, NY: State University of New York Press, 1983.

Nanjio, Bunyiu. *Catalogue of the Chinese Tripataka.* London: Oxford University Press, 1883.

Neumann, Erich. *The Great Mother: An Analysis of the Archetype.* Bollingen Foundation Series XLVII. New York: Pantheon Books, 1955.

Nichols, Marianne. *Man, Myth and Monument.* New York: William Morrow, 1975.

Norman, Dorothy. *The Hero: Myth, Image, Symbol.* New York and Cleveland, OH: World Publishing, 1969.

Pagels, Elaine. *The Gnostic Gospels.* New York: Random House, 1979.

Park, H. W. *Greek Oracles.* London: Hutchinson, 1967.

Parrot, André. *The Arts of Assyria.* New York: Golden Age Press, 1961.

———. *Sumer*. New York: Golden Age Press, 1961.

Patai, Raphael. *The Hebrew Goddess*. Philadelphia: Ktav Publishing House, 1967.

Pausanias. *Description of Greece*. 4 vols. Translated by W. H. S. Jones. Cambridge, MA: Harvard University Press, 1926–54.

Philpot, J. H. (Mrs.). *The Sacred Tree, or the Tree in Religion and Myth*. New York: Macmillan, 1897.

Piankoff, Alexander and Natasha Rambova. *Mythological Papryi*. 2 vols. Bollingen Foundation Series XL-3. New York: Pantheon Books, 1957.

Piggott, Juliet. *Japanese Mythology*. New York: Paul Hamlyn, 1969.

Piggott, Stuart. *Prehistoric India*. Harmondsworth, England: Penguin Books, 1950.

Pliny the Elder. *Natural History*. 11 vols. Translated by H. Rackham. Cambridge, MA: Harvard University Press, 1938–62.

Plutarch, *Vit. Alexander I.*

Pollard, John, *Birds in Greek Life and Myth*. London: Thames and Hudson, 1977.

Porada, Edith. *L'Art dans le Monde: Iran Ancien*. Paris: Editions Albin Michel, 1963.

Reichard, Gladys. *Navajo Religion: A Study of Symbolism*. Bollingen Foundation Series XVIII. Princeton, NJ: Princeton University Press, 1950.

Reinach, Saloman. *Orpheus: A Study of Religions*. New York: Horace Liveright, 1942.

Renfrew, Colin. *Before Civilization*. New York: Alfred A. Knopf, 1973.

Roess, A. "Der Hallstatt Vogel." *IPEK* 14 (1939).

Ross, Anne. *Pagan Celtic Britain*. New York: Columbia University Press, 1967.

Rundle-Clark, R. T. *Myth and Symbol in Ancient Egypt*. London: Thames and Hudson, 1978.

Ruz Lhuillier, Alberto. "The Mystery of the Mayan Temple." *Saturday Evening Post* (29 August 1953).

———. "The Mystery of the Temple Inscriptions." *Archaeology* (1953).

———. "The Pyramid Tomb of the Prince of Palenque." *London Illustrated News* (1953).

Rydh, Hannah. "On Symbolism in Mortuary Ceramics." *Bulletin of the Museum of Far Eastern Antiquities* 1 (1929).

Salmony, Alfred. *Antler and Tongue*. Ascona, Switzerland: Artibus Asiae, 1954.

———. "Die Künst des Aurignacien im Mal'ta (Sibirien)." *IPEK* 1 (1931):1–6.

Sanders, N. K. *Prehistoric Art in Europe*. Harmondsworth, England: Penguin Books, 1985.

Schafer, Edward H. *The Divine Woman: Dragon Ladies and Rain Maidens in T'ang Literature*. San Francisco: North Point Press, 1980.

Schliemann, Heinrich. *Ilios: The City and Country of the Trojans*. New York: Harper & Brothers, 1880.

Scully, Vincent. *The Earth, the Temple and the Gods: Greek Sacred Architecture*. New Haven, CT: Yale University Press, 1963.

Sejourne, Laurette. *Burning Water*. New York: Grove Press, 1960.

Seligman, C. G. "Further Note on Bird-Chariots in Europe and China." *Journal of the Royal Anthropological Institute of Great Britain and Ireland* 58 (1928):247–54.

Shakespeare, William. *Anthony and Cleopatra*. New York: Harper & Brothers, 1847.

Shepherd, Paul, and Barry Sanders. *The Sacred Paw*. New York: Viking Press, 1985.

Shorter, Alan W. *The Egyptian Gods*. London: Routledge & Kegan Paul, 1981.

Smith, W. Robertson. *The Religion of the Semites*. New York: Shocken Books, 1972.

Spence, Lewis. *Myths and Legends of Mexico and Peru*. Boston: David D. Nickerson, 1913.

———. *Myths and Legends of the North American Indians*. Blauvelt, NY: Multimedia Publishing, 1975.

Srejović, Dragoslav. *Europe's First Monumental Sculpture: New Discoveries at Lepenski Vir*. New York: Stein and Day Publishers, 1972.

Stanton, Elizabeth Cady, with the Revising Committee of 1894. *The Woman's Bible*. Reprint, Seattle, WA: Coalition Task Force on Women and Religion, 1974.

Stone, Merlin. *Ancient Mirrors of Womanhood*. New York: New Sibylline Books, 1979.

―――. *When God Was a Woman*. New York: Dial Press, 1976.

Tacitus. *Germania*. Translated by H. Mattingly. Harmondsworth, England: Penguin Books, 1948.

Temple, Robert K. G. *The Sirius Mystery*. London: Sidgwick and Jackson, 1976.

Torbrugge, Walter. *Prehistoric European Art*. New York: Harry N. Abrams, 1968.

Vats, Madho Sarup. *Excavations at Harappa*. Delhi: Bhartiya Publishing House, 1974.

Vermaseren, Maarten J. *Cybele and Attis: The Myth and the Cult*. London: Thames and Hudson, 1977.

Von Cles-Redon, Sibylle. *The Realm of the Great Goddess*. Englewood, NJ: Prentice-Hall, 1962.

Waley, Arthur. *The Way and Its Power: A Study of the Tao Tê Ching and Its Place in Chinese Thought*. Boston and New York: Houghton Mifflin, 1935.

Walker, Barbara. *The Woman's Encyclopedia of Myths and Secrets*. San Francisco: Harper & Row, 1983.

Warren, Peter. *Myrtos*. London: Thames and Hudson, 1972.

Waterbury, Florence. *Bird Deities in China*. Ascona, Switzerland: Artibus Asiae, 1952.

Waters, Frank. *Book of the Hopi*. New York: Viking Press, 1963.

Wawrytko, Sandra A. *The Undercurrent of Feminine Philosophy in Eastern and Western Thought*. Washington, D.C.: University Press of America, 1981.

Webb, W. S., and R. S. Baley. *The Adena People*. Columbus, OH: Ohio State University Press, 1957.

Westermark, E. A. *Ritual and Belief in Morocco*. 2 vols. New York: Macmillan, 1968.

Wolkenstein, Diane, and Samuel Noah Kramer. *Inanna: Queen of Heaven and Earth*. New York: Harper & Row, 1983.

Woolley, Leonard. *Excavations at Ur*. New York: Thomas Y. Crowell, 1954.

―――. *History Unearthed*. New York: Frederick A. Praeger, 1963.

Zimmer, Heinrich. *The Art of Indian Asia*. 2 vols. Edited by J. Campbell. Bollingen Foundation Series XXXIX. New York: Pantheon Books, 1955.

―――. *The King and the Corpse*. Bollingen Foundation Series XI. New York: Pantheon Books, 1948.

―――. *Myths and Symbols in Indian Art and Civilization*. Bollingen Foundation Series VI. New York: Pantheon Books, 1946.

Zvelebil, Marek. "Postglacial Foraging in the Forests of Europe." *Scientific American* 254 (1986).

Credits

If not otherwise indicated, drawings and photos are courtesy of author.

PHOTOGRAPHS AND DRAWINGS

1. Drawing.

2. Nude figure, Petersfel, Germany. Photo: © Alexander Marshack, 1972.

3. Figures on a boulder, La Roche, Dordogne, France.

4. Drawing.

5. Ivory head of a woman from Grotte Du Pape, Brassempouy, Landes, France. Musée des Antiquités Nationales, St. Germain-en-Laye, France. Photo: Cliché des Musées Nationaux, Paris.

6. Drawing.

7. *La Polichinelle* found outside the Cavern of the Grimaldi, Menton, France. Musée des Antiquités Nationales, St. Germain-en-Laye, France. Photo: Cliché des Musées Nationaux, Paris.

8. Gravatian adolescent figure from the rock shelter of Cazelle, Sireuil, France. Musée des Antiquités Nationales, St. Germain-en-Laye, France. Photo: Cliché des Musées Nationaux, Paris.

9. Ice-Age deity—Venus I from Dolní Věstonice. Moravské Museum, Anthropos Institut, Brno, Czechoslovakia (U.S.S.R.).

10. Venus of Lespugue (side view), Haute Garonne, France, Paleolithic. Ivory. Courtesy of Department of Library Services, American Museum of Natural History, New York (negative #127136).

11. Venus of Lespugue (back view), Haute Garonne, France, Paleolithic. Ivory. Collection Musée de l'Homme, Paris. Photo: J. Oster.

12. Mezin figures. Photo: © Alexander Marshack, 1972.

13. Drawing.

14. Bird-masked figures, Addaura, Sicily. Cave engraving.

15. Drawing.

16. Drawing.

17. Drawing.

18. Drawing. After Gimbutas, *Goddesses and Gods.*

19. Drawing. Courtesy of Marija Gimbutas. From *The Goddesses and Gods of Old Europe*, by Marija Gimbutas (Berkeley: University of California Press, 1982).

20. Goddess of Vidra. Historical Museum of the City of Bucharest, Rumania.

21. Tarxien figure, Malta, ca. 3000 B.C.E. Clay. Photo: Adam Woolfitt/ Susan Griggs Agency Ltd.

22. Nut the Creatrix, tomb of Ramesses VI, Thebes, Egypt, 20th Dynasty, ca. twelfth century B.C.E. Papyrus. Egyptian Museum, Cairo.

23. Drawing.

24. Drawing.

25. Mycenaean divinity with doves, from Shaft Grave 3, Citadel, Mycenae, ca. 1550–1400 B.C.E. Gold. Courtesy of the National Archaeological Museum, Athens.

26. Laksmi riding an owl, nineteenth century C.E. Bronze. Photo: Reuben Goldberg, Philadelphia.

27. Aerial view of Silbury Hill, U.K. Photo: © Marilyn Bridges, 1985. From *Markings*, by Marilyn Bridges (NY: Aperture, 1986).

28. Minoan terra-cotta figurine of a goddess with raised arms, and crowned with birds, cone and bull's horns, Gazi (near Heraklion), ca. 1400–1200 B.C.E. Heraklion Museum, Crete. Photo: Constantine Koulatsoglou. Also on p. 6.

29. Bird woman, Senofu tribe, Ivory Coast, contemporary. Multi-colored wood, H. 126 cm. Collection Musée de l'Homme, Paris. Photo: J. Oster.

30. Dove on altar of Salerno Cathedral. Photo: Bildarchiv Foto Marburg.

31. Drawing.

32. Drawing.

33. Costantino Nivola, *Mother's Secret*, 1986–1987. Pink marble, 22×31 in. Courtesy of Washburn Gallery, New York.

34. Amratian dish of cosmic creation, Egypt, Prehistoric. Egyptian Museum, Cairo.

35. Hourglass figure of water goddess on water jar, from Traian. Historical Museum of the Socialist Republic of Rumania, Bucharest.

36. Drawing. Courtesy of Marija Gimbutas. From *The Goddesses and Gods of Old Europe* (Berkeley: University of California Press, 1982).

37. Drawing. Courtesy of Marija

129. Drawing. Courtesy of Marija Gimbutas. From *The Goddesses and Gods of Old Europe*, by Marija Gimbutas (Berkeley: University of California Press, 1982).

130. Hellenistic goddess of death with her hound. Reproduced by courtesy of the Trustees of the British Museum.

131. Worship of Dog Anubis. Photo: Hirmer Fotoarchiv München. Detail on p. 112.

132. Anubis reclines on a gold pylon, tomb of Tutankhamun, Egypt, 18th Dynasty, ca. fourteenth century B.C.E. Egyptian Museum, Cairo.

133. Mimbre Bowl, ca. 900–1150 C.E. Taylor Museum of the Colorado Springs Fine Arts Center, TM 4589.

134. Drawing. After Giedion.

135. Drawing. After Mundkur.

136. Neolithic painted terra-cotta figurine of seated mother with child, fourth millennium B.C.E. Courtesy of the National Archaeological Museum, Athens.

137. Cucuteni figure from Bernovo-Luka. Hermitage Museum, Leningrad.

138. Goddess with bifid tongue, Kamnik, Albania, Neolithic. Painted terra-cotta. Courtesy of Professor Balaji Mundkur.

139. Mycenaean goddess with child. Clay. Photo: Laurie Platt Winfrey Inc.

140. Neolithic statuette of a seated deity covered with engraved bands, from Kato Ierapetia, Crete, fourth millennium B.C.E. Heraklion Museum, Crete, collection of Dr. Giamalakis. Courtesy of TAP Service.

141. Deity with serpent child, sixth century B.C.E. Terra-cotta. Staatliche Antikensammlungen München, Inv. 5289.

142. Terra-cotta model of a shrine with divinity inside. Archanes, Crete, ca. 1100–1000 B.C.E. Heraklion Museum, Crete, collection of Dr. Giamalakis.

143. Bird-headed deity with diagonal stripes holding snake child, Mycenae, ca. 1400 B.C.E. Courtesy of the National Archaeological Museum, Athens.

144. Drawing.

145. Drawing. After Gimbutas, *Goddesses and Gods*.

146. Lady of Pazardzik, mid-third millennium B.C.E. Museum of Natural History, Vienna.

147. Neith, tomb of Tutankhamun, Egypt, 18th Dynasty, ca. fourteenth century B.C.E. H. 22¼ in. Photo: Lee Boltin Picture Library.

148. Renenutet in cobra form. Egyptian Museum, Cairo.

149. Drawing.

150. Winged Isis. Egyptian Museum, Cairo.

151. Horned Isis. Metal. Reproduced by courtesy of the Trustees of the British Museum (Department of Egyptian Antiquities).

152. Anat holding serpents, Ras Shamra, Syria, thirteenth century B.C.E. Gold. Musée du Louvre. Photo: Cliché des Musées Nationaux, Paris. Also on p. 346.

153. Serpent-headed goddess with child. Courtesy of Ministry of Culture and Information, State Organization of Antiquities and Heritage, Baghdad, Republic of Iraq.

154. Drawing.

155. Lady of the Beasts and Mistress of Water, Khafaje, Iraq, ca. 2700 B.C.E. Stone relief, H. 4.5 in. Reproduced by courtesy of the Trustees of the British Museum (Department of Western Asiatic Antiquities).

156. Dea Syria, Atargatis, Rome. Bronze. Museo Nazionale Romano.

157. Minoan Snake Goddess figurine, Palace of Knossos, Crete, ca. 1500 B.C.E. Faience, H. 23 cm. Heraklion Museum, Crete.

158. Serpent goddess of Knossos brandishing snakes, Palace of Knossos, ca. 1500 B.C.E. Faience. Heraklion Museum, Crete. Photo: Nimatallah / Art Resource.

159. Minoan snake goddess, Crete, 1600–1500 B.C.E. Gold and ivory, H. 6.5 in. Courtesy of Museum of Fine Arts, Boston. Gift of Mrs. W. Scott Fitz.

160. Drawing. After Gimbutas.

161. Drawing.

162. Minoan gold ring with a ritual scene picturing the descent of a deity, Isopata, Crete, fifteenth century B.C.E. Heraklion Museum, Crete. Photo: Constantine Koulatsoglou.

163. Drawing.

164. Terra-cotta representation of four women dancing, Crete, ca. 1400 B.C.E. Heraklion Museum, Crete. Photo: Constantine Koulatsoglou.

165. Bird-headed figurine with double spiral curls, Sitagroi mound, East Balkan civilization. Philipi Museum, Sitagroi, Greece. Courtesy of Marija Gimbutas.

166. Drawing.

167. Medusa with snake locks. Museo Nazionale di Villa Giulia, Rome. Photo: Scala / Art Resource.

168. Gorgon Medusa in swastika position, Temple of Artemis, Corfu, 590–580 B.C.E. Marble relief. Museum of Corfu. Photo: Art Resource.

169. Herakles in the Garden of the Hesperides, attributed to the Pasithea Painter, Greece, fifth century B.C.E. Red-figured vase, H. 9¹³⁄₁₆ in. The Metropolitan Museum of Art, Rogers Fund, 1908 (08.258.20). Detail on p. 120.

170. Serpent head, Athens, Greece. Photo: Bildarchiv Foto Marburg.

171. Athena's snake-fringed mantle, sixth century B.C.E. Bronze. Courtesy of the National Archaeological Museum, Athens.

172. Drawing.

173. Drawing.

174. Zeus as serpent, Zea Islands, Cyclades, fourth century B.C.E. Marble. Staatliche Museen zu Berlin, GDR.

175. Hecate with a snake,

sanctuary of Artemis Orthia, Sparta, eighth century B.C.E. Ivory plaque. Courtesy of the National Archaeological Museum, Athens.

176. Medea and Jason with the guardian serpent. Basilica de Porta Maggiore, Rome, Italy.

177. Demeter with wheat, poppies and snakes. Terracotta relief. Museo Nazionale Romano. Reproduced courtesy of the Soprintendenza Archeologica di Roma.

178. Coatlicue, Aztec serpent goddess, pre-Columbian. Stone. Archivo Fotografico del Instituto Nacional de Antropologia y Historia, Mexico City.

179. Coyolxauhqui, moon goddess. Stone, Diam.10 ft. Museo Templo Mayor, Mexico City.

180. Drawing.

181. Serpent guardian, base of the Castillo, Chichen Itza, Yucatan, Mexico. Archivo Fotografico del Instituto Nacional de Antropologia y Historia, Mexico City.

182. Drawing.

183. Neolithic Chinese head. Museum of Far Eastern Antiquities, Stockholm, Sweden.

184. Chinese Fu Xi and Nu Gua. Reproduced by courtesy of the Trustees of the British Museum (Stein Collection).

185. *Savasana*, 18th century C.E. Collection: Navin Kumar, New York.

186. Drawing.

187. Fardal figurines, Denmark, eighth century B.C.E. Bronze. National Museum, Copenhagen, Denmark. Photo: Lennart Larsen.

188. Serpent goddess in snake-prowed boat, eighth century B.C.E. From P. V. Glob, *The Mound People*. Reconstruction by P. V. Glob. Photo: Lennart Larsen.

189. Drawing.

190. Snake-holding deity in the birth-giving position, Gotlands, Sweden, ca. 400 C.E. Gotlands Historical Museum, Visby, Sweden. Photo: Raymond Hejdström.

191. Serpent mound, Adams County, Ohio. Photo: George Gerster / Photo Researchers.

192. Kakilambe, python goddess worshiped by the Baga tribe of Guinea. Wood and paint, H. 68.5 in. Metropolitan Museum of Art, The Michael C. Rockefeller Memorial Collection, bequest of Nelson A. Rockefeller, 1979 (1979.206.101).

193. Moses with serpent, ca. twelfth century C.E. University Library, Liège, Belgium. Photo: Bildarchiv Foto Marburg.

194. Serpent of St. Ambrogio, Church of St. Ambrogio, Milan, Italy.

195. Chaldean cylinder seal of Gula Bau, ca. 2500 B.C.E. Reproduced by courtesy of the Trustees of the British Museum.

196. Greek coin from Myra. 238–244 C.E. Reproduced by courtesy of the Trustees of the British Museum.

197. Adam and Eve and the serpent, *Codice Vigilano y Albeldense*, fol.17, Biblioteca de El Escorial, reproduced courtesy of the Patrimonio Nacional, Madrid. Photo: © MAS.

198. Drawing.

199. Minoan terra-cotta figurine of a goddess, Palace of Knossos, Crete, ca. 1400–1200 B.C.E. Heraklion Museum, Crete. Detail on p. 192.

200. Drawing.

201. Drawing. After a drawing by Grace Huxtable, reproduced courtesy of Professor James Mellaart.

202. Goddess worshiped as a sheep, Sahara-Atlas, Algeria (Nr. F:1241). Rock engraving. Courtesy of Frobenius-Institut, Wolfgang Goethe Universität, Frankfurt.

203. Ram on an altar between the reed bundles of the deity, Sumerian, ca. 2500 B.C.E. Cylinder seal. Staatliche Museen zu Berlin, GDR. Detail on p. 198.

204. Ram and tree from Ur, 2500 B.C.E. Gold on wooden core, lapis lazuli, shells and red

limestone. Reproduced by courtesy of the Trustees of the British Museum.

205. Minet el Beida, fertility goddess, Ras Shamra, Syria, thirteenth century B.C.E. Fragment of lid of ivory box, .137×.115 m. Department of Oriental Antiquities, Musée du Louvre. Photo: Cliché des Musées Nationaux, Paris.

206. Aphrodite Epiragia Riding a Sheep, first century C.E. Cabinet des Medailles, Bibliothèque Nationale, Paris.

207. Hermes the shepherd wearing winged hat and boots, sixth century B.C.E. Bronze. Courtesy of the National Archaeological Museum, Athens.

208. Phrisus carried across the sea by a ram, Greece, fifth century B.C.E. Terra-cotta, L. 24.6 cm. H. 18.1 cm. The Metropolitan Museum of Art, Rogers Fund, 1912 (12.229.20).

209. Winning of the golden fleece, Syria, fourth to sixth centuries C.E. Limestone, 41¾×34⅜ in. The Nelson-Atkins Museum of Art, Kansas City, Missouri (NAMA 41–36).

210. Medea's magic rejuvenates the ram, sixth century B.C.E. Reproduced by courtesy of the Trustees of the British Museum.

211. Veneration of the spider, Uruk, 3000 B.C.E. Cylinder seal. Courtesy of Musée du Louvre.

212. Shell gorget incised with spider design, mound near Moccasin Bend, Hamilton County, Tennessee. Diam. 5½ in. Courtesy of Museum of the American Indian, Heye Foundation, New York, H. L. Johnson Collection. Also on p. 208.

213. Mimbre bowl showing vinegarone (spider), 900–1150 C.E. Photo: © Western New Mexico University Museum.

214. Drawing.

215. Baying stag, Paleolithic, Cave of Lascaux, France. Photo by Jean Vertut courtesy of Mme. Yvonne Vertut.

216. Mask of red deer skull and antlers. Star Carr, Yorkshire, England, ca. 7500 B.C.E. Reproduced by courtesy of the Trustees of the British Museum.

217. Ritual vase in the form of a doe, Muldava mound, central Bulgaria, early sixth millennium B.C.E. Terra-cotta, L. 64 cm. H. 39 cm. Plovdiv Archaeological Museum. Courtesy of Marija Gimbutas.

218. Drawing.

219. Drawing.

220. Plaque from Ninkhursaq's temple. Al Ubaid. Reproduced by courtesy of the Trustees of the British Museum.

221. François Vase signed by Kleitias, Chiusi, Tuscany, sixth century B.C.E. Detail of Attic black-figured krater. Reproduced courtesy of the Soprintendenza Archeologica per la Toscana, Firenze. Detail on p. 214.

222. Villa Nova cult wagon. Landesmuseum Joanneum Graz, Abteilung für Vor-und Frühge-schichte im Schloss Eggenberg, Austria. Photo: Hofstetter-Dia.

223. Drawing.

224. Paleolithic deer, fish and diamond glyph. Engraved on a tyne from Lorthet, France. Musée des Antiquités Nationales, St. Germain-en-Laye, France. Photo: Roger-Viollet, Paris.

225. Drawing.

226. Drawing.

227. Drawing.

228. Geometric Greek shard, Tiryns, Greece, mid-eighth century B.C.E. Nauplion Museum, Greece.

229. Dolphins on Magdalenian deer horn, France. Photo: Bildarchiv Foto Marburg.

230. Drawing.

231. Lepenski Vir fish goddess.

232. *Ninurta shooting An.Zu.* Assyrian cylinder seal. Courtesy of The Pierpont Morgan Library, New York, no. 689.

233. Figures dancing around a phallus. Reproduced courtesy of the Soprintendenza Archeologico per L'Etruria Meridionale.

234. Rites of the Haloa Harvest Festival. Staatliche Museen zu Berlin, GDR.

235. Vishnu in his fish incarnation (Matsya Avatar). Philadelphia Museum of Art: purchased.

236. Fish and lozenge, Han Dynasty. Musées Royaux d'Art et d'Histoire, Brussels, Belgium.

237. Drawing.

238. Christian loaf and fishes with glyphs from a Byzantine church, Tabgah, Israel. Photo: Zev Radovan.

239. Loaves and fishes. Detail of base of North Cross, Castledermot, County Kildare, Ireland. Courtesy of The Photographic Section, National Parks and Monuments Branch, Office of Public Works, Dublin, Ireland.

240. Drawing.

241. Drawing. After Hentze, "Le Poisson Comme Symbole du Fecundité dans la Chine Ancienne."

242. Artemis with fish on her apron, Boeotia, seventh century B.C.E. Terra-cotta amphora. Photo: Laurie Platt Winfrey Inc. Detail on p. 222.

243. Paul Klee, *Around the Fish*, 1926. Oil on canvas, 18⅜×25⅛ in. Collection, The Museum of Modern Art, New York. Abby Aldrich Rockefeller Fund.

244. Aphrodite on a dolphin. Staatliche Museen zu Berlin, GDR.

245. Drawing.

246. Drawing.

247. Goddess of the flowing vase. Mari, Iran, eighteenth century B.C.E. Photo: Jean Mazenod, *L'Art Antique Du Proche Orient*, Editions Mazenod-Paris.

248. God of the flowing vase. Staatliche Museen zu Berlin, GDR. Photo: Bildarchiv Foto Marburg.

249. Drawing.

250. Early Cycladic bronze mirror, incised with sun, connecting spirals and fish, Naxos, third millennium B.C.E. Courtesy of the National Archaeological Museum, Athens.

251. Detail of fish from a stained glass window, Chartres Cathedral, France.

252. Drawing.

253. Shell cup, Lambayeque, Peru. H. 9⅜ in. Courtesy of Museum of the American Indian, Heye Foundation, New York.

254. Drawing.

255. Hat Mehit crowned with a fish, Egypt, 1580–1100 B.C.E. Bronze. Liverpool Museum.

256. Hathor in fish form. Egyptian Collection, Kunsthistorisches Museum, Vienna.

257. Anubis with the fish as mummy, Thebes, Deir el Medinah, tomb of Kha'beknet #2, 19th Dynasty, Ramesses II, or 1304–1237 B.C.E.

258. Stone Age tomb in the form of a shark. Courtesy of Cambridge University Museum of Archaeology and Anthropology, England.

259. Sacred garden and fish pond, tomb painting, wall fragment. Reproduced by courtesy of the Trustees of the British Museum.

260. Drawing.

261. Drawing.

262. Drawing.

263. Head of a pig from the site of Leskavica, eastern Macedonia, ca. mid-fifth millennium B.C.E. Terra-cotta, H. 19 cm. National Museum, Belgrade, Yugoslavia. Courtesy of Marija Gimbutas.

264. Drawing. After Neumann.

265. Fragment of a marble drapery from Demeter's statue, from Despoina's sanctuary at Lykosoura, second century B.C.E. Courtesy of the National Archaeological Museum, Athens.

266. Drawing.

267. Sow goddess, India. Photo: Laurie Platt Winfrey Inc. Also on p. 260.

268. Black-headed cow, Cave of Lascaux, France. Photo by Jean Vertut courtesy of Mme. Yvonne Vertut.

269. Leaping cows with horses, Cave of Lascaux, France. Photo by Jean Vertut courtesy of Mme. Yvonne Vertut.

270. Kneeling bull holding vessel, Iran, ca. 2900 B.C.E. Silver. H. 6⁷⁄₁₆ in. W. 2½ in. The Metropolitan Museum of Art, Purchase Joseph Pulitzer Bequest, 1966 (66.173).

271. Cow with suckling calf. Musée du Louvre. Photo: Cliché des Musées Nationaux, Paris.

272. Drawing.

273. Drawing.

274. Amratian slate palette. Egyptian Museum, Cairo.

275. Hathor emerging from the papyrus, Book of the Dead of Userhetmos, Egypt, 19th Dynasty, 1320–1200 B.C.E. Painting on papyrus. Egyptian Museum, Cairo.

276. Sistrum: Head of the goddess Hathor, Egypt, Saite Period (663–529 B.C.E.). Faience. The Metropolitan Museum of Art, purchase, Edward S. Harkness gift, 1926.

277. Drawing.

278. Hathor and Amenofis II, Deir el-Bahri, 18th Dynasty, Egypt. Egyptian Museum, Cairo. Photo: Borromeo/EPA/Art Resource.

279. Europa riding the bull. Museo Nazionale di Palermo. Photo: Hirmer Fotoarchiv München.

280. Minoan rhyton as ox-drawn cart with driver and three heads of bulls, Crete, twelfth to eleventh centuries B.C.E. Heraklion Museum, Crete. Photo: George Xylouris.

281. Cow kachina, Zuni, ca. 1850. Cottonwood, feathers, beads, buckskin, 8½ × 15 in. Millicent Rogers Museum, Taos, New Mexico (MRM 1978–8).

282. George A. Catlin, *Mandan Indian Buffalo Dance*. Oil on canvas. Transparency No. 904(2), Courtesy of Department of Library Services, American Museum of Natural History, New York.

283. Drawing.

284. Lao-tzu on a water buffalo, Chinese, Sung Dynasty (960–1280 C.E.). Bronze incense burner. Worcester Art Museum, Worcester, MA (1931.100).

285. Çatal Hüyük goddess giving birth to a bull. Photograph from a drawing by Grace Huxtable, reproduced courtesy of Professor James Mellaart.

286. Nude goddess stands on a bull, ca. 1300 B.C.E. Musée du Louvre.

287. Drawing.

288. The bull as figurehead on the Harp of Ur. Reproduced by courtesy of the Trustees of the British Museum.

289. Balinese funeral sarcophagi.

290. Drawing.

291. Drawing.

292. Cretan bull's head with quatrefoils. Reproduced by courtesy of the Trustees of the British Museum. Also on p. 268.

293. Drawing.

294. Votary bull's head mask, Cyrpus, pre-1200 B.C.E. Terra-cotta. The Metropolitan Museum of Art, The Cesnola Collection, purchased by subscription, 1874–76 (74.51.1619).

295. Cretan bull game. Heraklion Museum, Crete. Photo: Nimatallah / Art Resource.

296. Head of great black bull, Cave of Lascaux, France. Photo by Jean Vertut courtesy of Mme. Yvonne Vertut.

297. Bull with rosette. Courtesy of the National Archaeological Museum, Athens.

298. Hadad seated on a bull with lightning in each hand, eighth century B.C.E. Musée du Louvre. Photo: © Arch. Phot./S.P.A.D.E.M.

299. Moon and god Sin. Hermitage Museum, Leningrad.

300. Drawing.

301. Cult boat with Inanna's altar. Staatliche Museen zu Berlin, GDR.

302. Mithra slaying the bull.

Karlsruhe Museum. Photo: Alinari/ Art Resource.

303. Catafalque of the Apis bull. Egyptian Museum, Cairo.

304. Apis bull before an obelisk. Reproduced by courtesy of the Trustees of the British Museum.

305. Drawing.

306. Durga killing the buffalo Titan. Philadelphia Museum of Art: Purchased.

307. Bull as capital at Persepolis. Musée du Louvre. Photo: Editions Tel (D.R.).

308. Silver pin with gold decoration in the shape of the Lady of the Plants, Mycenae, sixteenth century B.C.E. Courtesy of the National Archaeological Museum, Athens.

309. Moses and the Golden Calf, English psalter. Photo: Bildarchiv Foto Marburg/Art Resource.

310. The ox and the ass at the nativity of Christ, Byzantine stone relief, fourth to fifth centuries C.E. Byzantine Museum, Athens. Courtesy of TAP Service.

311. Sassoferrato, *The Virgin and Child Seated on the New Moon*. Biblioteca Vaticana, Rome. I.C.C.D. Roma D 3041.

312. The Venus of Laussel, Dordogne, France, 20,000–18,000 B.C.E. Limestone relief. Musée d'Aquitaine, Bordeaux. Photo: J. M. Arnaud. All rights reserved.

313. Weather god on triple bucranium. Hermitage Museum, Leningrad.

314. Weather god driving water-spewing bull. Detail from gold bowl, Hasanlu, Iran, 1000 B.C.E. Archaeological Museum, Teheran, Iran.

315. Chou Dynasty ceremonial bowl with buffalo heads on handles, Chinese, 1027–256 B.C.E. Bronze, 9⅛ in. × 14⅝ in. Courtesy of the Freer Gallery of Art, Smithsonian Institution, Washington, D.C. (#31.10).

316. Venus and the virgin from astrological treatise from arabic of Albumasar, abridged from the Latin

translation from Hermann the Dalmatian. Ca. 1403. Courtesy of The Pierpont Morgan Library, New York. n. 785, folio 44v.

317. Prehistoric women dancing, cave painting, Cogul, Lerida, Spain. Photo: © MAS. Detail on p. xiv.

318. Drawing.

319. Selket, the scorpion deity of Egypt, as sphinx. Courtesy of Musée du Louvre.

320. Drawing.

321. Drawing.

322. Drawing.

323. Selket protecting the canopic shrine, tomb of Tutankhamun, 18th Dynasty, ca. fourteenth century B.C.E. Egyptian Museum, Cairo. Photo: Lee Boltin Picture Library. Detail on p. 330.

324. Mimbre bowl showing scorpion, ca. 900–1150 C.E. © Fred Kabotie, *Designs from the Ancient Mimbreños with a Hopi Interpretation* (Flagstaff, AZ: Northland Press, 1982).

325. Indian scorpion goddess raising the world. Collection of the author.

326. Drawing.

327. Ice Age engraving of bear, Finnhaugen rock carving, Norland, Norway. Photo: University Museum of National Antiquities, University of Oslo, Norway.

328. Headless bear mother and cub, Cave of Ekain, Spain. Photo: © G. de G. Sieveking.

329. Amber bear from Resen Mose, Mesolithic. National Museum, Copenhagen, Denmark. Photo: Lennart Larsen.

330. Bear-shaped vase. Smilčić site near Zadar, Adriatic coast of Yugoslavia. Second half of sixth millennium B.C.E. H. 10 cm. Archaeological Museum, Zadar, Yugoslavia. Courtesy of Marija Gimbutas.

331. Bear Madonna, from Fafos II at Kosovska Mitrovica, Yugoslavia. Terra-cotta, impure clay, H. 5.7 cm. National Museum, Belgrade, Yugoslavia. Courtesy of Marija Gimbutas.

332. Dea Artio, bear goddess, found at Muri, Switzerland, late second century C.E. Bronze, pedestal length 28.6 cm. Bern Historical Museum, Switzerland. Detail on p. 336.

COLOR PLATES

Plate 1. Water goddess in bell skirt, 700 B.C.E. Ceramic. Musée du Louvre. Photo: Cliché des Musées Nationaux, Paris.

Plate 2. *La Polichinelle* found outside the Cavern of the Grimaldi, Menton, France. Musées des Antiquités Nationales, St. Germain-en-Laye, France. Photo: Cliché des Musées Nationaux, Paris.

Plate 3. Venus of Lespugue (front view), Haute Garonne, France, Paleolithic. Ivory. Collection Musée de l'Homme, Paris. Photo: J. Oster.

Plate 4. Nut the Creatrix, tomb of Ramses VI, Thebes, Egypt, 20th Dynasty, ca. twelfth century B.C.E. Papyrus. Egyptian Museum, Cairo.

Plate 5. Tarxien figure, Malta, ca. 3000 B.C.E. Clay. Photo: Adam Woolfitt/Susan Griggs Agency Ltd.

Plate 6. Minoan terra-cotta figurine of a goddess with raised arms, and crowned with birds, cone, and bull horns, Gazi (near Heraklion), ca. 1400–1200 B.C.E. Heraklion Museum, Crete. Photo: Constantine Koulatsoglou.

Plate 7. Shaft with breasts, Dolní Věstonice, Paleolithic. Moravské Museum, Anthropos Institut, Brno, Czechoslovakia (U.S.S.R.).

Plate 8. Astarte holding a vessel, Turgi, Spain, fifth century B.C.E. Alabaster. National Archaeological Museum, Madrid, Spain.

Plate 9. Owl-headed Madonna, late Bronze Age, ca. 1450–1225 B.C.E. Clay, H. 14 in. By permission of the Director of Antiquities and the Cyprus Museum, Nicosia. 1964/IX-818.

Plate 10. Kwakiutl mask, contemporary. University of British Columbia Museum of Anthropology. Photo: J. L. Gijssen and M. Cotic.

Plate 11. Scene from sarcophagus of Hagia Triada. Photo: Nimatallah/Art Resource.

Plate 12. Altar in the form of a tripartite shrine with birds, shaft grave 4, citadel, Mycenae, ca. 1550–1500 B.C.E. Gold. Courtesy of the National Archaeological Museum, Athens.

Plate 13. Paleolithic shrine of mammoth bones, Ukraine. Photo: Hank Morgan.

Plate 14. Bird-headed temple model in human form. Photo: Giraudon/Art Resource.

Plate 15. Bird-masked man and bird on pole, Cave of Lascaux, France. Photo by Jean Vertut courtesy of Mme. Yvonne Vertut.

Plate 16. Egyptian tree goddess, Tomb of Panehsy, Thebes, Egypt. Wall painting.

Plate 17. Aphrodite on shell. Musée du Louvre. Photo: Cliché des Musées Nationaux, Paris.

Plate 18. Minoan gold ring with a ritual scene picturing the descent of a deity. Isopata, Crete, fifteenth century B.C.E. Heraklion Museum, Crete. Photo: Constantine Koulatsoglou.

Plate 19. Anubis reclines on a gold pylon, tomb of Tutankhamun, Egypt, 18th Dynasty, ca. fourteenth century B.C.E. Egyptian Museum, Cairo.

Plate 20. Coatlicue, Aztec serpent goddess, pre-Columbian. Stone. Archivo Fotografico del Instituto Nacional de Antropologia y Historia, Mexico City.

Plate 21. Lion Gate to the citadel, Mycenae, Greece. Photo: Scala/Art Resource.

Plate 22. Winged Isis. Egyptian Museum, Cairo.

Plate 23. Neith, tomb of Tutankhamun, Egypt, 18th Dynasty, ca. fourteenth century

B.C.E. H. 22¼ in. Photo: Lee Boltin Picture Library.

Plate 24. Bird-headed deity with diagonal stripes holding snake child. Mycenae, ca. 1400 B.C.E. Courtesy of the National Archaeological Museum, Athens.

Plate 25. Serpent goddess of Knossos brandishing snakes, Palace of Knossos, ca. 1500 B.C.E. Faience. Heraklion Museum, Crete. Photo: Nimatallah/Art Resource.

Plate 26. The Black Virgin. Collection of Tony Smith.

Plate 27. Mother Goose and Her Bird on a Broomstick. Cover art from *Mother Goose's Nursery Rhymes* (London: Frederick Warne & Co.). Collection of the author.

Plate 28. Goddess on lion birth throne, Çatal Hüyük, 7100–6300 B.C.E. Photo: courtesy of Eahr Joan and Lisa Foley.

Plate 29. Serpent-headed goddess with child. Courtesy of Ministry of Culture and Information, State Organization of Antiquities and Heritage, Baghdad, Republic of Iraq.

Plate 30. Terra-cotta model of a shrine with divinity inside. Archanes, Crete, ca. 1100–1000 B.C.E. Heraklion Museum, Crete, collection of Dr. Giamalakis.

Plate 31. *Savasana*, eighteenth century C.E. Collection: Navin Kumar, New York.

Plate 32. Serpent mound, Adams County, Ohio. Photo: George Gerster/Photo Researchers.

Plate 33. Minoan Snake Goddess figurine, Palace of Knossos, Crete, ca. 1500 B.C.E. Faience, H. 23 cm. Heraklion Museum, Crete.

Plate 34. The Venus of Laussel, Dordogne, France, 20,000–18,000 B.C.E. Limestone relief. Musée d'Aquitaine, Bordeaux. Photo: J. M. Arnaud. All rights reserved.

Plate 35. Dea Artio, bear goddess, found at Muri, Switzerland, late second century C.E. Bronze, pedestal length 28.6 cm. Bern Historical Museum, Switzerland.

Plate 36. Lepenski Vir fish goddess.

Plate 37. Detail of fish from a stained glass window, Chartres Cathedral, France.

Plate 38. Paul Klee, *Around the Fish*, 1926. Oil on canvas, 18⅜ × 25⅛ in. Collection, The Museum of Modern Art, New York. Abby Aldrich Rockefeller Fund.

Plate 39. Hathor emerging from the papyrus, Book of the Dead of Userhetmos, Egypt, 19th Dynasty, 1320–1200 B.C.E. Painting on papyrus. Egyptian Museum, Cairo.

Plate 40. Baying stag, Paleolithic, Cave of Lascaux, France. Photo by Jean Vertut courtesy of Mme. Yvonne Vertut.

Plate 41. Europa riding the bull. Museo Nazionale di Palermo.

Plate 42. Kneeling bull holding vessel, Iran, ca. 2900 B.C.E. Silver. H. 6⁷⁄₁₆ in. W. 2½ in. The Metropolitan Museum of Art, Purchase Joseph Pulitzer Bequest, 1966 (66.173).

Plate 43. Black-headed cow, Cave of Lascaux, France. Photo by Jean Vertut courtesy of Mme. Yvonne Vertut.

Plate 44. Ram and tree from Ur, 2500 B.C.E. Gold on wooden core, lapis lazuli, shells and red limestone. Reproduced by courtesy of the Trustees of the British Museum.

Plate 45. George Catlin, *Mandan Indian Buffalo Dance*. Oil on canvas. American Museum of Natural History, New York.

Plate 46. Hathor and Amenofis II, Deir el-Bahri, 18th Dynasty, Egypt. Egyptian Museum, Cairo.

Plate 47. The bull as figurehead on the Harp of Ur. Reproduced by courtesy of the Trustees of the British Museum. Photo: Lee Boltin Picture Library.

Plate 48. Minet el Beida, fertility goddess, Ras Shamra, Syria, thirteenth century B.C.E. Fragment of lid of ivory box, .137 × .115 m. Department of Oriental Antiquities, Musée du Louvre. Photo: Cliché des Musées Nationaux, Paris.

Plate 49. Cretan bull game. Heraklion Museum, Crete. Photo: Nimatallah/Art Resource.

Plate 50. Selket protecting the canopic shrine, tomb of Tutankhamun, 18th Dynasty, ca. fourteenth century B.C.E. Egyptian Museum, Cairo. Photo: Lee Boltin Picture Library.

Index